A PORTRAIT OF
THE
TREE

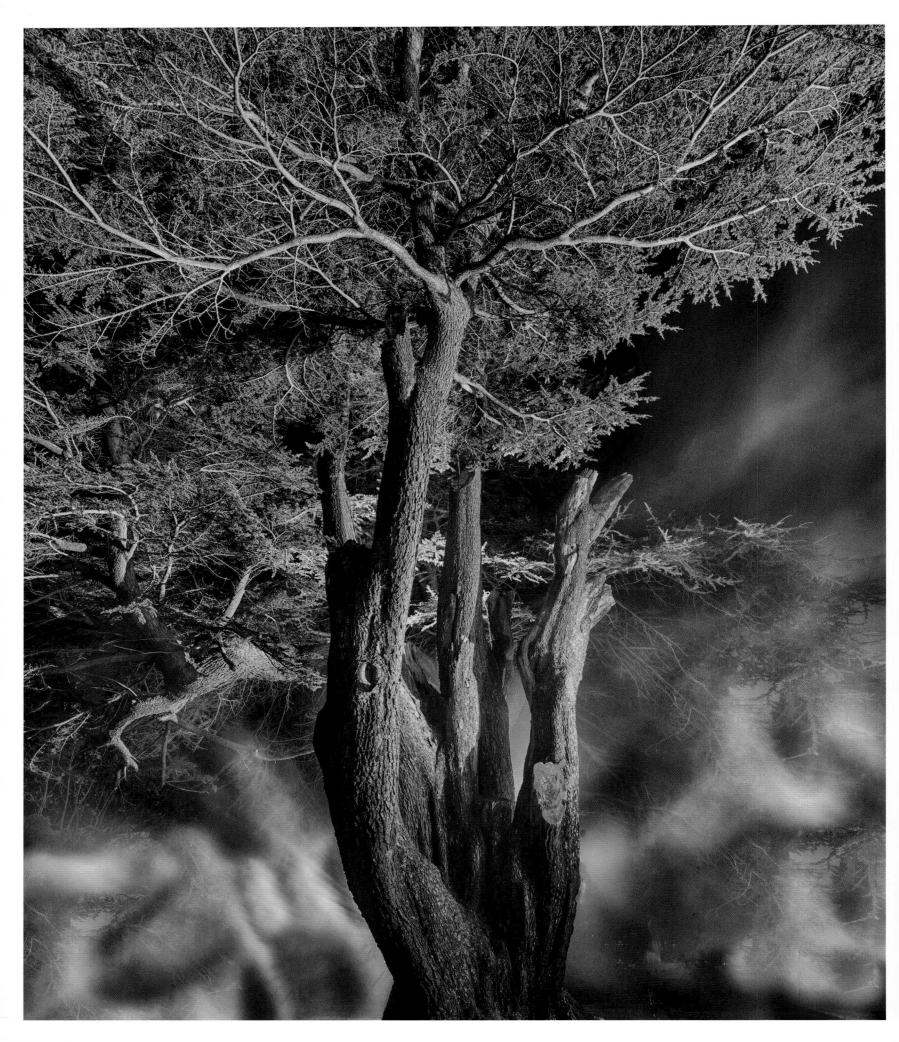

ADRIAN HOUSTON

A PORTRAIT OF
THE
TREE

A CELEBRATION OF FAVOURITE TREES
FROM AROUND BRITAIN

greenfinch

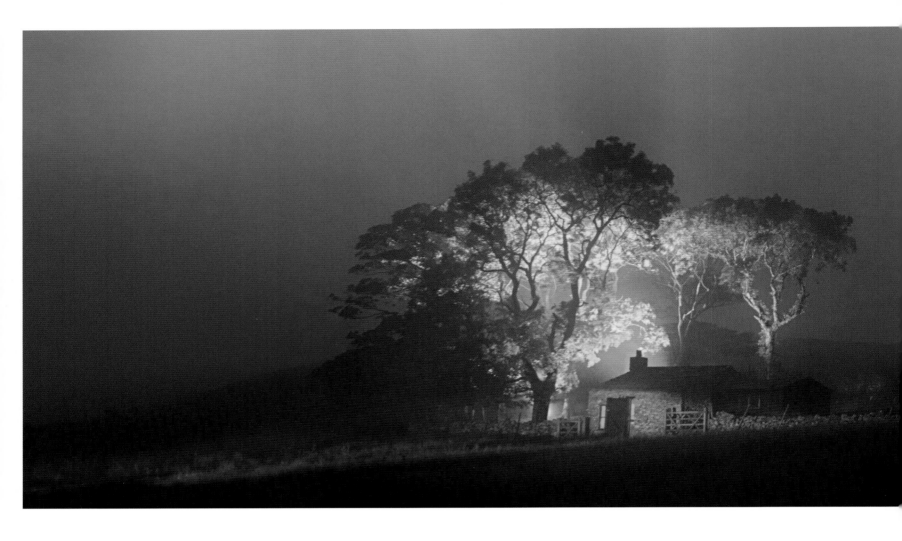

CONTENTS

FOREWORD

'The tree which moves some to tears of joy is in the eyes of others only a green thing which stands in the way. Some see Nature all ridicule and deformity...and some scarce see Nature at all. But to the eyes of the man of imagination, Nature is Imagination itself'
– William Blake

Nature has an intensity so strong it gives you a totally different view on the world. When you witness Earth's natural power, it is sometimes hard to see its underlying fragility. Yet scratch beneath the surface and it is there. This need to protect what we have before it is too late has influenced my work for as long as I can remember.

When you witness first-hand the natural power of the Earth, it makes you realize the sheer force of what surrounds us. Trees are one of the reasons that we exist, and ultimately our survival depends on them, so we must do all we can to protect them. They are part of our life, giving us oxygen, storing carbon, stabilizing our soil, cleaning our water, nurturing the world's wildlife and providing us with the tools for shelter, discovery and warmth.

Over the past four years I have immersed myself in the world of trees. Trees have lived decades longer than any human being on the planet. They are old and wise, and I have acknowledged that with this artistic vision – *A Portrait of the Tree*.

This book was conceived as a way of illustrating how trees connect us all on a universal level. A portrait has to capture the atmosphere, beauty, strength and soul in a moment of time. The trees in this book have been chosen by a diverse group of people who all have strong environmental goals, and the stories behind the chosen subjects are an important link to the photographs themselves. Together, they offer a powerful tool to help educate people, from children through to adults, about the vital role that trees play in all of our lives, which in turn gives these trees a voice.

Trees are the longest-living organisms on the planet and one of the Earth's greatest natural resources. Yet our trees are being affected by deforestation, pollution, global warming and disease. The forest canopy is the Earth's secret ocean, but many are vanishing before they have even been seen by human eyes. So, it's up to us to help, by raising awareness and finding ways for trees to be protected.

The inspiration and mindfulness that I have received through this journey have been rewarding. I think that understanding the importance of our natural world and the need to protect it are part of our soul. I have used the knowledge and experience from my life as a photographer, understanding composition and light, as well as the way light moves across your subject, changing its mood and form throughout the day; connecting with the subject as much as possible to understand its qualities and capture that moment in its life. I have, in some cases, used a warm light source to pick out the structure of the tree from its surroundings, mixed with the twilight of the day or night, keeping the subject as natural as possible. Stimulating people's understanding of trees – not just through the pictures but also through the stories connected with them – is so important. You may often wonder when you see ancient trees how old they might be and what they have seen in their lives: the stories in this book will tell you.

My passion is conservation, and I have been lucky enough to have travelled to some of the world's most unexplored and inhospitable regions. All of these places have given me a true sense of perspective on why it's so important for us to take care of nature. When you understand how insignificant we all are to the natural power of our world, you know that we should do our utmost to not upset it. I hope this book will enable people to look at trees in a different way and not take them for granted. We all need to do our part to protect them and our planet.

Adrian Houston

INTRODUCTION

As Head of the Arboretum at the Royal Botanic Gardens, Kew, responsible for one of the most diverse tree collections on earth, with over 14,000 specimen trees represented from every corner of the temperate world, I have so much admiration, fascination and passion for these remarkable denizens of nature. I have spent much of my working life travelling around the globe visiting native forests, observing how trees grow in their natural habitat and creating arboricultural programmes modelled on these observations.

At Kew we have pioneered new management and conservation techniques such as soil-decompaction and mulching programmes in tree root plates to keep trees healthy and stress-free. Following technical research, we have developed detailed tree-planting specifications to ensure successful tree establishment with few, if any, failures. I have also led expeditions collecting seeds to replant and replenish the scientific tree collections in the arboretum at Kew. This initiative followed the 'Great Storm of 16 October 1987', which felled over 15 million mature trees in the south-east of England alone, with over 700 of these in the Kew arboretum.

Without trees, both in their natural habitats and in our artificial urban environments such as parks, gardens, open spaces and streets, we would struggle to survive as they use the carbon dioxide that we expel as a waste product to produce, through the process of photosynthesis, the oxygen that we need to breathe. There are also many other benefits of growing and maintaining a healthy tree population, such as the prevention of soil erosion and reduction of flooding by slowing water run-off following heavy downpours of rain. Trees provide us with much needed shade under their broad, dense canopies on hot summer days, while at the same time absorbing harmful pollutants and dust from the air that we breathe through their leaves and bark, reducing serious respiratory problems in humans and animals. Established trees break up the vertical

TREES AND THE ENVIRONMENT

According to experts, the world is in the grips of a climate emergency and teetering on the brink of a tipping point, after which the damage to our planet will be irreversible. We need to take drastic action, and we need to take it quickly.

One vital resource in the fight against climate change is the world's trees and woodlands. Through the process of photosynthesis, trees capture carbon and lock it away within themselves. According to the Woodland Trust, a young wood with mixed species can capture as much as **400+ tonnes of carbon per hectare**. As well as capturing carbon, trees can also help prevent flooding and soil erosion, reduce temperatures and pollution in urban areas, and support a diverse ecosystem – all part of tackling the impact of climate change.

However, the UK currently has the lowest woodland coverage of any European nation – only 13 per cent. The Woodland Trust estimates that to achieve the UK's target of reaching carbon neutral by 2050, 1.5 million trees need to be planted.

By planting more trees – and protecting our existing woodland – we will also be tackling another environmental crisis: the biodiversity crisis. A single tree can support a staggering array of wildlife, from small mammals to thousands of different species of invertebrates, from bats and birds to fungi and lichen.

Since 1970, 41 per cent of all woodland species in the UK have been in decline, and globally scientists are warning that we are entering the sixth mass extinction. By increasing woodland coverage, we can support the diverse range of wildlife that thrive there, and help combat this decline.

scale of buildings and hard landscape, and help to absorb city life, improving our mental well-being when we are immersed in their beauty; and it has been medically proven that they help to speed up our recovery time following illness during periods of convalescence when we can see trees and all the biodiversity that they are home to from our hospital beds.

THE CHALLENGES WE FACE

There is no doubt that we are experiencing a shift in our climate, with seasonal change in the UK, and are witnessing more named storms and extreme weather patterns that bring record weather-related events such as 50 mile-per-hour winds and heavy rainfall, with single days of over 40 millimetres in the height of summer, followed by prolonged periods of drought and record temperatures of 30 degrees Centigrade and above becoming the norm. These are natural events that test us every day as professional arboriculturists, tree planters and managers, as we work hard to maintain a healthy treescape.

Our landscape is also under threat from an increasing number of introduced pests and diseases. In the 1960s and 70s, Dutch elm disease ravaged our native elm population, spread by a beetle vector, changing the appearance of the hedgerows and treescape across the British Isles as these large specimen trees were removed for health and safety reasons. Today we are faced with a similar fungal problem with native ash trees. Chalara dieback of ash, spread by wind and causing untold damage to our ash woodlands from England to Scotland, Wales and Ireland, has the potential to kill up to 80 per cent of our ash population, which will have a devastating effect on the landscape.

Not far away from our shores is the threat of another invasive species in the form of a beetle, the emerald ash borer. Native to north-east Asia, it was introduced to the USA and has killed tens of millions of

native American ash trees so far. Should, or rather when, it reaches our shores, it will most probably kill all the remaining ash trees that have shown some resistance to and survived Chalara dieback.

PLANTING FOR THE FUTURE

We plant trees in our gardens and landscape to enjoy their seasonal, ornamental beauty. Whether it be in winter, for the skeletal, architectural network of their branching structure and outline form; or the spring and summer colour, size and shape of the foliage and flowers; running through into the autumn and the myriad shades of colour before leaf fall in preparation for another round of winter rest. All of these attributes increase the value of our trees in the landscape while at the same time producing a robust refuge for biodiversity. All trees play an important role in supporting myriad forms of biodiversity – including fungi and mosses, invertebrates, birds and mammals – and the more biodiversity in a tree or a woodland, the healthier and stronger the ecosystem is deemed to be.

Woodland cover in the UK is the lowest in Europe, and we need to protect and preserve the trees that we already have growing while at the same time increase canopy cover by planting and establishing more trees with a diverse population of species that will be more resilient to climate change, more resistant to invasive pathogens from around the world, and have the ability to absorb human activity across the UK and the world, to help mitigate all of these abnormal events. To help us do this, we need to inspire more people, from children to adults, to have a greater understanding of trees, tree biology and the importance of trees. Capturing trees at their best through the camera – as Adrian has done in this collection – can help achieve this.

Tony Kirkham, MBE, VMH
Head of the Arboretum, Gardens and Horticultural Services,
Royal Botanic Gardens, Kew

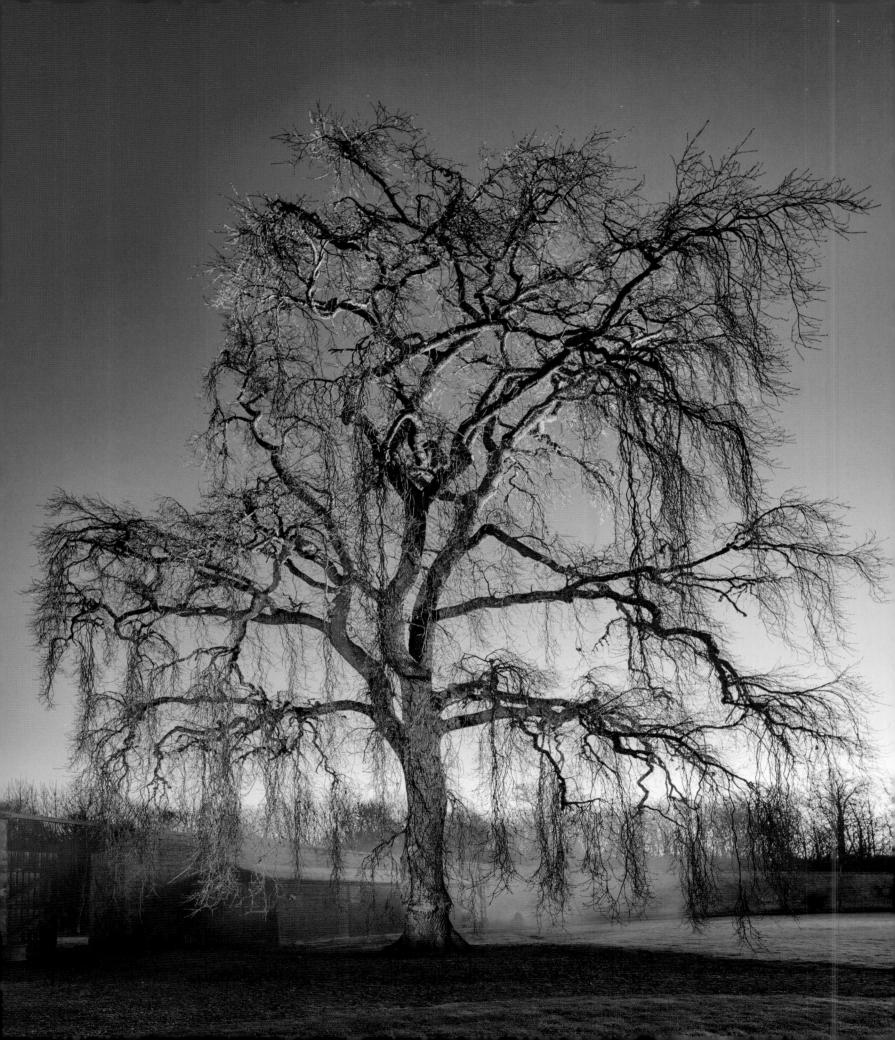

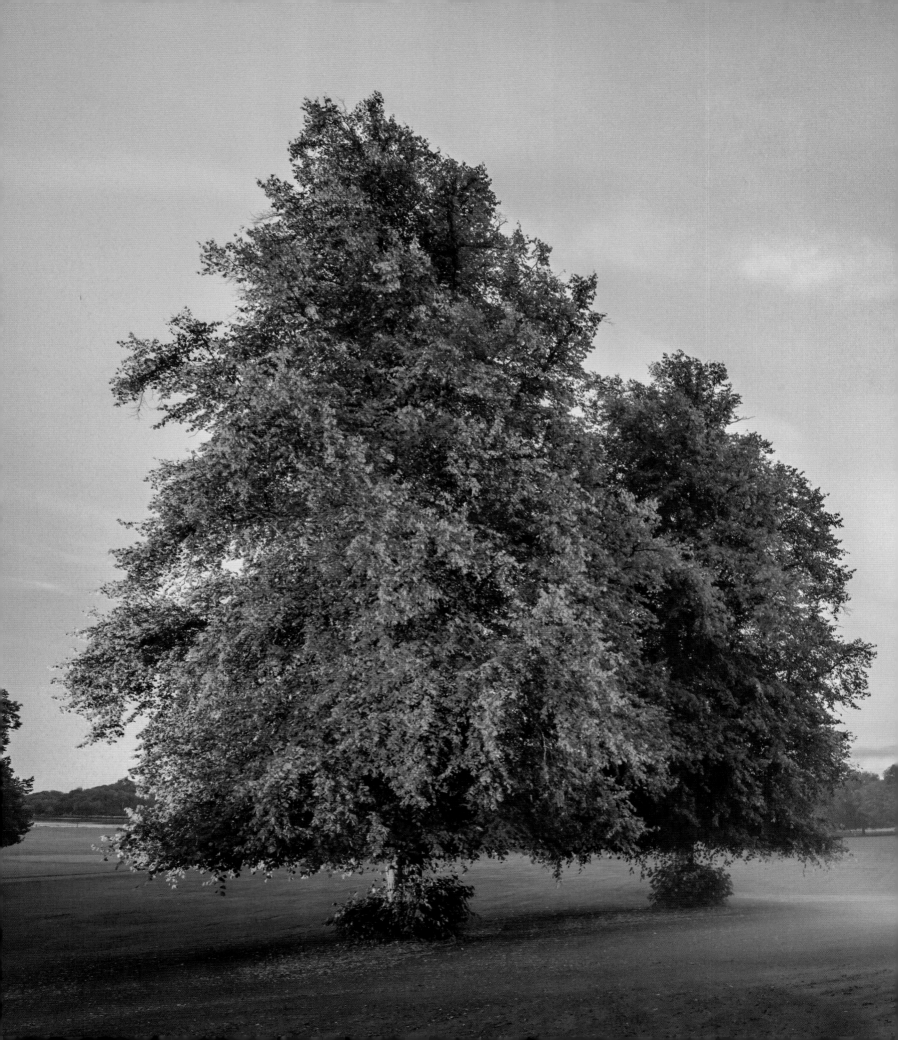

THE TREES

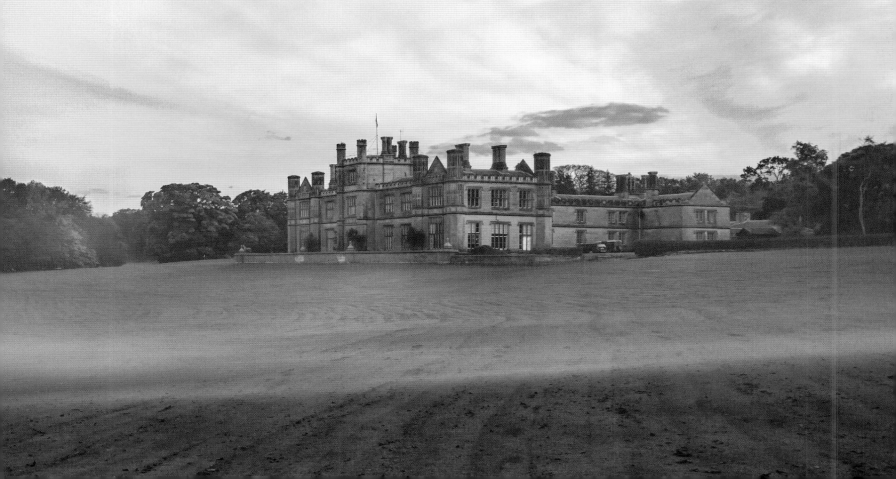

SCOTS PINE

(Pinus sylvestris)

COMMON NAMES
Scots pine

Pinaceae

DESCRIPTION
Evergreen conifer with scaly bark and
needle-like leaves; small red-purple
flowers mature into grey-brown cones

HEIGHT
35m

Native

As the only native pine in the UK,
the Scots pine provides a natural
habitat that is of much benefit to
rare species and local wildlife.

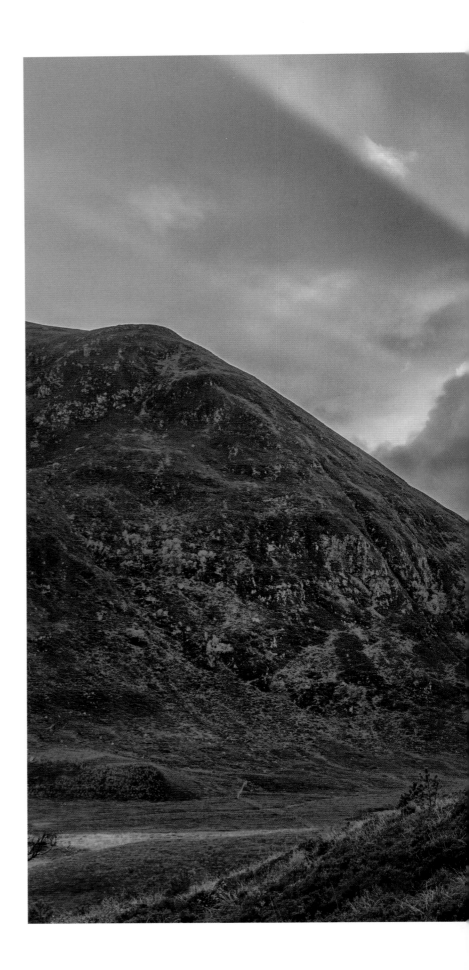

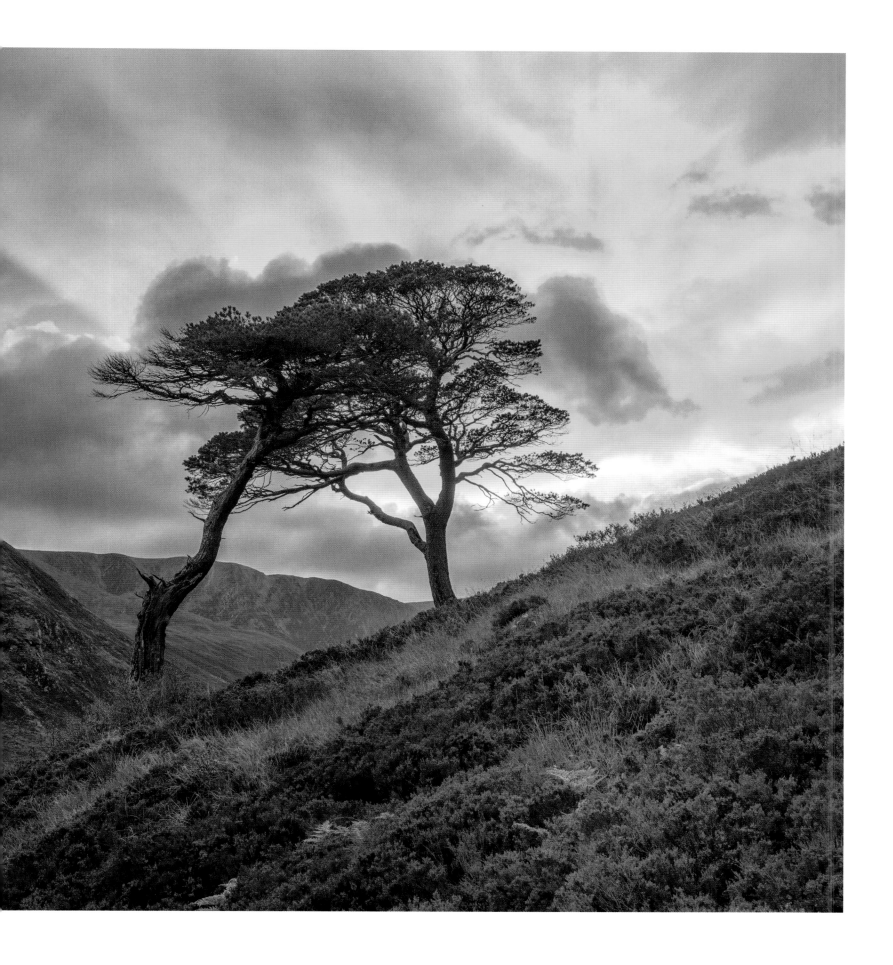

'Britain is one of the most nature-depleted countries on the planet, a result of our "so-called" development. The Scots pine photographed here has spent over 400 years growing, clinging to and surviving a steep scree face on the north face of Glen Alladale. What a life this specimen has had, surviving the logger's axe; it's old enough to have seen wolves passing under its branches and marking their territory on its trunk. However, sadly now too old, this so-called "granny pine" is unable to reproduce, which gave rise to Alladale's planting programme. We have hopefully inspired other neighbours and landowners to follow suit, in an attempt to help restore what the Romans once called "The Great Wood of Caledon". All too often, we humans believe we are apart from nature, but very much to the contrary, we are part of it.'
PAUL LISTER

The significance of trees to the ecology of the UK cannot be underestimated, and it is certainly fully appreciated by Paul Lister, Laird of Alladale Wilderness Reserve in the Scottish Highlands. As he says, 'Apart from their natural beauty, trees, woods and forests are of vital importance for all life on Earth. Not only are they a refuge for thousands of animals, birds and insects but they also mitigate soil run-off, flooding and act as a vital carbon store.'

Alladale encompasses around 100 square kilometres of heather-filled moorland, mist-covered mountains, native woodlands, and sparkling rivers and lochs, just an hour north of Inverness. Alladale was purchased by Lister in 2003 with the intention of creating a sustainable

THE FISSURES of the bark, which develop over time, allow for lichen to grow.

A DETAIL of the ancient flora and fauna on the forest floor.

wilderness teeming with wildlife. Trees, and particularly the Scots pine, are at the heart of this vision, with an ambitious planting scheme underway that Lister calls 'the most significant conservation initiative we have embarked upon to date'. In partnership with The European Nature Trust and the Scottish Government, one million saplings have been planted at Alladale – the majority being Scots pine but also including a plethora of native broadleaves.

It will, of course, take many years for these saplings to grow and become forests, but Lister is hoping that one day these forests, alongside other rewilding projects, will help foster a growing list of species that once thrived here in the Scottish Highlands.

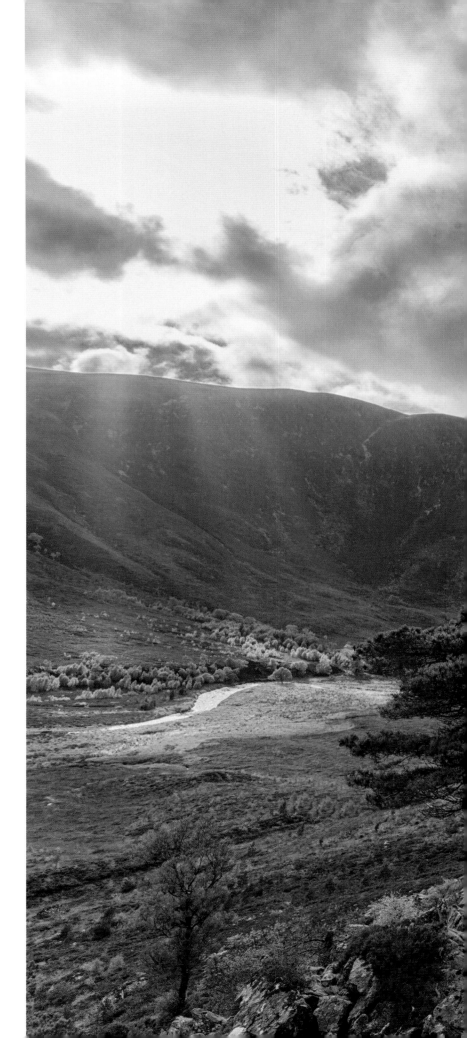

THIS ANCIENT Scots pine was photographed halfway up the Alladale valley. The tree is surrounded by fallen rocks and still stands proudly above the valley.

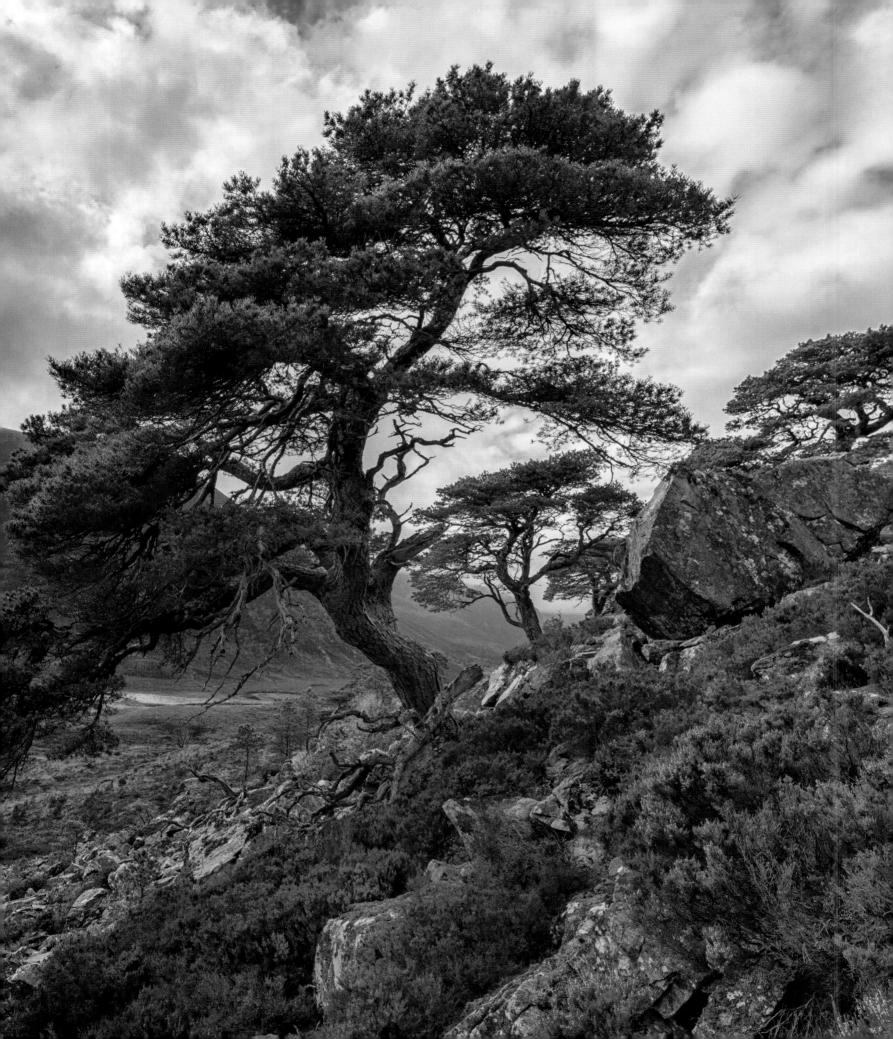

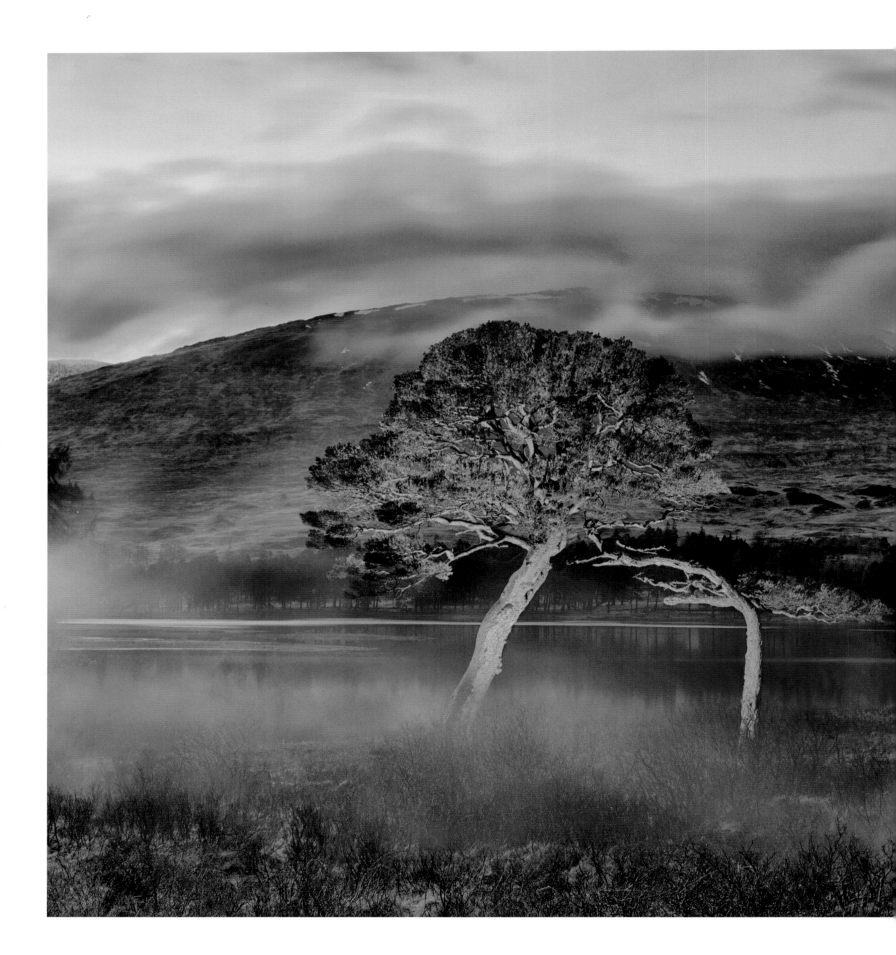

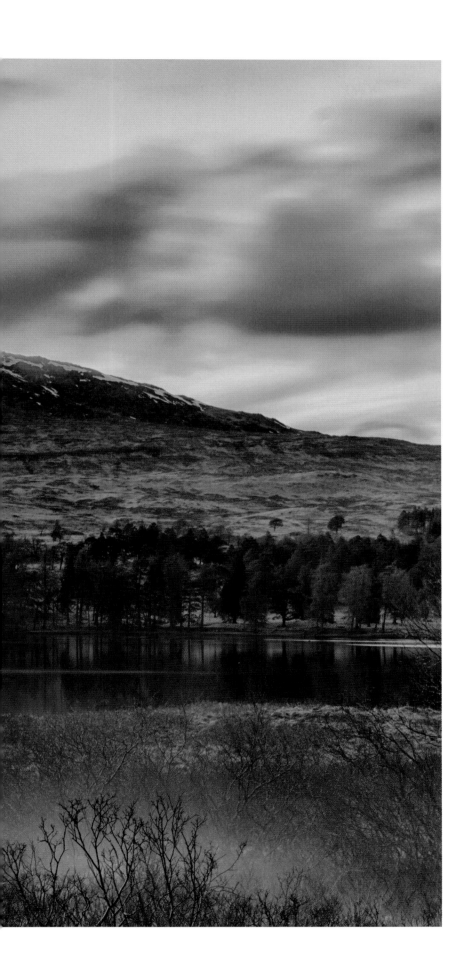

SCOTS PINE

(Pinus sylvestris)

COMMON NAMES
Scots pine

FAMILY
Pinaceae

DESCRIPTION
Evergreen conifer with scaly bark and
needle-like leaves; small red-purple flowers
mature into grey-brown cones

HEIGHT
35m

Native

Crowned as the national tree of Scotland
in 2014, the mighty Scots pine is found in
abundance in the Scottish Highlands.

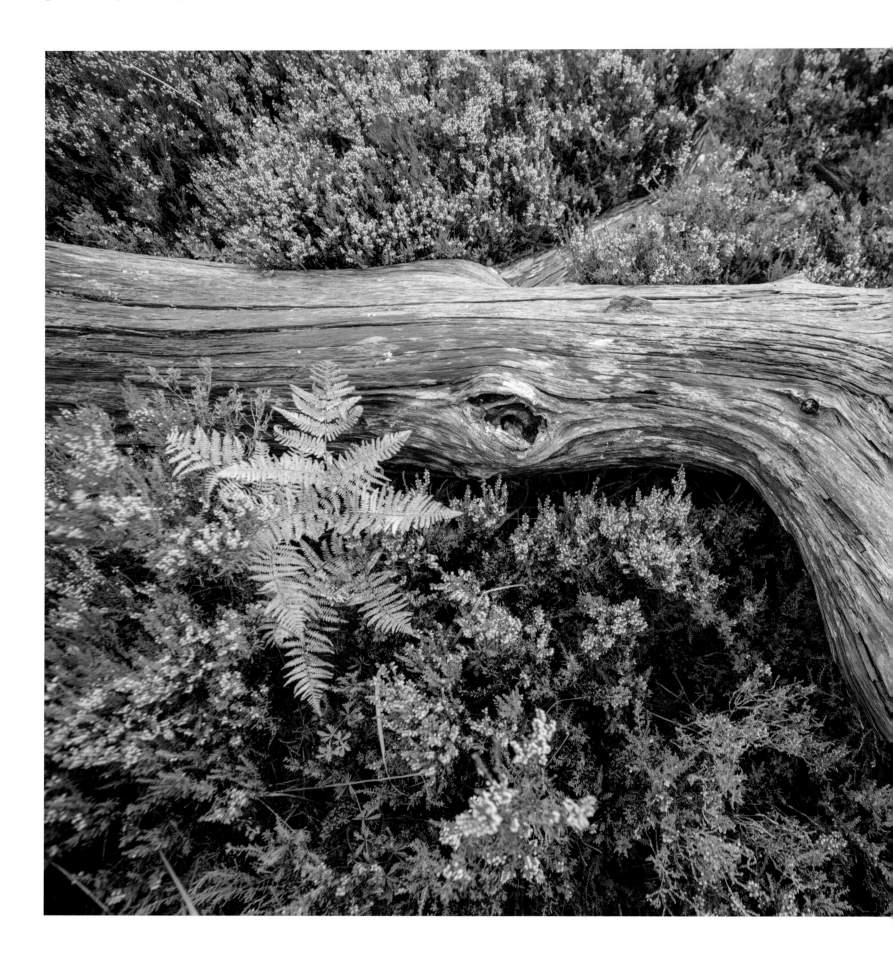

'*The Scots pine is the national tree of Scotland, which is where I grew up. These ancient trees expanded into Scotland around 8,000 years ago. I have spent many days fishing the high lochs with the Scots pine as my main companion. I have known this particular pine since first visiting Glen Coe with my father and catching my first brown trout from the river that runs out of the loch. The tree's distinctive shape has been moulded by the wind.*'

ADRIAN HOUSTON

With its glorious reddish-brown bark and blue-green needle-like leaves that remain all year round, the Scots pine can grow up to 35 metres and live for up to 700 years. Noted for being one of the strongest of softwoods, the Scots pine is now widely planted for timber, but its origins are much more mystical. Folklore that has been passed down through the generations reveals that Druids lit bonfires with Scots pine at the winter solstice to celebrate the passing of the seasons and the rebirth of the sun. Other customs included decorating glades of Scots pines with lights, shiny objects and stars, as a representation of the Divine Light. These ancient rituals have perhaps inspired some of our modern-day festive customs such as decorating Christmas trees and making Yule logs.

This particular Scots pine is found in one of Scotland's most famous and scenic glens, the spectacular Glen Coe, where the volcanic origins and rugged landscape combine to create an otherworldly scenery that has appeared in many feature films, including James Bond's epic *Skyfall*.

As the only native pine in the UK, the Scots pine is incredibly beneficial to rare wildlife of the Scottish Highlands. It provides a crucial habitat for creatures such as the red squirrel, the capercaillie and the Scottish wildcat.

A DETAIL of a fallen Scots pine – deadwood such as this is an important habitat for many insects.

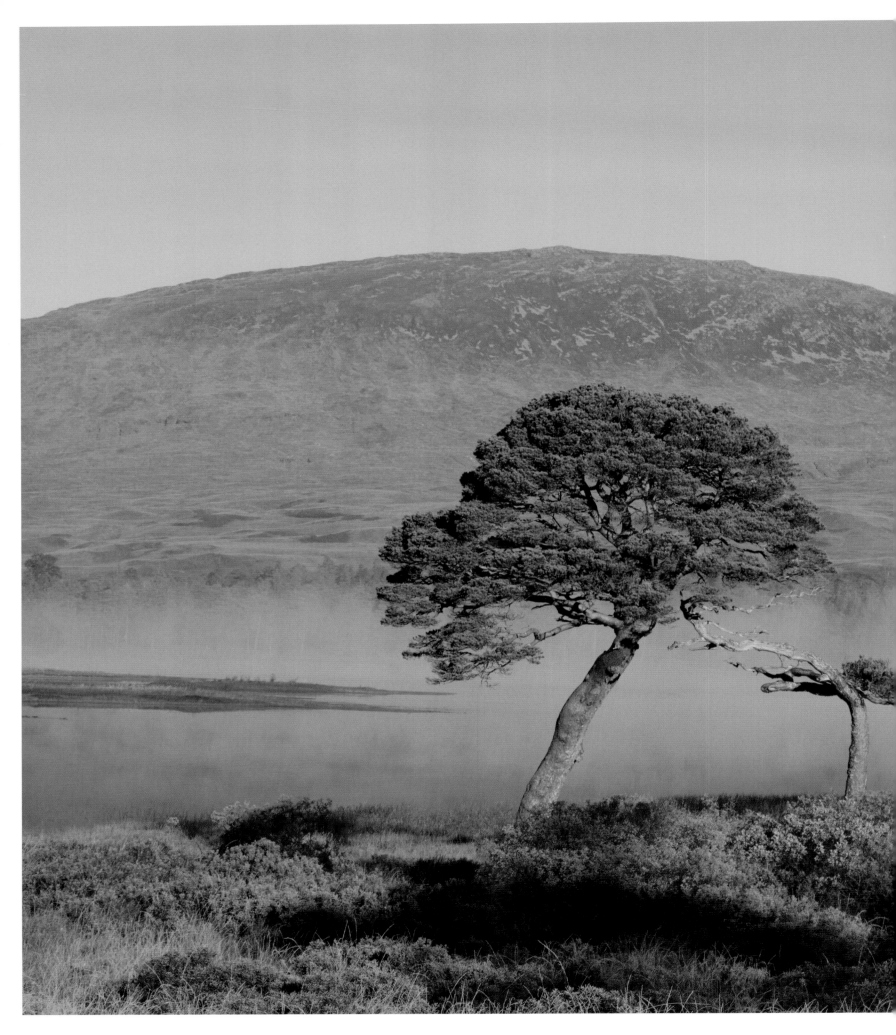

THIS PHOTOGRAPH was taken as the first rays of sunlight moved across Loch Tulla, framing the Scots pine in its mist.

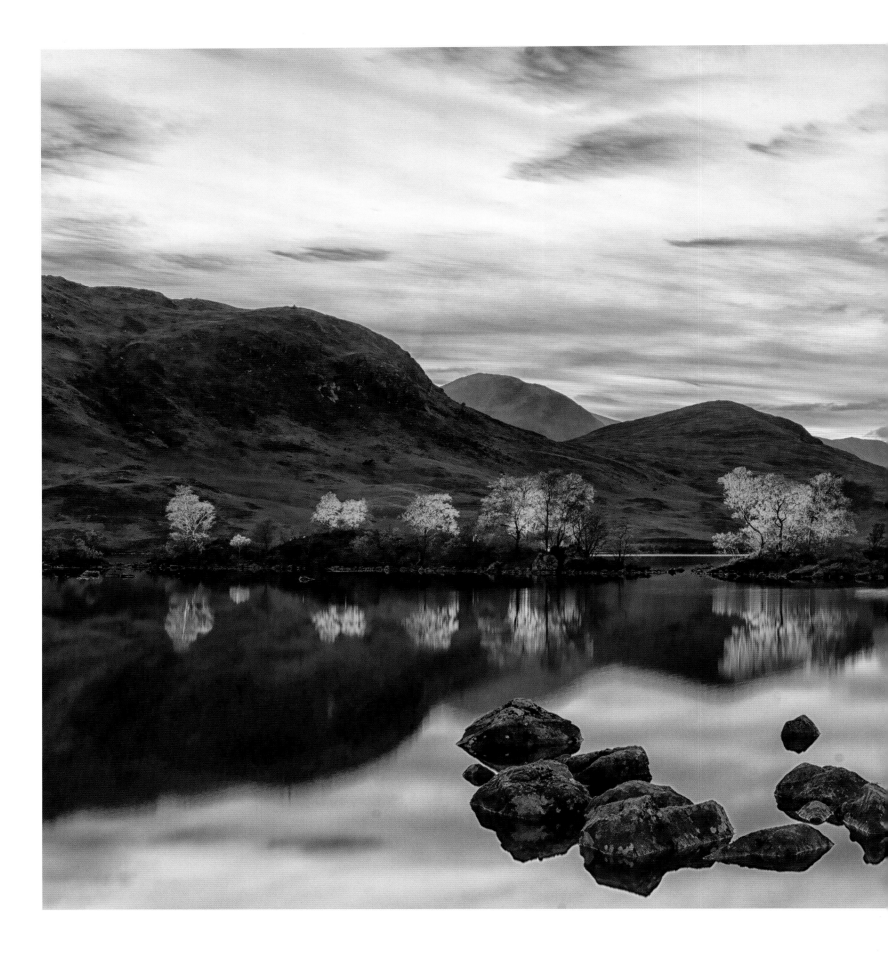

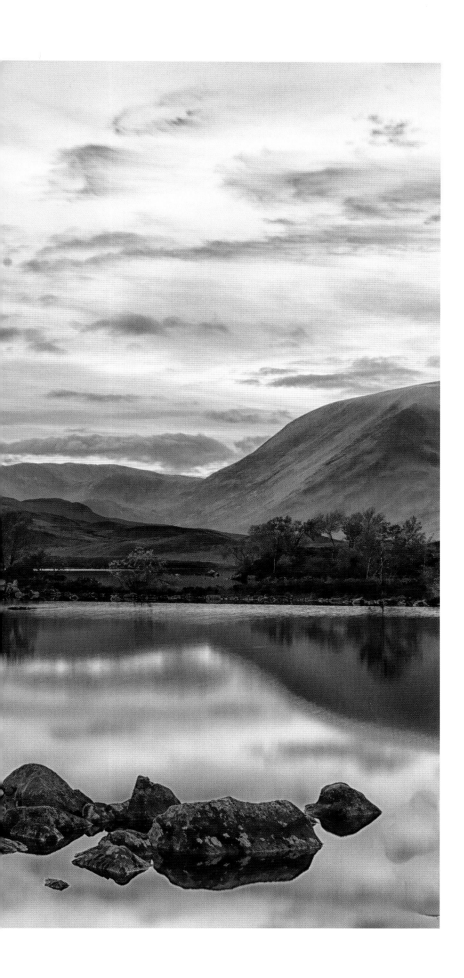

SILVER BIRCH

(Betula pendula)

COMMON NAMES
Silver birch

FAMILY
Betulaceae

DESCRIPTION
Medium-sized deciduous tree with
distinctive white bark that sheds in layers

HEIGHT
30m

Native

Tolerant of a range of temperatures,
the pretty silver birch is a popular
tree in gardens around the UK.

'The silver birch is native to Scotland and one of my favourite trees. White-stemmed and ethereal in winter, understated and elegant in summer and a blaze of golden glory in the autumn. This little line of silver birches takes me back to my childhood, when we holidayed in Glen Coe and used to pass this way en route to our hotel at Bridge of Orchy. Our mother, an artist, would always point out the silver birches growing around and often painted them in her landscapes. She would love it that Adrian continues to depict their delicate beauty in his own work. In ancient Scottish folklore, the silver birch was a symbol of renewal and purification. Very apt in the modern world of today, in which we are endeavouring to renew and reuse, and should be striving to purify our world for future generations.'
HELEN SCOTT

The silver birch thrives in woodlands and can be used to improve the soil quality of an area, as its widespread roots gather nutrients into the tree, relinquishing them into the soil when the leaves fall. The silver birch provides a vital habitat for over 300 insect species, as well as for hole-nesting birds such as the woodpecker. One of the oldest native tree species in Scotland, and one of the first trees to burst into leaf in the spring, it's easy to understand its association with fertility and renewal in Celtic mythology.

This row of striking silver birch trees, with their silver-white bark and light canopies of golden leaves, looks magical against the awe-inspiring scenery of Glen Coe in the Scottish Highlands. The dramatic mountains here were formed from volcanic eruptions and carved out by glaciers, providing a powerful reminder of the intensity of nature in this haunting landscape.

THE OVAL toothed leaves turn yellow and orange in the autumn.

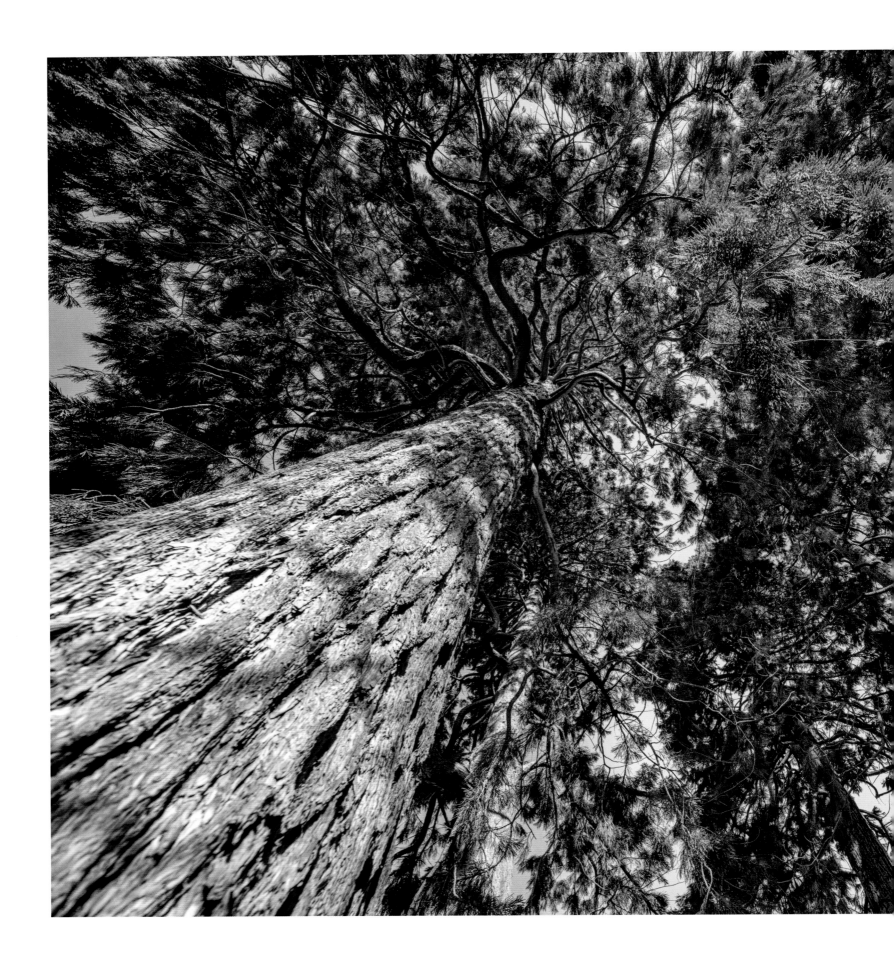

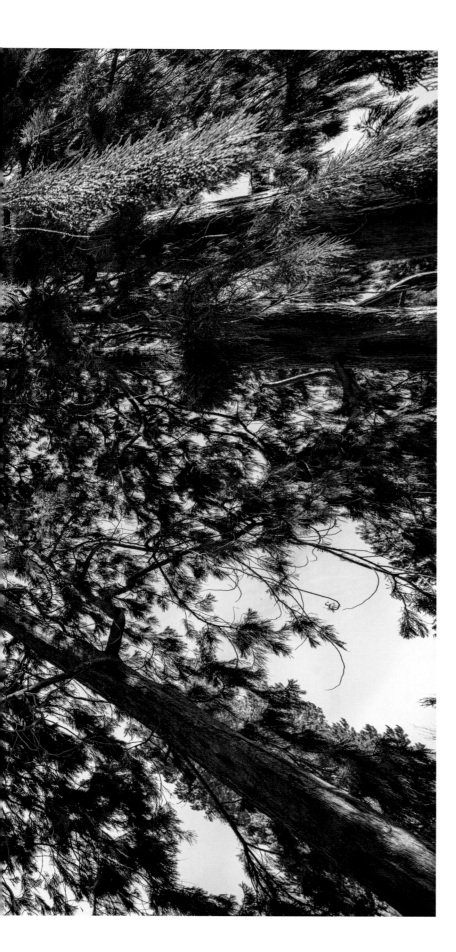

GIANT REDWOOD

(Sequoiadendron giganteum)

COMMON NAMES
Giant redwood, big tree, wellingtonia, giant sequoia,
mammoth tree, Sierra redwood, washingtonia

FAMILY
Cupressaceae

DESCRIPTION
A large evergreen tree with thick,
deeply grooved, reddish-brown bark

HEIGHT
Up to 90m

Non-native

Native to northern California, Oregon and
Washington, giant redwoods became extremely
popular and widely cultivated in the
UK during the Victorian era.

Native to the Sierra Nevada area of California, the giant redwood is one of the biggest trees in the world, reaching heights of over 90 metres, and can live for over 3,200 years, making this species one of the oldest organisms on the planet. This immense tree has gargantuan proportions, with a dense crown at the top of its distinctive red trunk, and lower swooping branches of small, spiral green leaves.

The giant redwood was introduced into cultivation in the UK when the first specimens were brought back from California by plant hunter William Lobb in the autumn of 1853. The seeds and shoots collected by Lobb would provide thousands of saplings within two years, and became vastly fashionable among wealthy Victorians, who planted them in their grand estates as the ultimate status symbol.

AN ENDANGERED SPECIES

Sadly, the giant redwood is included in the International Union for Conservation of Nature's Red List of Threatened Species, meaning it is facing a very high risk of extinction in the wild. Long overexploited by unsustainable logging practices, it is also threatened due to changes in forest fire management regimes, which have allowed fires to burn more devastatingly, impacting the redwood's ability to reproduce. Conservation efforts spearheaded by scientists at a number of institutions, including the Royal Botanic Garden Edinburgh, hope to combat these threats and preserve this colossal tree for future generations.

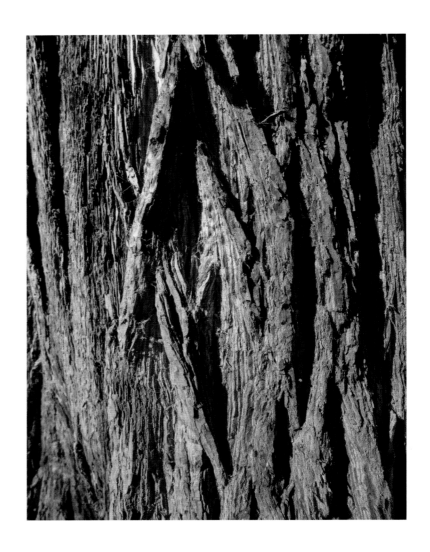

A DETAIL of a giant redwood tree showing the bark, which is fibrous and furrowed. While the bark can be thick, it is strikingly soft to touch.

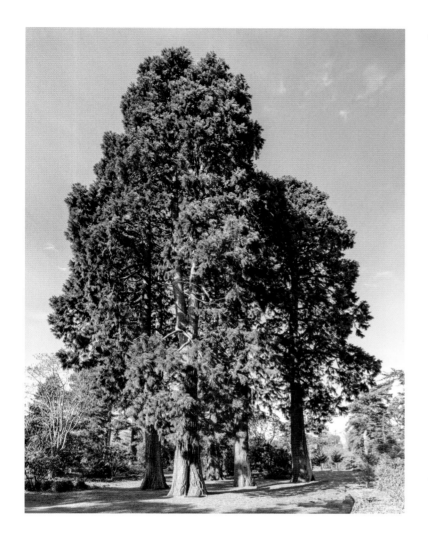

'*My favourite trees, among the many cultivated within the Living Collection of the Royal Botanic Garden Edinburgh, are the Sequoiadendron giganteum, or giant redwoods. There is a group of small trees in Edinburgh that has been named the John Muir Grove after the Scottish-born environmentalist who pioneered the conservation of wilderness areas in the USA, while a number of taller and larger-diameter specimens are at Dawyck Botanic Garden in the Scottish Borders. At Benmore Botanic Garden is an avenue of 49 trees planted in 1863, now all over 50 metres tall, which stretches over 500 metres, creating perhaps one of the most impressive entrances to any botanic garden in the world.*

This iconic tree now faces a number of challenges: in its native habitat, human settlement has resulted in many groves of the trees being in decline; and in cultivation at Benmore, the impacts of climate change and subtle changes in rainfall patterns, wetter winters and drier springs, now require remedial intervention by the horticultural team to save this iconic avenue and inspire future generations.'
DAVID KNOTT

THIS GROUP of redwoods photographed in the early afternoon in March is a fitting dedication to the conservationist John Muir.

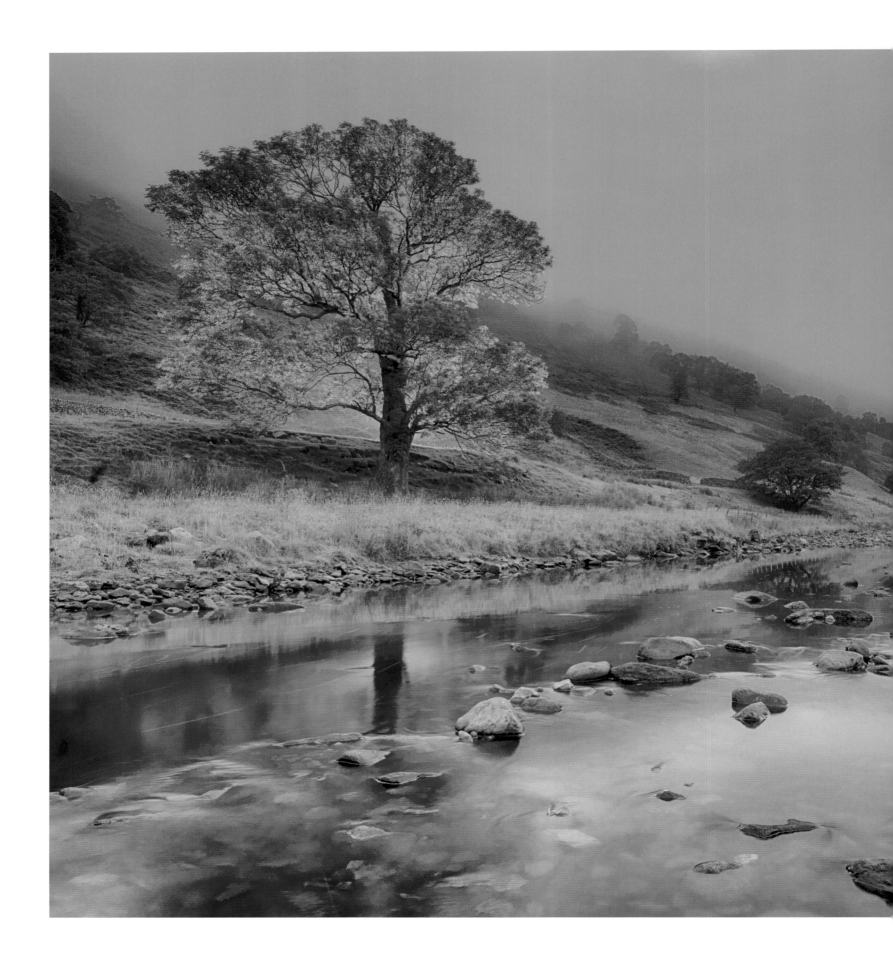

ASH

(Fraxinus excelsior)

COMMON NAMES
Ash, common ash, European ash

FAMILY
Oleaceae

DESCRIPTION
A tall deciduous tree with a domed canopy of
light green leaves, purple flowers in the spring
and black, velvety buds in the winter.

HEIGHT
Up to 35m

Native

A native tree to Europe, Asia Minor and Africa,
the ash is part of the olive family, Oleaceae.

'This majestic photograph of an ash tree beautifully captures its delicate and ephemeral quality echoed in the translucent reflection in the river below. Native to the British Isles, in summer the ash tree in full leaf epitomizes daydreams of dappled sunlight falling upon picnics, reading books or sketchbooks during lazy days out of doors under its shade. In winter the pale colour of the ash tree's bark and relative lightness of its branches suggest a vulnerability to the elements, in stark contrast to other, bolder native species. The distinctive black buds of the ash tree contain the reassuring promise of spring and summer leaves soon arriving, to start all over again.'

EMMELINE HALLMARK

The noble ash tree has a rich and long history in ancient legend and folklore. Yggdrasil, the World Tree in Norse mythology, was a mighty ash tree whose trunk rose up to the heavens, and boughs reached out over all the countries of the Earth, while the Viking gods Odin and Thor both carried magical spears carved from ash wood.

In both Gaelic and Druid folklore, the ash tree was a symbol of protection, and it was said to have a range of healing and curative properties, including reducing fevers and treating infections. Sacred to the Druids, the ash was also considered to provide a connection between man and the natural world. It's easy to imagine that sense of spiritual attachment to the Earth when gazing at the tall silhouette of this ash gracefully embellishing the banks of the River Swale in Gunnerside in the historic Yorkshire Dales.

THE INTERTWINED, moss-covered roots hark back to mythology and folklore.

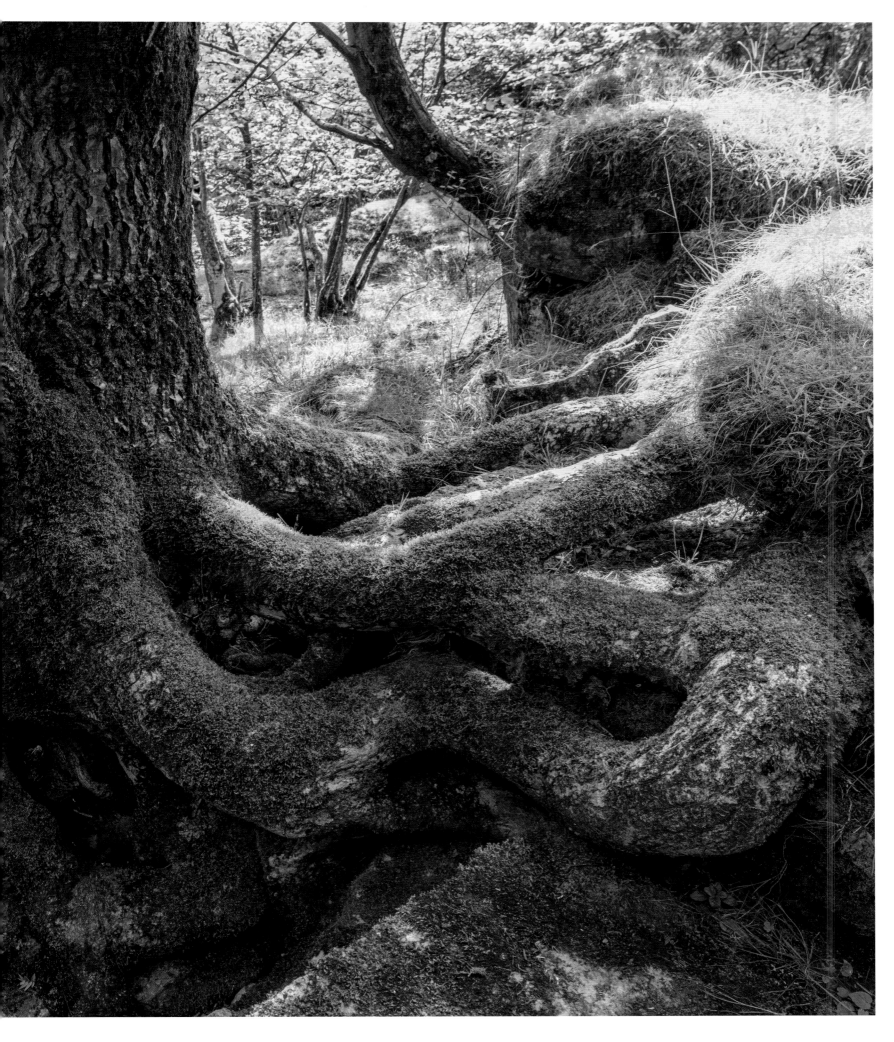

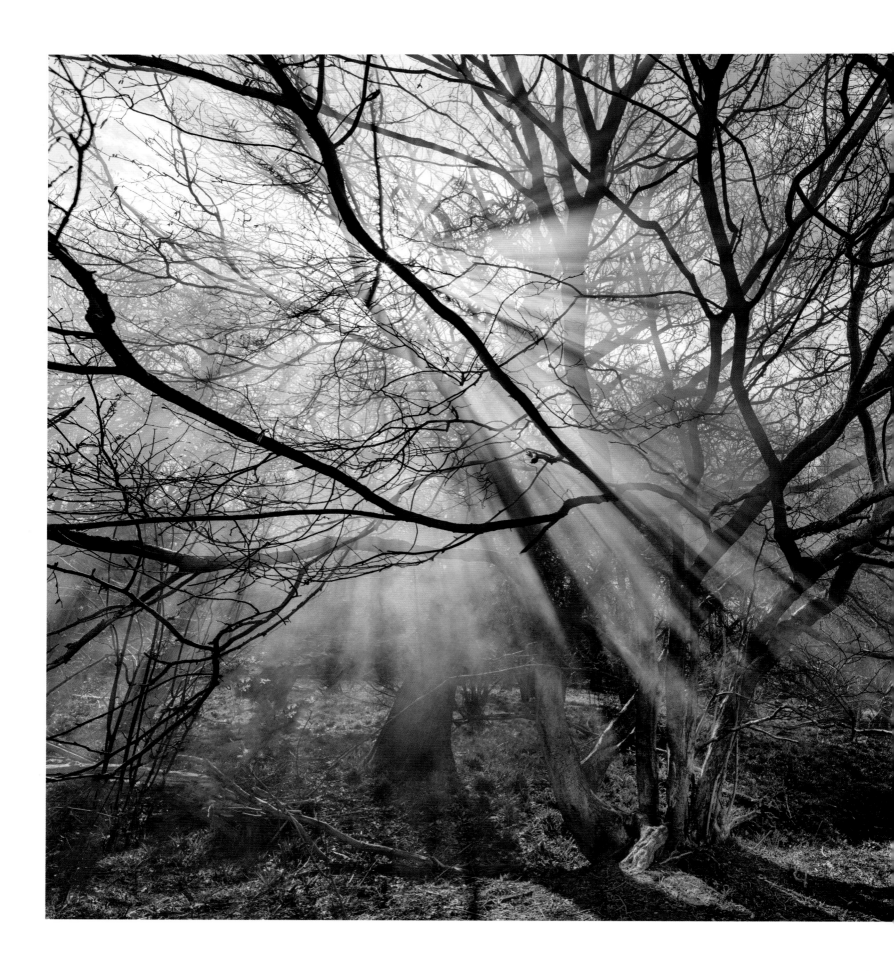

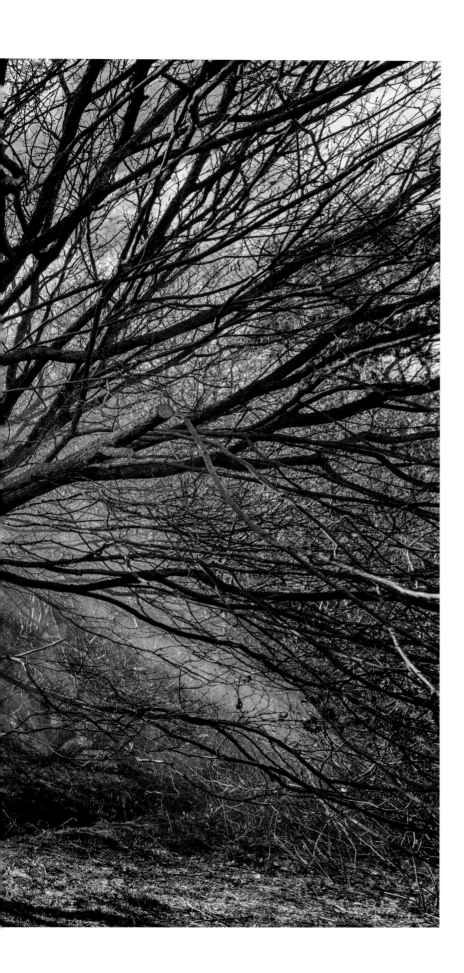

HAZEL

(Corylus avellana)

COMMON NAMES
Hazel

FAMILY
Betulaceae

DESCRIPTION
A deciduous tree with furry oval leaves,
yellow catkins and tiny flowers that develop
into fruits, and eventually nuts

HEIGHT
Up to 12m

Native

The hazel tree has long held a reputation as a magical tree. In ancient mythology, including Roman, Norse and Celtic, it has strong associations with wisdom and knowledge.

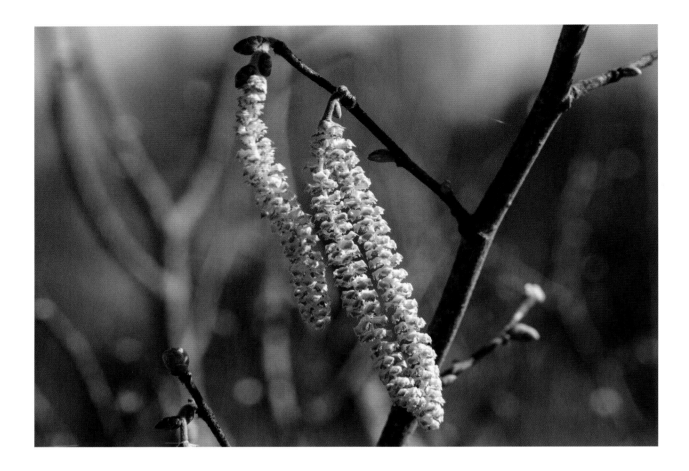

The hazel tree, with its flexible stems and plentiful nuts, is one of the UK's most useful and versatile native trees. While most hazelnuts for human consumption are now imported into the UK, our native trees provide great sustenance for a wide range of wildlife, including the famous dormouse, but also other small mammals and myriad birds such as woodpeckers, jays and tits. The bendy stems of the hazel tree can be twisted and knotted, meaning it can be used for thatching and making furniture, and it has many useful gardening applications, including bean poles and polytunnel frames.

Coppicing of hazel trees is a vital part of woodland conservation. This sympathetic management of felling the tree stump near ground level, allowing shoots to regrow, can extend the life of a hazel tree from 80 years to several hundred years. In this way, hazel woodland can build a diverse ecosystem over the years that becomes a unique habitat for a wide range of insects, birds and mammals.

The Woodmeadow Trust at Three Hagges Woodmeadow in Escrick, Yorkshire, a charitable project founded by the Forbes Adam family, is supporting this method of rewilding the countryside, with a vision to create a thriving network of woodmeadows across the UK by merging meadow grasslands and woodland to create areas of natural biodiversity. Hazels, which flourish in lowland woodland, as well as in scrub and hedgerows, play an important role in this.

A CLOSE-UP detail of the hazel blossom in late March.

'Sifting through the outlines, habits, textures, colours of familiar trees, which do I cherish the most? In the garden and the untrimmed hedgerows and the woods, the ones I love best are those elegant vases that alert me to spring each year with their playful decorations, even in the starkest months. In Nightingale Wood there is a corner of coppice where I walk to savour the pale greeny-yellow of the catkins, shivering in the breeze, a filigree lattice hung with golden tassels. With a flick in late February a cloud of pollen erupts and I go on a treasure hunt for the teeny crimson sea anemones of the female flowers and marvel how the pollen manages to find them. The humble hazel provides precious pollen and nectar for early flying insects. Its fruits, hazelnuts, are tempting to many, including woodpeckers, nuthatches, tits, wood pigeons, jays and dormice.

The timber, which in years gone by was coppiced for wattle and daub and thatching, I now put to other uses – cutting the tallest, straightest stems to make sailing boats for the beans and, with the brash, cat's cradles for the delphiniums. At Three Hagges Woodmeadow volunteers have created a circle of dead hedge with hazel brash that is as evocative of our traditional, lowland woods as Andy Goldsworthy's dry-stone wall Outclosure of the upland farmed landscape.

Perhaps best of all is the promise of spring under the canopy of the old hazel. Green shoots start to show in darkest winter. Soon the floor beneath will be covered with a tapestry of bluebells, primroses, wood sorrel, dog violets, greater stitchwort, pale cream climbing corydalis and hart's tongue ferns. The most generous little nut tree in my secret corner is on the edge of the ride. It must be a forgotten nugget of ancient woodland.'

ROSALIND FORBES ADAM

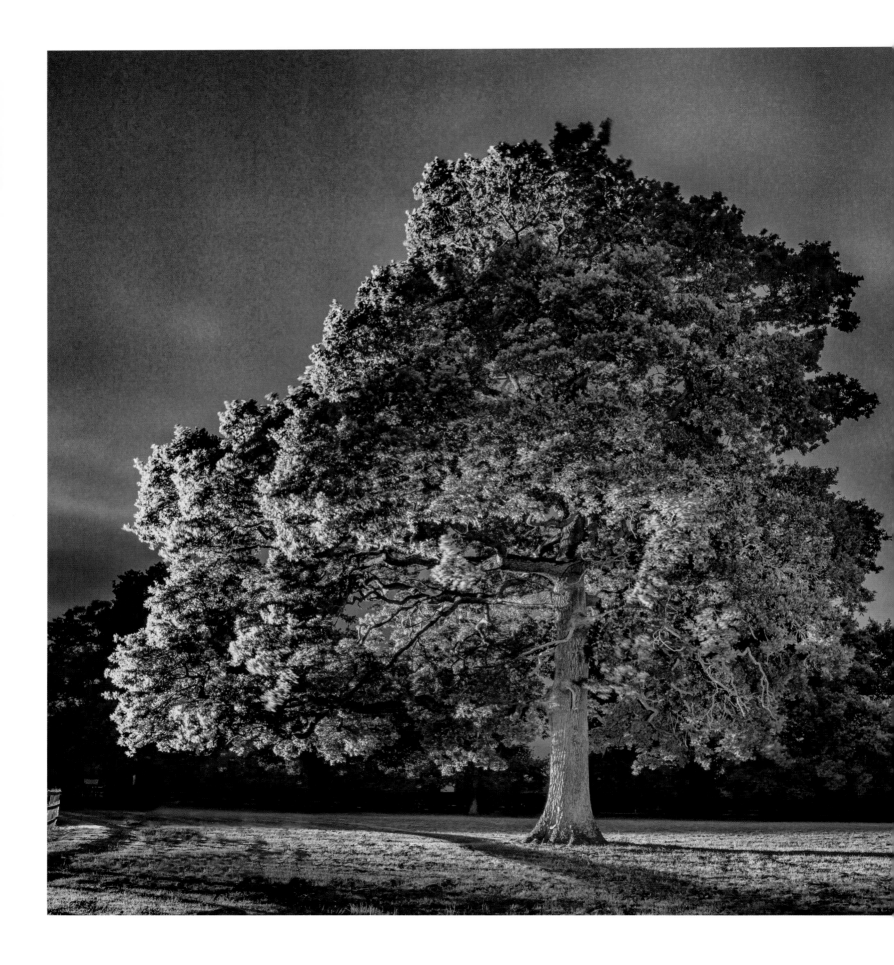

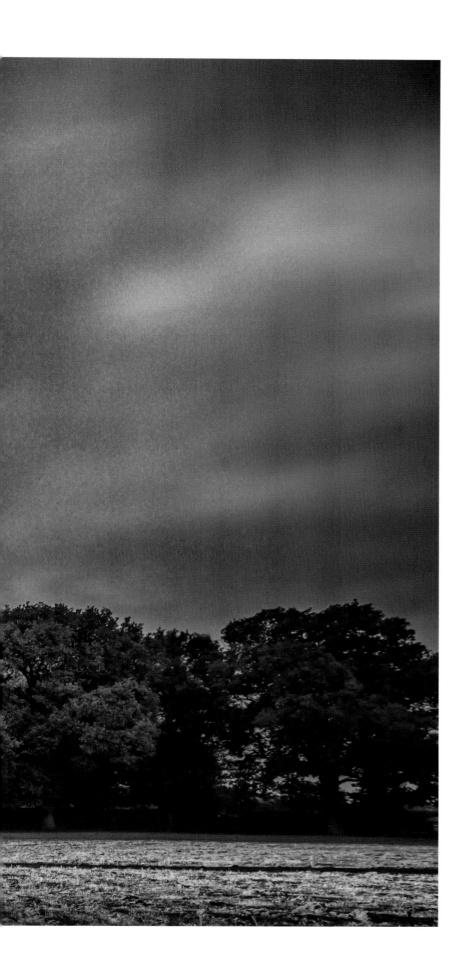

ENGLISH OAK
(Quercus robur)

COMMON NAMES
English oak, common oak, pedunculate oak

FAMILY
Fagaceae

DESCRIPTION
Deciduous tree with broad crown and lobed leaves;
catkins are followed by acorns

HEIGHT
20–40m

Native

While there are over 600 different
species of oak trees around the world,
currently around 78 species are thought
to be in danger of extinction.

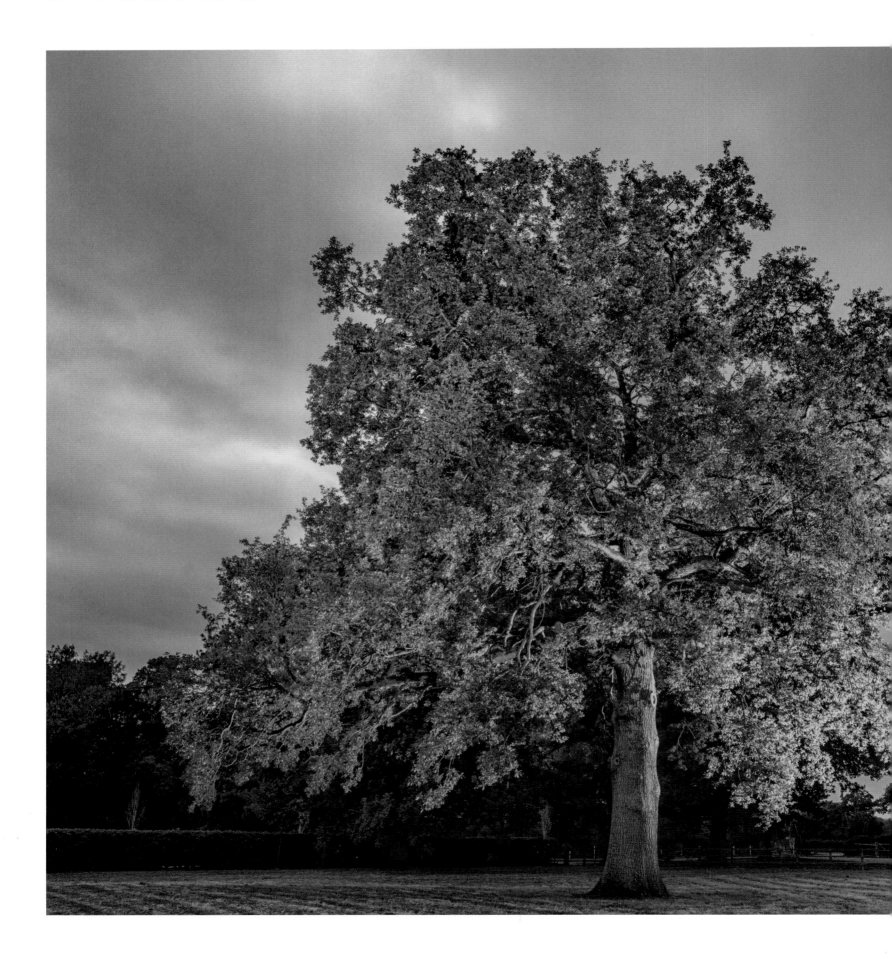

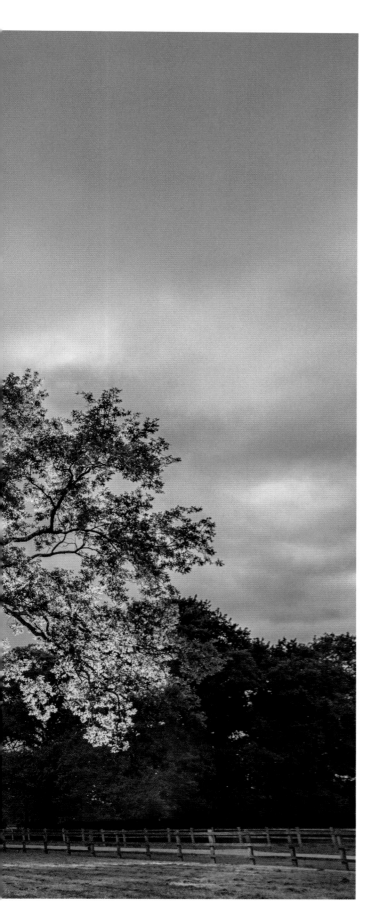

'One of several great oaks in the grounds of Rookery Hall, and certainly the most striking. Aligned with the due-west orientation of the front of house, this particular tree creates a magical backdrop at sunset, perfectly capturing the timeless beauty and elegance of rural Cheshire, and indeed, the finest of English countryscapes.'

ADRIAN HALLMARK

THIS OAK was photographed in the late twilight in July, with the warm light being used to pick out the tree from its background.

The elegant Rookery Hall was first built in 1816 with extensive grounds encompassing some 500 acres. The late Georgian hall building was converted into a beautiful hotel and restaurant in around 1975. Today, the parkland of the hotel is set over 38 acres and includes formal gardens, a woodland and a small lake. Situated next to the River Weaver, the gardens are included in the Register of Parks and Gardens of Special Historic Interest in England.

While the specific history of this majestic oak tree within the estate is unknown, the head gardener at Rookery Hall believes it was planted around 150 years ago. Established opposite The Mews, the Cheshire residence of Bentley Chairman and CEO Adrian Hallmark that sits within the grounds of the estate, the tree is one of a pair of English oaks that provide a stunning view from his home, standing the test of time and marking the changing of the seasons.

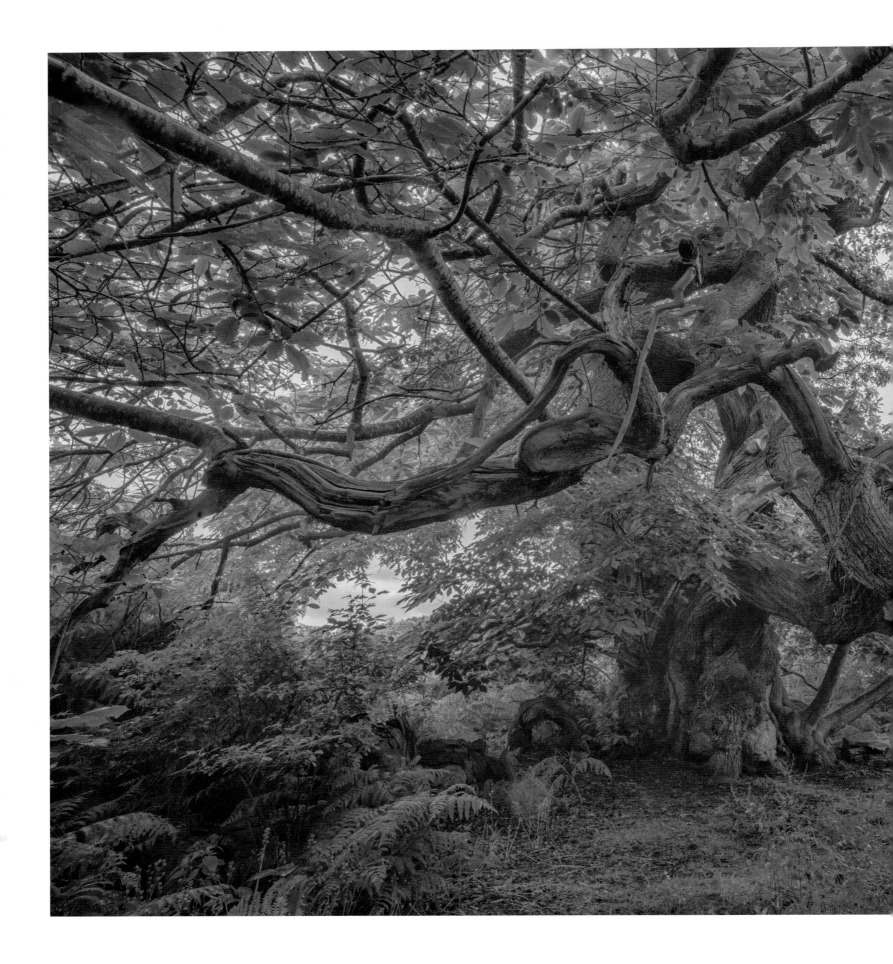

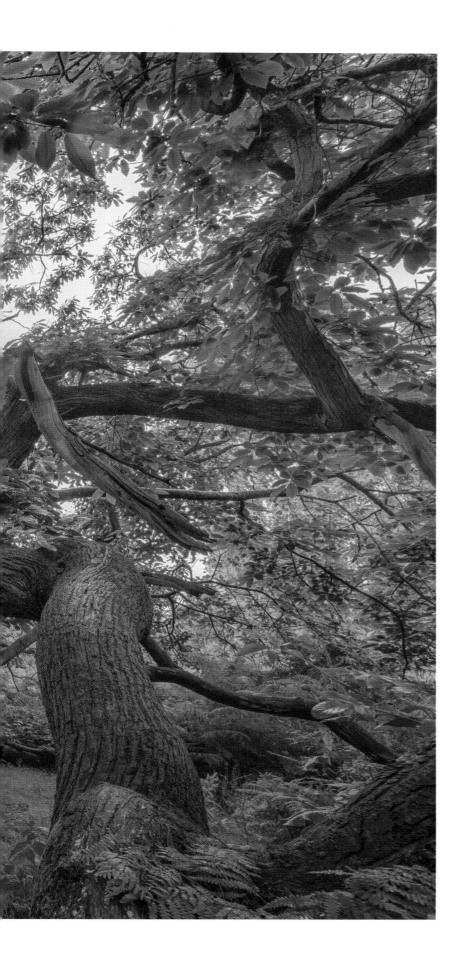

SWEET CHESTNUT
(Castanea sativa)

COMMON NAMES
Sweet chestnut

FAMILY
Fagaceae

DESCRIPTION
A deciduous tree with a wide girth; shiny, brown fruits
develop, wrapped in a green spiky case

HEIGHT
Up to 35m

Non-native

The sweet chestnut is famous for its attractive,
shiny brown fruits, which are hidden within
distinctive green, spiky casings.

'I remember playing around in the canopy of this sweet chestnut (Castanea sativa) as a young boy. Fifty years later, when I took Adrian Houston to see it, almost nothing seems to have altered. It is now, and always was, akin to an elephant, or mammoth or rhino, with toughened skin. Quite immutable. Four decades ago I also introduced it to that great tree man Thomas Pakenham, who much admired it.

Sweet chestnuts begin with quite a smooth bark, then attain some minor fissures like oak, but around 150 years of age, the bole starts to twist into a giant corkscrew and become very deeply fissured, making the bark akin to that of a long-lost behemoth. This tree feels timeless, like yew trees. It should have many years to live, despite this being its declining era. It is a stark reminder of how we must let the trees of the future grow truly old and venerable.'

JULIAN FREEMAN-ATTWOOD

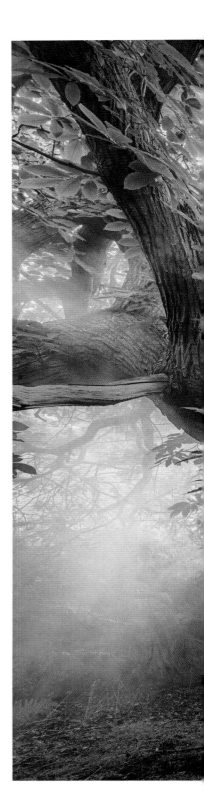

Chirk Castle was built from around 1295 by Edward I as a fortress in the Welsh Marches, intended as a symbol of England's dominance over its neighbour. The castle was bought by Sir Thomas Myddelton in 1595 and has been inherited through generations of the Myddelton family since that time.

The castle estate is in an Area of Outstanding Natural Beauty and encompasses over 480 acres of parkland filled with roaming sheep, wild ponies and ancient woodland, including some ancient oaks such as the Great Oak at the Gate of the Dead, which is thought to date back to the reign of Anglo-Saxon King Egbert in 802.

The gigantic sweet chestnut tree at Chirk Castle is a youngster by comparison, yet still dates back to Tudor England in the reign of Henry VIII, and was made part of the enclosed deer park at the time of the Restoration. The tree's vast, contorted trunk and gnarled limbs have borne witness to centuries of history within the castle grounds.

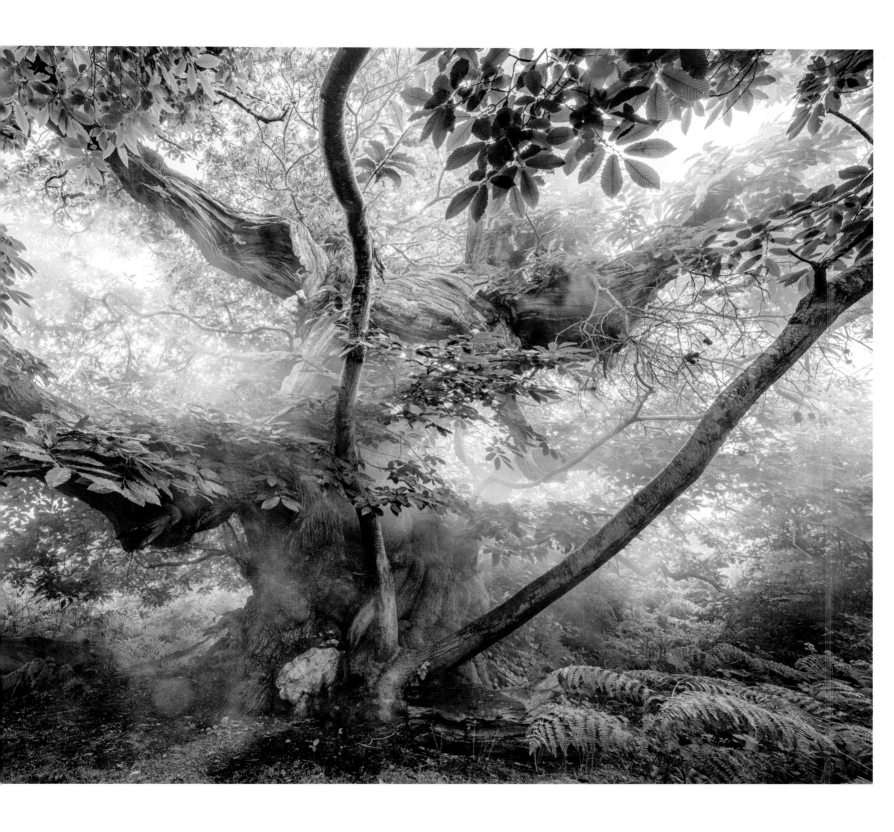

THE EARLY morning mist surrounds
this ancient sweet chestnut,
enhancing its aura of mystery.

SYCAMORE

(Acer pseudoplatanus)

COMMON NAMES
Sycamore

FAMILY
Sapindaceae

DESCRIPTION
A wide-canopied broadleaf tree with distinctive
winged fruits known as samaras

HEIGHT
Up to 35m

Non-native

Wood from the sycamore is traditionally
used for making love spoons, the intricately
carved wooden spoons that have been given
as symbols of love in a Welsh custom
datingback to the 17th century.

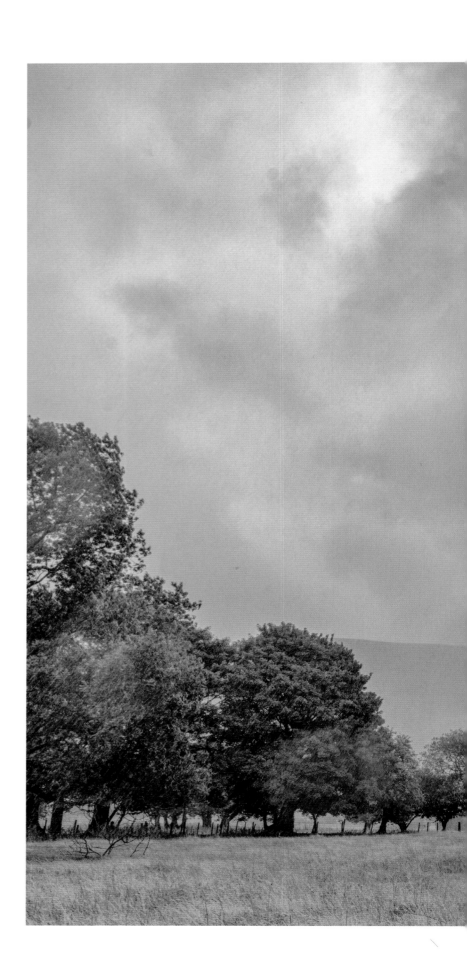

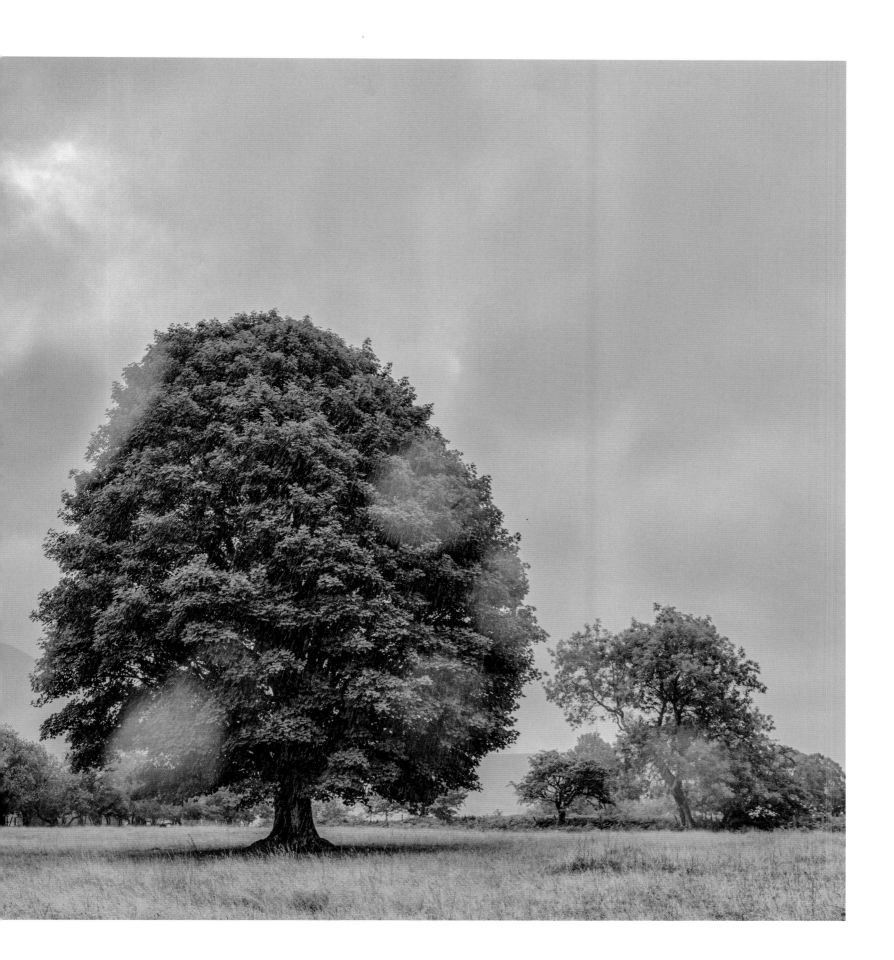

'I spend a lot of time in California and have an irrational love of palm trees. Consequently I've got dozens of prints and photographs of palms at home. But my favourite tree is on some common ground not far from our house in Wales. We've got a huge Chinese palm and a eucalyptus in one of the fields behind our house, but the tree I like best is the sycamore on the common. It is almost perfectly symmetrical, a thing of beauty, and a species to be celebrated.'

DYLAN JONES, OBE

Talgarth, an ancient market town in southern Powys, has been a centre for trade and commerce for centuries. Situated on the northern edge of the Brecon Beacons National Park and in the foothills of the Black Mountains, its buildings of historical importance include the 14th century St Gwendoline's Church and the water-powered Talgarth Mill, which was built in the 1840s.

The area offers an array of diverse terrain and scenic views and is popular with walkers and hikers keen to explore the dramatic scenery of the Black Mountains. Talgarth is also a place rich in biodiversity. Within a kilometre of the town centre, there is an ancient woodland at Pwll-y-Wrach on the banks of the River Ennig that has been designated a Site of Special Scientific Interest. While nearby, the Park Wood is another 140-acre ancient woodland, which provides a habitat for rare redstarts and pied flycatchers.

THIS SYCAMORE was photographed on a beautiful clear March morning, showing the almost perfect shape of its structure.

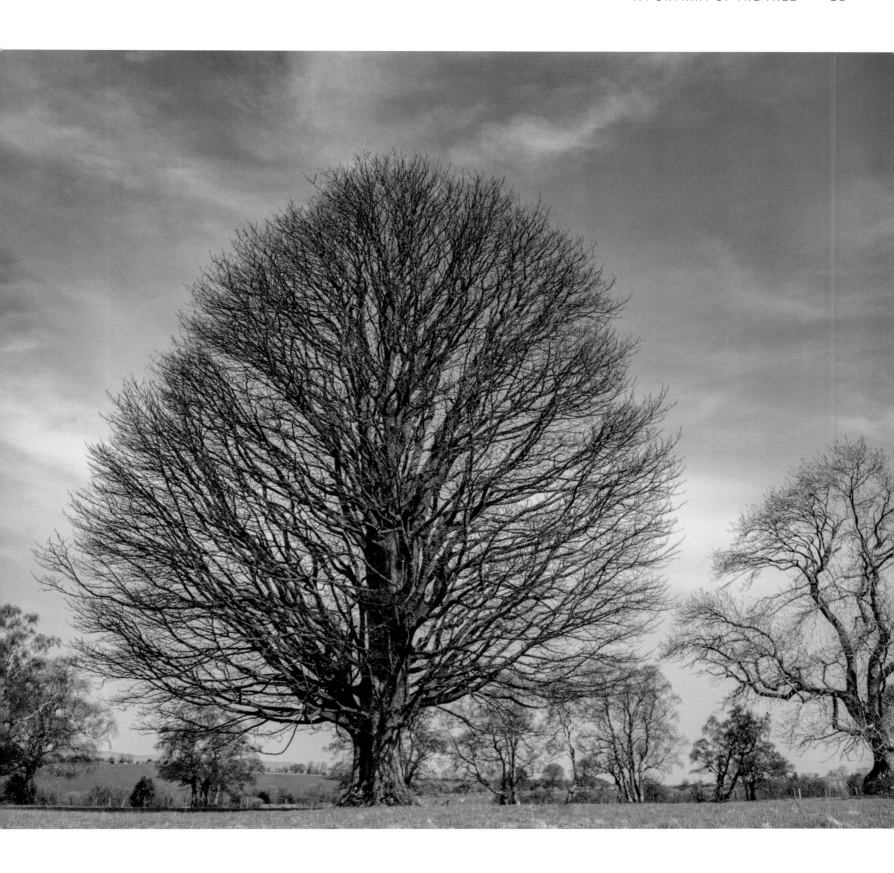

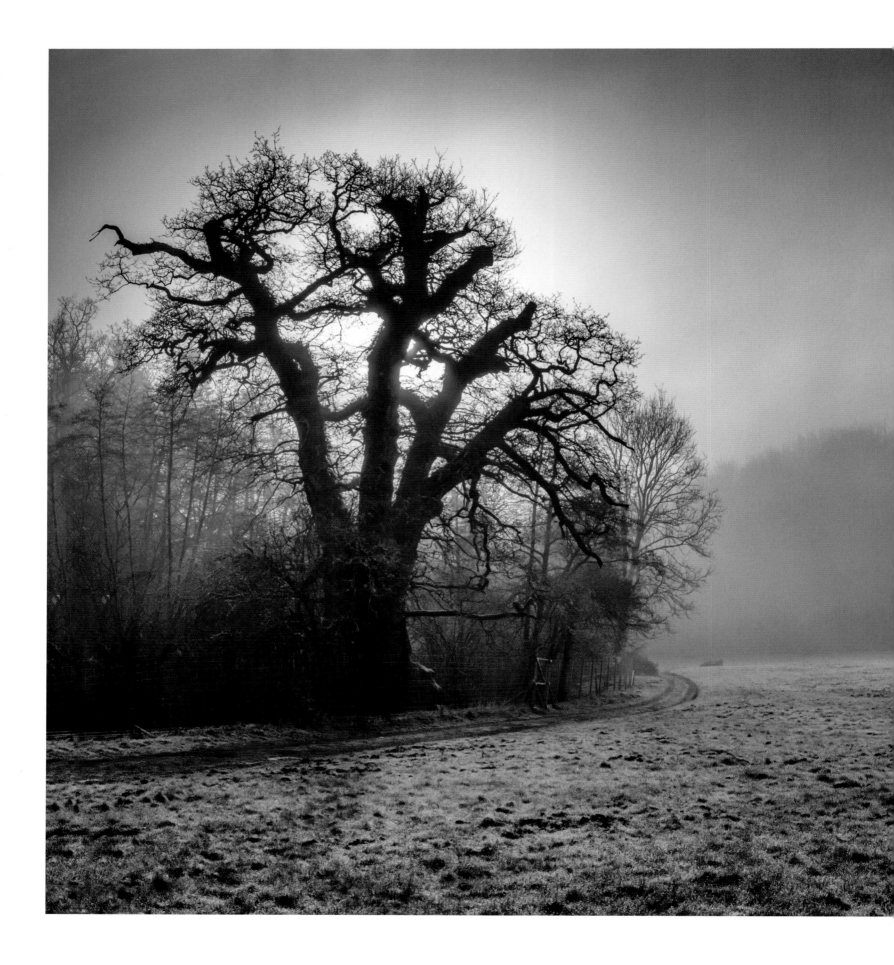

ENGLISH OAK

(Quercus robur)

COMMON NAMES
English oak, common oak, pedunculate oak

FAMILY
Fagaceae

DESCRIPTION
Deciduous tree with broad crown and lobed leaves;
catkins are followed by acorns

HEIGHT
20–40m

Native

The park at Dinefwr is a designated
Important Plant Area due to the number
of veteran trees, which support numerous
rare lichens and interesting fungi.

'One of my favourite trees is the "Castle Oak" in the shadow of Dinefwr Castle on the outskirts of Llandeilo in Carmarthenshire. This tree is said to date back to 1160, just 100 years after the Norman conquest. It's incredible to think that when this tree was a sapling, it would have witnessed the presence of wild boar, beaver and wolves, and the rule of the Welsh princes. If only this tree could talk!'

IOLO WILLIAMS

Nestled on a ridge on the northern bank of the River Tywi, Dinefwr Castle has held a strategic position since the 10th century, when it was the chief seat of Hywel Dda, the first ruler of Deheubarth. Now a ruin, the fortress castle was rebuilt in the 12th century under the rule of The Lord Rhys, one of the most successful Welsh princes, whose reign prompted a flourishing of Welsh culture, music and poetry.

The castle itself lies within Dinefwr Park, an 800-acre National Nature Reserve that is home to thousands of trees, as well as deer and rare White Park cattle, which have grazed here since the late 10th century. Among the many veteran trees in Dinefwr Park is the venerable Castle Oak, which is thought to be between 800 and 850 years old. With a vast, leafy canopy providing shelter, and a hollow trunk so enormous you can even walk inside it, this mighty oak provides a tangible link to the extensive history of the ancient Dinefwr Castle.

LOOKING UP at this ancient oak on a cold March morning you feel the age of the tree with its moss and lichen growing on its branches.

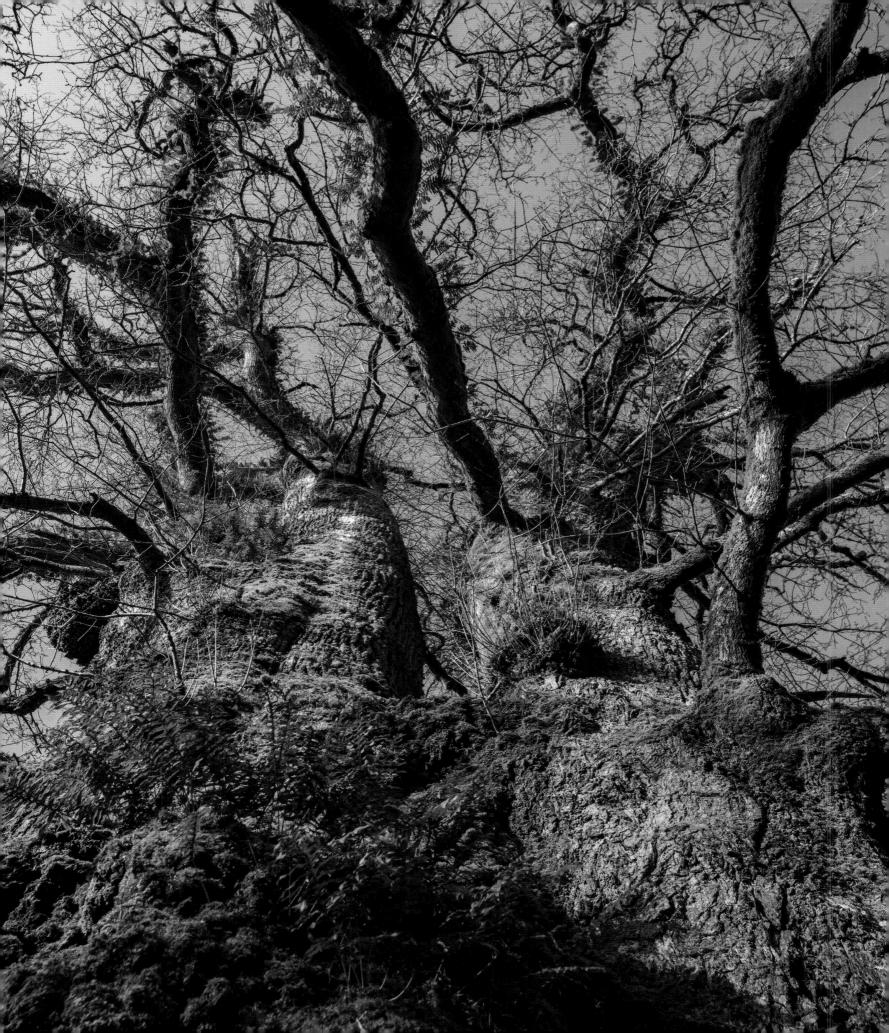

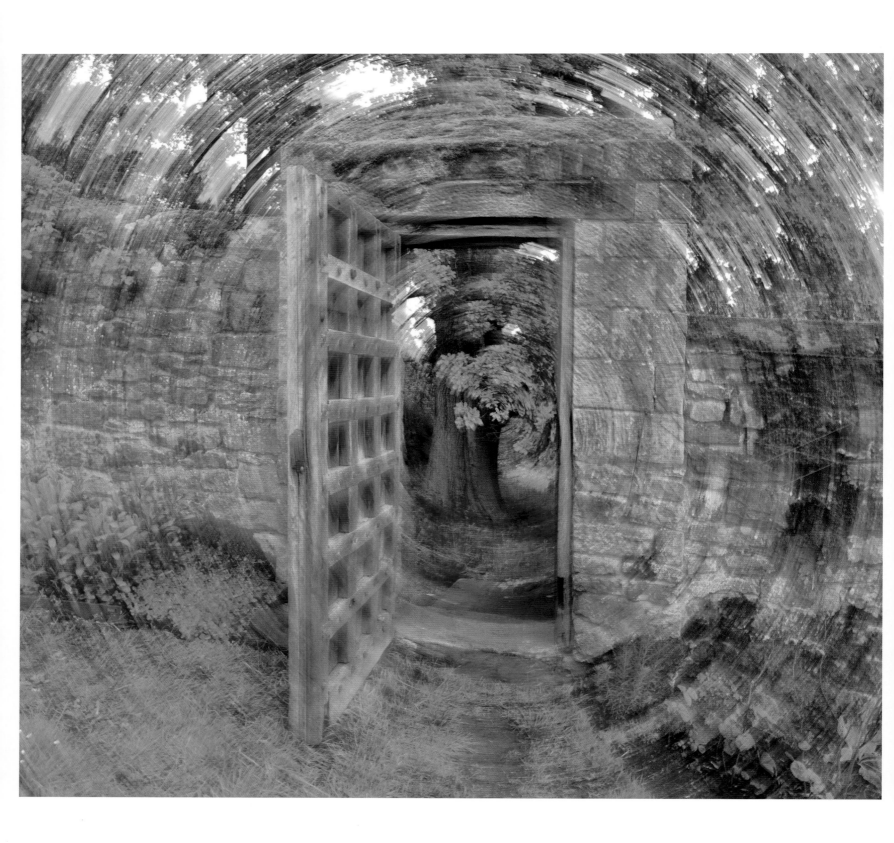

ENGLISH OAK

(Quercus robur)

COMMON NAMES
English oak, common oak, pedunculate oak

FAMILY
Fagaceae

DESCRIPTION
Deciduous tree with broad crown and lobed leaves;
catkins are followed by acorns

HEIGHT
20–40m

Native

Sacred to the great gods of thunder and lightning –
Greek Zeus, Roman Jupiter and the Celtic Dagda –
the oak tree is imbued with the symbolism of storms.

This dramatic reputation has some basis in reality: oaks are often taller than surrounding trees and have a high moisture content, making them uniquely well placed to conduct electricity. When a tree is hit by lightning, the sap is rapidly heated and evaporates into steam. The pressure of this causes the bark of the tree to blow off, creating a scar of exposed trunk charting the path of the lightning.

The tree at Haddon Hall is one such survivor, bearing its proud battle scars. Just as Lord Salisbury recalls of the oak at Hatfield – 'I grew up with them and they are part of me too' (see page 134) – so Lady Edward Manner's words similarly reveal the depth of human connection with these giants of the natural world. More than part of the landscape, they are friends, a comfort, part of the family psyche.

Able to live for over 1,000 years, oak trees are witnesses to history: Druids have worshipped in their groves; young couples in Cromwell's era were married beneath their canopy; King Charles II is even believed to have concealed himself in an oak from Parliamentarian soldiers. Glastonbury Tor, Somerset, is home to two of the most ancient examples – named Gog and Magog, these trees are thought to be over 2,000 years old; while Sherwood Forest boasts the UK's largest oak tree, the Major Oak (see page 66), weighing in at 23 tonnes and with a spread of 28 metres.

MOTHER NATURE, MAMA OAK

'A private paradise for all that coexist with her' is an apt description of a species that supports such a wealth of life. As well as the tawny owl that nests in this particular tree, it is estimated that a 400-year-old oak can host as many as 284 different species of insect in its canopy and support 2,000 different types of bird, lichen and fungi.

'Mama' seems an appropriate name for a tree so rich in meaning and memory, both national, personal and of the natural world.

Mama Oak

Can a tree be a friend? I believe so.
They can watch you and wait for you.
Providing comfort in their shadow and presence.

This tree stands imposingly behind the garden wall.

A sentry at the garden gate.
Monitoring all that leave and enter.
Greeting you as you leave the order of the Tudor walled gardens to enter the wilderness beyond.

As a family, we call this tree 'Mama Oak'.
Her trunk is perfectly sculptured for our twin boys to nestle into her and hide from the wind.
She has a hollow for an owl to enjoy and she provides a private paradise for all that coexist with her.

Moss covers her comfy roots and somehow a court exists at her base where stinging nettles and thistles never grow.

As a family we celebrate this tree.
Her strength.
Her gentle, calming composure.
Her four hundred years of existence.
Her age and her lightning-scarred trunk.
Her connection to and physical manifestation of what, in this world, is most important to all: nature.

LADY EDWARD MANNERS

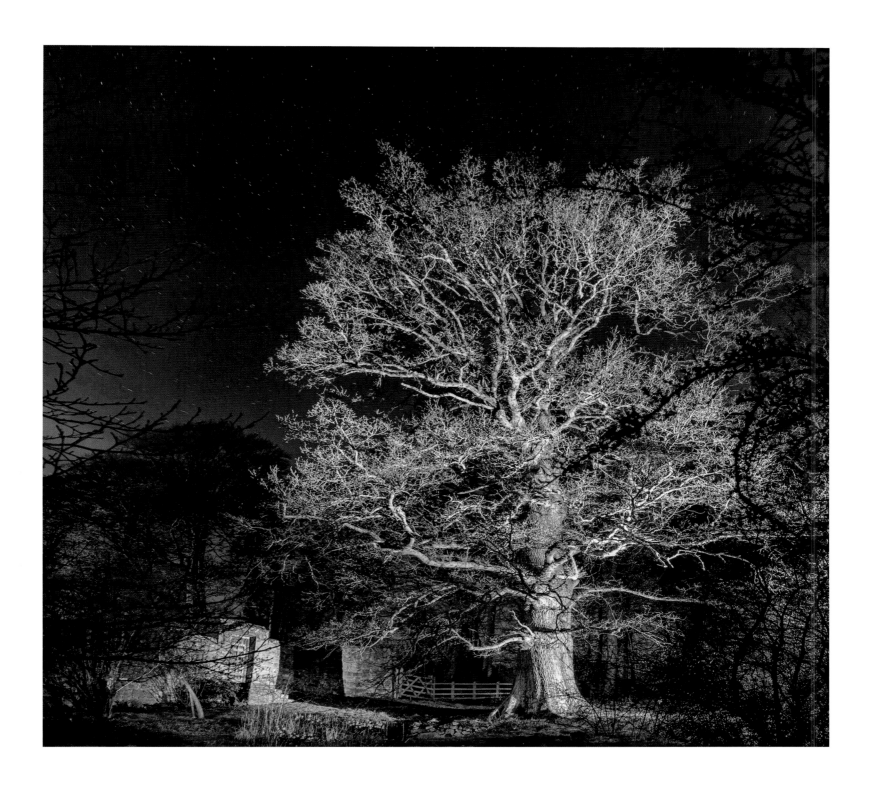

THE OAK was photographed at night here, with the ancient garden doorway in its shadow.

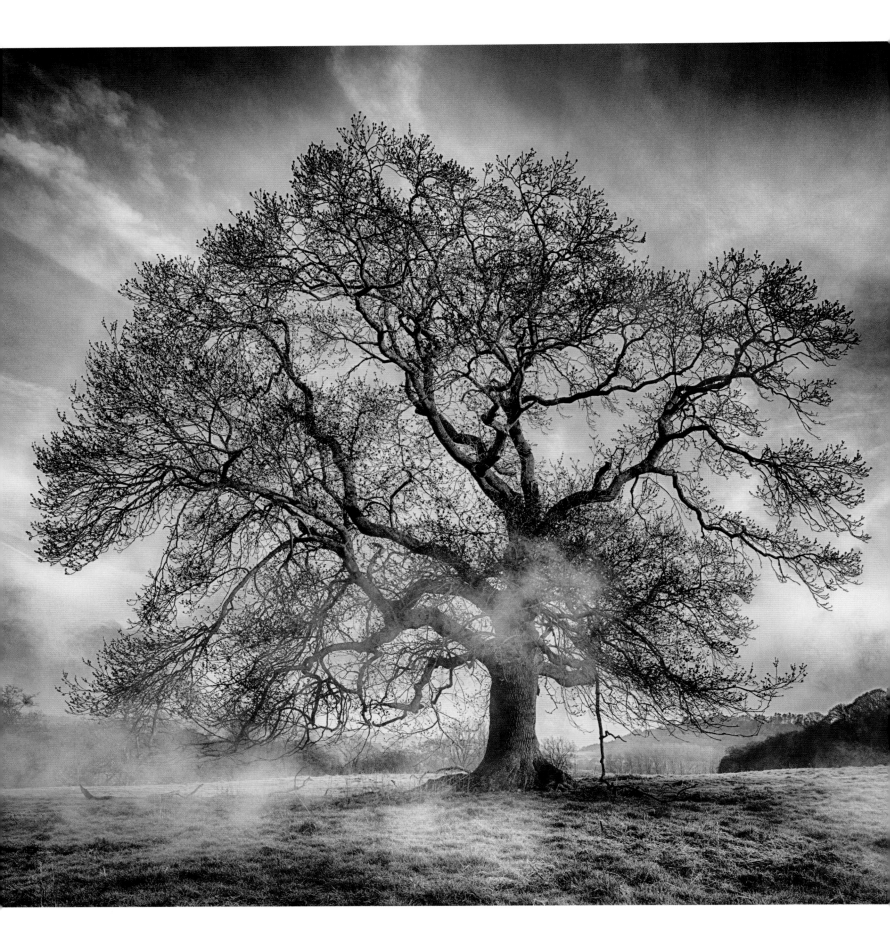

ASH

(Fraxinus excelsior)

COMMON NAMES
Ash, common ash, European ash

FAMILY
Oleaceae

DESCRIPTION
A tall deciduous tree with a domed canopy of light green leaves, purple flowers in the spring and black, velvety buds in the winter

HEIGHT
Up to 35m

Native

Known in Norse mythology as the 'Tree of Life', the ash is the third-most common tree in Britain. Celebrated through the ages for its supposed medicinal properties, it can typically live for up to 400 years.

As one of the oldest houses in the country, Haddon Hall, in the valley of the River Wye in the Peak District, boasts a rich and extraordinary history. Remaining in the care of one family for its entire 900-year existence, it houses many spectacular features from the medieval period, including rare 15th-century frescoes, a Tudor tapestry gifted by Henry VIII and a beautiful Elizabethan Long Gallery designed by noted English architect Robert Smythson.

Also stretching back through the mists of time in the grounds of this illustrious estate, which includes 600 acres of woodland, is this beloved ash tree. Regarded by the Druids as sacred, and said to be the origin of the first man on Earth in Norse mythology, the ash is sometimes called the 'Venus of the Woods', and it's not hard to see why when gazing at its graceful form among the ancient parkland and the rugged landscape of the Peak District beyond.

UNDER THREAT

Sadly, this most cherished of native trees is facing decimation with the onslaught of ash dieback – a disease that causes its leaves to wilt and die, as well as blocking its water transport systems, slowly killing the tree. While the gradual progress of this disease means the full impact is as yet unknown, it is thought that the UK could lose around 80 per cent of its ash trees. This will be a devastating blow to the biodiversity of woodlands and a major loss of habitat. There is a glimmer of hope on the horizon, though, as research suggests some ash trees may be resistant to ash dieback and could help the species eventually recover over time.

'This lovely old ash is not the oldest or grandest, but is rooted in an ancient pasture untouched by the plough. This combination provides a wonderful and diverse habitat for all manner of flora and fauna. Visually these stand-alone ash trees provide structure and character to the landscape, and will be sorely missed should the dreaded ash dieback disease take hold.'

LORD EDWARD MANNERS

DETAILS OF the ash tree show off the pinnate leaves and the brown-grey bark that typically fissures with age.

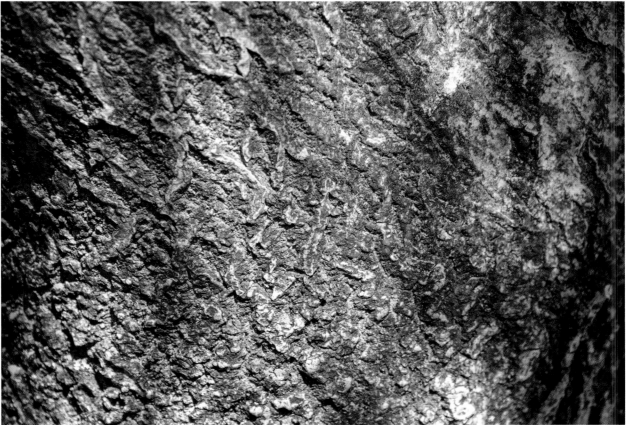

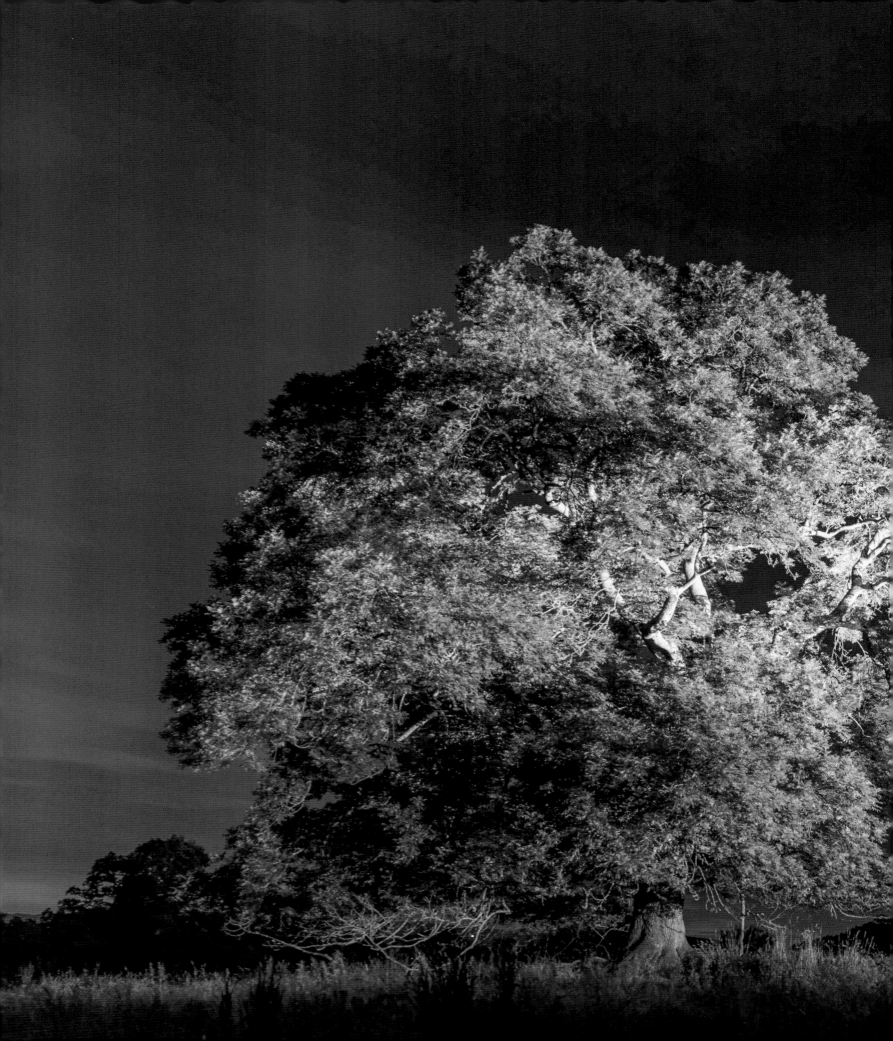

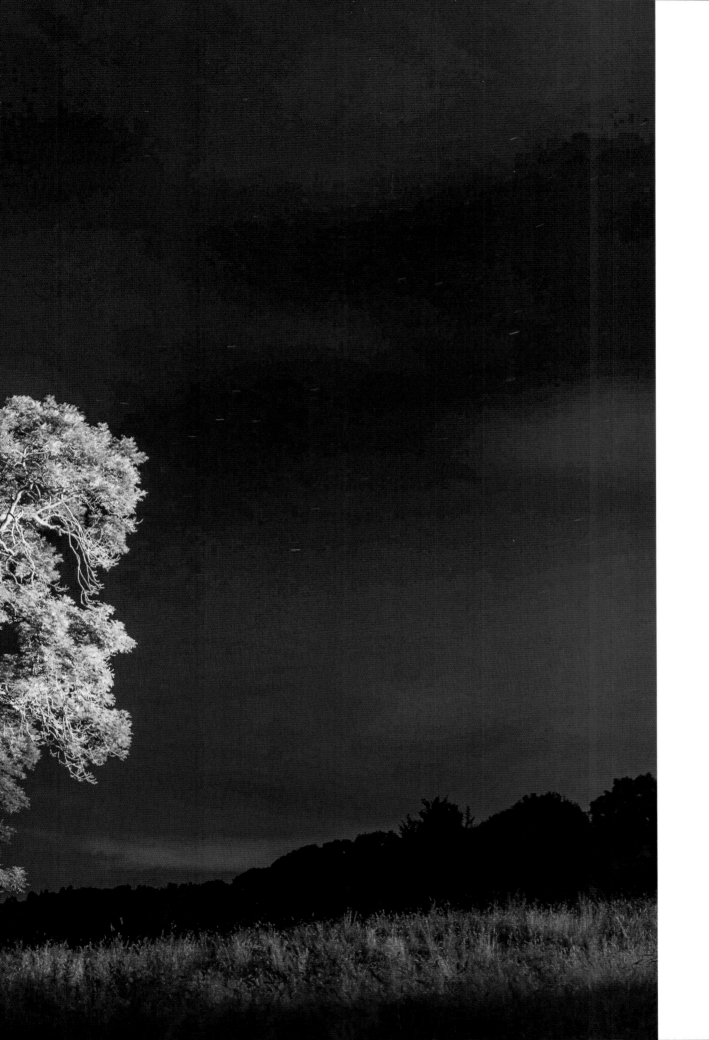

THIS HADDON ash was photographed at night, with the lights of Bakewell on the horizon giving the clouds an orange glow.

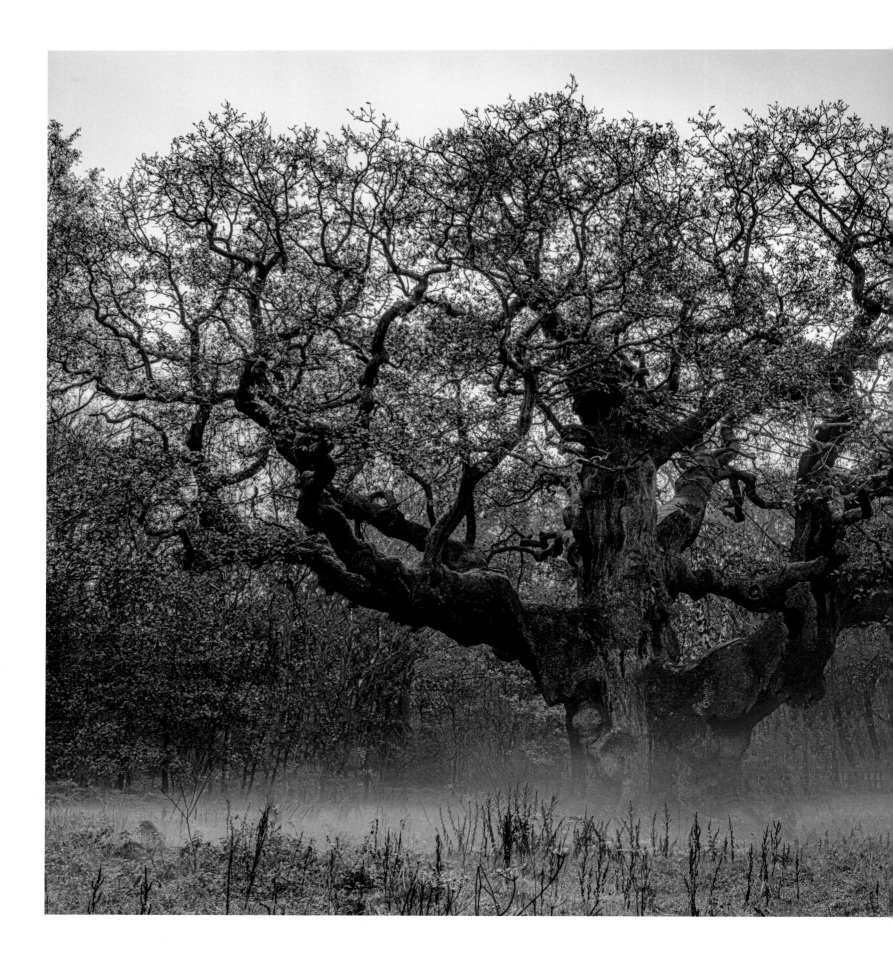

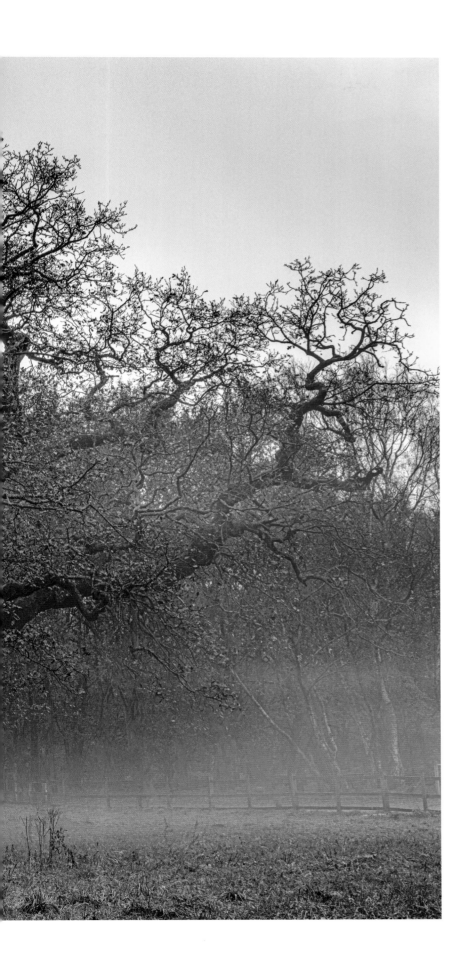

ENGLISH OAK

(Quercus robur)

COMMON NAMES
English oak, common oak, pedunculate oak

FAMILY
Fagaceae

DESCRIPTION
Deciduous tree with broad crown and lobed leaves;
catkins are followed by acorns

HEIGHT
20–40m

Native

According to legend, this giant oak provided
shelter and protection to Sherwood Forest's
most notorious residents, the famous outlaw
Robin Hood and his band of Merry Men.

Although one of nearly a thousand ancient oak trees in the tree-laden Sherwood Forest, the Major Oak stands tall. Quite literally, in fact, as it is the largest oak tree in Britain, with a canopy spanning 28 metres and weighing in at an estimated 23 tonnes. While you might be forgiven for thinking that this ancient colossus acquired its name due to its gargantuan proportions, it is instead named in honour of Major Hayman Rooke, whose 1790 book, *Remarkable Oaks*, detailed this particular oak, along with a number of others in the area.

While the Major Oak's exact age is unknown, it is thought to have stood in the midst of Sherwood Forest for between 800 and 1,100 years. Although it has been fenced off since the 1970s for protection and conservation purposes, visitors can still follow the Major Oak trail from the visitor centre to admire this magnificent tree and marvel at its incredible history. Its role is still as vital in the modern day, as it provides a natural habitat for a wide variety of wildlife in the forest, including bats, squirrels, beetles and more.

'The Major Oak embodies all that is precious about our ancient trees. Its huge squat trunk, gnarled beauty, wildlife value and cultural heritage make it one of our most iconic trees. Such trees are living green monuments linking us to our past. There is a possibility that it may have been a "Wayfaring tree" used by the Romans, after examining data found in our investigation below.

Our TreeRadar© survey found that the tree is rooting down to at least 2.5 metres deep and out to 40 metres from the trunk, but this is only part of the story. From this a myriad of fine roots and a huge interconnected network of beneficial soil fungi fuse and explore the soil to gather soil nutrients, water and boost the tree's immune system. This fungal network links to other trees to share information and resources.

The popularity of this tree has led to soil compaction, making it harder for the tree to "breathe", so there is an expert team working to give the tree a boost. Trees are the "canaries in the coalmine", and their decline in health is a wake-up call for us to respect the air and soil, and ultimately save ourselves.'

SHARON DURDANT-HOLLAMBY, FICFOR

THIS OAK has stood on the edge of Sherwood Forest for over 800 years, tinged with green lichen, and still commands the forest that surrounds it.

HOLM OAK

(*Quercus ilex*)

COMMON NAMES
Holm oak, holly oak

FAMILY
Fagaceae

DESCRIPTION
An evergreen broadleaf tree with a
rounded crown of dark green leaves

HEIGHT
Up to 20m

Non-native

Prized in Ancient Greece as a source and
symbol of fertility, the acorn of the holm
oak was often used as a motif in jewellery
to improve chances of conception.

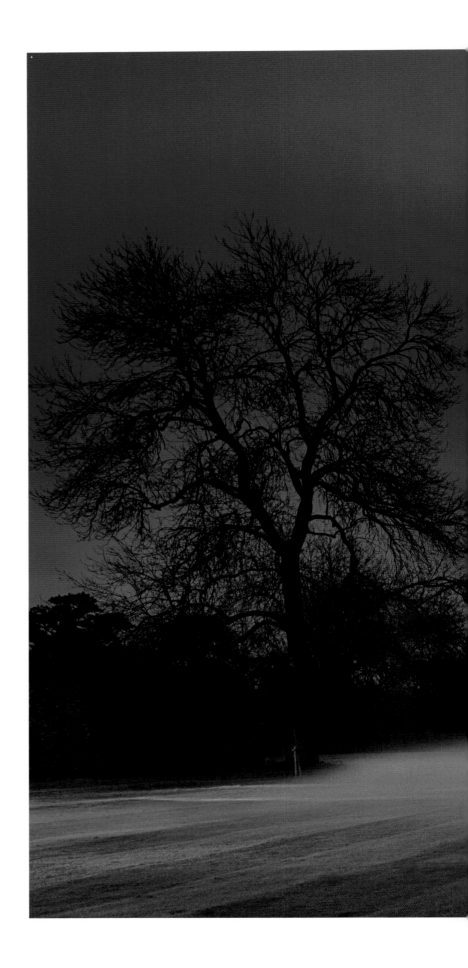

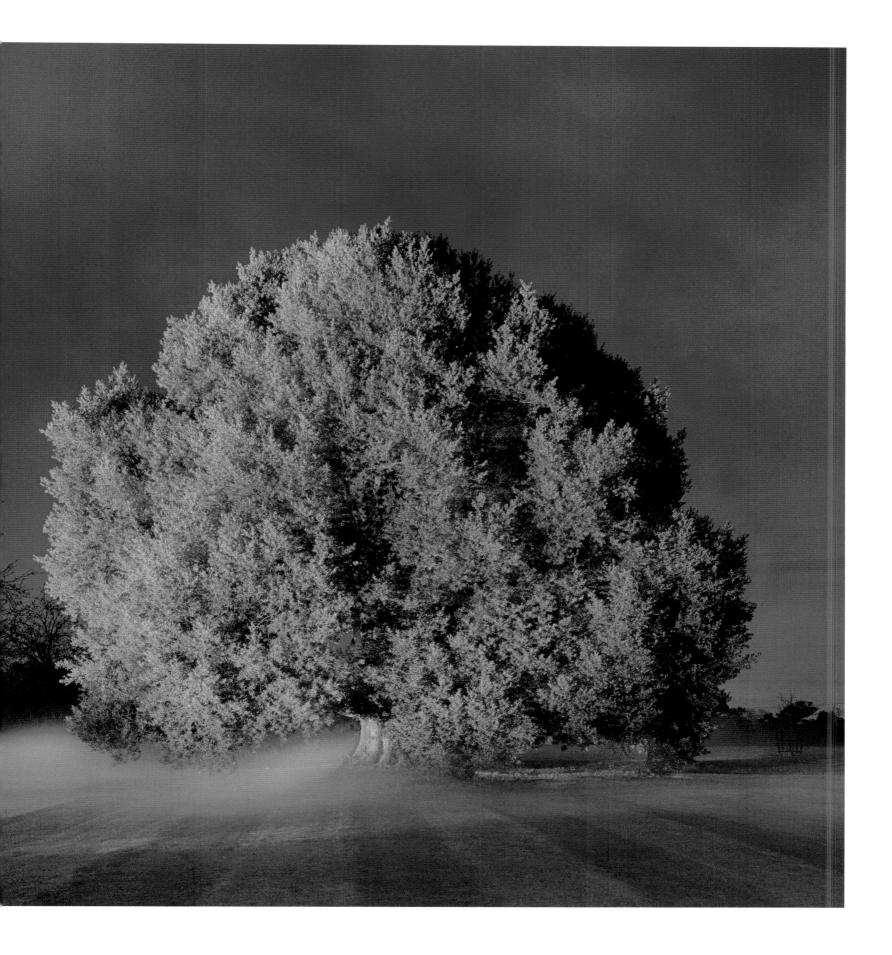

Belonging to the Acton family from 1585, nothing is known of the Elizabethan house that must have stood on the site of Wolverton Hall in Worcestershire. However, the present Grade II-listed Queen Anne residence, with its stately brick facade, was built in the early 18th century. Wolverton was home to generations of the Acton family until the late 20th century, with only a brief interruption during the Second World War, when the Hall was requisitioned as a base for part of Churchill's 'secret resistance army', who trained there in readiness for an anticipated German invasion.

Wolverton Hall has been home to the Coleridge family since 2004. Author Nicholas Coleridge was captivated by the elegant holm oak in the grounds when he first saw it. 'One of the reasons we fell in love with our house, Wolverton Hall, near Pershore in Worcestershire, was the evergreen holm oak,' he says. 'It stands magisterially at the end of the lawn, with a near-perfect silhouette.'

While nobody knows exactly how old the holm oak at Wolverton is, it is believed to have been planted between 1840 and 1860, during the ownership of the Acton family. A native of the eastern Mediterranean, the holm oak has been naturalized in the UK since it was first introduced in the late 1500s, and its bright, evergreen canopy provides valuable year-round shelter for birds and other wildlife. The holm is a versatile tree being both resistant to sea-salt spray and also able to withstand air pollution. This makes it a natural choice for coastal locations, where it can act as a natural wind break, and for city planting.

'Three years after we moved to Wolverton, a terrible disaster struck the tree. I heard about it in Mumbai airport, while waiting at the carousel for my luggage. My mobile rang, it was the tree expert. The holm oak had been struck by lightning, and the trunk split down the middle, right down to ground level; you could see an inch-wide gap through the whole trunk. The remedy was drastic. We had to remove 35 per cent of the weight of the tree, and then have a steel brace fitted. It was fired in a furnace in Wolverhampton, and took three weeks before it could be fitted, during which time the tree could have collapsed in two at any time. At last the job was done. The poor holm oak looked distinctly sick for the next three years, and rather lopsided. I prayed weekly for its recovery. Then slowly, by the healing powers of nature, it regained its shape. We were blessed to save it.'

NICHOLAS COLERIDGE, CBE

THE HOLM oak sits in the middle of the lawn at Wolverton and was photographed here as the full moon rose behind it.

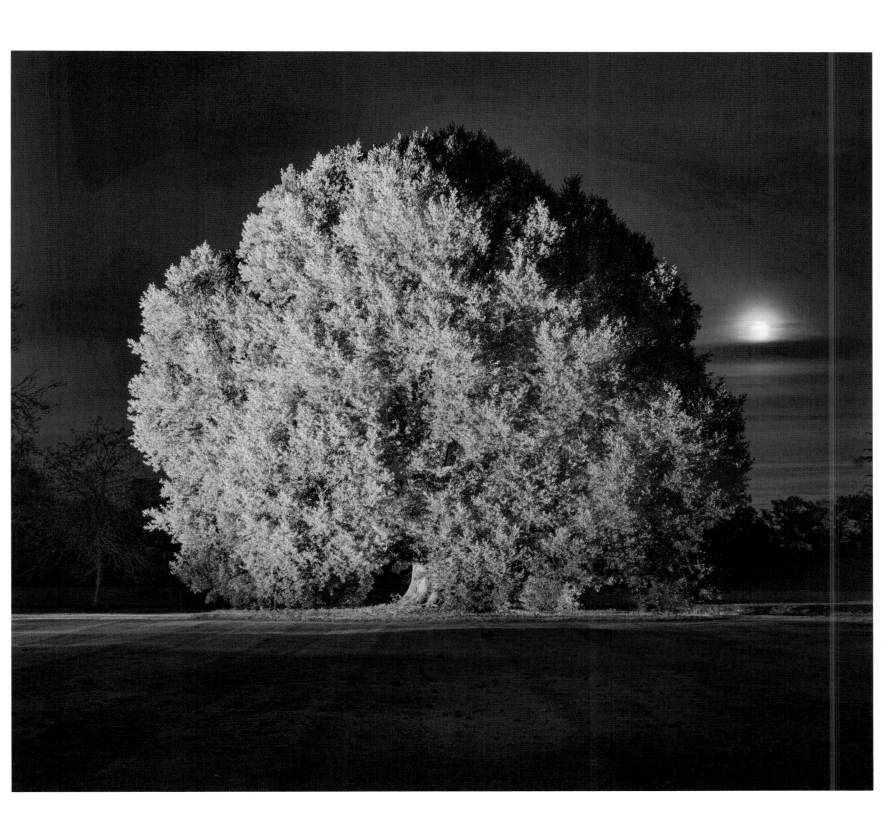

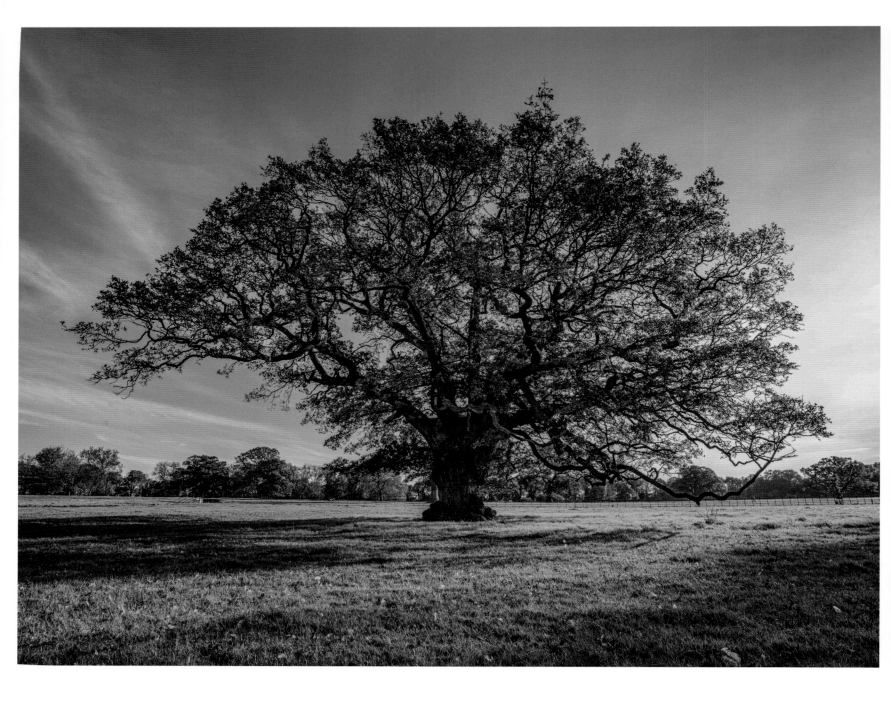

Raveningham Estate, Norfolk • July 2020

ENGLISH OAK

(Quercus robur)

Supporting more life forms than any other native tree, the majestic
English oak also has historic links with royalty, when Roman
emperors and ancient kings wore crowns made of oak leaves.

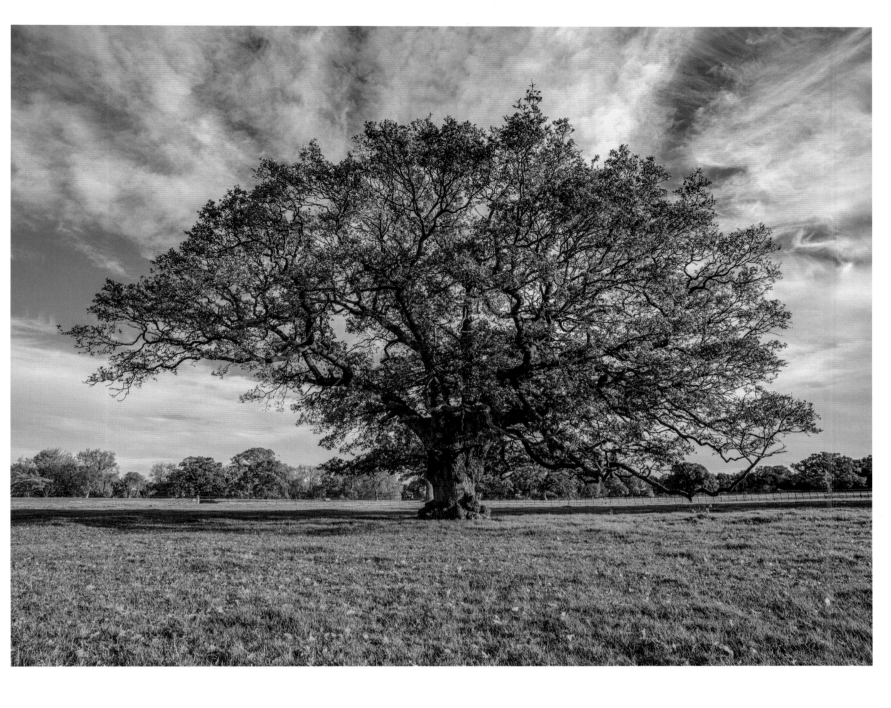

COMMON NAMES
English oak, common oak, pedunculate oak

FAMILY
Fagaceae

DESCRIPTION
Deciduous tree with broad crown and
lobed leaves; catkins are followed by acorns

HEIGHT
20–40m

Native

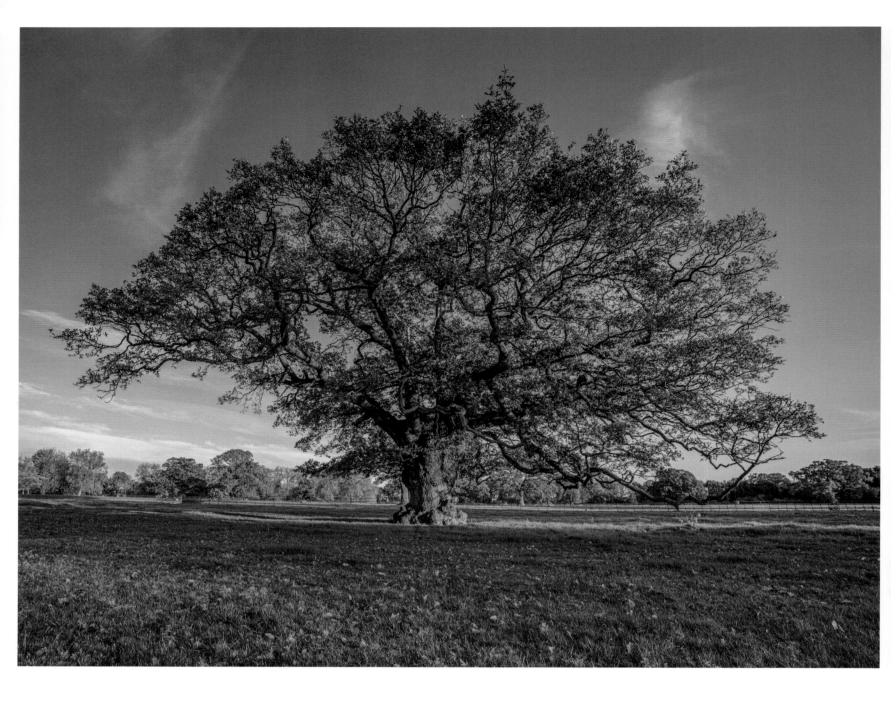

'Craggy, gnarled and once a boundary between pastures before the park was enclosed in the 18th century, the oak holds a history of England in its heart. It lives on, possibly awaiting the pollard axe which has been absent for the past 250 years.'

SIR NICHOLAS BACON, OBE

THE FOUR pictures of this oak were taken in the same position from the early morning through to dusk, showing how the light affects the tree throughout the day.

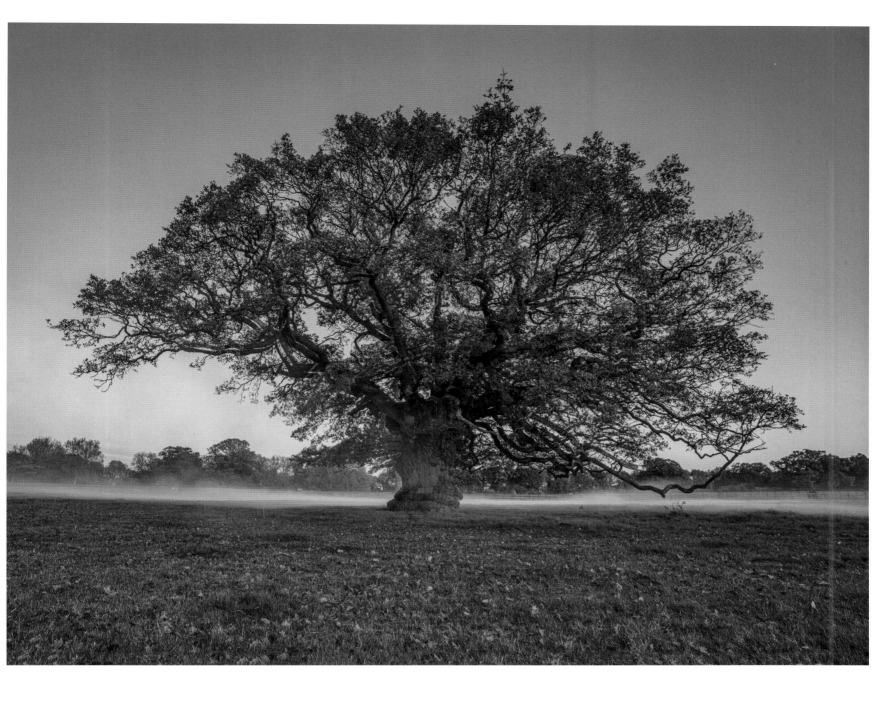

Home to the Bacon family since 1735, the 5,500-acre rural estate at Raveningham Hall in Norfolk is mainly farmed, but also plays a vital role in conservation and biodiversity. The glorious grounds incorporate a medicinal herb garden, rose garden, arboretum, formal lawns and lake, a walled Victorian kitchen garden, as well as the Time Garden, designed to honour Sir Francis Bacon's essays on the passage of Time.

Within the parkland on the estate stands this statuesque English oak, thought to have been planted around 400–500 years ago as a hedgerow tree. This estimable oak contributes to more than simply history. Its branches host insect species and small birds, while its leaf buds provide sustenance for caterpillars, and its acorns feed mammals such as deer. The oak is host to as many, if not more, invertebrates as any other tree in the UK. Their future is vital as both a habitat and a resource.

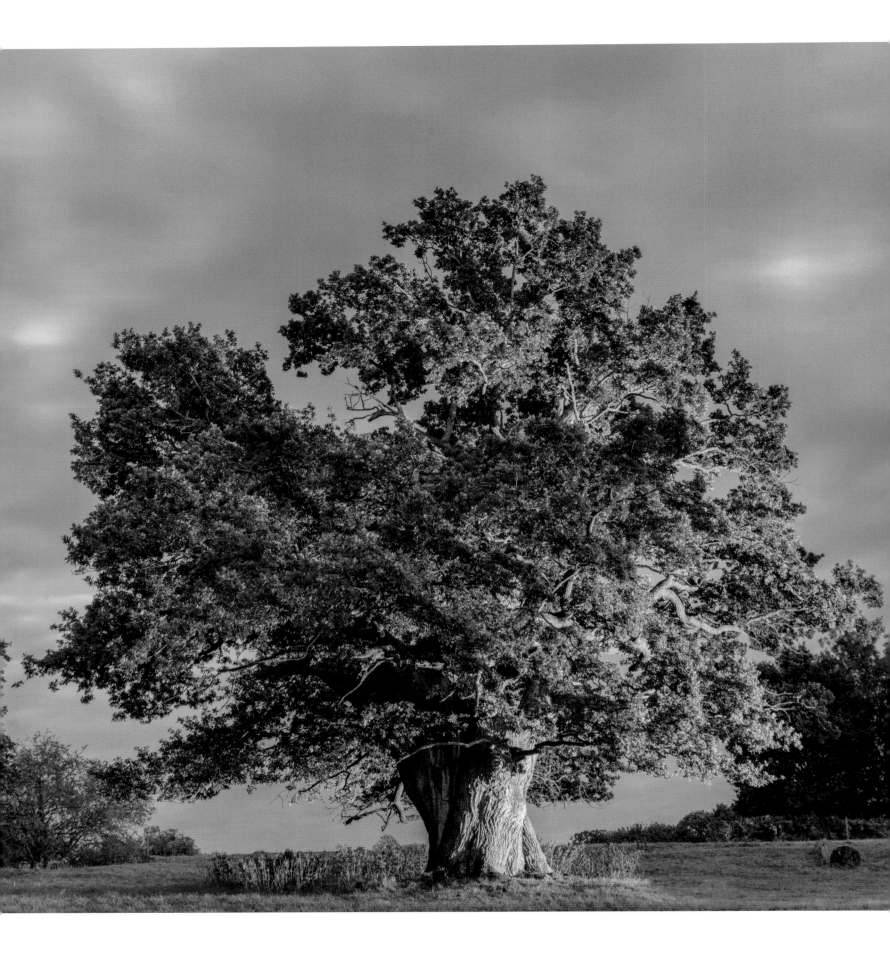

ENGLISH OAK

(*Quercus robur*)

COMMON NAMES
English oak, common oak, pedunculate oak

FAMILY
Fagaceae

DESCRIPTION
Deciduous tree with broad crown and lobed leaves;
catkins are followed by acorns

HEIGHT
20–40m

Native

Dating back to the 14th century, this English oak
at Kimberley Hall is in illustrious company among
some of the finest ancient oaks in the UK.

'The magnificent oak at Kimberley Hall was a challenge to climb as a small child and seemingly changeless in my lifetime. The notion that it has survived seven centuries of history is hard to comprehend. Every year we witness broods of Egyptian geese hatch in the palm of its hand, little owls and myriad species of insect – indeed an entire ecosystem dependent on its existence. For me, it represents a living jewel in my life – the pinnacle of this remarkable collection of ancient oaks once described as the "coral reefs of England".'
ROBBIE BUXTON

Oak trees are not only quintessentially characteristic of the English landscape, they are also the workhorses of the tree world, their limbs plundered for multiple uses in past centuries such as shipbuilding (indeed, Norfolk's most famous seaman Admiral Lord Nelson used 6,000 trees to build HMS *Victory*), hence the distinctive squat 'pollard' form of this oak and many others here in the park at Kimberley Hall.

The collection of ancient oaks in the extensive woodland here has been recognized by experts at Kew Gardens as the finest in Norfolk and of great importance in the UK due to the great numbers of ancient parkland oaks, many of which date back to the 14th century. This particular English oak has always been a favourite with the Buxton family, who have lived at Kimberley since 1958 when they embarked on a major restoration of the building that, like many others of this ilk, was under threat of demolition. The house was built by William Talman in 1712 during the reign of Queen Anne.

The substantial gardens and park at Kimberley were designed in 1762 by Lancelot Capability Brown. The most successful landscape gardener of the 18th century, Capability Brown's designs were restrained and unfussy with an emphasis on the quiet beauty of the English countryside. Thankfully, native trees were crucial to this natural vision, and as Robbie and Iona Buxton remarked, 'It is fortunate that Capability Brown wove his landscape around these oaks, unlike many landscape designers at the time who considered them unsightly and removed them.'

A DETAIL of an ancient fallen oak at Kimberley Hall, showing the colours of decay yet still managing to display its beauty.

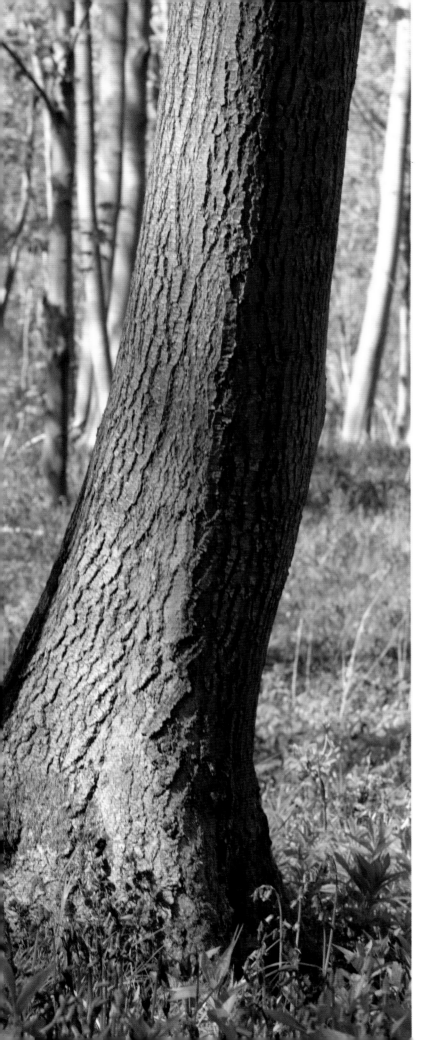

THIS PHOTOGRAPH looking through an ash tree into a Kimberley bluebell wood reminds me of the importance of organisms supporting each other in the natural world.

SYCAMORE
(*Acer pseudoplatanus*)

COMMON NAMES
Sycamore

FAMILY
Sapindaceae

DESCRIPTION
A wide-canopied broadleaf tree with distinctive
winged fruits known as samaras

HEIGHT
Up to 35m

Non-native

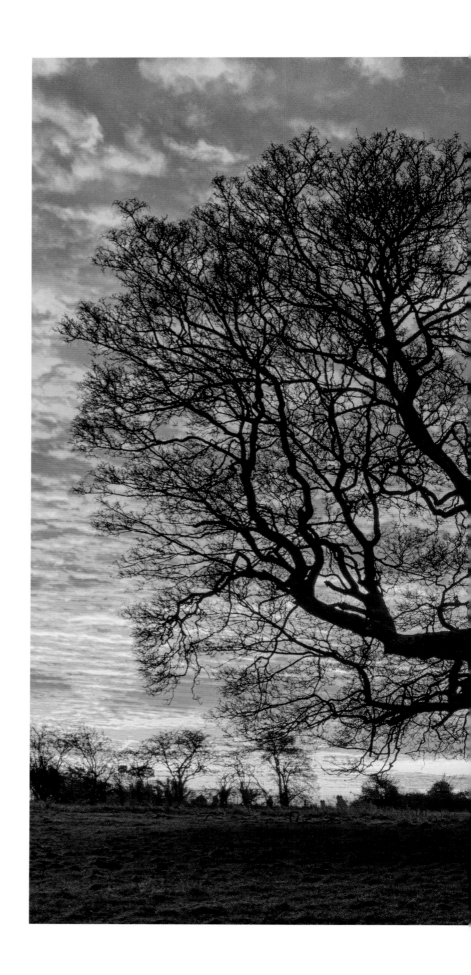

The origins of the sycamore in the UK
are uncertain; it may have been introduced
by the Romans or perhaps arrived in the
1500s during the Tudor era. Whichever is true,
this non-native tree is now widespread
throughout the British Isles.

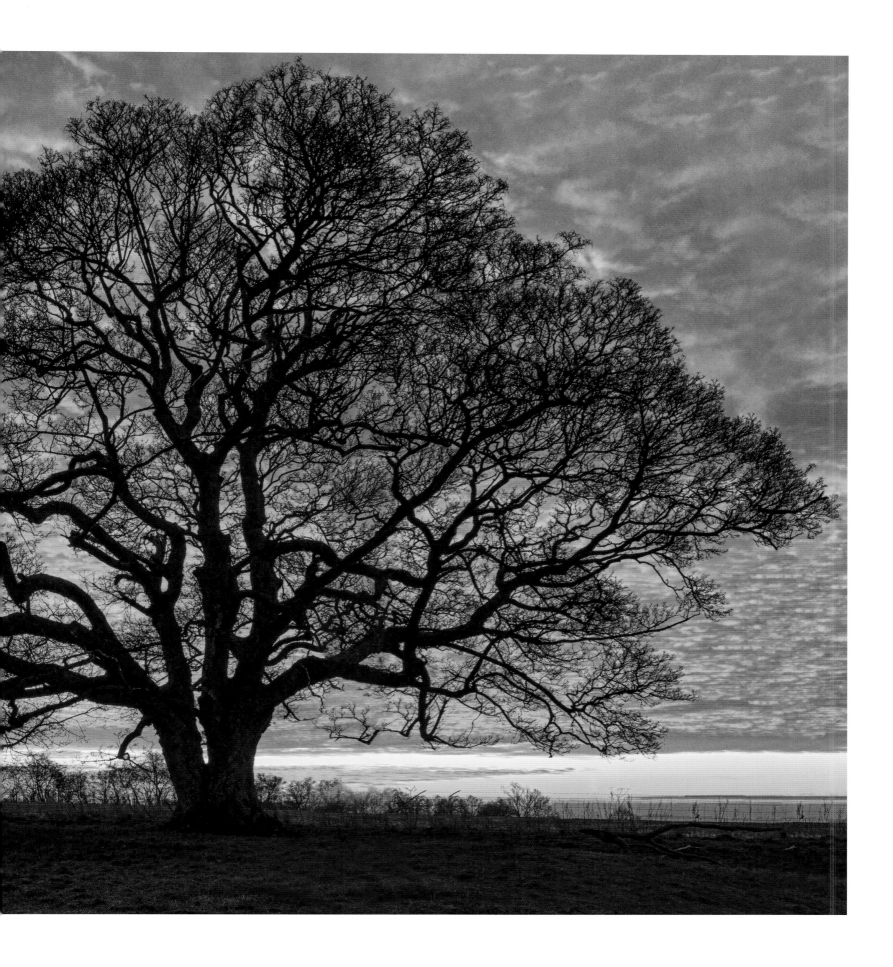

'This tree lies on the skyline at the border of our land. When you arrive here you see it immediately to the south as you come out of the woods and cross the cattle grid and the start of pasture.

This sycamore expresses a searching vitality that spreads wide against the sky. We built the look-out tower next to it and can now enjoy looking at it from ground to canopy. The stark geometry of the tower makes its striving branches all the more vigorous.

One of our artist friends climbed this tree and standing on a horizontal lower branch called out to ask a crowd gathered around its base, "Who will join me and speak the language of the spirits?"'

ANTONY GORMLEY

High House, now the home of celebrated sculptor Antony Gormley, is an 18th-century Palladian-style villa built by writer Edward Spelman, who had been inspired by the classic architectural style on show in Europe in the era of the Grand Tour. Along the edge of 50 acres of woodland and fields here, stands this elegant tree, tall and proud against the horizon in this peaceful Norfolk landscape.

Often planted in parks and large gardens due to its broad silhouette, the sycamore's numerous green dangling flowers are very attractive to bees and provide an excellent source of pollen. Their distinctive winged seeds have long been a favourite in children's games – the 'helicopters' swirling and twisting in the wind to great delight, adding a spark of fun and wonder.

THIS SYCAMORE was captured during a biblical sunrise, the tree silhouetted against the fiery sky.

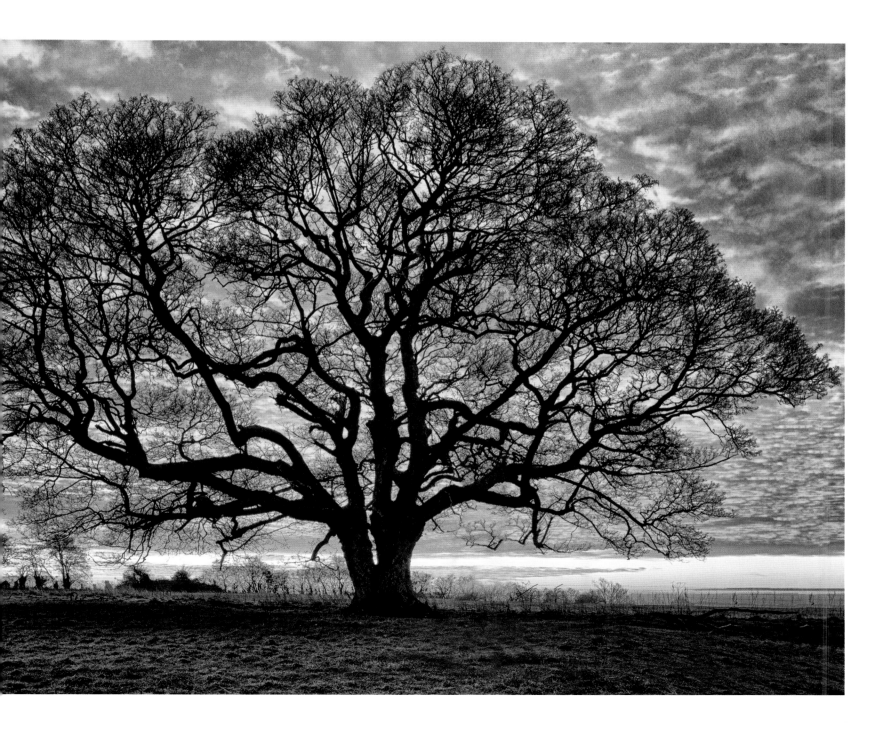

ENGLISH OAK

(Quercus robur)

COMMON NAMES
English oak, common oak, pedunculate oak

FAMILY
Fagaceae

DESCRIPTION
Deciduous tree with broad crown and lobed leaves;
catkins are followed by acorns

HEIGHT
20–40m

Native

Once they have fallen in the autumn, the leaves of the
oak tree break down with little assistance and provide
an excellent source of mulch to condition the soil.

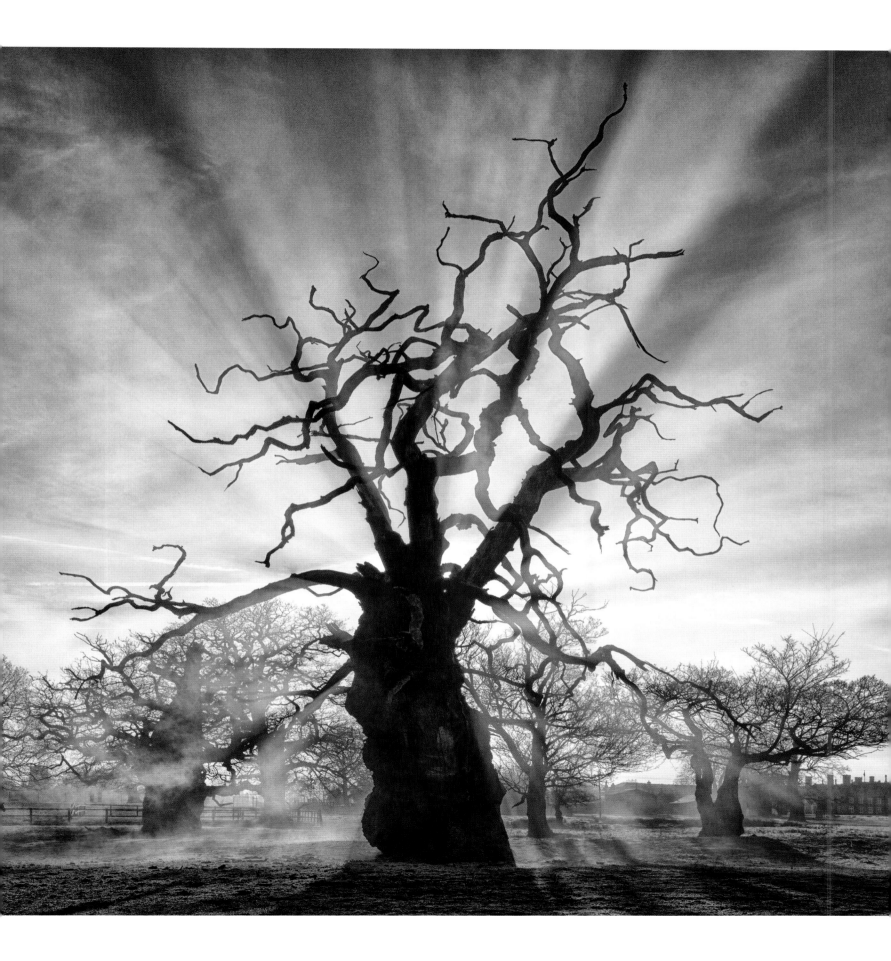

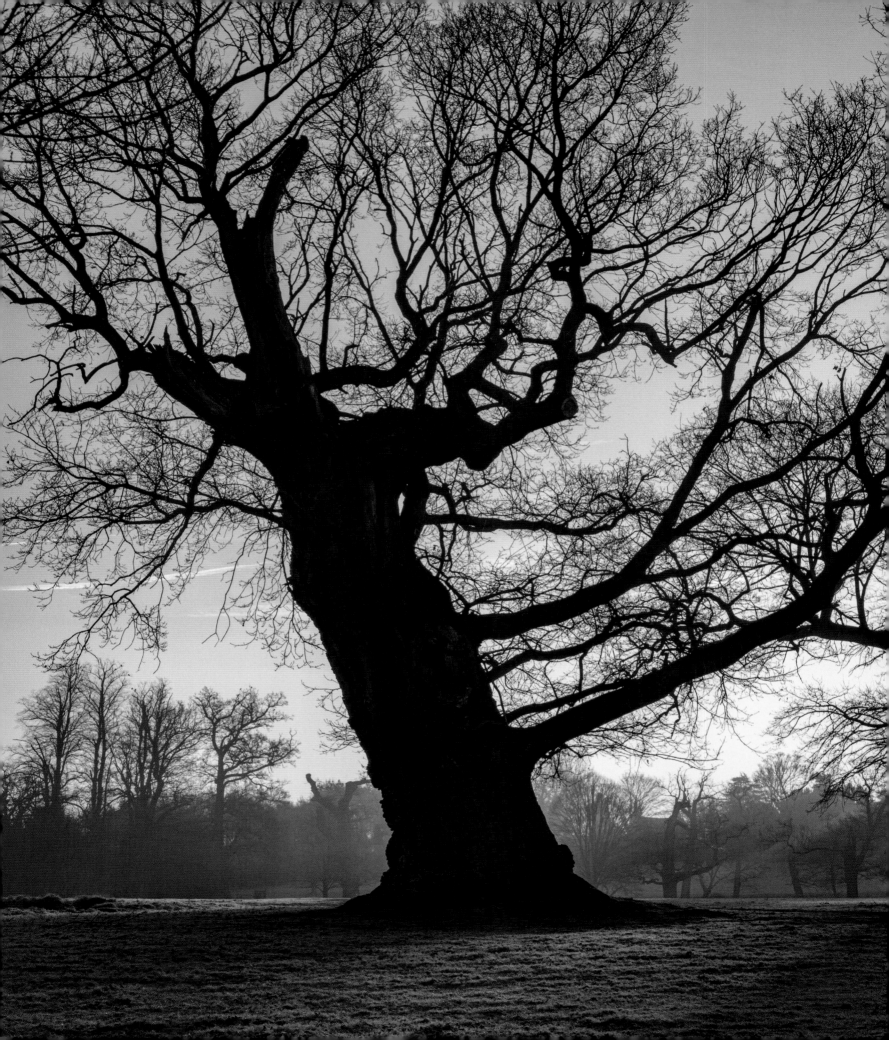

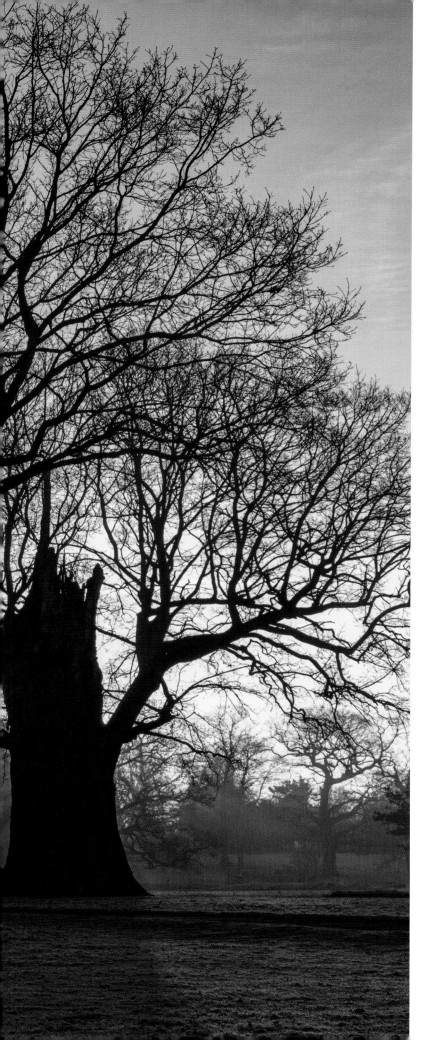

'Her Majesty The Queen for many years stayed at Helmingham Hall during the month of November. This was the oak tree in whose hollow trunk she sheltered when walking in Helmingham Park.'
LORD TOLLEMACHE

The extensive park at Helmingham Hall in the Suffolk countryside covers over 400 acres. As well as providing a space to roam for large herds of red and fallow deer, the park is home to many oak trees, some estimated to be up to 900 years old. Parks such as these, often developed by the aristocracy in the medieval period for hunting deer, are one of the reasons that the British Isles can boast such a high density of oak trees – England has more oak trees than all other European countries combined. One famous oak tree in the grounds here was captured by the acclaimed English landscape artist John Constable, in his oil painting *Helmingham Dell*.

The impressive oak avenue that leads up to Helmingham Hall was planted in around 1680, and while it sadly suffered damage in the hurricane of 1987, a replanting scheme has subsequently been embarked upon. With the original building completed in 1510, the beautiful red-brick Hall, surrounded by its 60 foot-wide moat, has been home to generations of the Tollemache family for over 500 years. In recent years, the Hall and the grounds have been visited on a number of occasions by Queen Elizabeth II.

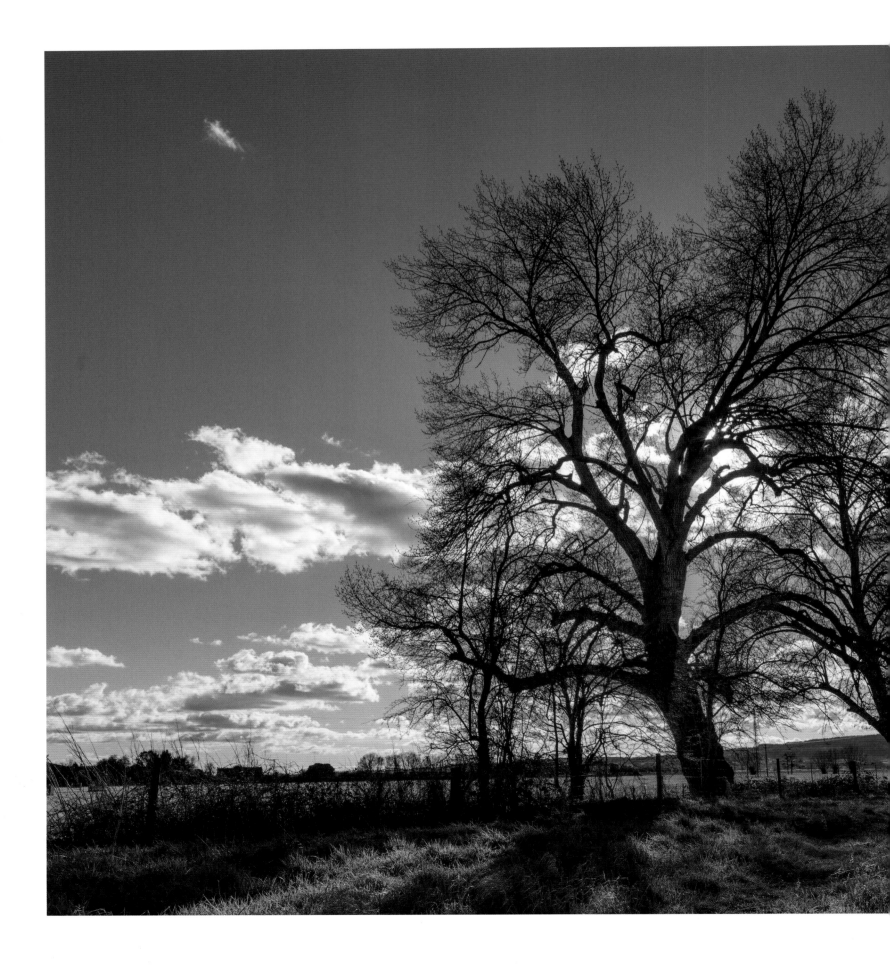

BLACK POPLAR

(Populus nigra subsp. *betulifolia)*

COMMON NAMES
Black poplar

FAMILY
Salicaceae

DESCRIPTION
A large deciduous tree with green heart-shaped leaves; a dioecious tree, the male catkins are red and the female catkins yellow, developing into fluffy cotton-like balls once fertilized

HEIGHT
30m

Native

Black poplars grow easily with vigorous and invasive root systems, but rely on floodplains and other waterside locations to thrive, and cannot tolerate dry conditions.

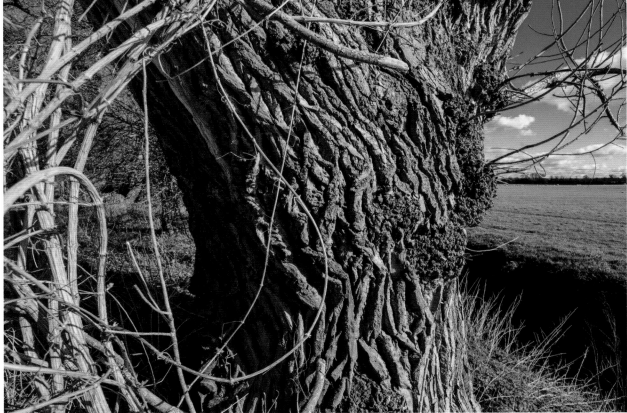

THE TRUNK of an ancient poplar, with its deep bark forming patterns of light and shade.

'*I have to make an admission here. I am far more used to writing about the birds that inhabit the trees that adorn some of our British landscapes than the actual trees themselves. So, when I was asked to pen this piece about the black poplar I greeted it with a sense of panic. The black poplar is a tree that I have no intimate relationship with as a child; I did not spend time climbing its limbs (that would have proved tricky given the tree's structure) or pondering its height. My recollections of this tree are far more recent. They involve noticing, or to be more precise, having one pointed out to me while out birding in Cambridgeshire and seeing them in forests within Serbia and other places in south-eastern and eastern Europe*

Birds love being around black poplars, hence my interest in this species. They are important hosts for a multitude of insects which in turn attract a range of birds from warblers and flycatchers to the wondrous woodpeckers. I was saddened to hear that there are only approximately 120 individual trees remaining in Cambridgeshire, with many coming towards the end of their lifespan. I want to see this, and the other declining British tree species, protected and encouraged to prosper within our remaining ancient woodlands. Our lack of tree cover is an embarrassment compared to the rest of Europe. When will we learn start to respect these calming, life-giving giants?'

DAVID LINDO

The black poplar can be a huge, broad, leafy tree when mature, growing to 30 metres tall with heavy, outward-arching main branches. Native to north-west Europe, it has a large distribution area that stretches from the UK, throughout mainland Europe, into northern Africa, and east to Kazakhstan and China.

It is popularly hybridized with other poplar species and hybrids, making pure black poplars harder to locate, especially in the UK where it is now an endangered tree. Indeed, the latest statistics conclude that there could be as few as 7,000 trees remaining in Britain, with only 600 of those being female. Individual black poplars are dioecious, meaning they are either male or female and rely on wind for pollination. The rarity of female trees means regeneration of truly wild black poplars is unlikely. However, with conservation projects helping to protect existing trees, as well as taking cuttings and planting in floodplain woodlands, we may yet be able to save this elegant tree. The trees pictured here are situated at Westbury Court Garden, one of the only surviving 17th-century Dutch water gardens in the UK. Their large collection of mature black poplars is vital to initiatives to prevent the decline of this native species.

ENGLISH OAK

(*Quercus robur*)

COMMON NAMES
English oak, common oak, pedunculate oak

FAMILY
Fagaceae

DESCRIPTION
Deciduous tree with broad crown and lobed leaves;
catkins are followed by acorns

HEIGHT
20–40m

Native

The iconic English oak holds a unique place
in our hearts and our history, and loving couples
were often married under the boughs of ancient
oak trees during the time of Oliver Cromwell.

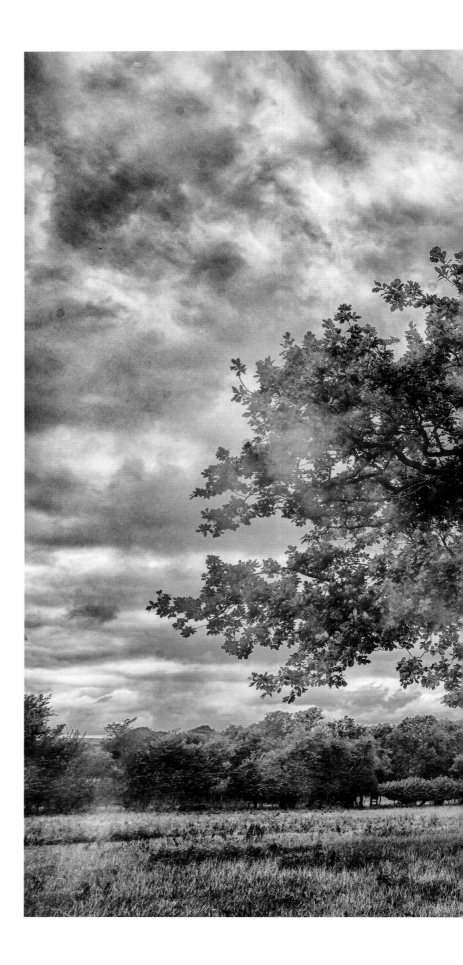

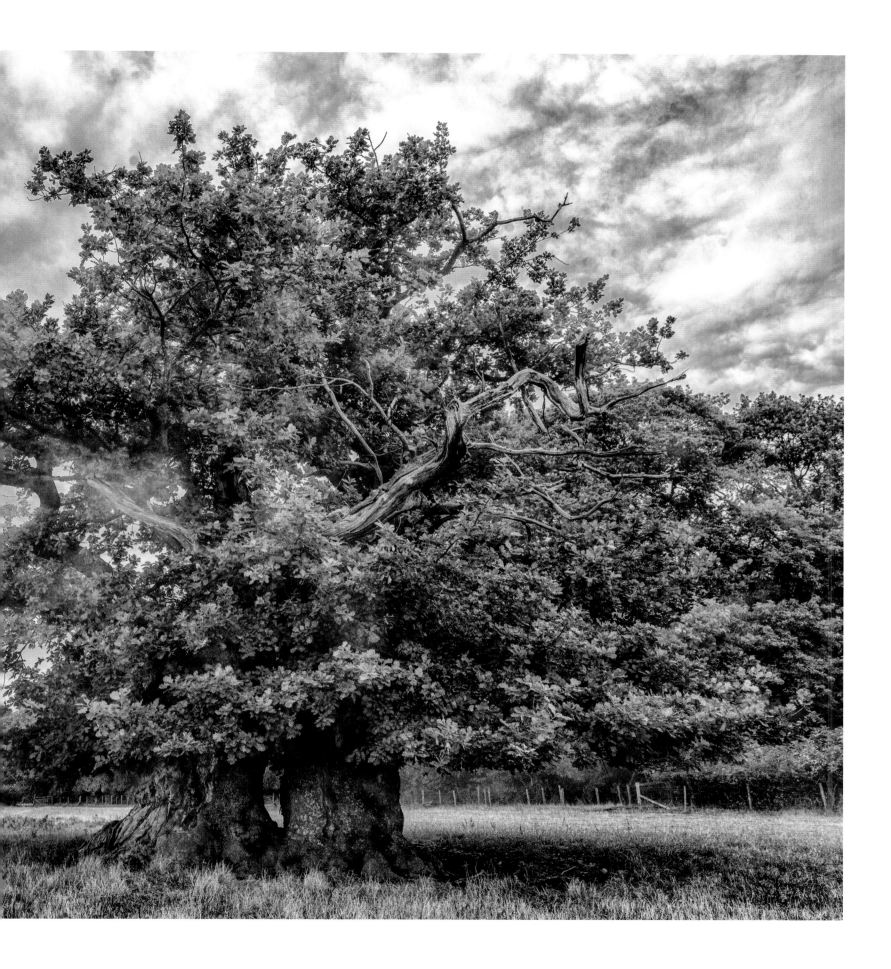

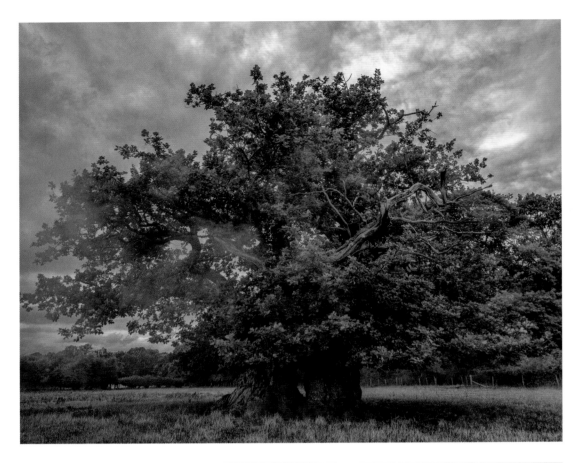

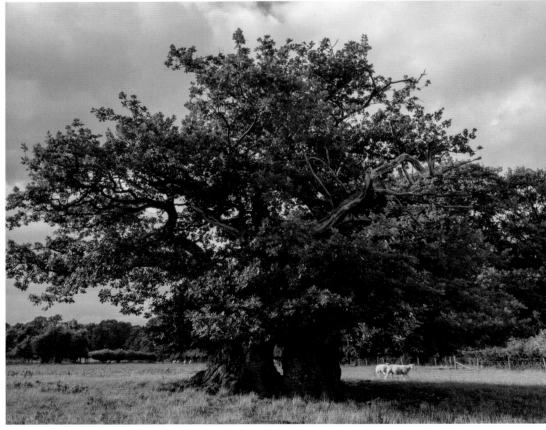

THIS OAK and its unusual form with two trunks was captured at different times during a summer day in July.

'For me, old oaks conjure up images that stretch from Robin Hood and the British Navy confronting the Spanish Armada, to my childhood treehouse, perched in low splaying branches above the footpath and bridleway that ran past our house.

I have heard of oaks being referred to as both matriarchs and patriarchs of their surroundings – but this unique specimen somehow seemed to point to a union beyond those opposites – a sacred marriage, or what 15th-century German polymath Nicolas de Cusa called a "coincidence of opposites".

Along with a handful of other points on the globe, this spot reminded me of what the Hindus call a tirtha, *a bridge to a sacred place, beyond space and time – or what T S Eliot called that "still point of the turning world". One of those rare spots on the globe, where magic seems to hang heavy and pregnant in the air, like atomic drops of sparkling diamond dew – seen but unseen.'*

RORY SPOWERS

As writer and campaigner Rory Spowers says, 'Few trees can match the majestic renown of the English oak.' He first stumbled across this particular tree with his partner Saskia, while walking near a friend's house in the Golden Valley, a few miles from Hay-on-Wye.

At the foot of the Black Mountains, this enchanting valley winds its way along the banks of the River Dore past picturesque and time-forgotten villages such as Peterchurch, Vowchurch and Abbey Dore. The gently rolling countryside in this unspoilt part of Herefordshire is a boon for walkers, keen to explore the patchwork fields and shaded woodlands.

As such, it is just the place to happen upon such an imposing tree, which Spowers admits to begin with, 'was hard to determine whether it was one tree that had split into three – or three trees that had grown into one'. In any case, he says, 'The far side of the trunk was hollow enough for the two of us to stand inside and had either been hit by lightning, or somehow rotted and fallen away, leaving three distinct bastions entwined together.' A true spectacle nestled in this tranquil landscape.

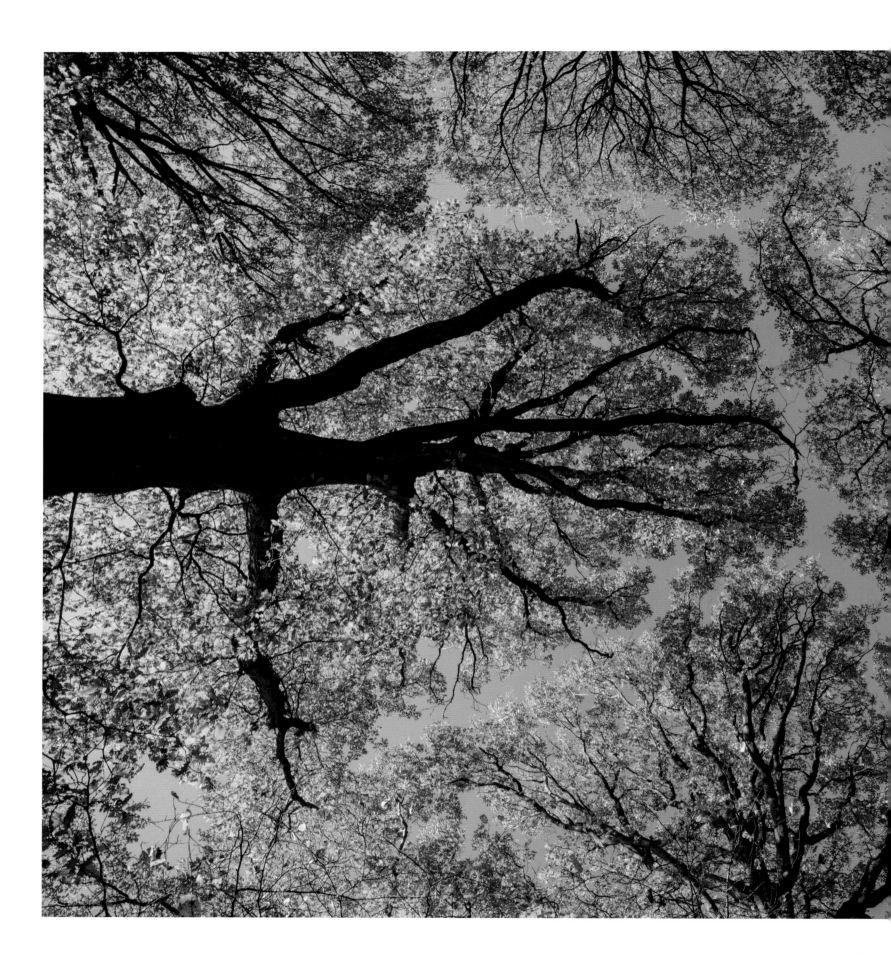

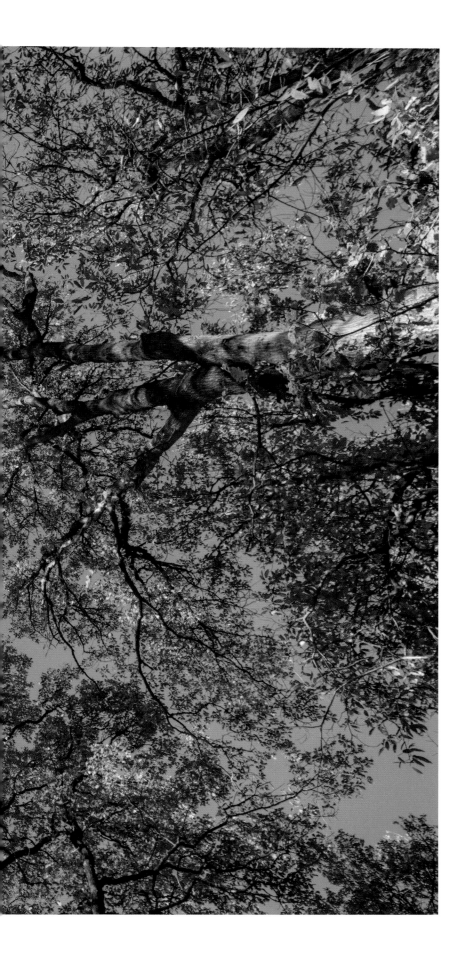

ACONBURY WOOD

Aconbury Wood has existed in some form here in Herefordshire for centuries. Classed as an area of ancient and semi-natural woodland, careful human intervention through activities such as coppicing has also occurred here for centuries, creating the rich and biodiverse woodlands that we appreciate today.

'Aconbury Wood is the jewel in the crown of the Duchy of Cornwall's Hereford Estate. Growing on a prominent hilltop, visible from the city of Hereford and for miles around, the woodland is steeped in history, both natural and human. An ancient and semi-natural woodland, rich in biodiversity and with a large Iron Age hill fort at the top of the wood, Aconbury Wood is enjoyed by local people and inhabited by abundant wildlife while also growing high-quality timber, particularly oak. Whenever I visit Herefordshire, there is a feeling of excitement once I see Aconbury, which only grows as I enter this majestic woodland.'

GERAINT RICHARDS

Aconbury Hill and its surrounding woodland is a celebrated feature of Herefordshire, visible in the landscape for miles around, with an illustrious archaeological site in its remarkable Iron Age hill fort. Aconbury 'forest', as it was originally known, first appears in the historical record in 1213 and once again in 1216, when King John granted a licence for oaks from the wood to be used to fortify Hereford Castle and a portion of Aconbury forest was granted to farmland. The royal connection remains to this day, as Aconbury Wood was purchased by The Duchy of Cornwall in 2000.

As part of the Duke of Cornwall's commitment to conservation, Aconbury Wood is now a venue for The Prince's Trust's woodland training course. In partnership with Herefordshire and Ludlow College, the 'Get into Woodlands' programme, led by the Duchy's Head Forester Geraint Richards, is a four-week course teaching practical skills such as tree planting, harvesting and coppicing. This initiative, which aims to combat local skills shortages and rising youth unemployment, encourages young people to investigate careers in the forestry sector, a vital element in maintaining our ancient woodlands.

THE FIRST rays of the morning light flowing through the mist give this forest the atmosphere it deserves.

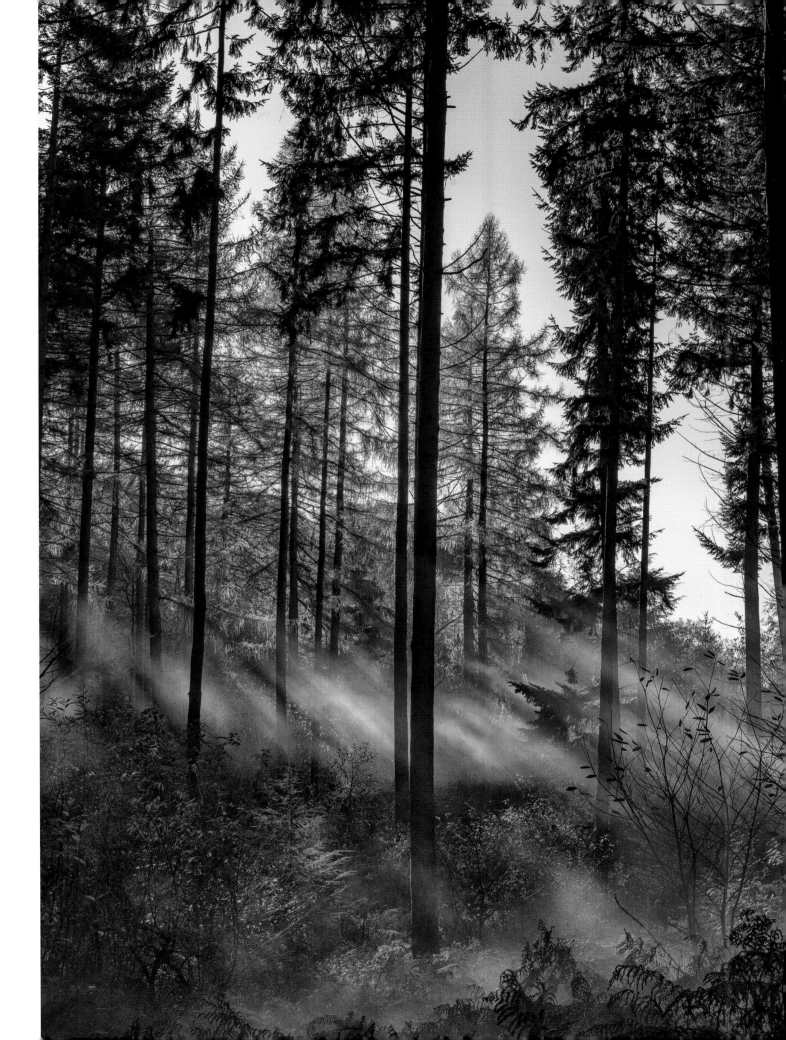

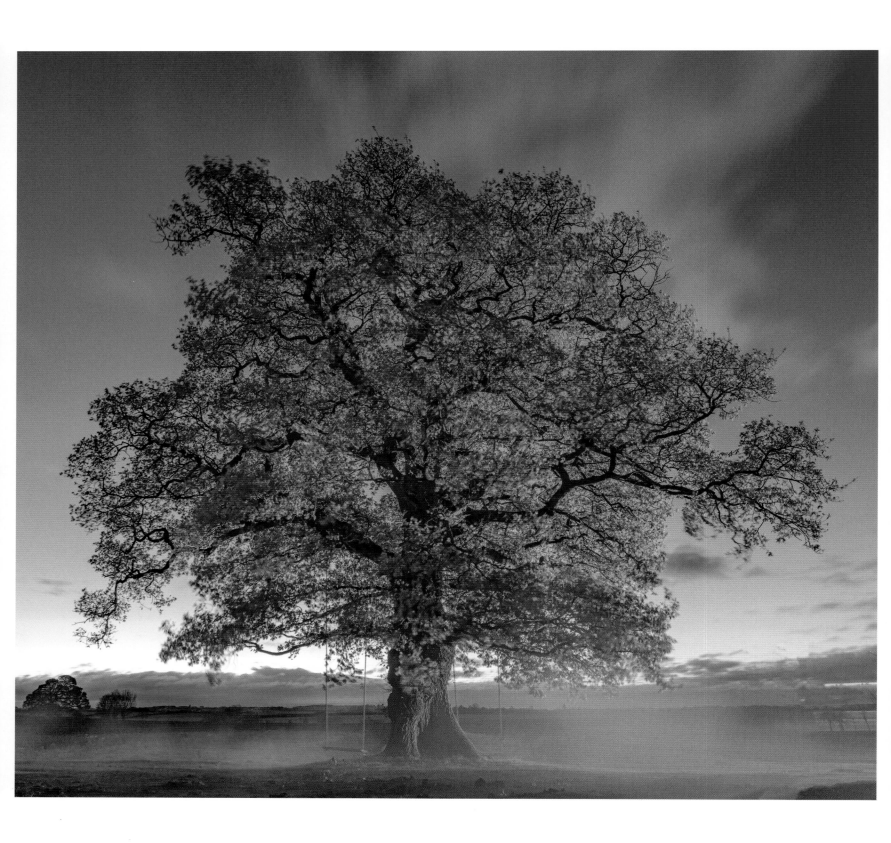

ENGLISH OAK

(*Quercus robur*)

COMMON NAMES
English oak, common oak, pedunculate oak

FAMILY
Fagaceae

DESCRIPTION
Deciduous tree with broad crown and lobed leaves;
catkins are followed by acorns

HEIGHT
20–40m

Native

The English oak is also sometimes known
as the pedunculate oak because its
acorns grow on 'peduncles', or stalks.

Carole Bamford has been a champion of sustainable living for over 40 years, driven by her profound belief that we need to work in harmony with nature, to nurture and protect it. As the founder of Daylesford Organic, she is recognized as a visionary in organic farming. The farm is renowned for its pioneering work in sustainable practice, farming towards 100 per cent self-sufficiency and setting itself ambitious annual sustainability targets with regard to its environmental footprint, carbon emissions and waste reduction.

The farm encompasses over 2,000 acres of organic farmland, with heritage-breed hens, sheep and cattle roaming freely; a vibrant market garden growing fresh vegetables, fruits and herbs; and over 40 kilometres of traditional hedgerows which provide homes for much local wildlife. Trees are also at the heart of life at Daylesford, with willow trees along the edge of the River Evenlode, a large wood of ashes along the footpath to Oddington and the mighty oak that stands proud in the market garden, welcoming visitors with its powerful form and calming presence.

'The oak tree at Daylesford stands at the head of our market garden. Its distinct features and the vastness of its sweeping form make it a very strong and steadying presence; a dependable symbol of constancy and support even when everything around us sways and alters. We think the oak is about 400 years old. Although oaks have three different phases of life, each lasting around 300 years, it's thought that most trees rarely get past the first phase, but I hope that ours will be standing for hundreds of years to come. It's extraordinary to think what it will have seen and how many others will have enjoyed its beauty before us; a daily reminder to respect the wisdom of nature and its resilience.'

CAROLE BAMFORD

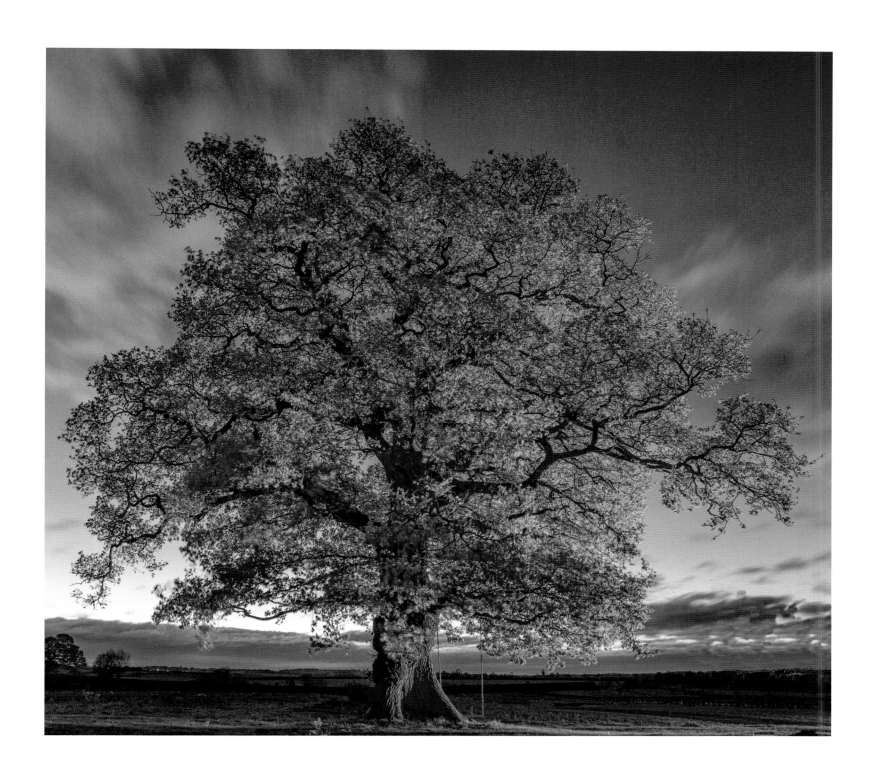

THIS BEAUTIFUL autumnal oak was photographed early in the morning as the sun began to rise in the distance.

ORIENTAL PLANE

(*Platanus orientalis*)

COMMON NAMES
Oriental plane, Eastern plane, Chinar tree

FAMILY
Platanaceae

DESCRIPTION
A deciduous tree with fresh green, lobed leaves

HEIGHT
Over 12m

Non-native

A large tree with a noble appearance,
the Oriental plane has attractive maple-like
foliage and pleasingly patterned bark.

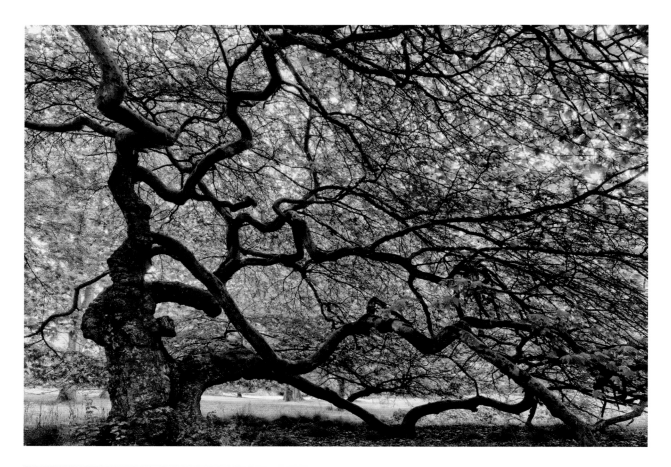

'The gnarled Oriental plane in Colesbourne Gardens comes from a cutting taken by my great-grandfather, plantsman Henry John Elwes FRS, from a tree growing on the Empress of China's tomb. A fine specimen collected elsewhere is growing nearby in the arboretum of 300 trees from around the world, 13 of which are UK Champions.'
SIR HENRY ELWES

THE BRANCHES of this Oriental plane call you in towards its trunk. As the tree sits on its own, the branches can spread wherever they wish.

THE BARK of the Oriental plane flakes off in patches to reveal an attractive pattern.

Set in the heart of the picturesque Cotswolds, the Colesbourne Estate was purchased in 1789 by John Elwes and now encompasses 2,500 acres, including 900 acres of forestry. Colesbourne Gardens itself is known for its spectacular, formal snowdrop walks set around the house and lake, along with its magnificent arboretum, which was established by renowned botanist Henry John Elwes.

The unique collection of trees in the arboretum at Colesbourne includes many notable and rare species, including 13 specimens recognized as Champion Trees by The Tree Register of the British Isles, meaning they are the largest, tallest or widest of their kind in the UK. While those with the widest girth will usually be ancient trees, some of the tallest may be quite young but rare. Ancient trees are defined as those that have passed the common maturity of their species. Most ancient trees share distinct characteristics such as a wide, squat trunk that is often hollow. Ancient trees are incredibly important for wildlife, providing rich and diverse habitat as well as essential shelter. In both cases, these exceptional trees are notable and can be properly managed and protected in the arboretum.

Within the parkland as a whole, there are more than 300 varieties of tree. A number of interesting specimens can also be found throughout the estate and gardens at Colesbourne. The attractive Oriental plane has been nurtured here for over a century. The tree's interestingly gnarled and twisted form drew comment from Chinese foresters on a visit some years after the cutting was taken, who felt that the tree may have grown taller and straighter if left to grow on the tomb of the Empress.

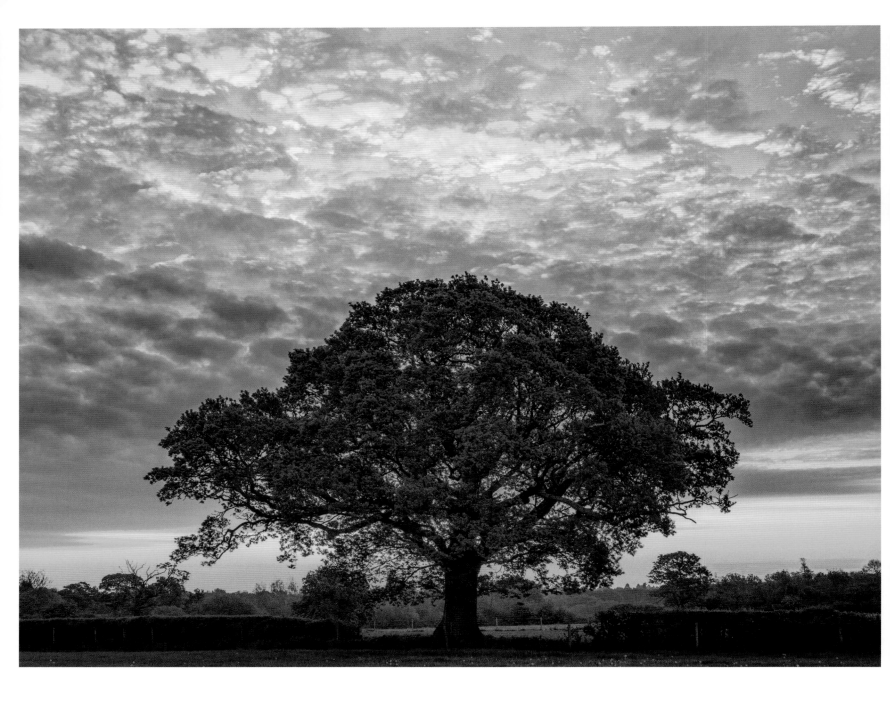

Dipple Wood, Buckinghamshire • July & January 2020

ENGLISH OAK

(*Quercus robur*)

Part of the Hall Barn Estate in Beaconsfield, Dipple Wood
sits on the edge of the estate's land and is home to a
number of tree species, including this impressive oak.

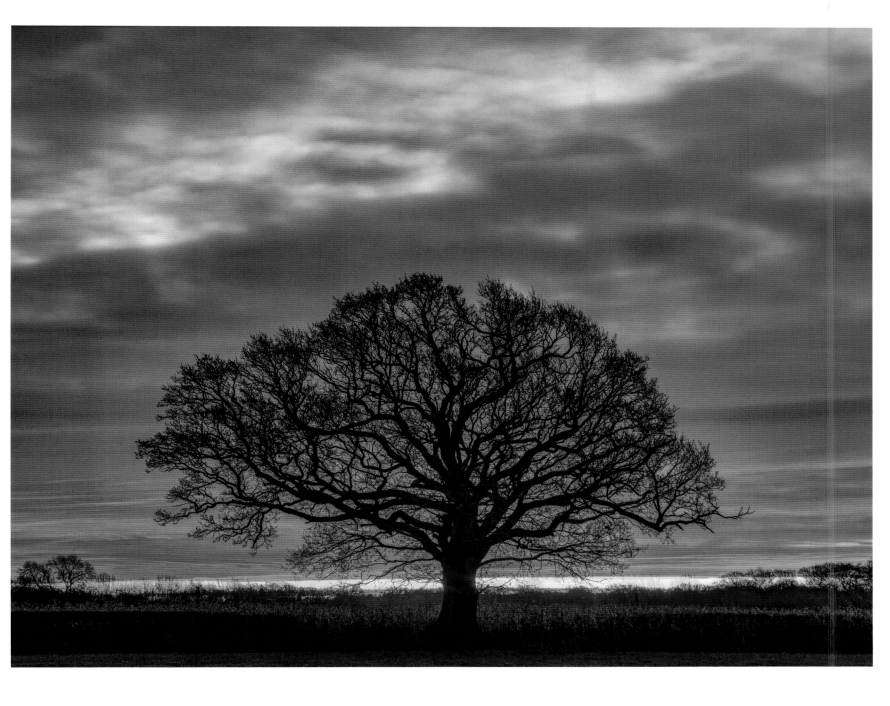

COMMON NAMES
English oak, common oak, pedunculate oak

FAMILY
Fagaceae

DESCRIPTION
Deciduous tree with broad crown and lobed leaves;
catkins are followed by acorns

HEIGHT
20–40m

Native

Song of a Tree

Druids and bards
Chanted in unison
Tales of nature
Mother's cradle
Of all humankind
Oak trees
In the forest
Holding court
Like old kings
Where the wise
Would meditate
Symbols of strength
Resistance and knowledge
The cosmic centre
Where wisdom resides
Celtic songs
Celebrate and revere
The ancient trees
Beloved by all
To love an Oak
Father of all
Is to hold in our heart
The memory of past times
When Nature gently
Ruled the rhythm of our lives
When the sun and the moon
Dictated our breaths
The dreams in our sleep
Keeping us in balance
With the cycles
Of our Earth
We seek anew
To feel the pulse
That runs deep
Like gnarled roots
Our bare feet
Bury their toes
To connect again
With the divine

ISABELLE MIAJA LORCA
10 FEBRUARY 2020, SINGAPORE

THIS OAK was photographed at sunrise on three separate occasions from the same position.

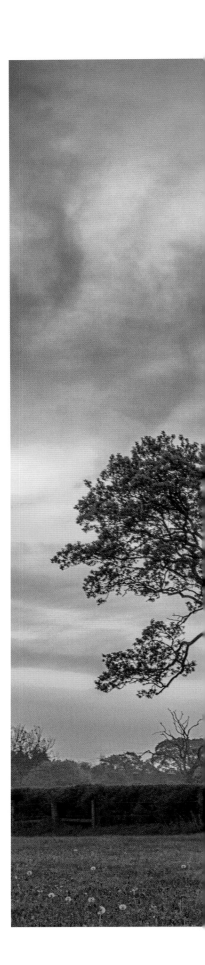

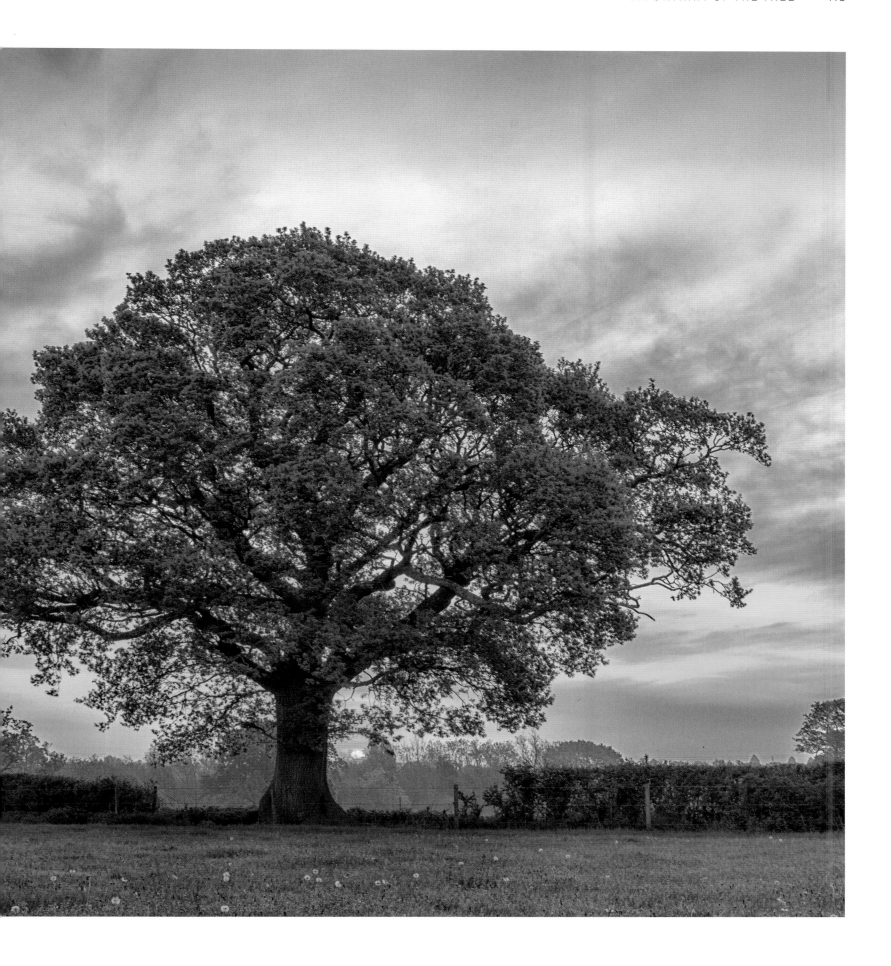

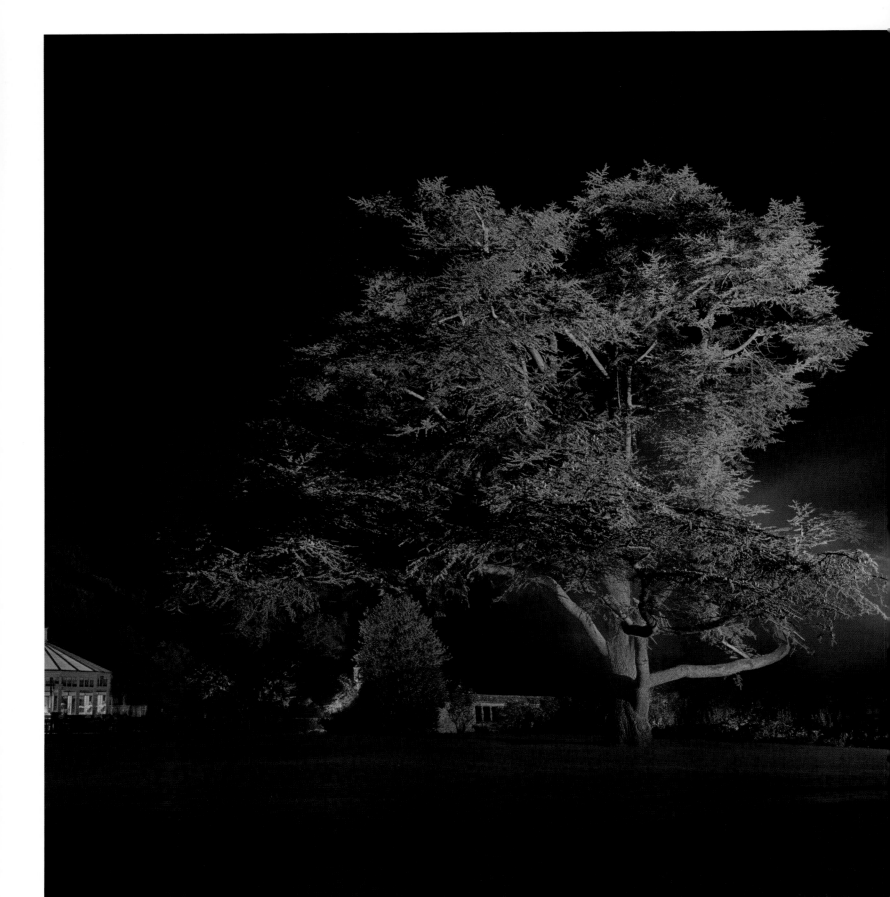

CEDAR

(Cedrus libani)

COMMON NAMES
Cedar, cedar of Lebanon, Lebanon cedar

FAMILY
Pinaceae

DESCRIPTION
Evergreen conifer with a wide canopy of layers of
branches; foliage is made up of green-grey needles,
with barrel-shaped cones in winter

HEIGHT
Up to 35m

Non-native

The mighty cedar has long been important
to human civilization, popular for its
ornamental as well as its functional properties.
Used by the Ancient Phoenicians for building
ships and houses, it was also used
for mankind's earliest perfumes.

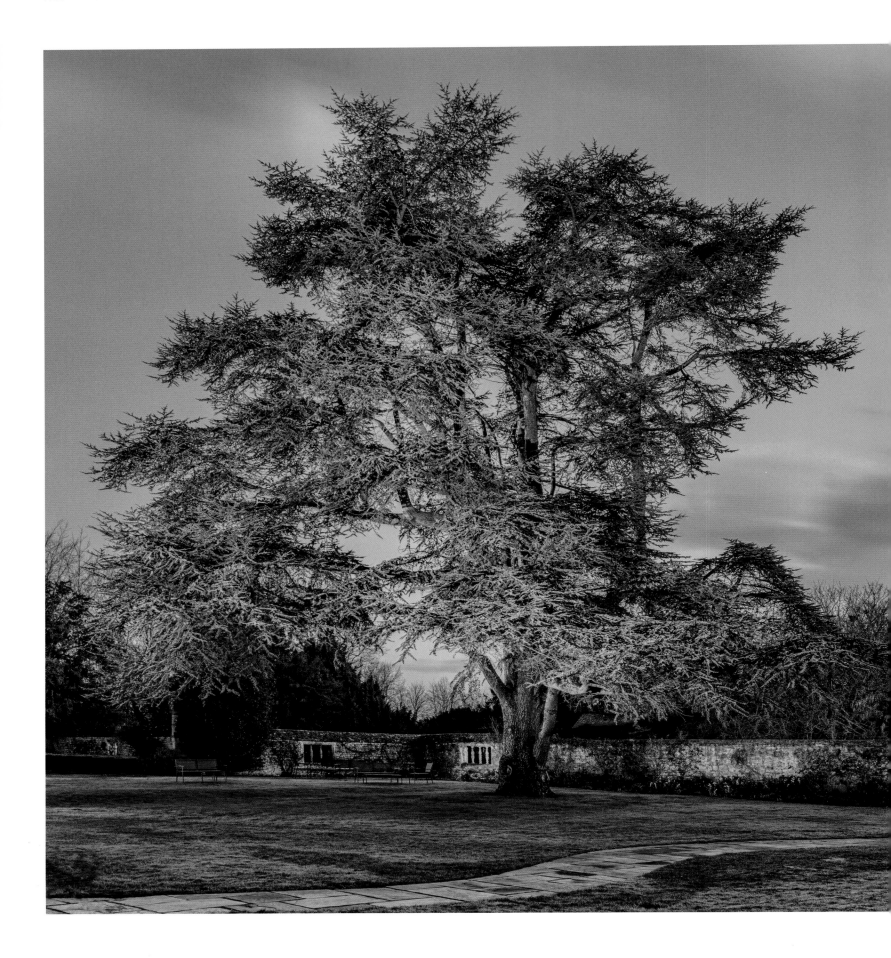

'This magnificent tree is part of the proud history and landscape of Le Manoir. The greatest memory I have of it is when the Queen Mother and her entourage of knights and ladies-in-waiting drank champagne and Dubonnet in the shadows of this glorious tree. Sadly this tree is diseased and is no longer with us; Adrian through his art has captured its beauty and grandeur so perfectly for us all to remember it.'

RAYMOND BLANC, OBE

The dilapidated 15th-century country manor house in Great Milton, just outside Oxford, bought in 1983 by celebrated chef Raymond Blanc, OBE, has long since become one of the ultimate gastronomic destinations in the UK. Yet, while there is no doubt about the culinary excellence on display at Le Manoir aux Quat'Saisons, it is not the only draw for the many visitors who flock there year on year. The now beautifully restored country house hotel also boasts 11 inspirational gardens.

In one of the gardens nestled in the picturesque Oxfordshire countryside stood this majestic cedar, a relic of the 18th century, when cedars were uniformly planted in the grounds of every stately home in the UK. Planted close to the main restaurant at Le Manoir, this beautiful tree, sadly, was in danger of dropping limbs out of the blue when it became diseased, so it was cut down in 2018 for safety reasons. Despite the loss of this beautiful tree, Raymond Blanc remains committed to preserving our native trees and has planted more than 2,500 heritage apple trees in a specially created orchard behind the gardens at Le Manoir.

THIS CEDAR was photographed as dawn broke over Le Manoir.

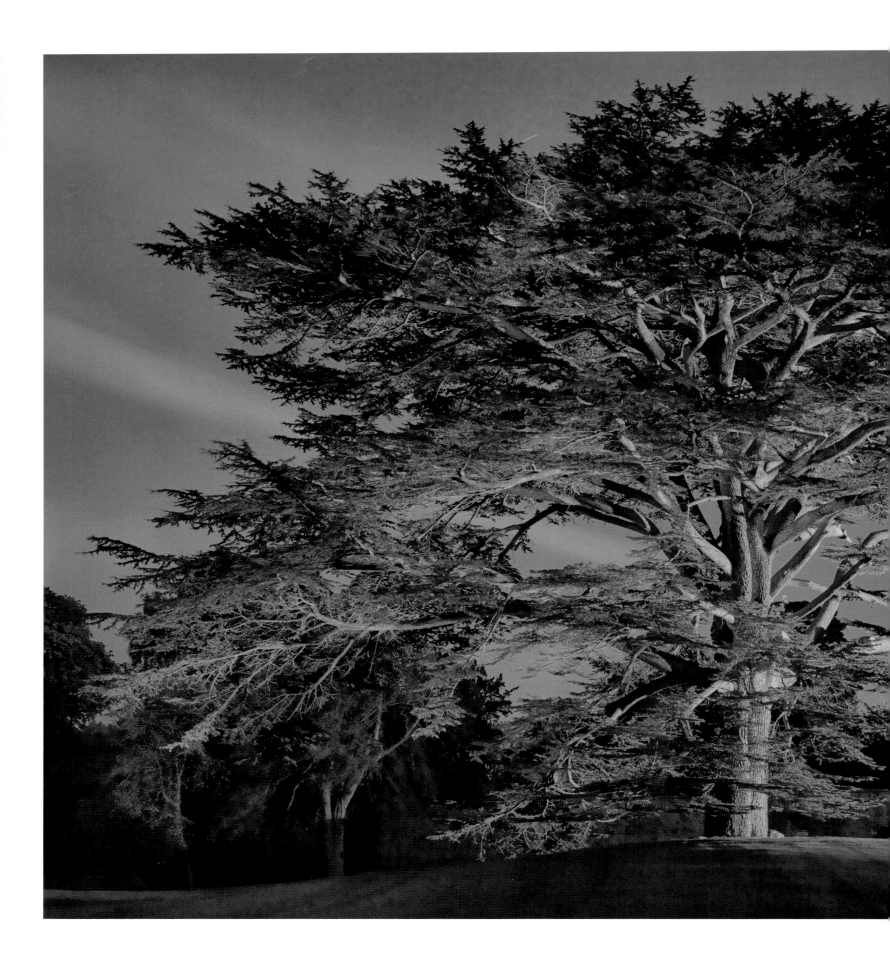

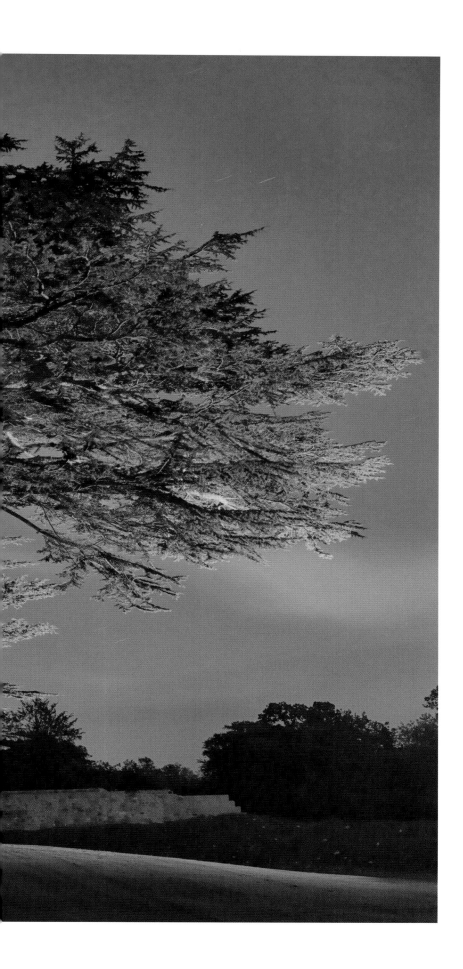

CEDAR

(*Cedrus libani*)

COMMON NAMES
Cedar, cedar of Lebanon, Lebanon cedar

FAMILY
Pinaceae

DESCRIPTION
Evergreen conifer with a wide canopy of layers of branches; foliage is made up of green-grey needles, with barrel-shaped cones in winter

HEIGHT
Up to 35m

Non-native

Long prized for its immense size and durability, the cedar of Lebanon features in one of our oldest-known pieces of literature, the Sumerian *Epic of Gilgamesh*, in which a cedar forest was fought over by demi-gods and demons.

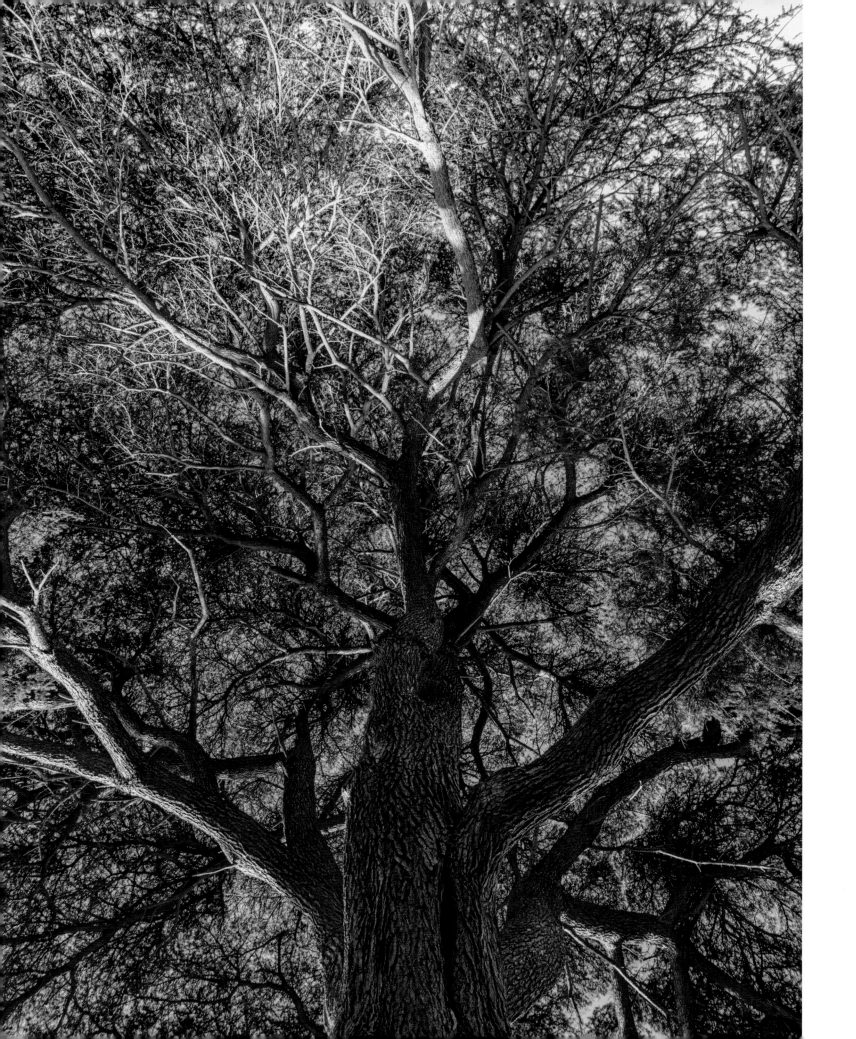

'Cedar of Lebanon are perhaps the most dramatic species within the cedar family, and this particular tree within my garden at Great Tew has captivated me for many years. Now this wonderful tree is entering the last few years of its life. Whether the backdrop for my children's daytime football games or illuminated at night giving artistic drama to the garden, it holds a special place in my heart.'

NICHOLAS JOHNSTON

The cedar of Lebanon was introduced to Britain in the 1630s when Edward Pocock, who had been Chaplain to the Turkey Company at Aleppo, became Rector at Childrey in Oxfordshire, where he planted a specimen in the rectory garden.

Some 400 years later, another fine cedar specimen still stands proudly in the Oxfordshire countryside at the estate at Great Tew. While it is uncertain how old the tree is, it may well have been planted here by the 17th century. During this period, Great Tew was the scene for much dialogue and debate before the Civil War through the presence of the Great Tew Circle, a group of scholars, clerics and philosophers led by the charismatic young owner of the estate at the time, Lucius Cary, 2nd Viscount Falkland. The circle would meet to discuss the pressing matters of state in the walled garden immediately behind the cedar's elegant spread-eagled branches.

Or perhaps the tree owes its position to the later Boulton family who purchased the estate in 1815. Industrialists and entrepreneurs based in Birmingham, successive generations of the family planted in and around the gardens in both quantity and quality. This magnificent tree may well be one of their romantic legacy plantings. Whatever its origins, this magnificent species has become an integral part of the landscape. In cedars of this age, cracks develop in the trunk and branches, creating perfect homes for tawny owls and bats.

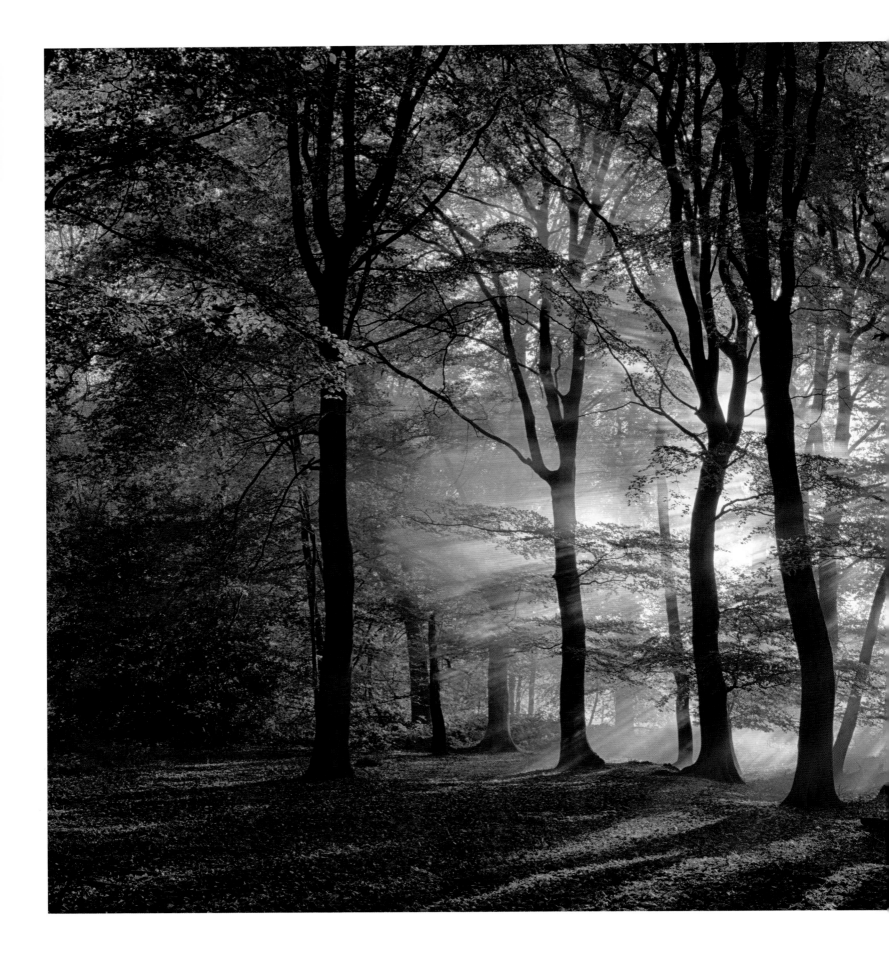

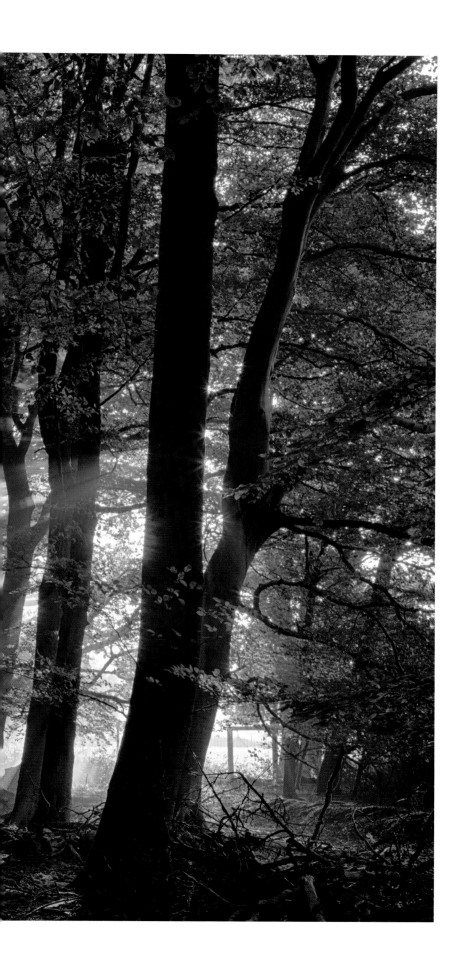

COMMON BEECH

(*Fagus sylvatica*)

COMMON NAMES
Common beech

FAMILY
Fagaceae

DESCRIPTION
A deciduous tree with a dense, leafy canopy
and branches that stretch upwards; often
retain their leaves during winter

HEIGHT
Over 40m

Native

Known as the 'queen of British trees',
the partner and consort to the English oak's
king, the beech is associated with femininity
and is also often referred to as mother
or empress of the woodland.

'*Fagus sylvatica is native to southern Britain and large areas of the Chilterns, which are covered with beech woods and bluebells, just like the woods where we live. Beeches are monoecious (bearing both male and female flowers on the same plant); they produce catkins in the spring and edible beechnuts in the autumn.*

Beech is widely used for hedging and, apparently, the tallest and longest beech hedge in the world (according to Guinness World Records) is the Meikleour Beech Hedge in Perth and Kinross, Scotland.

We have been going past the beech trees on our regular walk from the house for the last 20 years. A lot has changed in that time…the four children have grown up…but the beech woods remain. The trees are tall, elegant and sinuous with amazing dappled light coming through the leaves. In the spring the leaves are vivid fresh green against the bluebells, and in the autumn golden brown against the low sun.

The picture that Adrian has taken has some darkness remaining, but it is a story of the light shining through.'
NIGEL HOUSTON

Thought to have arrived in the UK in around 4000 BC, the common beech has naturally built up a rich history. In folklore it is believed to offer good luck through its seeds, leaves or bark. The beech tree also has deep associations with wisdom and knowledge, perhaps through the traditional practice of using thin slices of beech to create books. Indeed, some etymologists have suggested that the word 'book' has actually evolved from 'beech'.

Due to its dense canopy, the beech plays a vital role in the ecosystems of the woodlands in the southern British Isles. The beech can grow to a height of 40 metres or more, creating large leafy canopies, which provides much-needed sustenance for a myriad caterpillars and moths, while the nuts and seeds sustain many small woodland birds and mammals. The longevity of the beech tree, which can thrive for 300 years, also allows it to become a habitat for deadwood specialists such as hole-nesting birds and wood-boring insects.

These veterans of the woodland, therefore, are crucial to the survival and biodiversity of our natural environment.

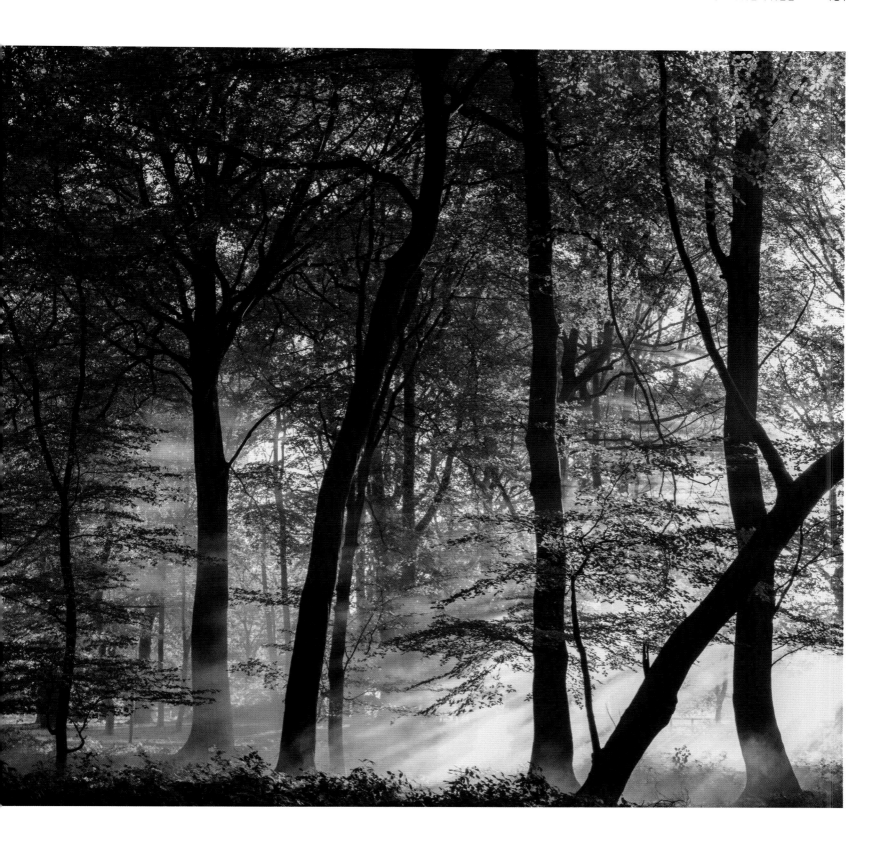

THE EARLY morning autumnal light filtering through the mist frames the beauty of the beech trees.

ENGLISH OAK

(*Quercus robur*)

COMMON NAMES
English oak, common oak, pedunculate oak

FAMILY
Fagaceae

DESCRIPTION
Deciduous tree with broad crown and lobed leaves;
catkins are followed by acorns

HEIGHT
20–40m

Native

Some of the oak trees planted in
the late 16th century at Cornbury Park
are still standing today in the
17,000-acre estate, which is a protected
environment for native wildlife.

'The oak – old and wise.

The tree's beautiful trunk takes five people hand-to-hand to hug. The full moon is lighting the sky and Adrian has captured its park prominence, framing its natural power.

This tree represents for me the important relationship between humans and nature. A stage or gathering space for ceremony and storytelling. A place where imagination can run wild. This ancient tree could tell you stories of kings, queens, the Wychwood fairs, of merriment and over 300 years of history.

Taking centre-stage towering over Cornbury Park, it was the place where our visions came alive for a new arts gathering now known as Wilderness Festival. I will never forget this tree – it will always be in my heart…its adventure continues.'

JOANNE ELIZABETH VIDLER (JO VIDLER)

The Cornbury Estate is home to some of the most ancient forest in the UK today, which provides a unique habitat for native wildlife. Recorded as far back as the Domesday Book, Cornbury was claimed as royal property until 1642, when Charles I gifted the park to Henry Danvers, the Earl of Danby. Danvers had a keen interest in gardening, constructing a physic garden over 5 acres of the grounds. This horticultural passion was shared by subsequent owners of Cornbury Park, including the Earl of Clarendon, who planted nearly 2,000 trees in a single year in 1661.

It is not hard to imagine that this mighty oak in the midst of the park may have stood here for hundreds of years, keeping watch over the changing landscape and weathering many a storm.

However, this majestic species is today facing pressure from environmental stressors such as drought, waterlogging and pollution. Acute oak decline and chronic oak decline can occur when a number of these factors combine to place trees under stress, resulting in poor tree health and often leading to the tree dying within a few years. We must act now to safeguard these faithful sages for future generations.

ONE OF the many ancient oaks at Cornbury, photographed at sunset with the last rays of light catching the hollow of the tree.

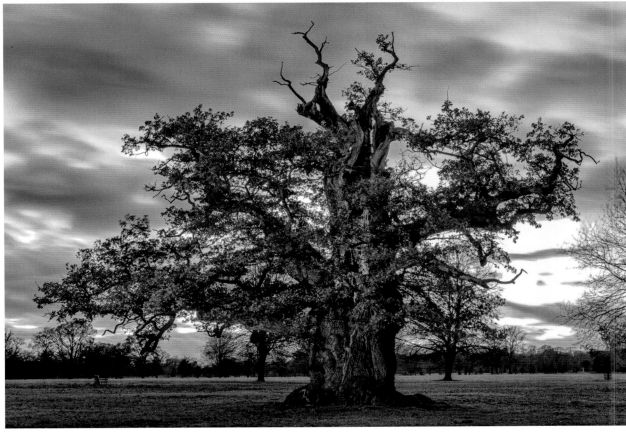

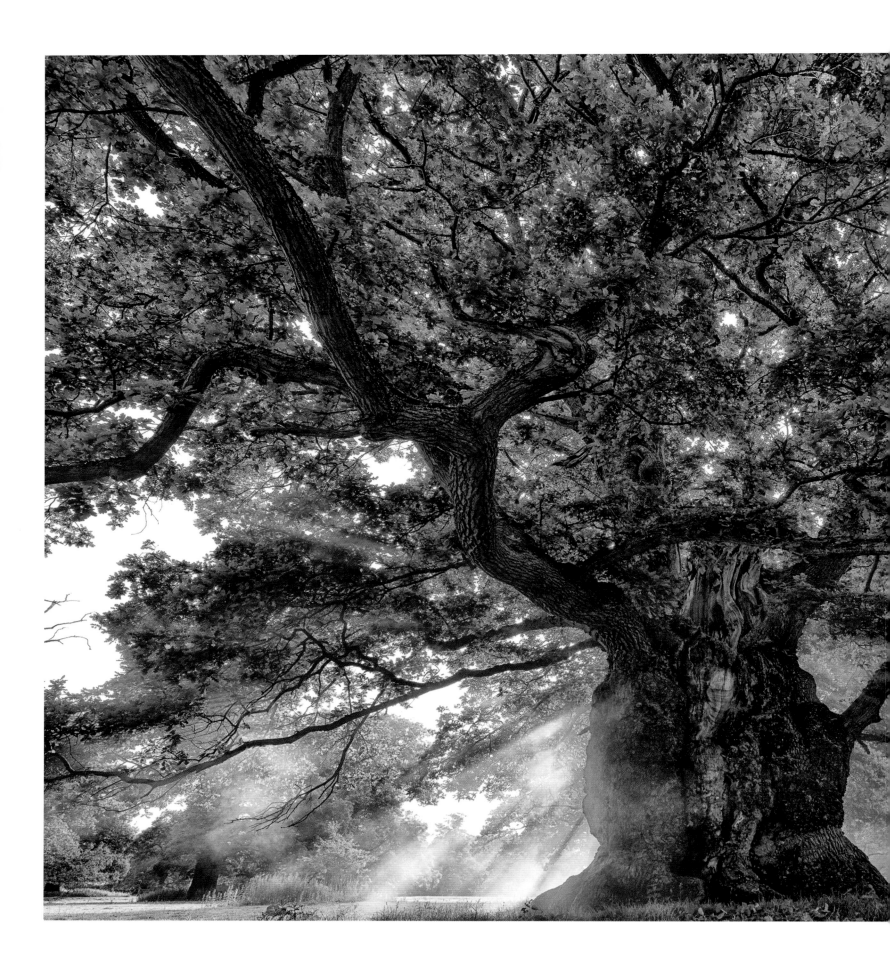

ENGLISH OAK

(Quercus robur)

COMMON NAMES
English oak, common oak, pedunculate oak

FAMILY
Fagaceae

DESCRIPTION
Deciduous tree with broad crown and lobed leaves;
catkins are followed by acorns

HEIGHT
20–40m

Native

Dating back to the reign of William the Conqueror, this tree at King's Walden is also known as the Domesday Oak.

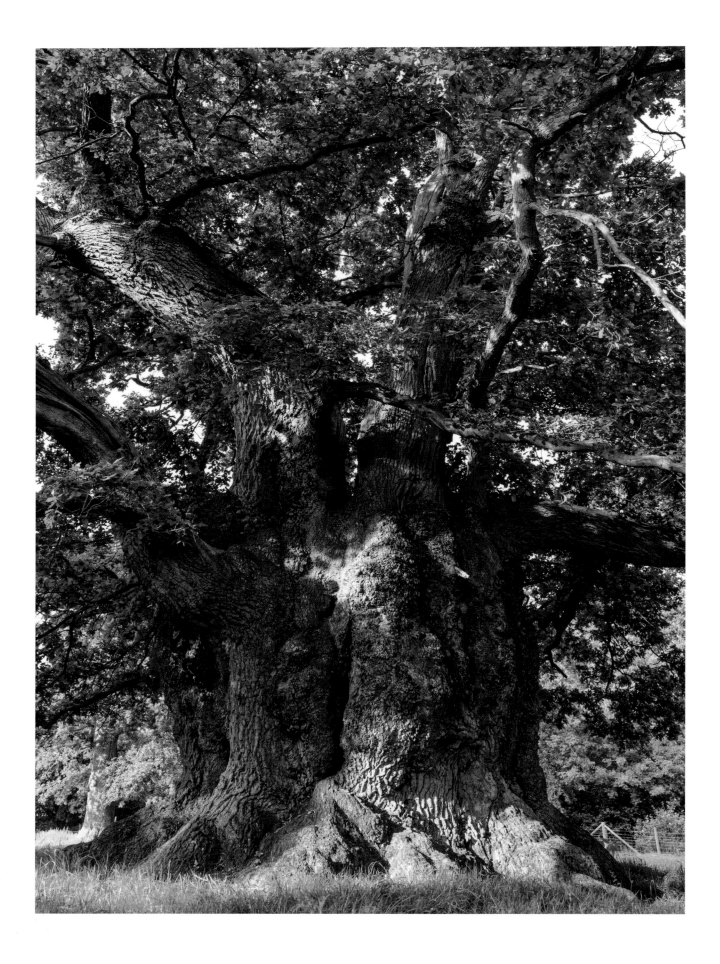

'The King's Walden Oak is indeed special to me –
the botanical artist and tree painter Masumi
Yamanaka painted a watercolour of this tree which
I bought from her and now has pride of place in my
house above the mantelpiece in my living room.
It is one of the great ancient oaks of England.'
ALJOS FARJON

With a girth of 11 metres, this magnificent oak tree can
be found in the estate at King's Walden along with 300
other oaks believed to be between 300 and 400 years
old. The Domesday Oak, so named because it is thought
to be up to 1,000 years old, is listed as a veteran tree.
Distinct from ancient trees, specimens achieve veteran
status when they have features of wounds or decay.
Unlike ancient trees, veteran trees are not necessarily
shaped by age, but may have gained these features
through other events such as storm damage or
environmental stressors. This tree's truly remarkable
age makes it of huge significance, both ecologically
and culturally.

This ancient oak is a survivor from the past, providing
a link to our historical heritage and a deep continuity in
an ever-changing landscape. The Domesday Oak has
been pollarded to restrict its growth, but this has not
impacted on its dramatic beauty, with its thick, gnarled
form standing proud in the parkland.

THE SHEER size of the
trunk almost makes you
bow in reverence to the
majesty of this tree.

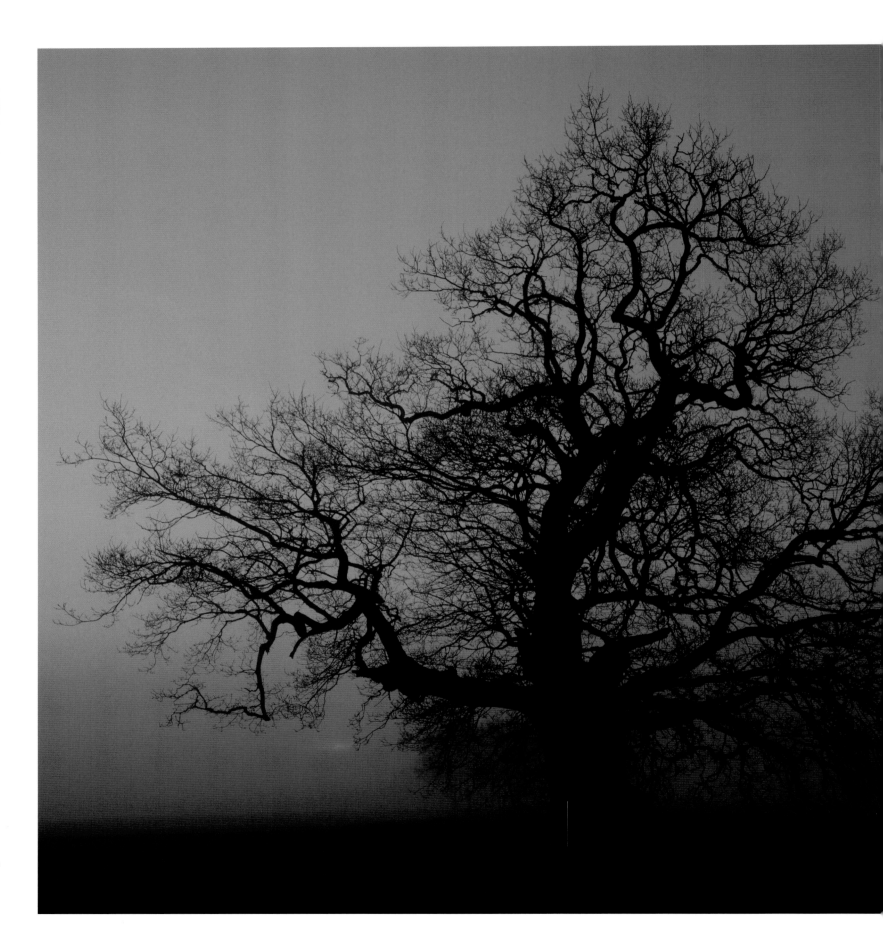

ENGLISH OAK

(*Quercus robur*)

COMMON NAMES
English oak, common oak, pedunculate oak

FAMILY
Fagaceae

DESCRIPTION
Deciduous tree with broad crown and lobed leaves;
catkins are followed by acorns

HEIGHT
20–40m

Native

A proud national symbol set in an
historical English estate, the Hatfield oak
frames the majestic beauty of this
much-loved species in appropriately
royal surroundings.

'The ancient oaks in Hatfield Park are one of our greatest treasures. Adrian's work shows them dramatically as physical specimens and as part of the spirit of the place. Like so many trees today, they could be carried off by disease and we would then lose part of the essence of England.'
LORD SALISBURY

The Old Palace at Hatfield was the childhood home of Elizabeth I, and it is here that the princess learned of her accession to the throne in 1558. Steeped in history, Hatfield House, as it stands today, was completed by Robert Cecil, 1st Earl of Salisbury, in 1611, and 400 years later it remains the home of the Cecil family.

The house itself is at the heart of extensive formal gardens and a large agricultural estate, which encompasses arable farming as well as let holdings for dairy and livestock. The estate is carefully managed with conservation in mind, and over 10 miles of hedges have been planted or restored here in recent years.

A NATIONAL SYMBOL

Tall and broad with its distinctive leaf shape and acorns, the English oak has become a national emblem – and fittingly so, as it is the second-most common species in the UK. Oaks are essential to biodiversity, supporting more life than any other native species, from insects living in the canopy to deer that feed on acorns, from fungi that thrive off the rich leaf mulch to roosting bats.

The hundreds of ancient oaks in Hatfield are relics of a medieval system of coppicing, and the estate team tries to cosset them in their old age. Lord Salisbury remembers the trees 'as among our great treasures', a part of both the landscape of Hatfield and also the lives of the people who live and work there.

THIS PHOTOGRAPH captures the structure of the tree at night with the orange glow of Hatfield in the far distance. The warmth of its nature is shining through.

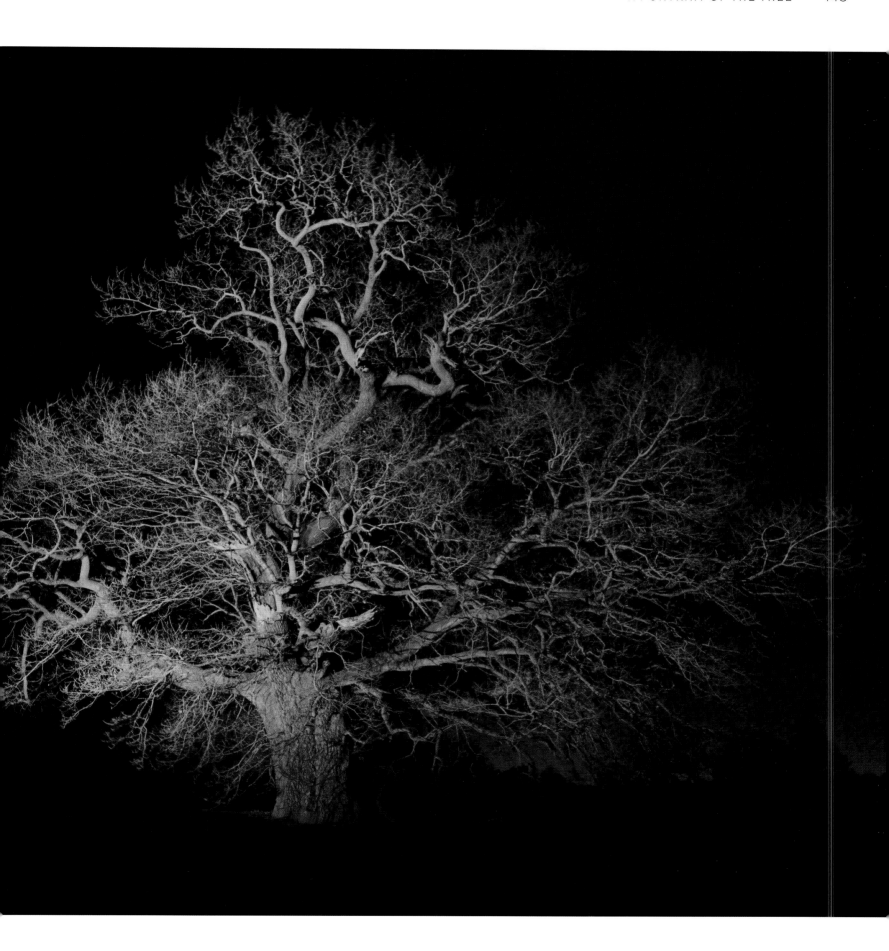

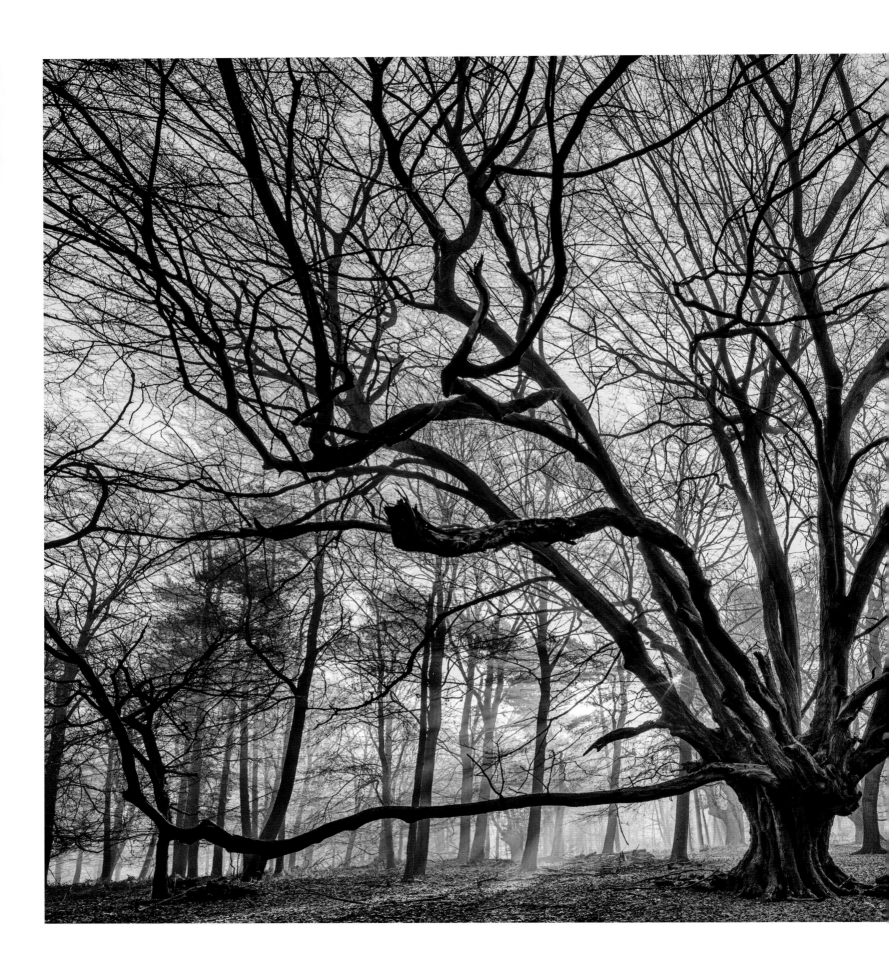

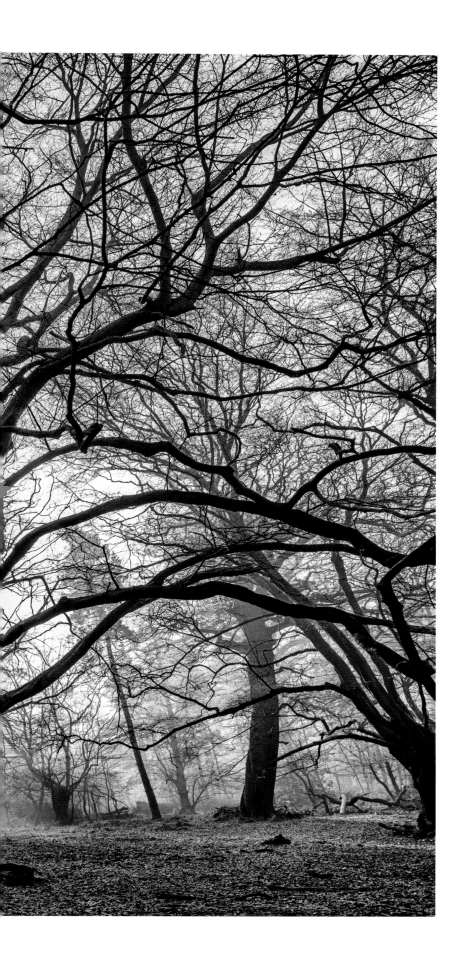

HORNBEAM

(Carpinus betulus)

COMMON NAMES
Hornbeam, common hornbeam,
European hornbeam

FAMILY
Betulaceae

DESCRIPTION
A deciduous, broadleaf tree with
year-round leaf cover

HEIGHT
Up to 30m

Native

Used by the Romans in the construction of
their chariots due to the strength of its wood,
the hornbeam nevertheless has some
more romantic associations: in Valenciennes in
northern France, lovers would lay a hornbeam
branch before their sweetheart's door.

Hatfield House lies at the centre of the largest private estate in Hertfordshire, with parkland and woodlands that cover an extensive area of the county, offering a wide range of habitat for local wildlife. Visitors wandering along the woodland trails will happily stumble across many imposing, ancient trees, including oak and beech, but none more so than this statuesque hornbeam.

Generally believed to be named for the hardness of its timber, the hornbeam has the hardest wood of any tree in Europe. Like the common beech, which has similarly shaped oval leaves, the hornbeam retains its leaves all year round, providing useful shelter for nesting birds and foraging for small mammals.

'This lovely hornbeam is one of a number in Coombe Wood in the park at Hatfield. I'm not sure of its age but what is so striking about hornbeam is the wonderfully sinuous way it spreads its branches, almost as if it is reaching towards things of interest. It grows its branches in a delightfully informal way without the conformity of so many other trees. It is an interesting tree and one that it is possible to think might be planning the way it grows. This example is special to me because it's such a good example and because it is part of the home I was brought up in.'

LORD VALENTINE CECIL

THIS MAJESTIC hornbeam sits in the middle of the wood. The challenge was to make the tree stand out from the crowd. Its long branches and sculptural form are visible much more in the winter months. Adding a small amount of light into the tree helped accentuate its beauty.

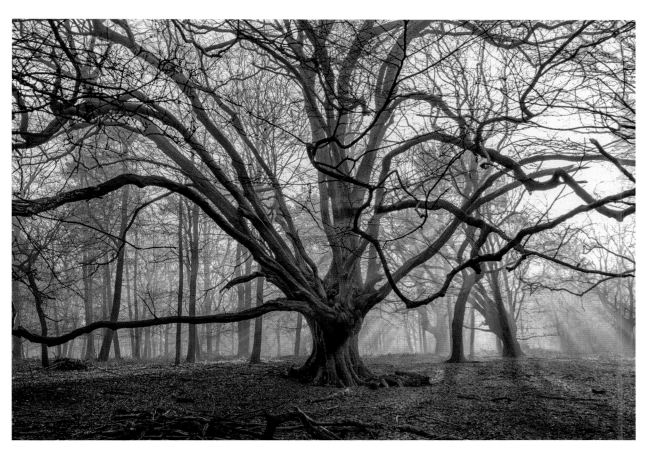

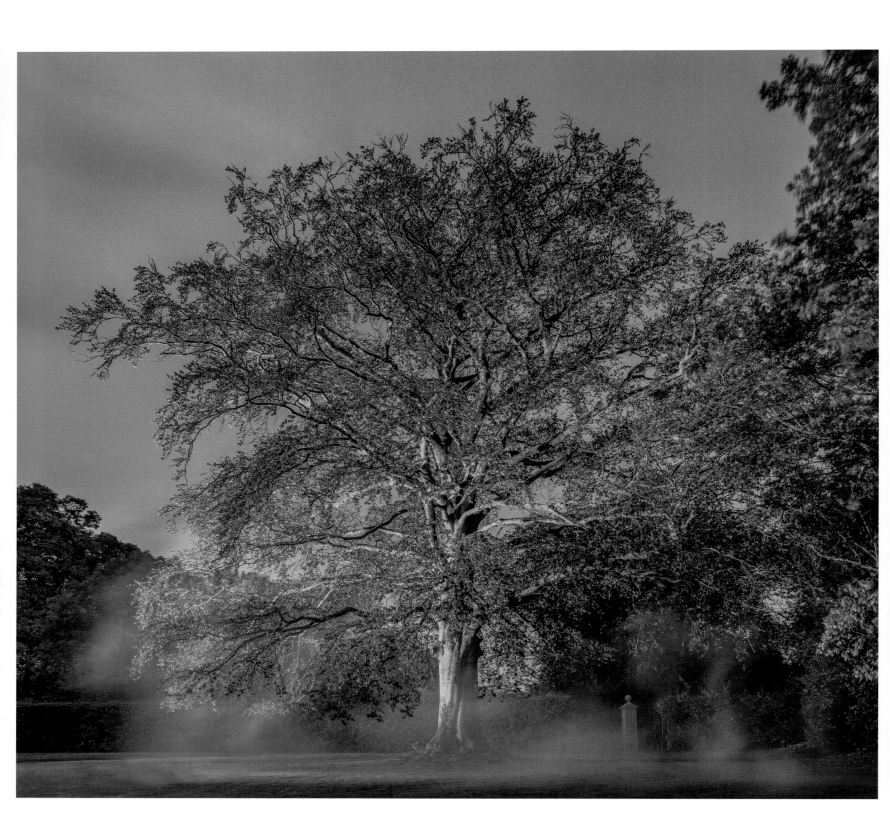

COPPER BEECH

(*Fagus sylvatica* f. *purpurea*)

COMMON NAMES
Copper beech, purple beech

FAMILY
Fagaceae

DESCRIPTION
A cultivated form of common beech with
distinctive purple leaves

HEIGHT
Over 40m

Non-native

This large, commanding cultivar of
the common beech creates a striking
visual impact with its deep purple leaves.

'My husband and I not only fell in love with our beautiful 1720 Grade II-listed home but also the magnificent gardens and beautiful, mature trees that form the structure of the landscape. Our favourite is the copper beech tree that stretches proudly over a peaceful lawn area under which we renewed our wedding vows, celebrating 10 years of marriage.'
PENNY LANCASTER

While this species of copper beech doesn't occur naturally in the UK, it has been extensively planted in parks and landscaped gardens, as well as in large private gardens – admired for its ornamental appearance and decoration. The dramatic colour makes it a popular choice, creating a larger-than-life silhouette in the surrounding countryside.

While the copper beech is prized by many, it is certainly not loved by all. Some find its striking leaves a little jarring in the natural environment. Yet, it is a curious fact that all beech trees have the potential for purple leaves. It is decided by a gene, which is usually dormant, allowing green leaves to be produced. Sometimes, however, the purple leaves appear without human interference and you may stumble across a copper beech growing in among a sea of green.

THESE PHOTOGRAPHS were taken in the rain as the sky turned the blue of night. The warm light that covers the tree is a reflection of the warmth that these beautiful trees give us everyday.

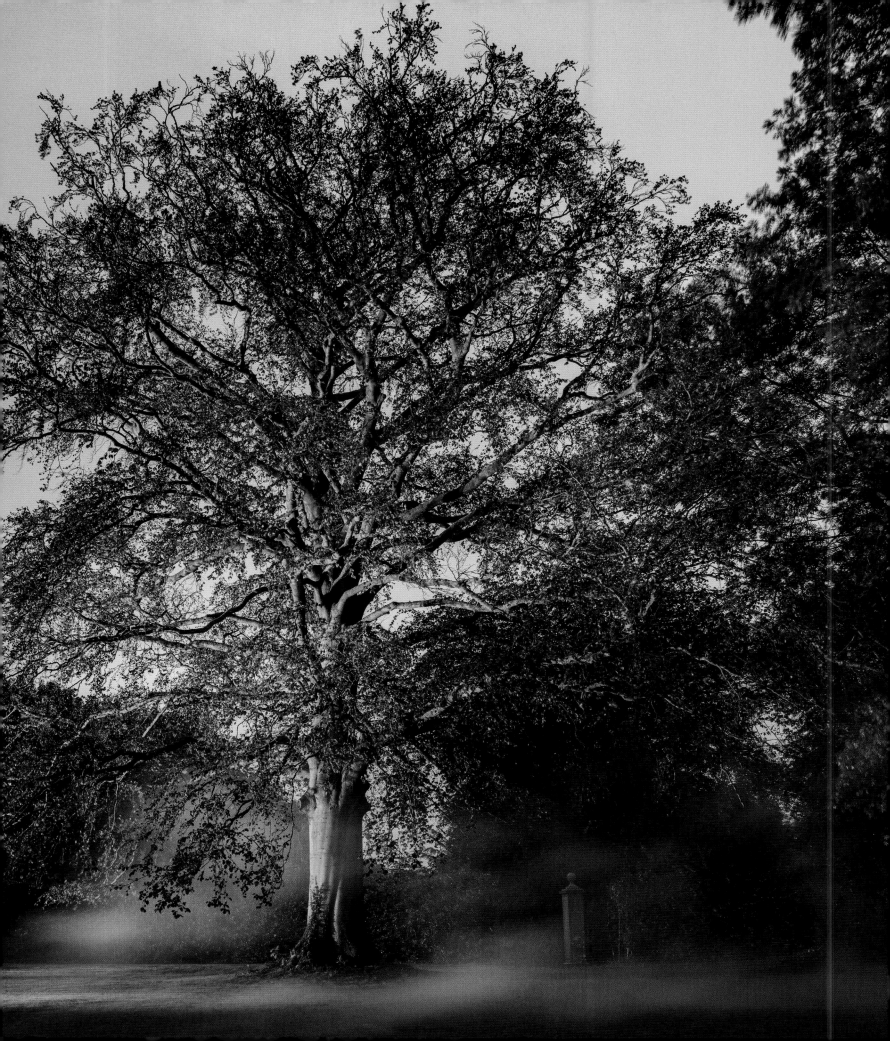

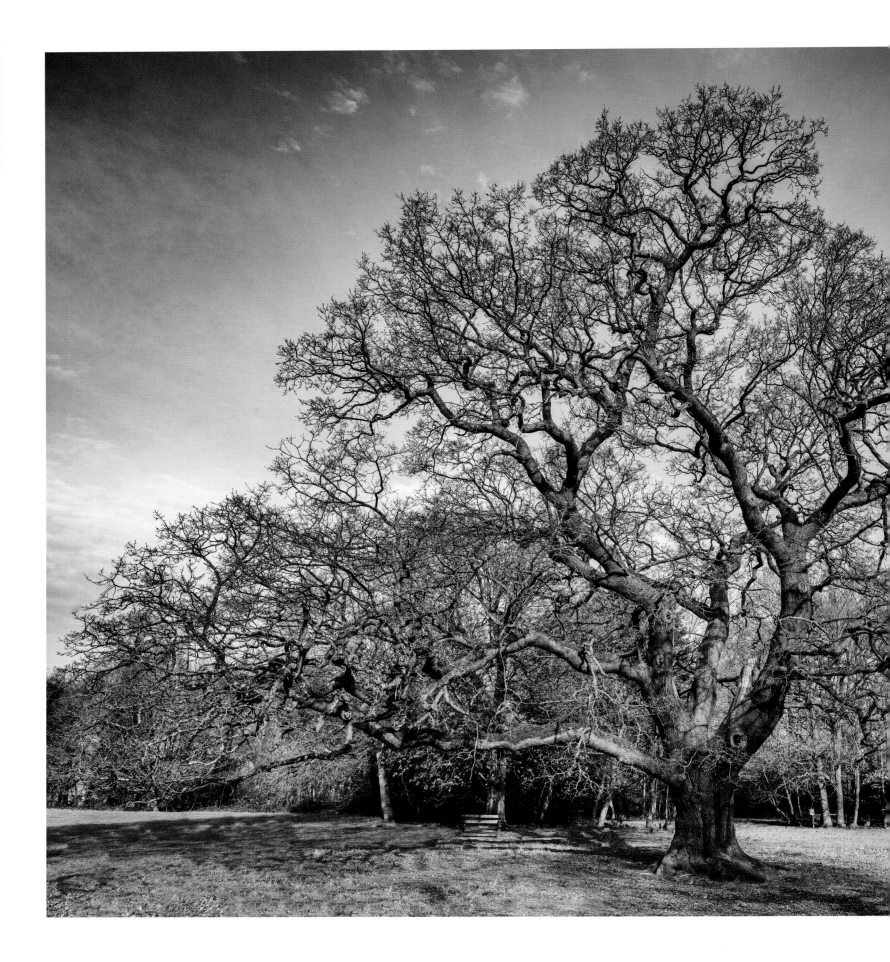

ENGLISH OAK

(*Quercus robur*)

COMMON NAMES
English oak, common oak, pedunculate oak

FAMILY
Fagaceae

DESCRIPTION
Deciduous tree with broad crown and lobed leaves;
catkins are followed by acorns

HEIGHT
20–40m

Native

This famous oak in Gilwell Park is 350 years old and has played an important role in the story and history of the Scout movement.

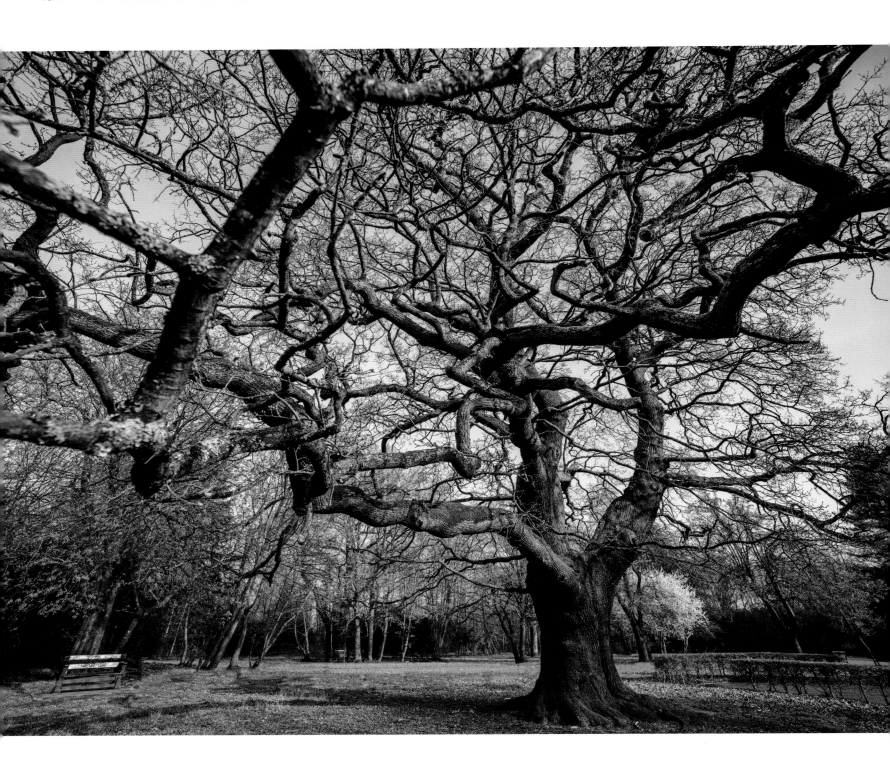

CAPTURED IN the early spring sunshine, this oak has given joy to the many children who have kept cool beneath it in the summer, climbed its branches and sheltered under it in the winter.

'In the late 1980s, when I first arrived in the UK, I found it difficult to find common ground and forge friendships with kids my age as we had very few shared experiences. I had come from rural Jamaica, a place where the lifestyle was very different. In the Scout movement I found a place where I could apply the lessons I learned from my earlier years, and this gave me a sense of confidence at a time when I needed it most.

So how does this tie back to the Gilwell Oak? Well, Robert Baden-Powell used the oak tree as an analogy for the vision he had for the Scout movement over 100 years ago, and it still applies as much now as it did back then. The Gilwell Oak still remains relevant to a large and increasing number of people; last year I was lucky enough to have a friendship knot tied for me by the granddaughter of Baden-Powell himself, right there under this 350-year-old oak. This is one of those trees that is not only visually pleasing but also has an established history as well as a presence in the now and a clear place in the future.'

DWAYNE FIELDS

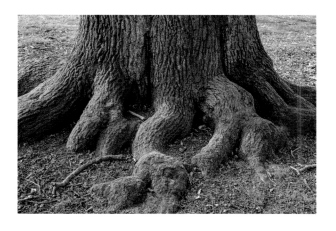

As explorer and naturalist Dwayne Fields says, the Gilwell Oak 'holds a special significance' for countless people around the world. Gilwell Park in East London is the physical and spiritual home of Scouting, with the oak inspiring founder Robert Baden-Powell to create his famous tenet of 'the moral of the acorn and the oak'. This analogy became central to the Scout story, symbolizing the growth and development of the movement itself, as well as the moral growth of its members. Today, the oak tree continues to be an important emblem in Scouting – the Young Leaders' badge features an acorn and oak leaves, and the Silver Acorn is awarded to adult volunteers for distinguished service.

Gilwell Park was purchased for the Scout Association by William de Bois Maclaren in 1919 to be used as a campsite and a training centre for future leaders. The first course ran there in September 1919, overlooked by the formidable Gilwell Oak. However, the famous Gilwell Oak is, in fact, the second to bear this name in Gilwell Park. Maps from the 1940s show the original Gilwell Oak located in Branchet Field, but by the 1950s, the name was bestowed on the iconic oak tree at the edge of the training area. To this day its sturdy branches offer shelter from both sun and rain to Scouts from across the world who have journeyed to visit their movement's home.

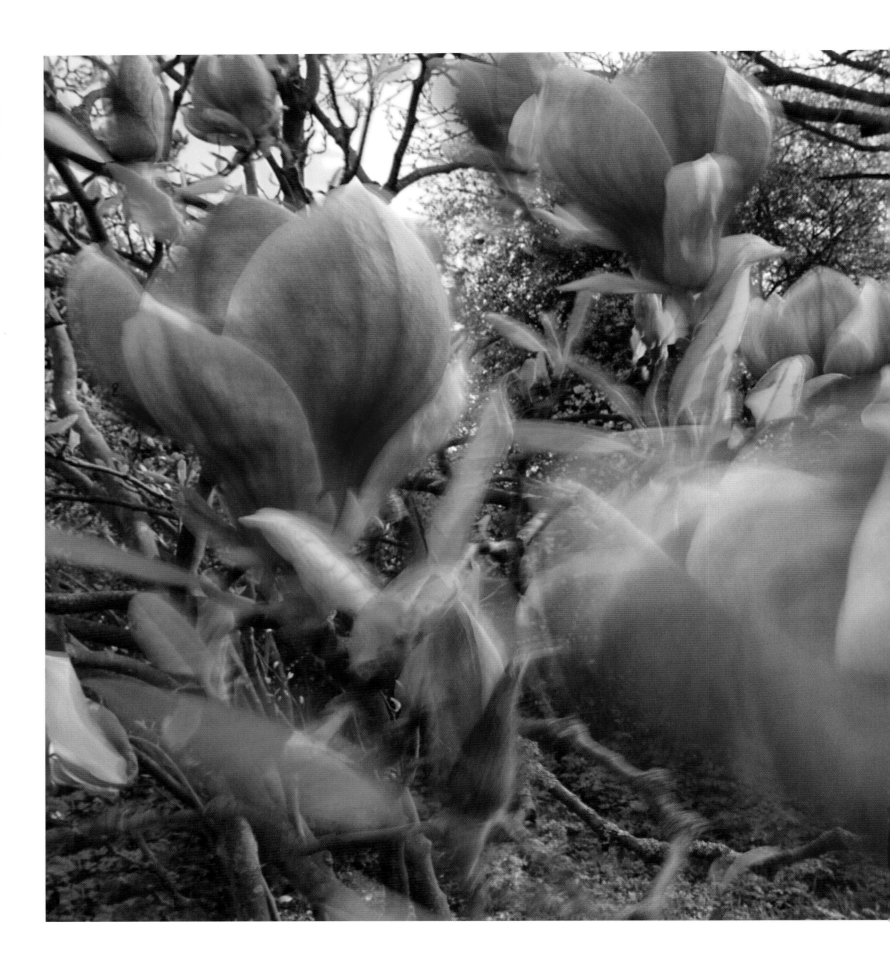

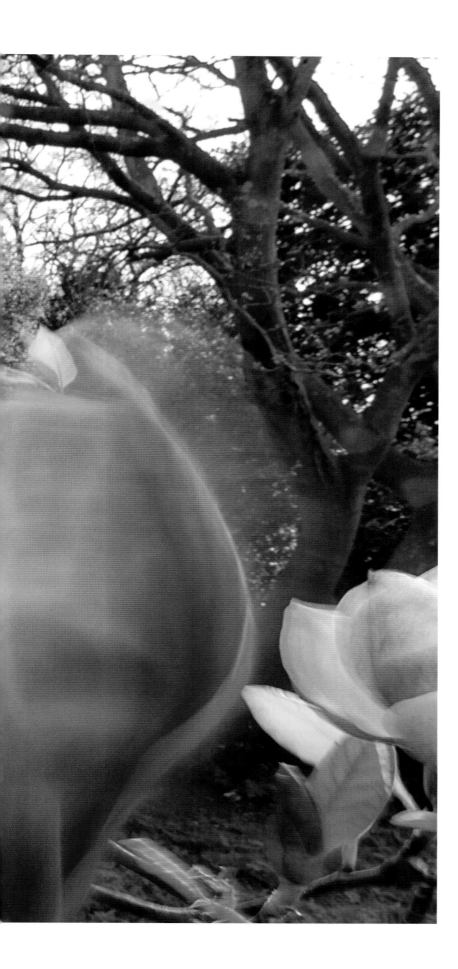

MAGNOLIA 'LEONARD MESSEL'

(Magnolia x loebneri)

COMMON NAMES
Magnolia

FAMILY
Magnoliaceae

DESCRIPTION
A deciduous small tree with
lilac-pink flowers

HEIGHT
4–8m

Non-native

This delicate tree is renowned for its large,
resplendent and sweet-smelling flowers
that burst forth in the springtime.

'This magnolia tree right in the centre of Regent's Park is one of my favourites. It doesn't flower for long but, when it does, its ombre-pink petals make a real impact. It's a showstopper, and on a warm spring day it really draws in the crowds, who marvel at its beauty. I live nearby and often visit the tree in the early morning when the crowds are fewer, or early evening as the sun starts to set. It brightens my day and never fails to inspire!'

MATTHEW WILLIAMSON

London's rather undeserved reputation as a grey, drab urban sprawl is turned on its head in the spring, when the city's streets and parks come alive with bursts of colour from blossoming magnolia trees. These spectacular trees only flower for a few weeks, and are easily damaged by the wind and spring frosts, so it's vital to catch sight of these glorious pink blooms while you can.

Regent's Park in the heart of the city is one place you are sure to find this prettiest of trees. Known as the 'jewel in the crown', Regent's Park was appropriated and used as a hunting chase by Henry VIII, and was later designed and developed as we know it today by John Nash, one of the foremost architects of the Regency and Georgian eras.

While this vast park has many delights to offer, including the abundant rosebeds of Queen Mary's Gardens and the Victorian-style Avenue Gardens, one of the 'jewels' in this park must surely be the remarkable magnolia: a riot of colour and beauty, dazzling in the spring sunshine.

THE DETAILS of the flowers on a magnolia are so beautiful. Although they only grace our presence for a short time, they are something to behold.

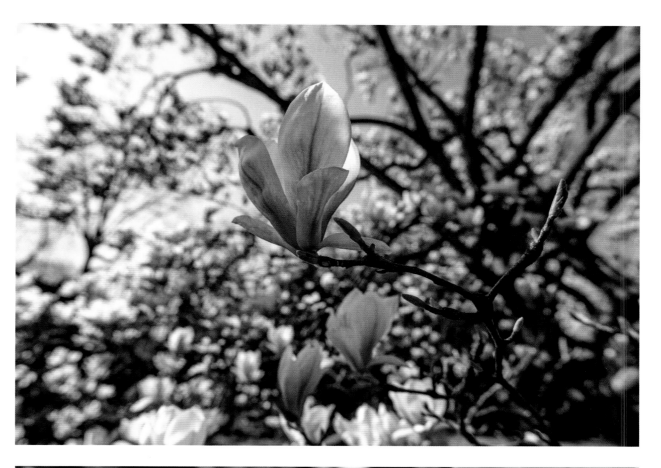

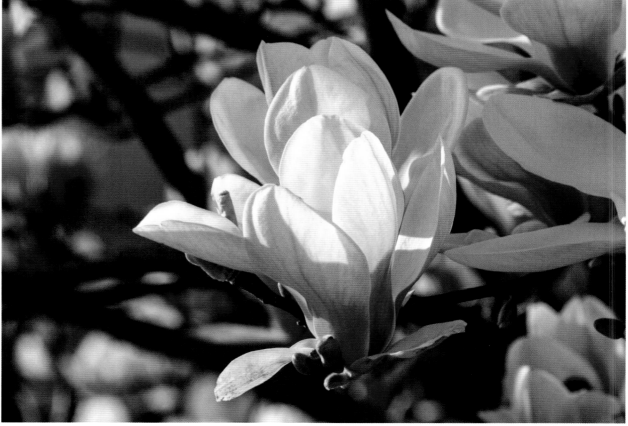

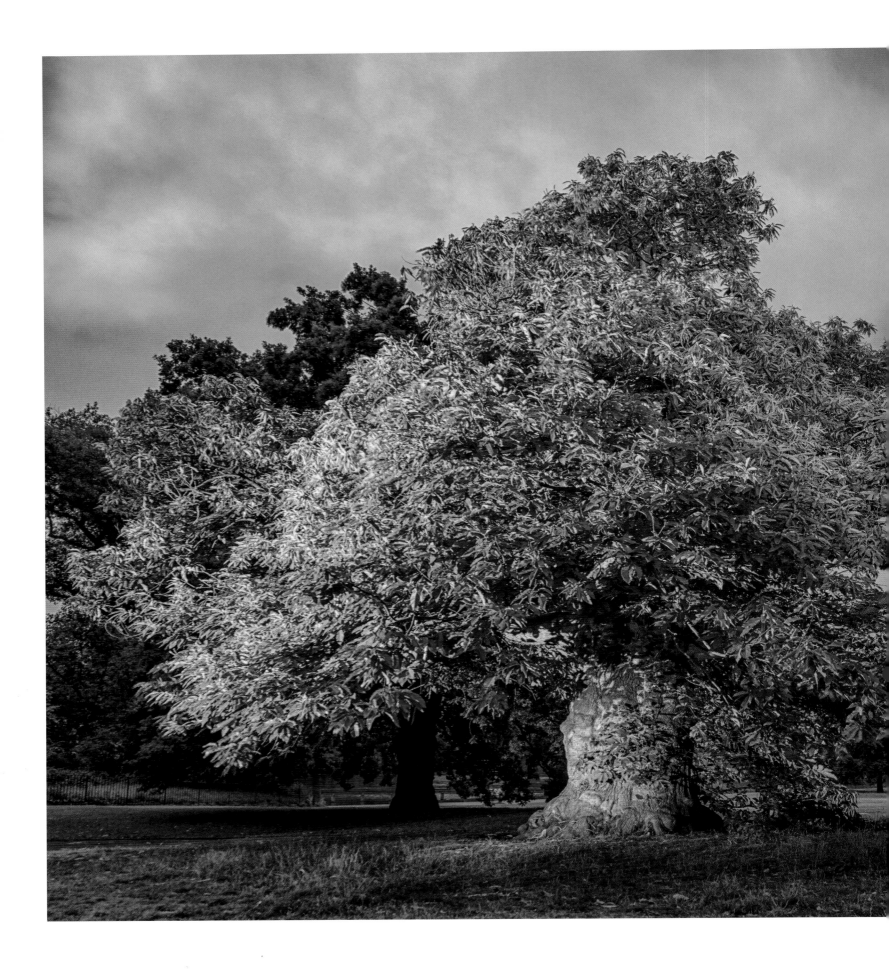

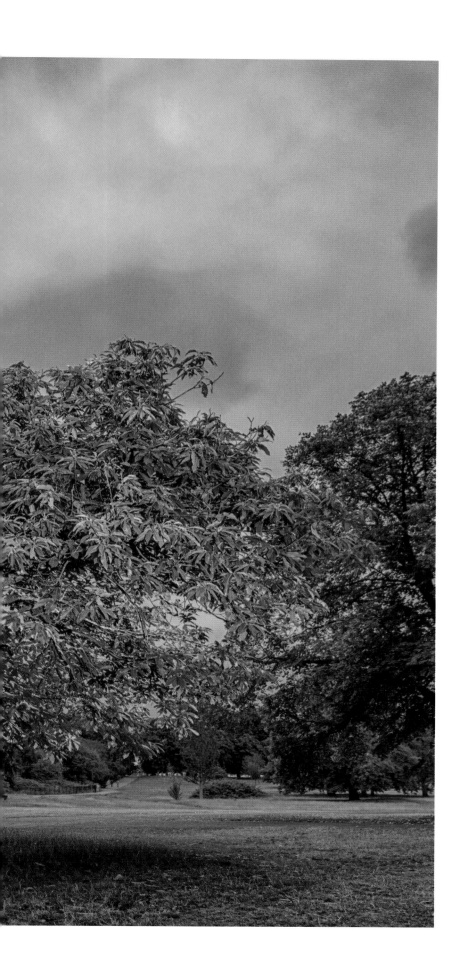

SWEET CHESTNUT
(*Castanea sativa*)

COMMON NAMES
Sweet chestnut

FAMILY
Fagaceae

DESCRIPTION
A deciduous tree with a wide girth; shiny, brown fruits
develop, wrapped in a green spiky case

HEIGHT
Up to 35m

Non-native

Belonging to the same family as the noble
oaks and beeches, the sweet chestnut is
thought to have been introduced
to the British Isles by the Romans.

'The sweet chestnut (Castanea sativa) is a personal favourite tree of mine; I enjoy its rugged looks, durability and large attractive foliage. The tree in the picture is a beautiful example of why I like this tree so much. Planted c1730, its squat shape reflecting its great maturity, growing downwards, as we put it, to cope with the stresses of old age. Autumn is my preferred time to visit as its leaves take on vibrant golds and russets, and the spiny fruits give up their delicious nuts.'

IAN RODGER

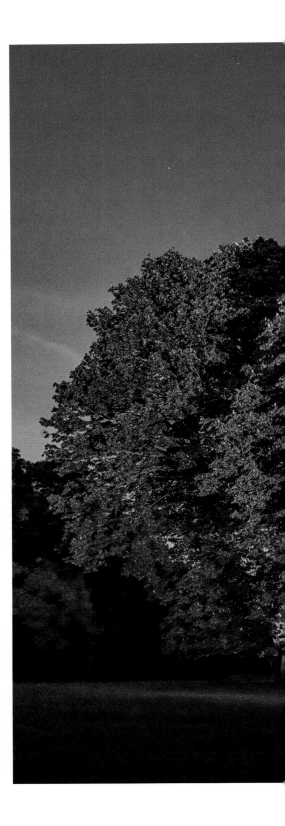

The sweet chestnut has somewhat immense proportions, which can reach up to 35 metres in height and up to 2 metres in girth, and it can live for up to 700 years. This long-lived giant is an important source of nectar and pollen for bees and other insects, while its nuts are good sustenance for the native red squirrel. Unlike the nuts of its namesake – the horse chestnut – those of the sweet chestnut are also edible for humans, and when roasted have become a classic treat at Christmas.

Although the sweet chestnut isn't native to the British Isles, its early introduction by the Romans means that today it is commonly found throughout the UK in many woodlands and parklands. Visitors to London's Kensington Gardens, one of eight Royal Parks, encompassing an area of 265 acres, will discover many sweet chestnut trees – 216 in total, of which 48 are considered veteran trees.

In his role as arboricultural manager, Ian Rodger is in charge of monitoring some 170,000 trees across the Royal Parks, taking care of some of the most well-loved landscapes in London. Ian is particularly fond of this particular sweet chestnut, the oldest tree in central London at over 300 years old, feeling a connection to not only the tree but also its custodians of years past.

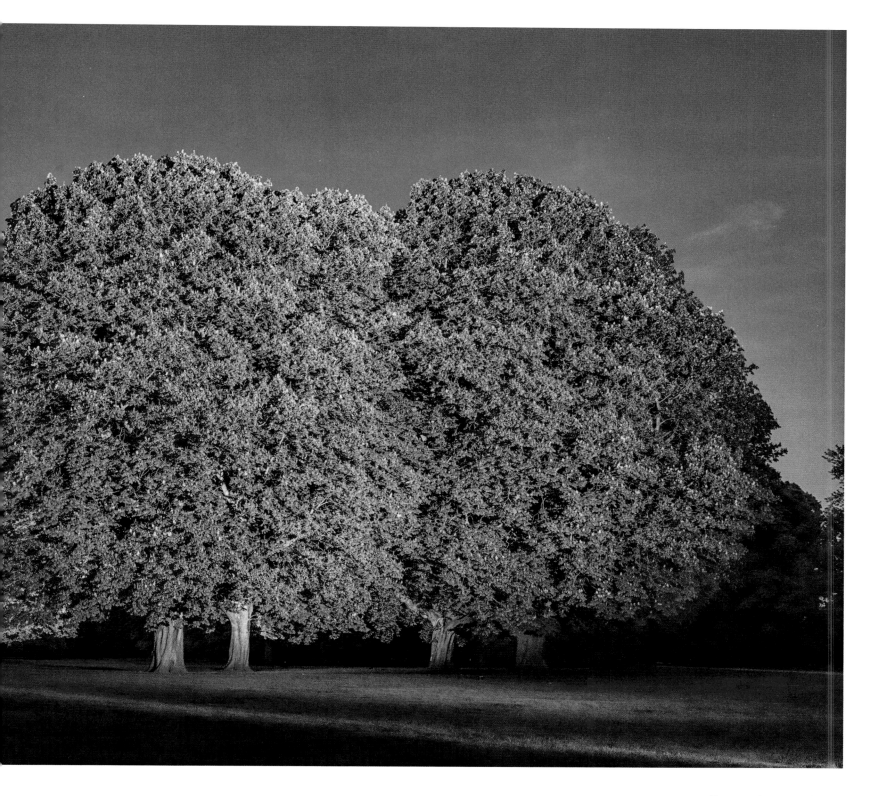

THIS GROUP of horse chestnuts in Kensington Gardens is known as 'The Famous Five'. While it has a similarity of leaves and fruits, the horse chestnut and sweet chestnut are from different families.

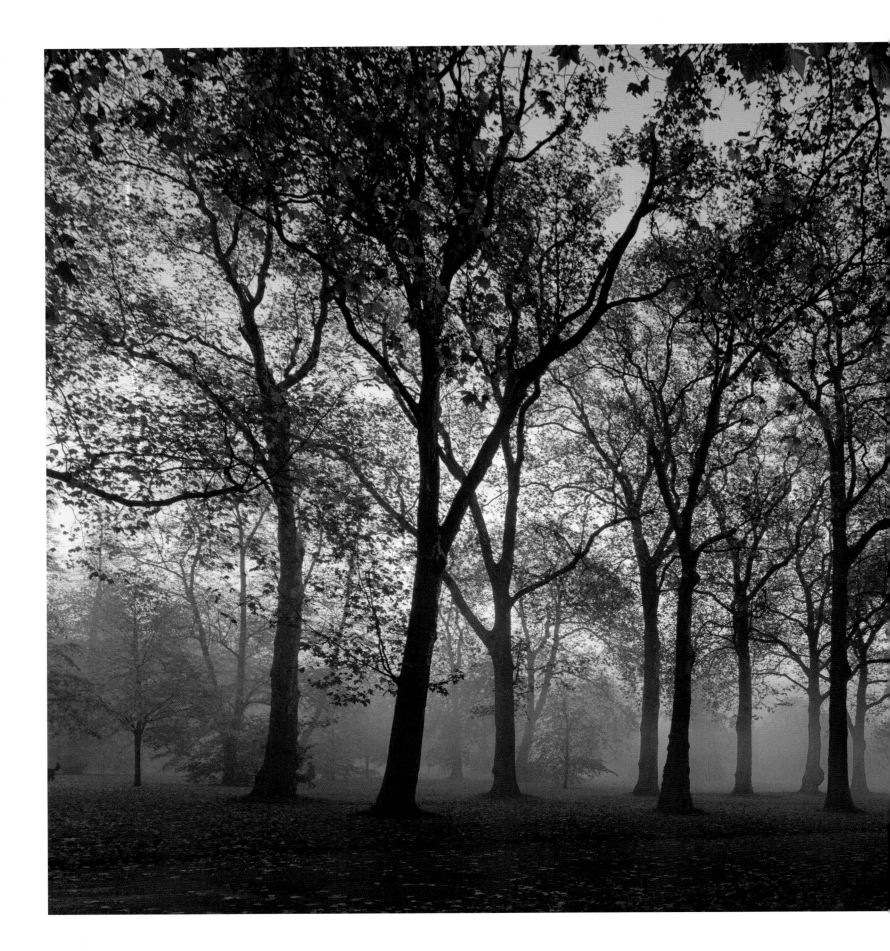

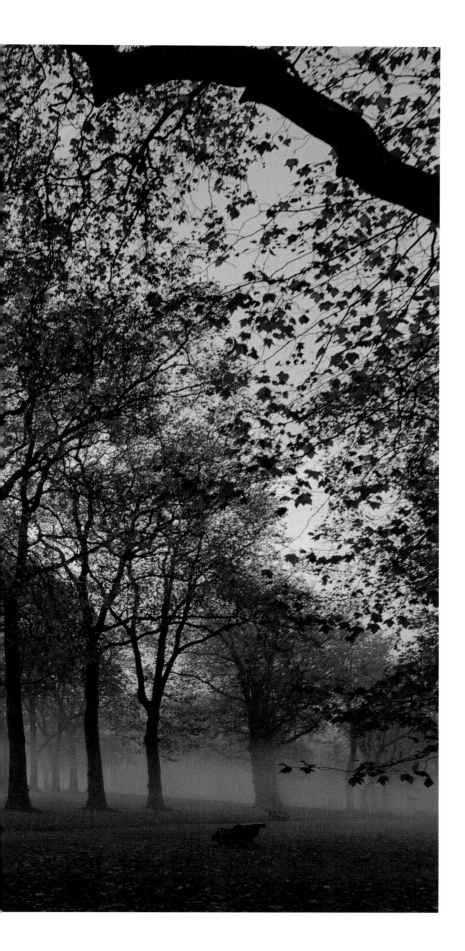

LONDON PLANE

(*Platanus* x *hispanica*)

COMMON NAMES
London plane

FAMILY
Platanaceae

DESCRIPTION
Tree with a large canopy, suitable for pollarding;
produces green spiky fruits that develop in clusters

HEIGHT
Up to 35m

Non-native

Influenced by the tree-lined boulevards of Paris,
the London plane was widely planted as a street
tree in London during the 18th and 19th centuries,
and is now the capital's most common tree.

'Was it from seeing them when I first came to London, aged eight, and noticed their dappled bark and sweeping branches? Was it when I saw how they spread down their arms to the river, and how their leaves crackle like cornflakes underfoot when they fall? I cannot remember a time when I didn't feel in awe of the mighty London plane tree; in parks and along the streets, in palace gardens and on recreation grounds, they tower up to the skies and suck up bad fumes and take care of squirrels and birds. They are giants protecting us while we sleep and shading us when we wake. They roar in storms and make us sneeze in springtime.

Their distant Asian cousin, the chinar, stood over me when I drew my first breath in Kashmir. I hope there will be one nearby when I breathe my last.'

JOANNA LUMLEY, OBE

The London plane is a tree that arrived quite literally by chance, a lucky discovery of the natural world. First spotted in the mid-17th century by famed botanist John Tradescant the Younger (1608–62) in his nursery garden in Vauxhall, it appears to have been the result of an accidental cross-pollination between the American sycamore and the Oriental plane.

This now ubiquitous, sturdy species is the perfect tree for city living, requiring little root space and having a unique ability to cope with high levels of air pollution. The mottled bark of the tree breaks away in large flakes, cleansing and dispelling the pollution stored in the outer bark, and leaving an attractive camouflage on the trunk.

With its adaptability and resistance to the city grime, while also providing an eye-catching arboreal presence on urban streets, the London plane is a remarkable tree. Named after the city where it originated, this tree is a true Londoner in every sense.

THESE LONDON planes were captured in the early morning twilight in Hyde Park, looking east as the horizon turned orange on a clear and misty morning.

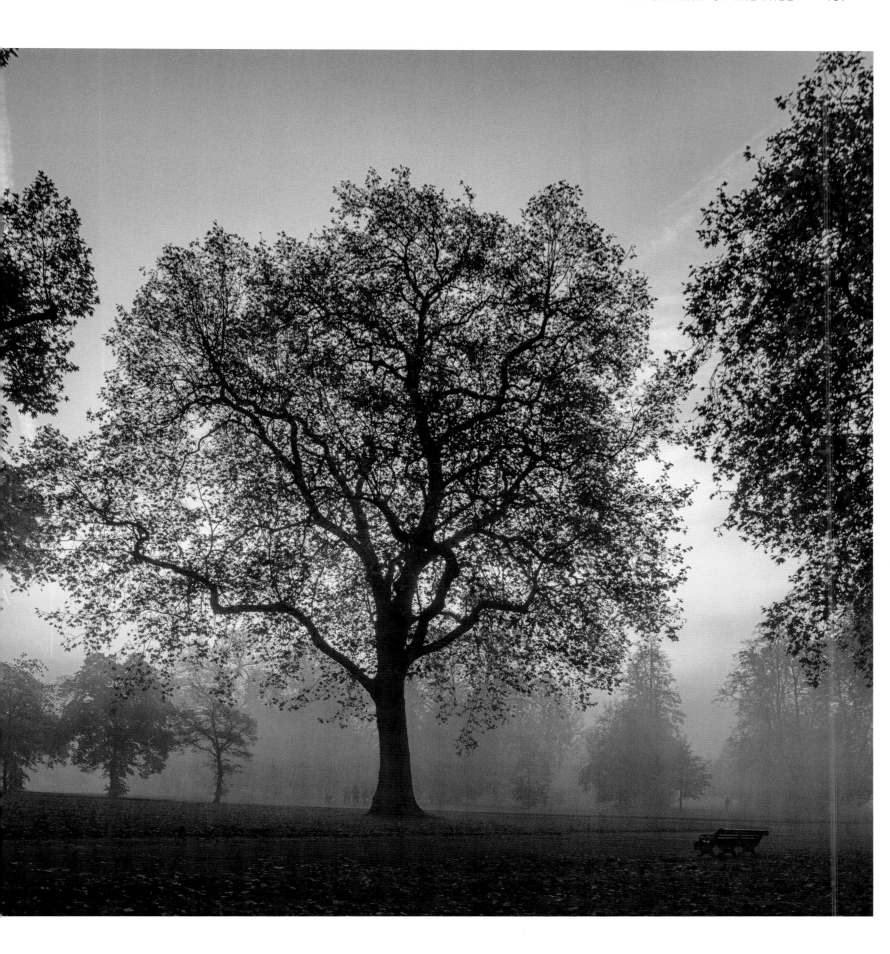

MAGNOLIA 'LEONARD MESSEL'

(*Magnolia x loebneri*)

COMMON NAMES
Magnolia

FAMILY
Magnoliaceae

DESCRIPTION
A deciduous small tree with lilac-pink flowers

HEIGHT
4–8m

Non-native

Named in honour of the French botanist
Pierre Magnol (1638–1715), there are
approximately 80 species of magnolia.

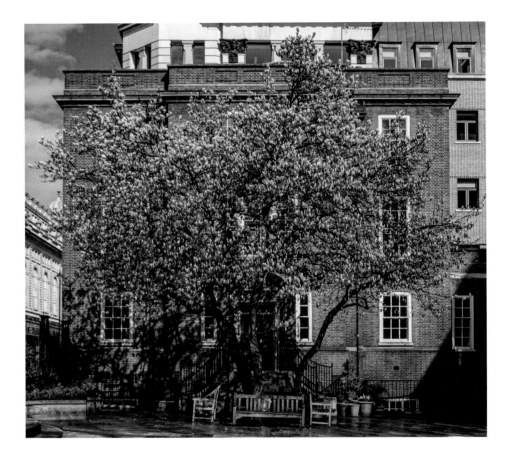

THE MAGNOLIA in its
full glory, having 'burst
into bloom', covering
the front of the Rectory
in vivid pink flowers.

The church of St James's Piccadilly was one of four similar-looking churches in London designed by English architect Christopher Wren and was consecrated in 1684 after eight years of construction. While alterations to the building were made in subsequent years, the building stood firm for over 250 years but could not withstand the dark days of the London Blitz.

At 7.54pm on 14 October 1940, St James's was hit by incendiary bombs. The blast weakened the foundations of the building and the fires raged. By morning it was gutted – the fires had consumed all within and the church was open to the elements. Luckily, the church's most precious possessions had been moved for safety prior to the bombings – the 17th-century altar carvings, altarpiece and organ casing survived. Services resumed in the church in 1941 after a temporary roof was constructed but it was not fully restored for seven years.

The Southwood Garden at St James's was created as a garden of remembrance to commemorate the courage of the people of London during the horror of war. Nowadays it provides a calm, tranquil space for contemplation and reflection. According to Catherine Tidnam, the gardener at St James's, the planting 'is chosen to bring interest throughout the seasons'. There can be no doubt that a highlight of the spring is the blossoming of the magnolia tree, filling the air with its sweet fragrance.

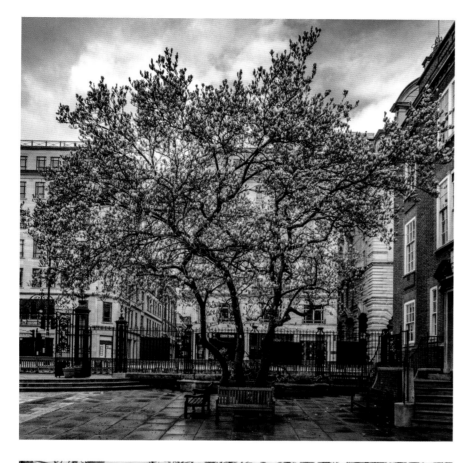

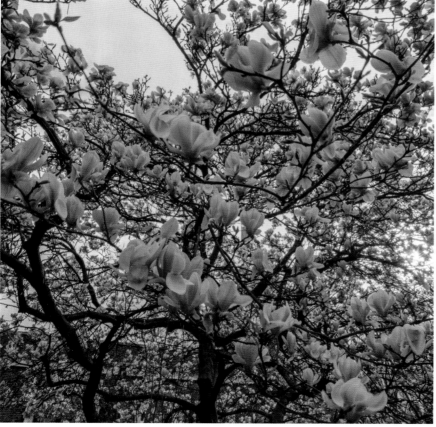

'*Every time I look out of my study window, I see this magnolia tree, planted after the church was bombed during the Second World War. Magnolias are an ancient species of tree, more than 100 million years old. This one has witnessed the rebuilding of the church and rectory after they were almost destroyed on the night of 14 October 1940.*

It has witnessed brides walking into church to get married, babies being carried in to be baptized; and coffins have been taken under its branches on their way into funerals. Market traders sometimes trade too, visitors sit on the bench in its shade and art installations often stand by its side.

For a few short days each year, the tree bursts into bloom, causing passers-by to stop on Piccadilly and take a photograph. Too quickly, the exuberant flowers are gone, but the tree stands tall and still, a strong reminder of the natural world, even in the chaotic and noisy environment of Piccadilly Circus.'

REVEREND LUCY WINKETT

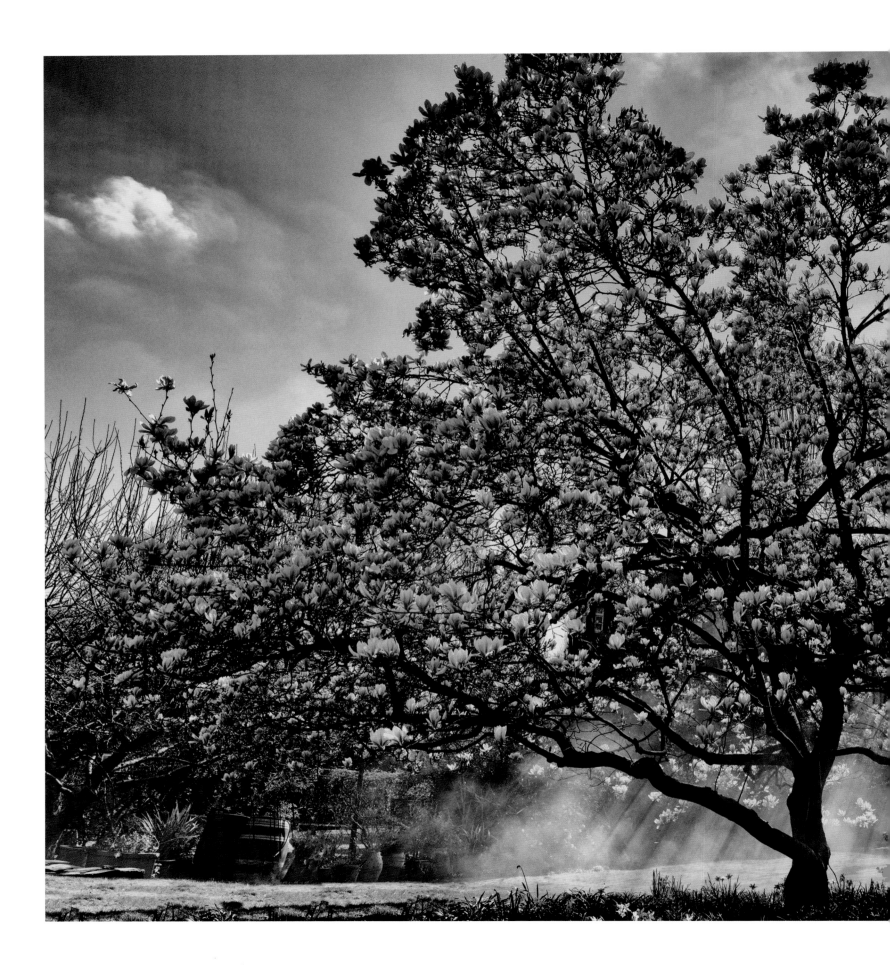

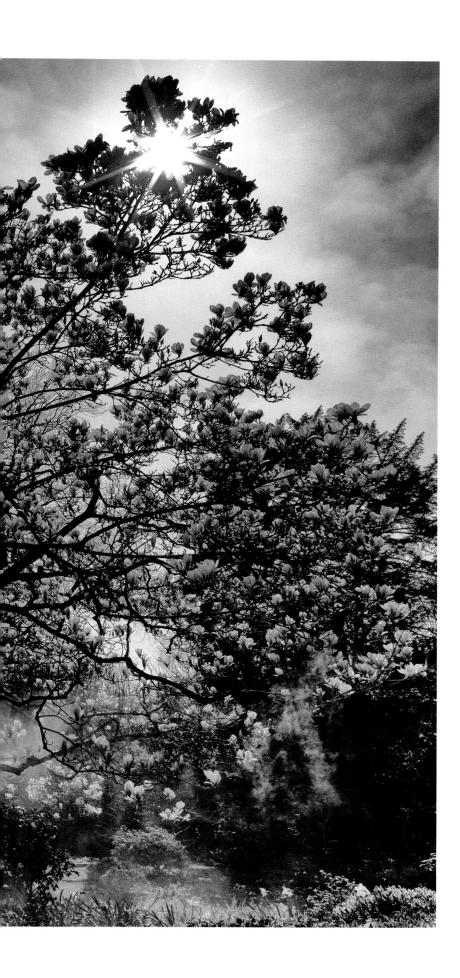

MAGNOLIA 'LEONARD MESSEL'

(*Magnolia x loebneri*)

COMMON NAMES
Magnolia

FAMILY
Magnoliaceae

DESCRIPTION
A deciduous small tree with lilac-pink flowers

HEIGHT
4–8m

Non-native

While fossil records show that magnolias existed in Europe, Asia and North America over 100 million years ago, today they are native only in southern China and the southern United States.

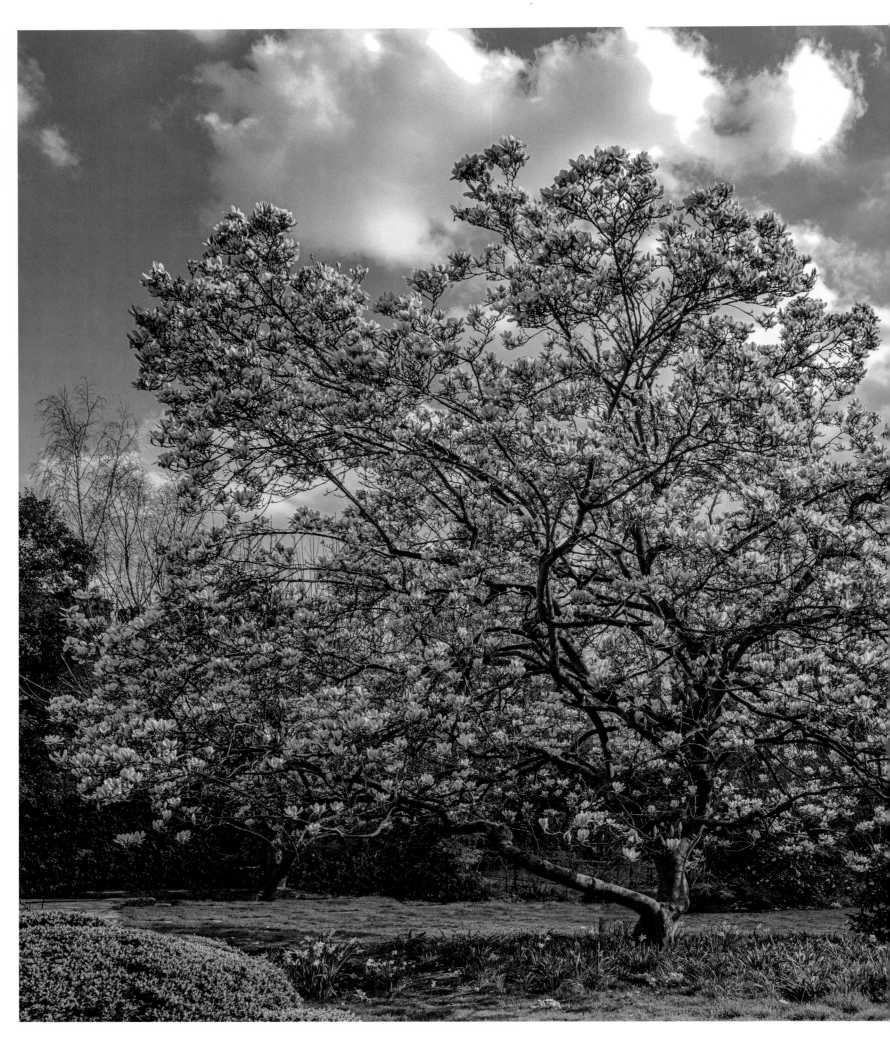

'We are fortunate to live next to Hampstead Heath – with a plethora of wonderful trees, but this magnolia is something extraordinary. The sheer beauty of it for the brief week or so that it's in full flower suggests it is the butterfly of trees, and worth planning on staying home for those few days to enjoy it.'

NICK MASON, CBE

THE FLOWERS of the magnolia together with the daffodils on the ground below announce the arrival of spring.

Covering over 800 acres of meadow and parkland, Hampstead Heath offers a wealth of nature in the heart of bustling London. With its spectacular views across the city, the heath has been a popular spot for locals and tourists since the early 1800s, and has always been a particular draw for those of an artistic inclination, with poets, painters and writers all finding inspiration among the grassy wilderness. Indeed, the author C S Lewis was so captivated by the magical landscape on the heath that he was inspired with the idea for a new novel, which later became *The Lion, the Witch and the Wardrobe*.

This essence of magic is alive as you roam the landscape of the heath, following main trails or discovering paths off the beaten track. And here you may be lucky enough to stumble across this glorious magnolia tree, in full bloom in the spring sunshine, casting a delicious spell over the surrounding parkland.

MIMOSA

(*Acacia dealbata*)

COMMON NAMES
Silver wattle, blue wattle

FAMILY
Fabaceae

DESCRIPTION
An evergreen tree with grey-green leaves
and bright yellow flowerheads

HEIGHT
4–10m

Non-native

Native to Australia, the mimosa tree has been widely
introduced to the temperate regions across the Mediterranean,
California, South Africa and the highlands of southern India.

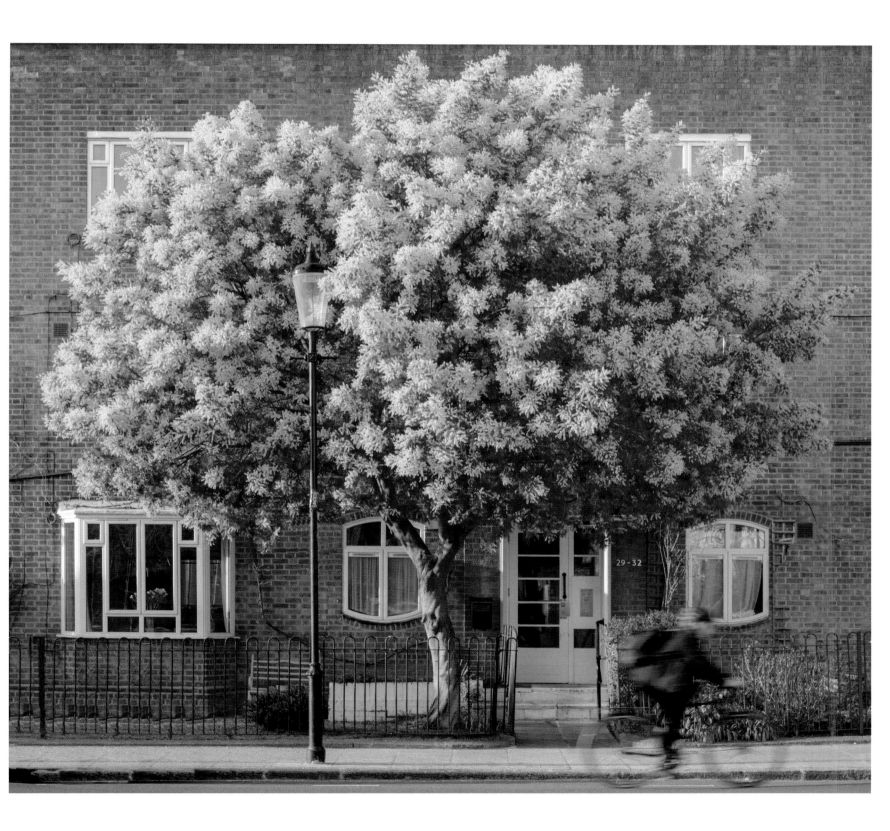

'Trees mean so much to human beings. They seem as if they are observing us and the surrounding planet. As the lungs of the Earth they emit oxygen and store carbon. Without them we, as a species, could not survive. Trees have obvious beauty and I believe our communities should be filled with them.

I have a real affinity with these large plants, which stems back to my childhood. I was often to be found with my mates playing in wooded areas, climbing and building dens with the discarded wood from these beauties.

On a recent walk in London I saw a most beautiful mimosa in a front garden. It transported me right back to the house that my family and I lived in when I was a child, where in a neighbour's garden there stood a magical tree of silver and gold. I recall the space being stark but for this wonderful ornamental specimen. It really stood out, as if behaving like a proper show-off.

This evergreen tree, which couldn't be ignored, reminded me of how I had wanted to get up close and personal by jumping the neighbour's fence. I was drawn to its beauty with the bluey-grey to silvery leaves and clustered bright yellow flowers. Just as well I didn't.'

DANNY CLARKE

CAPTURED IN the late afternoon sunlight, this mimosa in its spring blossom shines out like a beacon to anyone who might have the pleasure to walk past it.

The mimosa tree thrives in sunny spots with well-drained soil, sheltered from wind and frost. In the UK it has been introduced as an ornamental plant, but is likely to fare better in the southern regions, as it is too tender to survive cold winters. While it can grow up to around 30 metres in its native habitat, it will seldom reach above 10 metres in the UK.

However, it is well worth the effort to nurture this delicate tree. A winter-blooming tree, its attractive grey-green leaves are evergreen, and in the darkest months of the year its bold yellow blooms will enliven any garden. The flowers also have an appealing sweet fragrance that begins in bud and fills the air all around once the first flowers start to unfurl.

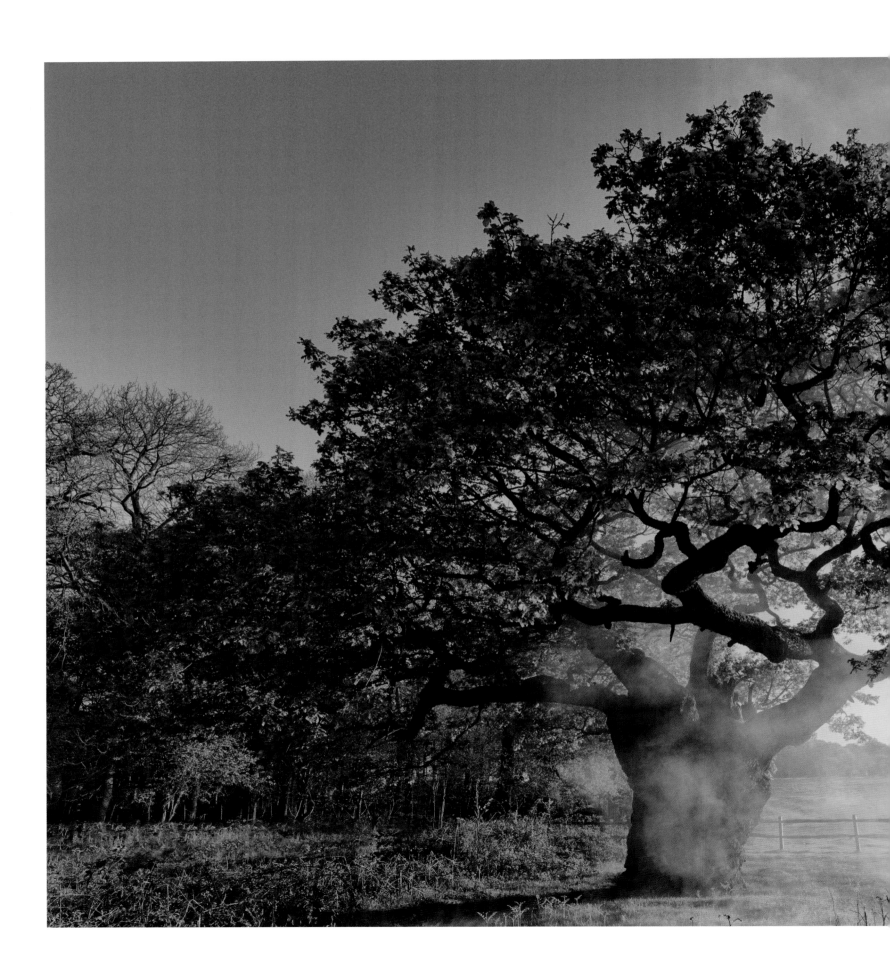

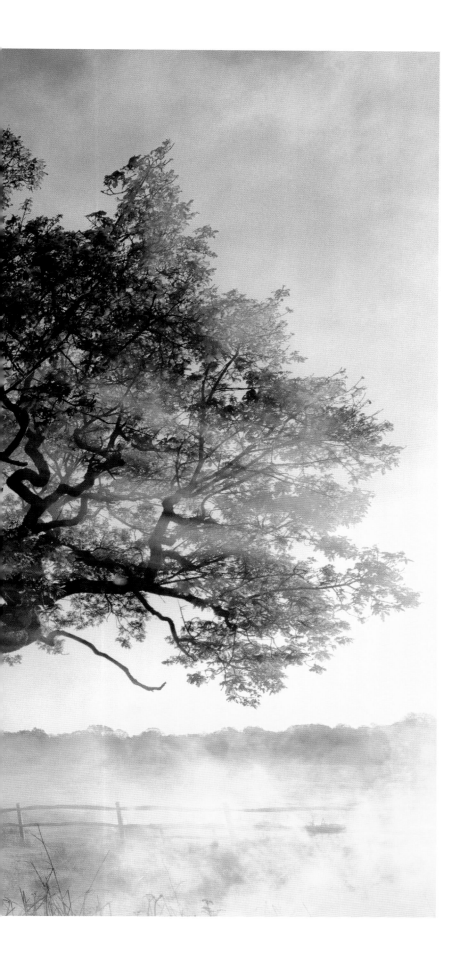

ENGLISH OAK

(*Quercus robur*)

COMMON NAMES
English oak, common oak, pedunculate oak

FAMILY
Fagaceae

DESCRIPTION
Deciduous tree with broad crown and lobed leaves;
catkins are followed by acorns

HEIGHT
20–40m

Native

The iconic Royal Oak was chosen to represent the 'Year of the Tree' in 2020 – a year-long conservation campaign to help protect Richmond Park's 130,000 trees.

'The Royal Oak in Richmond Park is estimated to be over 750 years old, and I regularly run past it on my morning jog with friends and never fail to notice its captivating beauty. It has a special energy about it, and has no doubt witnessed all sorts of life through the ages. It's particularly stunning in the morning mist, which Adrian has captured so beautifully.

I have always loved trees and spent much of my youth playing 40/40 with neighbours around a special tree in our garden. How sad, that today so many children grow up in this digital age with screen-based activities and have forgotten how to enjoy the simple pleasures of nature, whether playing hide and seek or picking up conkers.'

ANNABEL CROFT

Among 1,300 veteran trees recorded on the Ancient Tree Inventory in West London's Richmond Park, one ancient tree stands proud. Found close to Pen Ponds, its splendid gnarly and squat silhouette dominates the landscape, and its hollow trunk was once a popular playing spot for children before it was fenced off for its protection and conservation.

Thought to be around 750 years old, the Royal Oak has stood as witness to times past and the surrounding environment long before Richmond was established as a royal hunting park by Charles I in 1637. This stoic giant of a tree is of huge importance to biodiversity in the parkland, with myriad invertebrates, including the endangered stag beetle, feeding from its decaying wood.

THIS ANCIENT oak sits on its own at the bottom of a small hill in Richmond Park. The early morning mist flows through its branches in the golden light of dawn.

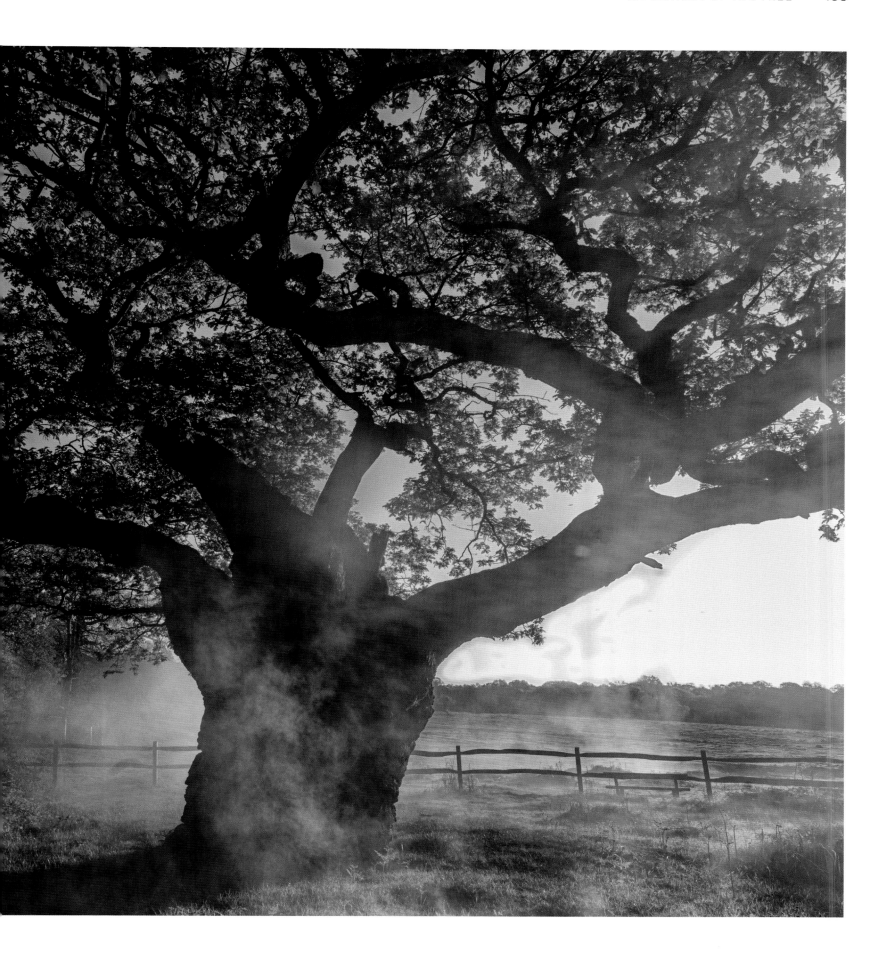

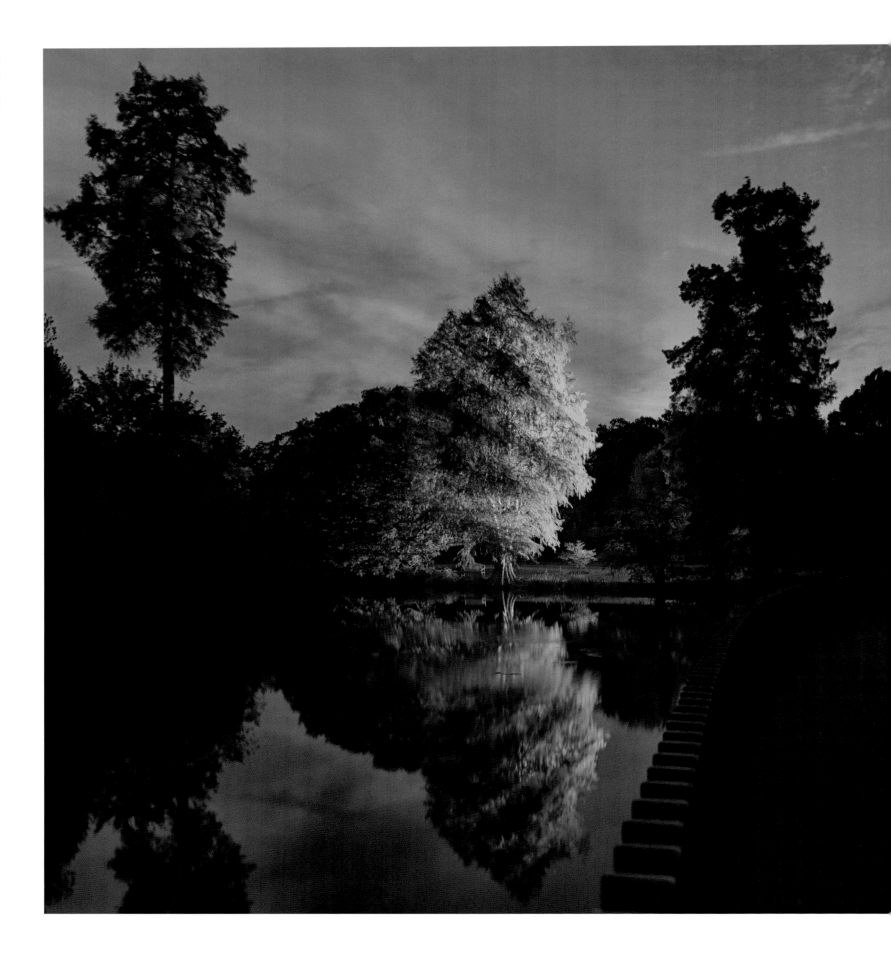

MONTEZUMA BALD CYPRESS

(*Taxodium mucronatum*)

COMMON NAMES
Montezuma bald cypress, Montezuma cypress,
Mexican cypress, ahuehuete, sabino

FAMILY
Cupressaceae

DESCRIPTION
A large needle-leaf tree, with tall, straight trunk
and broad crown

HEIGHT
36–72m

Non-native

A native of Guatemala, Mexico and Texas,
the Montezuma bald cypress is the
national tree of Mexico.

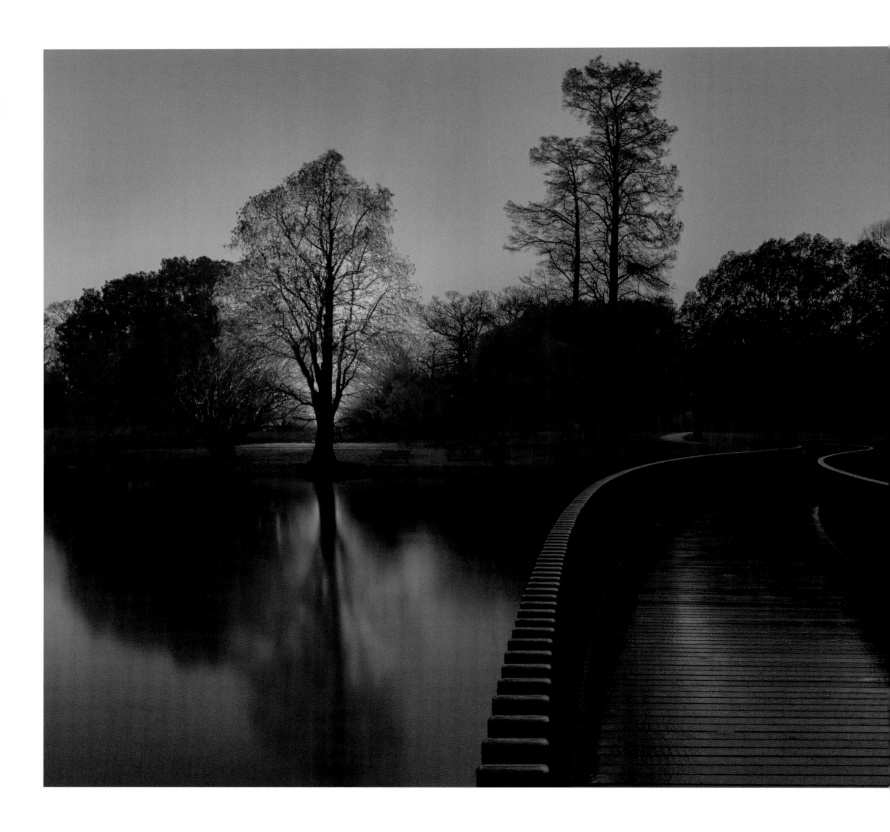

TAKEN IN late November, this
photograph used a little light to
backlight the tree, bringing out the
fading colour of its autumn leaf.

'The 300-acre arboretum at Kew holds one of the most diverse collections of temperate trees in the world, including many species of rare trees that cannot be found growing in any other gardens. This Montezuma cypress, a deciduous conifer native to Mexico, was planted in 1908 and is more suited to a warmer climate, but grows well by the lake at Kew, holding on to its leaves well into the winter, producing some of the best autumn colours to be seen. At any time of day or year, I always take time to stop and admire this majestic tree whenever I cross the Sackler Crossing.'

TONY KIRKHAM, MBE, VMH

With its graceful, tall form and weeping branches, the Montezuma bald cypress is an elegant tree for large lawns or open spaces. Its foliage is evergreen in mild climates but deciduous in colder environments, with its leaves turning golden in the autumn and winter months.

In its native Mexico, one particular cypress holds huge cultural significance: the Árbol del Tule in the town of Santa María del Tule is said to be the widest tree in the world. Believed to be around 2,000 years old, this remarkable tree draws thousands of visitors and tourists to the village each year.

The Montezuma cypress is just one of the 14,000 trees on display at Kew's arboretum, which represents more than 2,000 species in total. As well as a beautiful place to visit, the arboretum plays a vital role in botanical research. Each tree planted here provides the opportunity to gather knowledge and protect some of the world's threatened species.

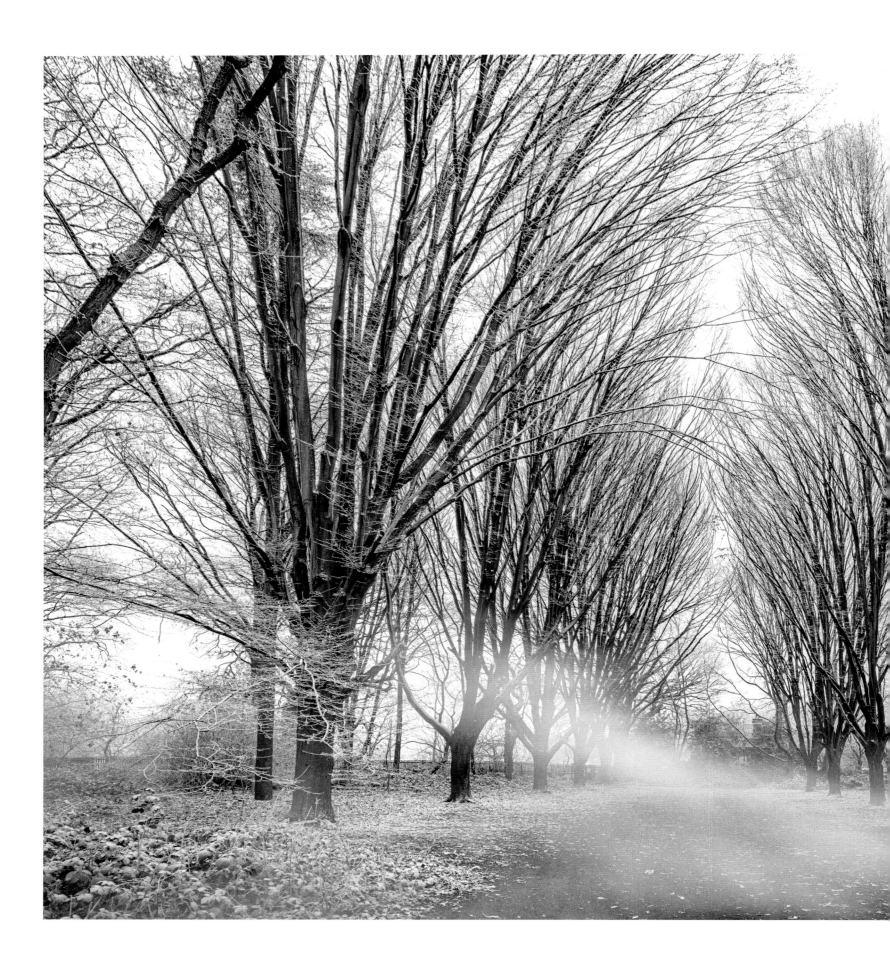

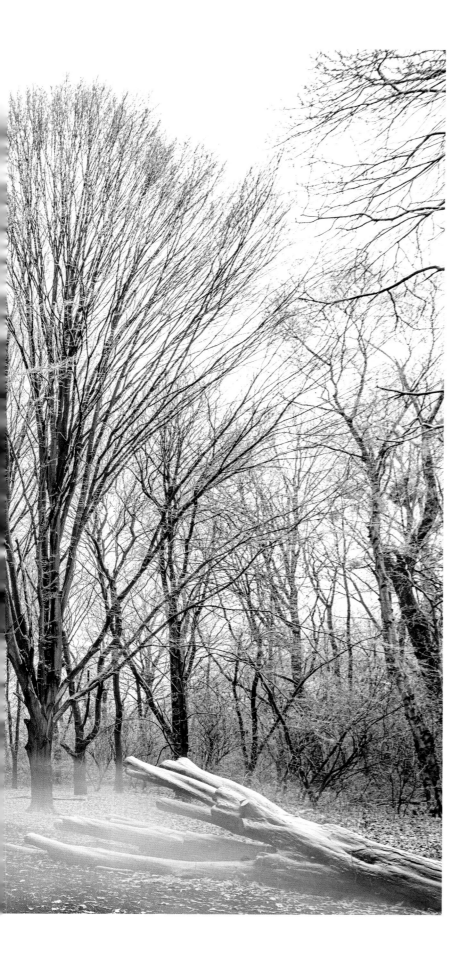

HORNBEAM

(*Carpinus betulus*)

COMMON NAMES
Hornbeam, common hornbeam,
European hornbeam

FAMILY
Betulaceae

DESCRIPTION
A deciduous, broadleaf tree with
year-round leaf cover

HEIGHT
Up to 30m

Native

While there are around
40 species of hornbeam,
there are only two species
endemic to Europe.

'Imagine a crisp, frosty morning. My fingers are aching in my gloves. I'm exploring Bushy Park, Henry VIII's old hunting ground at Hampton Court. As I cut through the Woodland Gardens, I come upon an avenue of hornbeams stretched out in all their winter beauty. It's a moment I will remember all my life, ambushed by the unexpected shapeliness of the branches, rising in the winter stillness. The hornbeam became my favourite tree. A practical tree, with a hard wood that's been used for piano hammers, ox yokes and coach wheels. The hornbeam makes excellent firewood too. Burning hot and long and bright, it fuelled London's bread ovens in times gone by. It's that balance of beauty and practicality that I love, and this image of Adrian's gives a brilliant sense of that – of the trees reaching out and working together. When I'm stuck indoors, I can imagine myself standing there, looking up, feeling the power of nature and our inter-connectedness. Wonderful.'

SARA LOM

Given as a gift to King Henry VIII by Cardinal Wolsey in 1529, Bushy Park has a long and rich history. One of London's eight Royal Parks, Bushy encompasses over 1,000 acres of grassland, gardens and waterways, linked to the spectacular Hampton Court Palace by the Longford River.

The trees of Bushy Park are one of its main attractions, and many mature specimens can be seen at every turn, with the parkland home to 140 veteran trees of varying species, including oak, hawthorn, silver maple and sweet chestnut. Chestnut Avenue provides a wonderful pathway of horse chestnut trees, while the aptly named Lime Avenue is a corridor of attractive lime trees. The avenue of sturdy hornbeams, however, with their gnarly shape and tactile catkins, is a true highlight of the Woodland Gardens.

THESE HORNBEAMS sit in a garden within Bushy Park lining a well-worn path, where they were captured on a cold and frosty January morning.

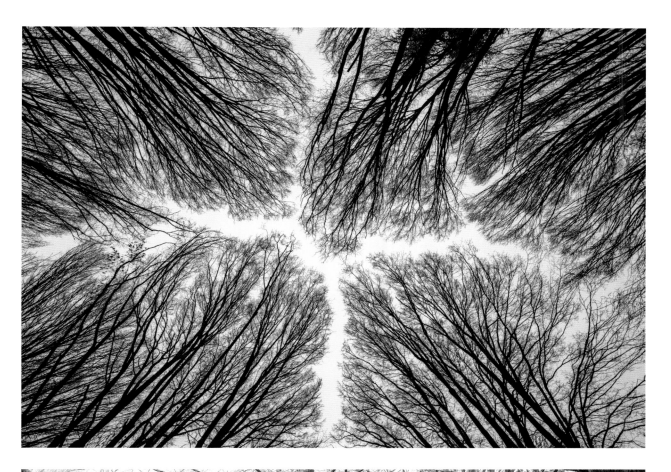

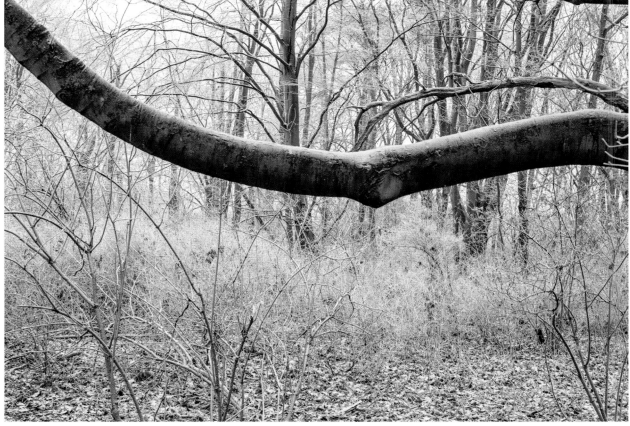

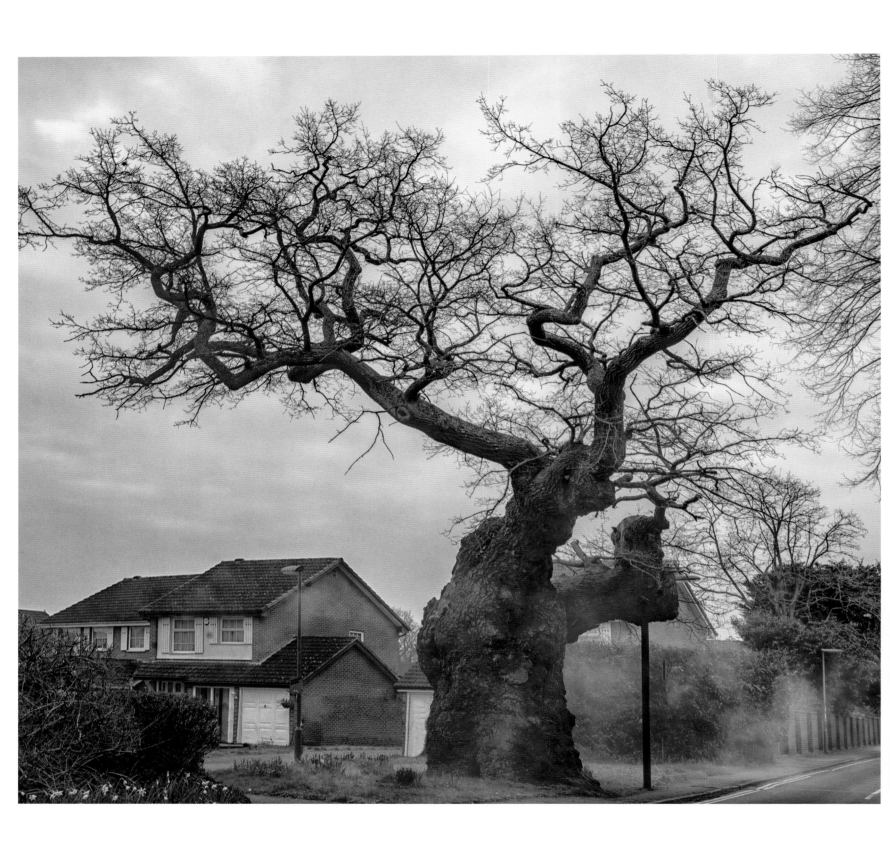

ENGLISH OAK

(*Quercus robur*)

COMMON NAMES
English oak, common oak, pedunculate oak

FAMILY
Fagaceae

DESCRIPTION
Deciduous tree with broad crown and lobed leaves;
catkins are followed by acorns

HEIGHT
20–40m

Native

A single oak tree can produce up to 25 million acorns during its long lifetime, but it will not start producing acorns until it reaches the age of 40. Each acorn contains only one seed.

'Seeing "my" oak tree again reminds me that we are living in dangerous, pivotal times. There is very little left of my childhood playground; houses stand where the trees once did, and the vibrant, mossy tapestry beneath is now a sterile monoculture of amenity lawn. I struggle to place where I used to hide, completely obscured by the veil of branches on a weeping willow. But the oak stands firm, as oaks do. They always have and always will…I think.

Oaks are the British national tree, strong and enduring. But my oak is now pathetic; shackled by a concrete curb, as the road squeezes past its broad base. A mean mat of grass covers what I know are cramped and suffocating roots. It may be dying, but we won't know for years; oak trees take hundreds of years to mature and decades to die. We will register its demise long after the developers have banked their cheques.

My oak is now alone, the sole survivor of once ancient woodland. Crouched, with my childhood friends, beneath the twiggy cover of our makeshift camps, I wove together legend and fantasy. We told tall tales and believed them all.'

JULIET SARGEANT

With their broad crown and sturdy branches, oak trees play just as vital a role in our urban landscapes as in more rural areas. The leafy canopy of the oak tree provides a natural filter for our homes and gardens – offering shelter and absorption of neighbourhood noise, odour and pollutants, as well as protection from strong winds.

Oak trees also offer a habitat of rich biodiversity, providing shelter and food that support a large number of insects, birds, small mammals and fungi. This not only creates a much-needed ecosystem but also makes our towns and cities more attractive places to live. However, urban life can take its toll on trees such as this, with soil compaction a particular challenge.

THIS OAK, which sits in a highly residential area, was photographed on a long exposure, capturing the lines of light as the cars passed by. I am sure at some point in time it would not have been disturbed by many humans at all.

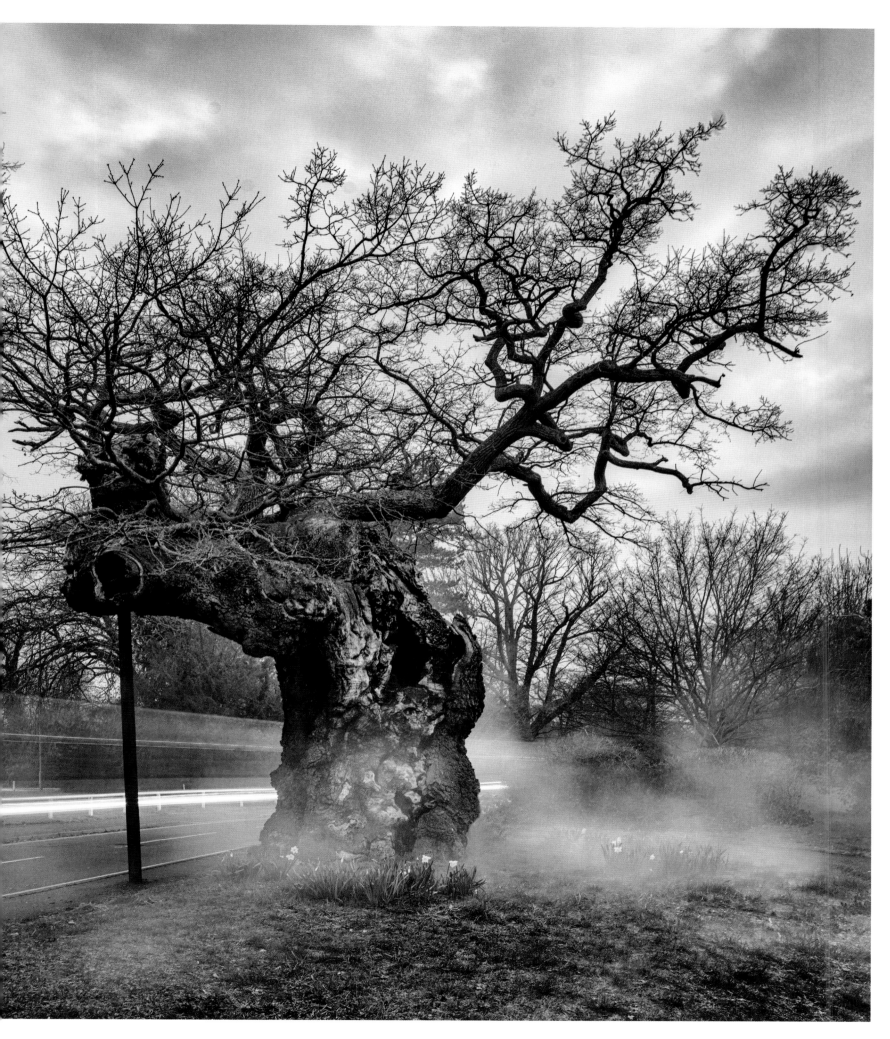

ENGLISH OAK

(Quercus robur)

COMMON NAMES
English oak, common oak, pedunculate oak

FAMILY
Fagaceae

DESCRIPTION
Deciduous tree with broad crown and lobed leaves;
catkins are followed by acorns

HEIGHT
20–40m

Native

Acorns of the oak tree usually take four to six
weeks to germinate, but many never get the
chance as they are a rich source of food
for small mammals and birds.

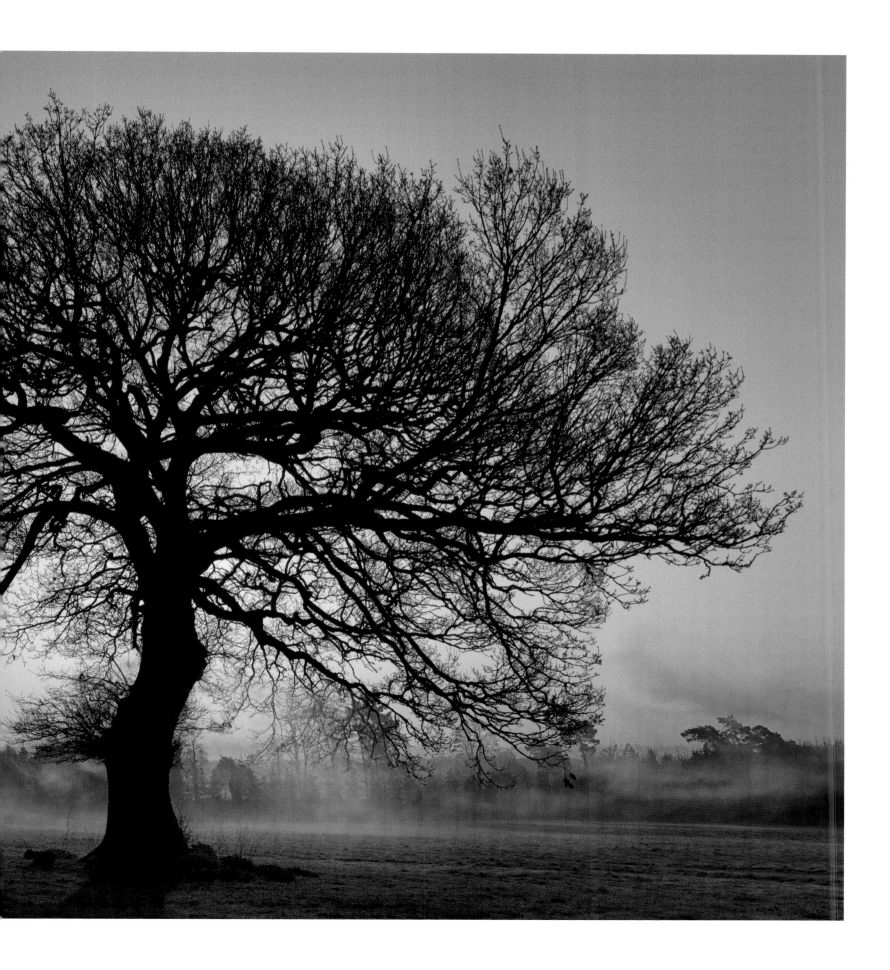

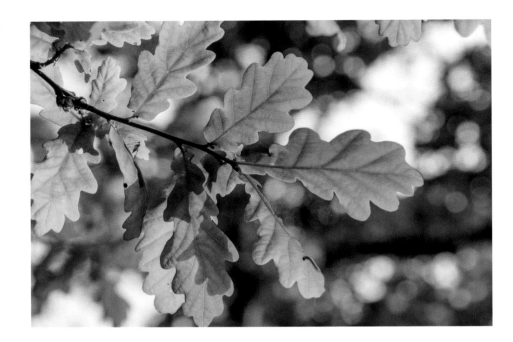

THIS DETAIL of an oak leaf was taken in late June.

When growing in wide-open spaces, such as this expansive field in Henley-on-Thames, English oak trees form a wide canopy, with their sturdy branches reaching out around them. The distinctive pale grey bark is smooth when young, but as the oak ages, this becomes more rugged and cracked, providing the perfect crevices and hiding spots for insects, bats and even small birds, such as the marsh tit.

HOSTILE INSECTS

Unfortunately, the English oak does not live in harmony with all wildlife. The oak processionary moth, a non-native species that was first found in London in 2006, is becoming a threat to our native oak. Its caterpillars nest almost exclusively on oak trees, moving down the tree as they develop and feeding on its leaves as they go. This exposes the oak and makes it vulnerable. Work is underway to identify and manage outbreaks of these pests, to prevent wide-scale damage to the English oak community in the UK.

'This magnificent oak tree sits in the middle of our field not far from the River Thames. We walk by it and admire it most days with our children and dogs. Spring, summer, autumn and winter, rain or shine, without fail we visit and reflect on its history and beauty… A happy place with beautiful memories to be shared with future generations.'

MAX GOTTSCHALK

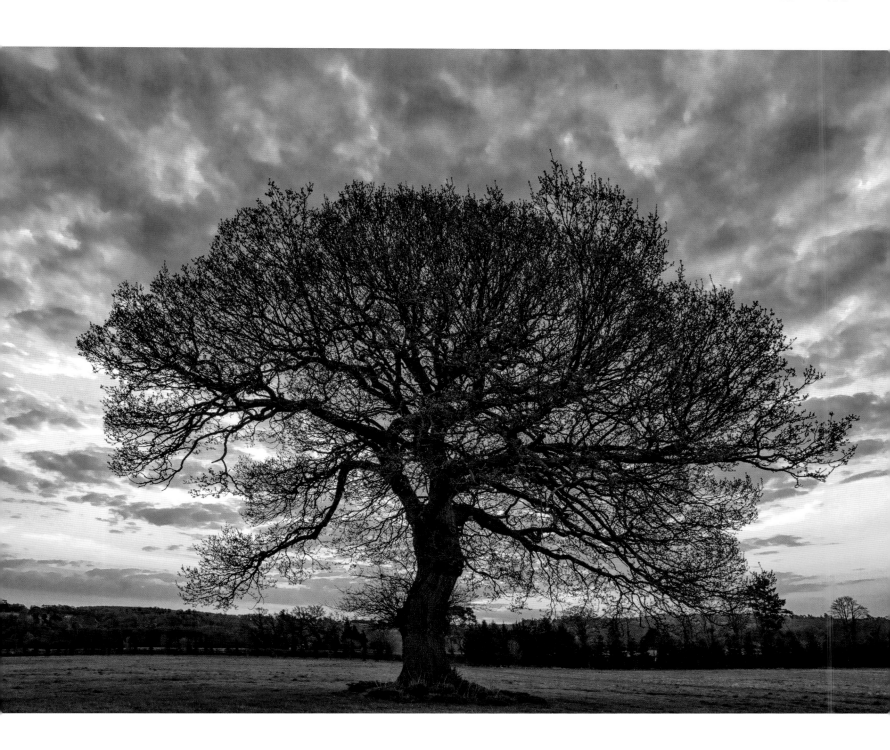

BLUEBELL WOOD

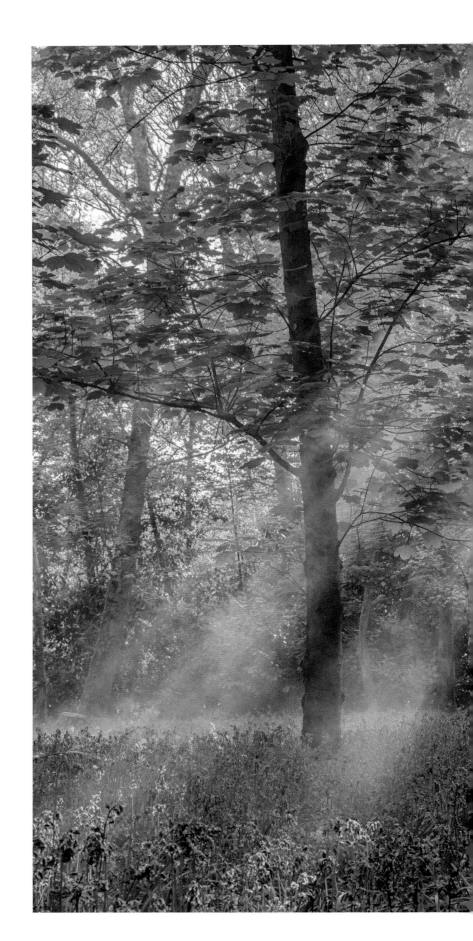

A gossamery blanket of bluebells covering the floor of a dense woodland in dappled sunlight signals that spring is well and truly underway, and it is the highlight of many a springtime stroll, particularly in the UK, where around 50 per cent of the world's bluebell population can be found. However, these delicate flowers are easily damaged if trodden on, so walkers should take care to watch where they tread and stick to marked pathways.

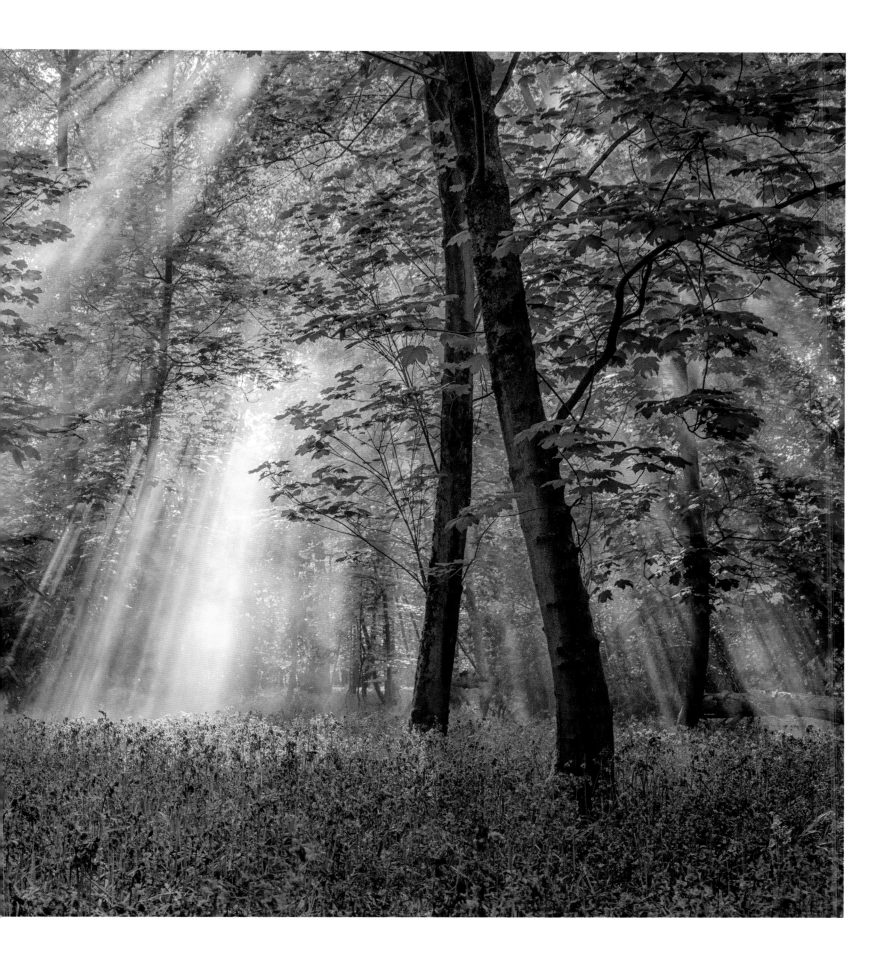

THIS BLUEBELL wood brought home
the beauty of nature – the way the
beams of light came through the trees
was a moment to behold.

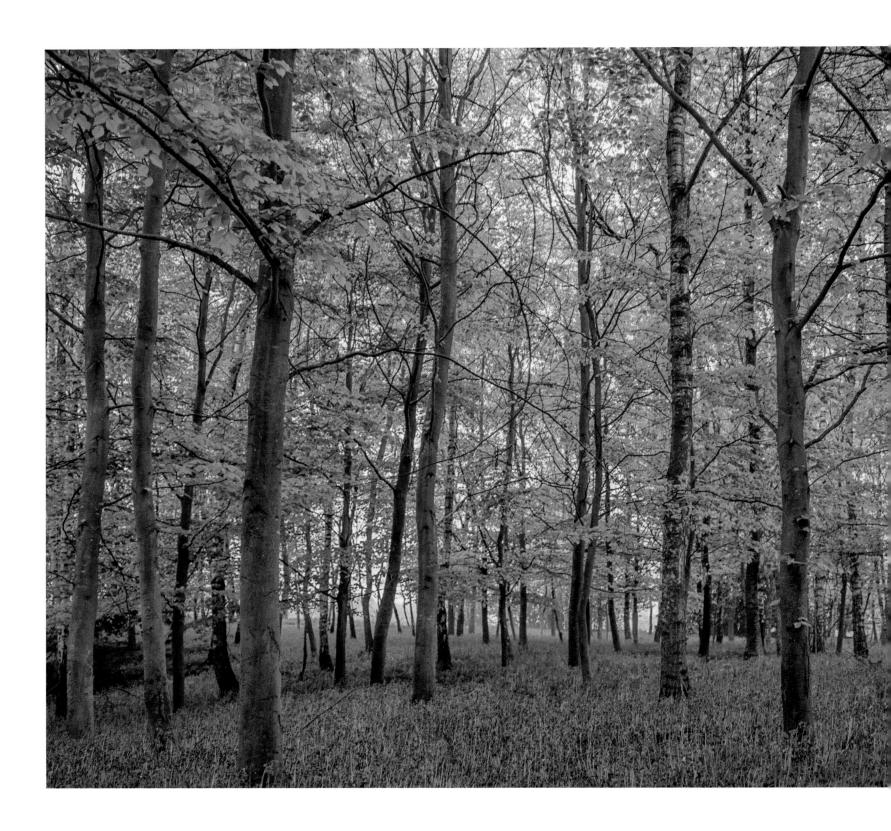

'For me, the arrival of the bluebells is a magical season in England. These delicate flowers which carpet the forest floor in blue are nature's (or elves'!) most lovely enchantment; the heralds of spring. How can we possibly compete with their beauty? Finding the perfect spot to inhale their magic and dream has become my yearly pilgrimage, and visiting this ancient forest of oak, beech and silver birch is a particular treat. On sunny days the light filters through the trees, illuminating the flowers to an impossible hue. You can only walk in silence and wonder at their magnificence.'

ANABEL CUTLER

Bluebells are a boon for pollinators, attracting bees, butterflies and hoverflies with their striking colour that stands out boldly against the greenery of the forest floor. They can take up to five to seven years to become established and are quite fragile, disliking any disturbance, so an abundance of these delightful blooms can often signal an area of ancient woodland. These precious landscapes are home to centuries of undisturbed soil, decaying woods and rich habitats, which are vital for varied plants, fungi, insects and other native wildlife.

THREATS TO ANCIENT WOODLAND

Ancient woods are simply irreplaceable: the complex environment within these woods has built up over centuries, mostly left undisturbed by human development, allowing threatened species to thrive in a unique ecosystem. Once covering a vast area, ancient woods now encompass only 2.5 per cent of the UK, and much of this is under threat from development, impacted by air pollution or the encroachment of non-native plants. Restoration projects are underway through charities such as the Woodland Trust, removing non-native plants and other threats, to enable natural regeneration. Hopefully an ongoing effort will preserve these incredible habitats, and ensure magical bluebell walks for years to come.

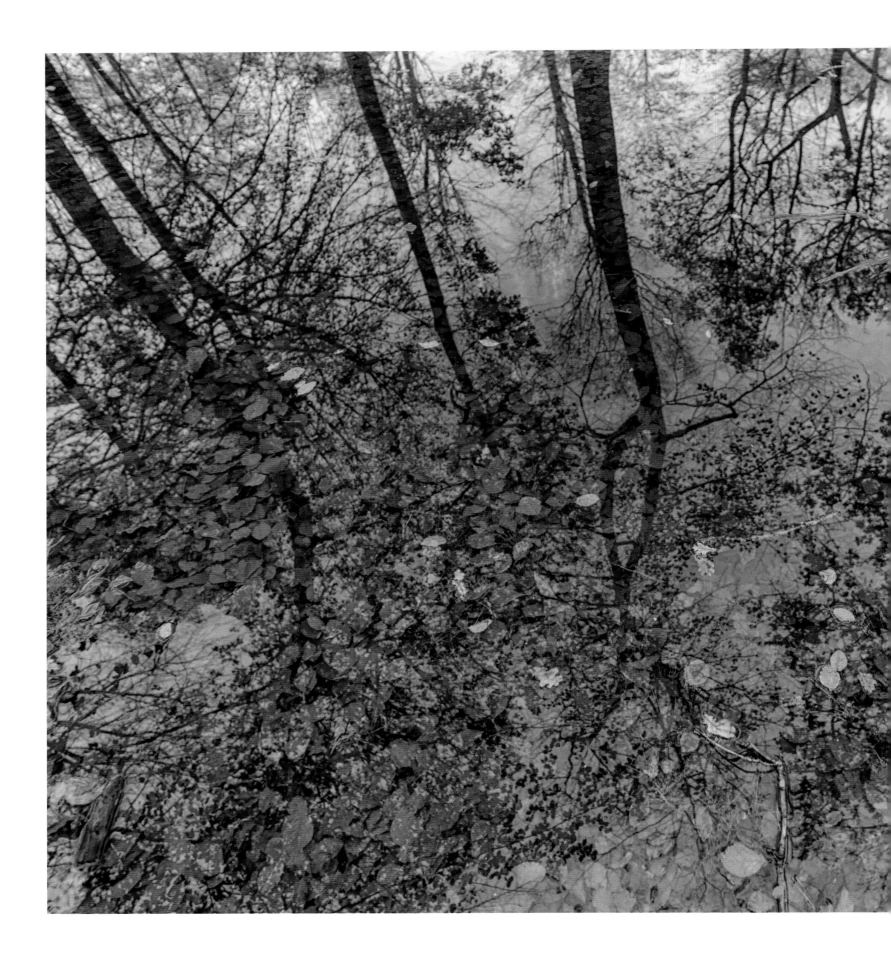

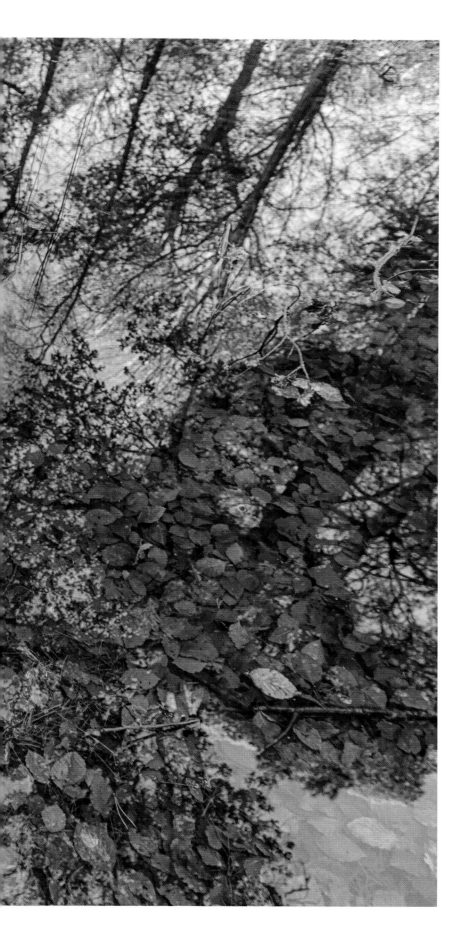

ASH & ENGLISH OAK

(*Fraxinus excelsior & Quercus robur*)

ASH

COMMON NAMES
Ash, common ash, European ash

FAMILY
Oleaceae

DESCRIPTION
A tall deciduous tree with a domed canopy of light green leaves, purple flowers in the spring and black, velvety buds in the winter.

HEIGHT
Up to 35m

Native

ENGLISH OAK

COMMON NAMES
English oak, common oak, pedunculate oak

FAMILY
Fagaceae

DESCRIPTION
Deciduous tree with broad crown and lobed leaves; catkins are followed by acorns

HEIGHT
20–40m

Native

Oak and ash trees are often found together in the quintessential woodlands of the UK lowlands.

The health benefits of trees and woodlands for humankind are now increasingly recognized; not simply in combatting air pollution and as a resource for physical exercise, but there is also a raised awareness of the mental health benefits of our forests. Woodlands provide a calm, restful environment that has been shown to relieve high blood pressure, as well as the symptoms of stress and depression.

The trees in our woodlands allow us the opportunity to connect with the natural world, observe wildlife and provide respite from a hectic modern world. The Japanese practice of *shinrin-yoku* (forest bathing) is one such method that embraces the concept of slowing down and spending time in a forest environment without distraction. This mindful activity encourages you to focus on the natural world around you, notice the sunlight filtering through the leaves and the sounds of birdsong from tree branches. The lowland forests of oak and ash tree as shown here in High Wood provide the perfect canopy for walking or sitting quietly and tuning into the natural surroundings.

'I am delighted how Adrian has captured and created this beautiful image of "Oak and Ash at High Wood". I believe we all have a natural affinity with trees and consider them my "great-grandparents". I love this picture with reflections of a turquoise autumnal sky, fresh leaves submerged in the still water with rich ochres, reds and browns to add to the atmospheric nature of his marvellous piece.

It is wise to enjoy shinrin-yoku, *the Japanese term for "forest bathing" and relishing the enriched oxygen and ozone that our trees provide every second of our lives, and which is scientifically proven to aid well-being.'*

PROFESSOR JOHN ROGERSON

THESE PHOTOGRAPHS of the reflection of the trees in a small flooded pond work well with the warm colours of the foliage. The fallen leaves' mixed hues give the picture a feeling of tranquillity on a cold winter day.

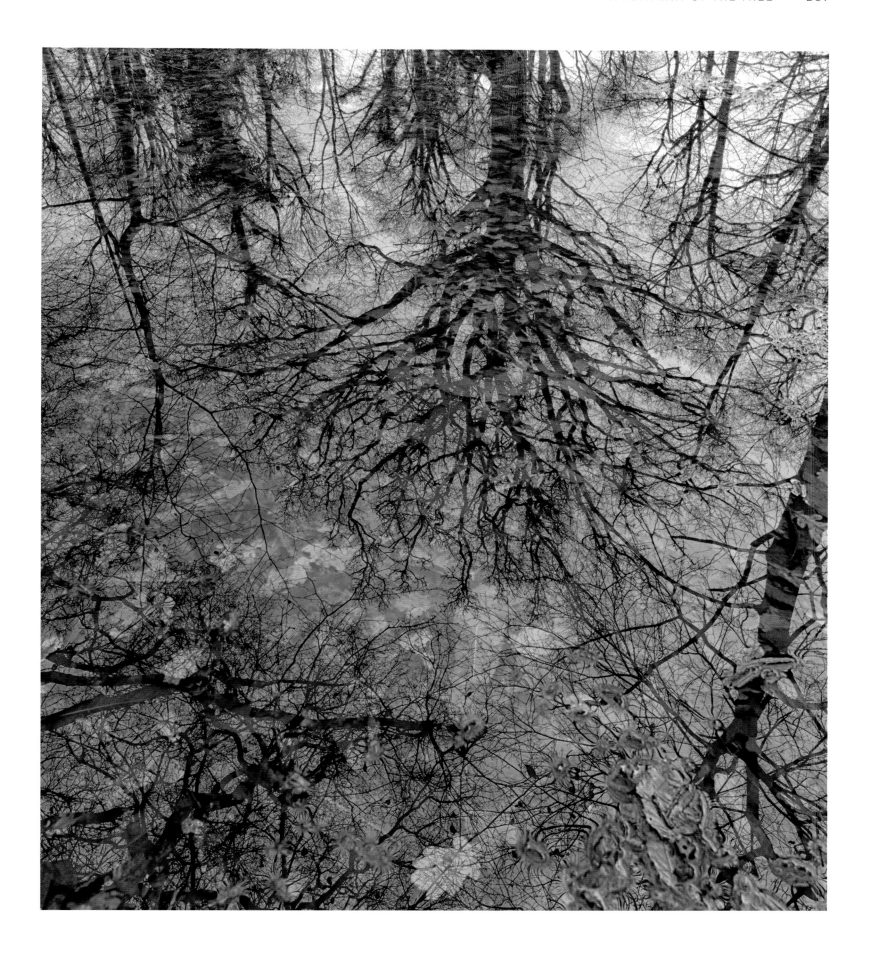

ENGLISH OAK

(*Quercus robur*)

COMMON NAMES
English oak, common oak, pedunculate oak

FAMILY
Fagaceae

DESCRIPTION
Deciduous tree with broad crown and lobed leaves;
catkins are followed by acorns

HEIGHT
20–40m

Native

Windsor Great Park dates back
to pre-Saxon times, and many of the
trees within the park have dominated
the landscape here for centuries.

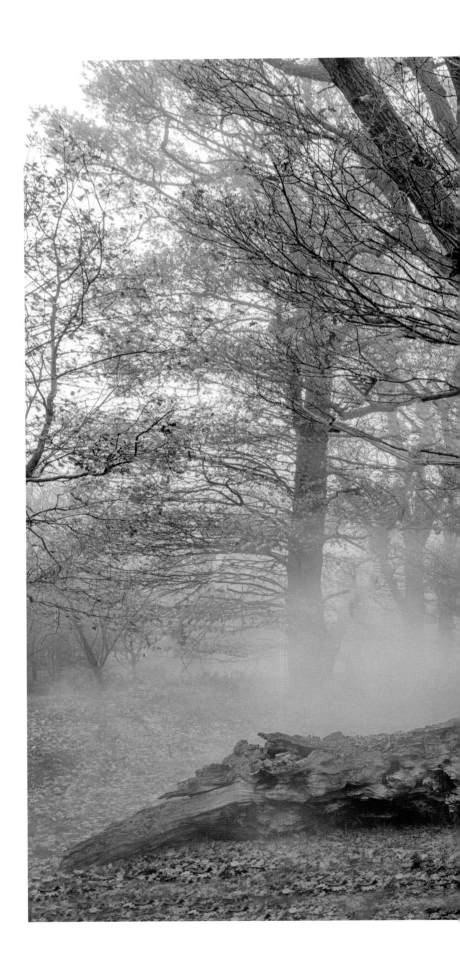

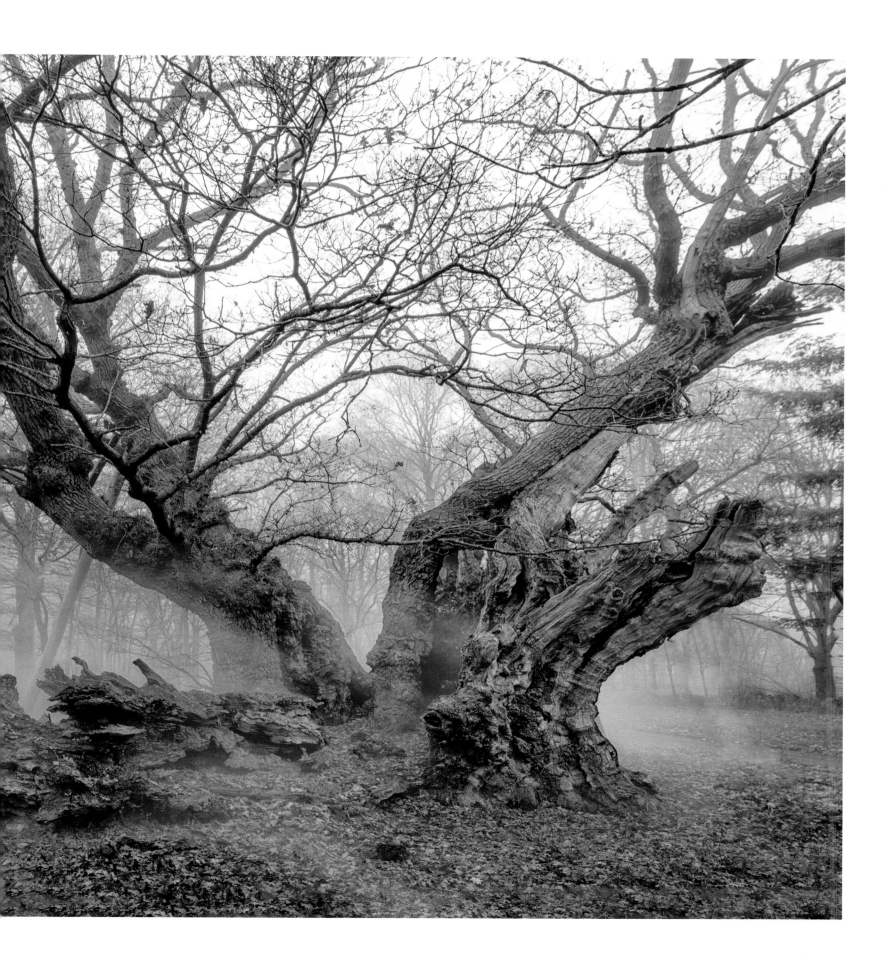

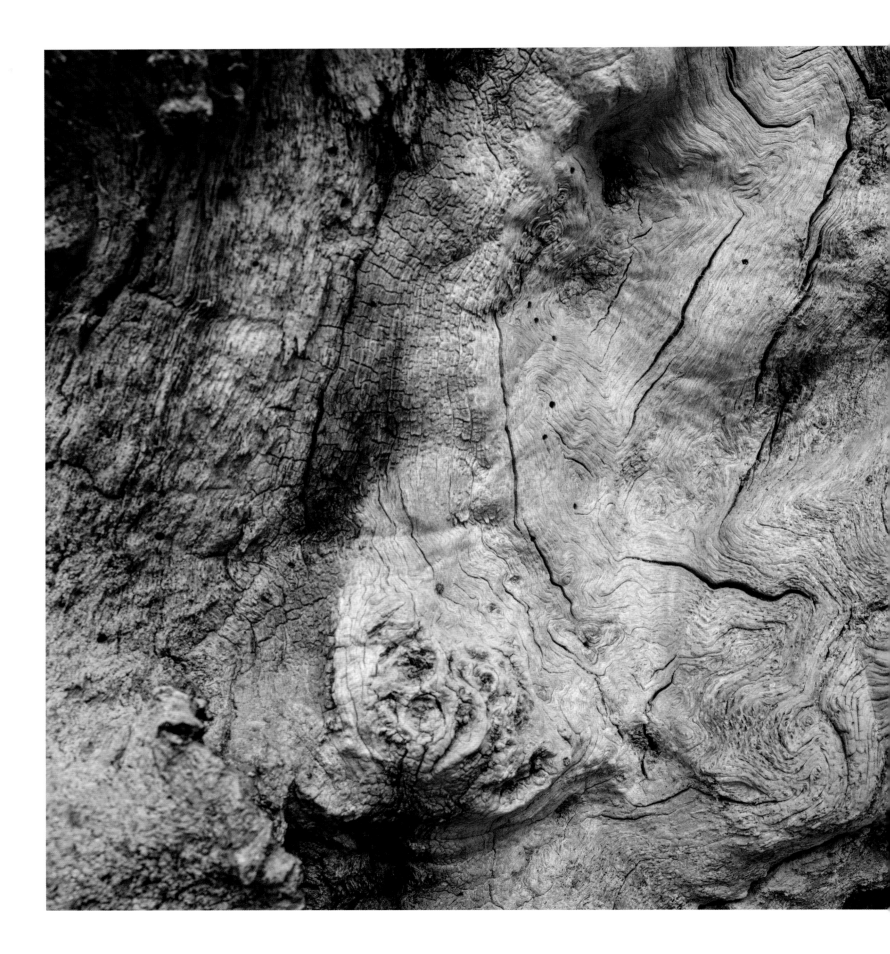

THE SPIRIT of this ancient oak is still very much alive, and it was truly rewarding to capture it.

With over 4,800 acres, Windsor Great Park is home to one of the largest collections of ancient and veteran oak trees in northern Europe, with many estimated to be between 500 and 1,000 years old. There are also over 125 trees in the park that have been awarded the status of Champion Trees by The Tree Register of the British Isles.

King Offa's Oak, which is situated in a private part of the park, is believed to be a staggering 1,300 years old. Perhaps Windsor Great Park's oldest oak, its trunk has long since split in two, but its twisted, gnarly form still grows, providing a rich habitat for invertebrate species and fungi. Indeed, Windsor Great Park is home to almost 2,000 species of beetle alone, many of which are endangered. Ancient trees such as this celebrated oak are invaluable in supporting these rare creatures.

'Standing in a private corner of Windsor Great Park is an oak tree, which some experts reckon is 1,300 years old. This means that the acorn from which it grew sent a little rootlet into the soil some time during the 8th century, when Offa, regarded by many as the most powerful Anglo-Saxon king before Alfred the Great, was ruler of a kingdom known as Mercia. Even as I write these words, I have to pause simply to take in their significance.

The only way to fully appreciate ancient trees like this is to be alone with them; to sit quietly in their shade, free from distractions and let your mind wander. I think about all the many billions of organisms to which this tree has given life and shelter, not to mention the tonnes of carbon it has plucked out of the atmosphere to build itself, and the millions of litres of oxygen it has produced in the process. So many English oaks were used to make the sturdy beams that held up the roofs over our heads or the great naval ships that defended our shores, it is a marvel that this one still exists.

King Offa's Oak is now much diminished through the onslaught of wind and rain and the centuries of slow decay brought about by fungi. But even in its dotage, parts of the crumbling body support some of our rarest invertebrates.

I have 20 healthy acorns from the crop King Offa's Oak produced last year and I am growing them in small pots filled with their native soil. This spring I will find out if any of them will emerge into the light. How different the world is now than when their parent started its life. One thing I am sure of is that we need these trees more than we ever did.'

DR GEORGE McGAVIN

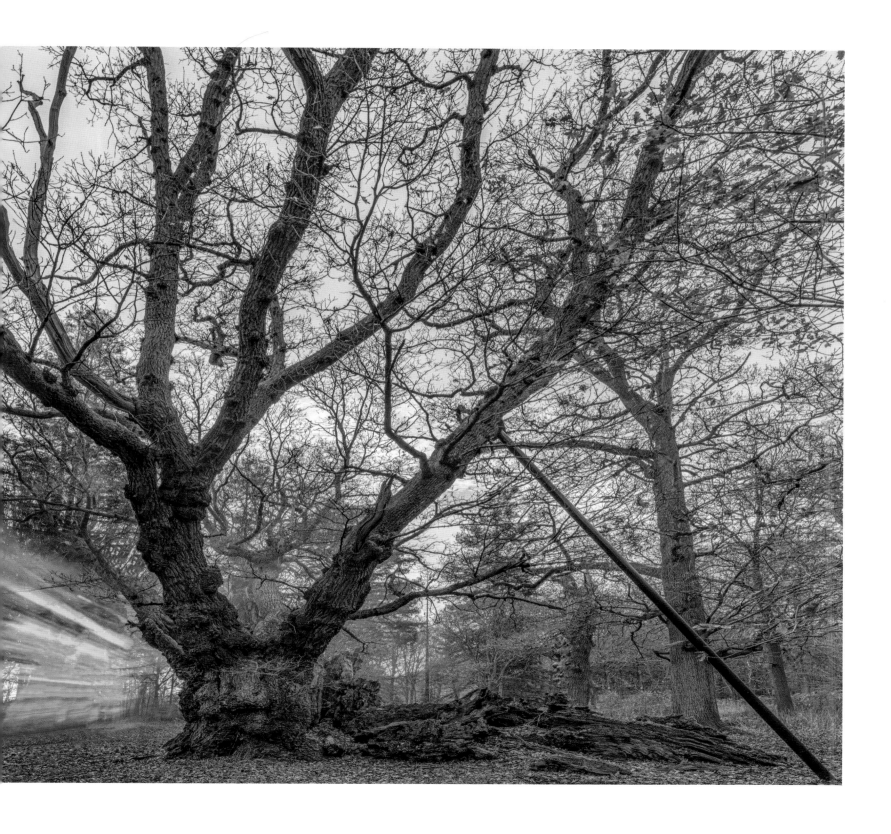

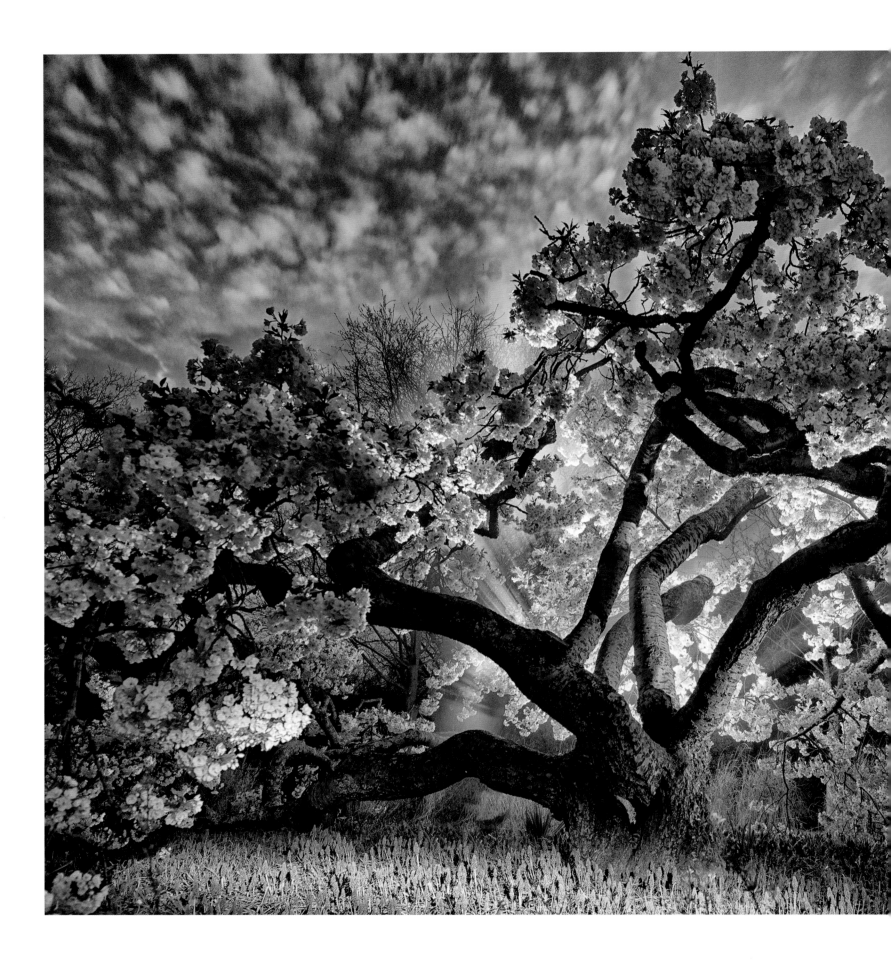

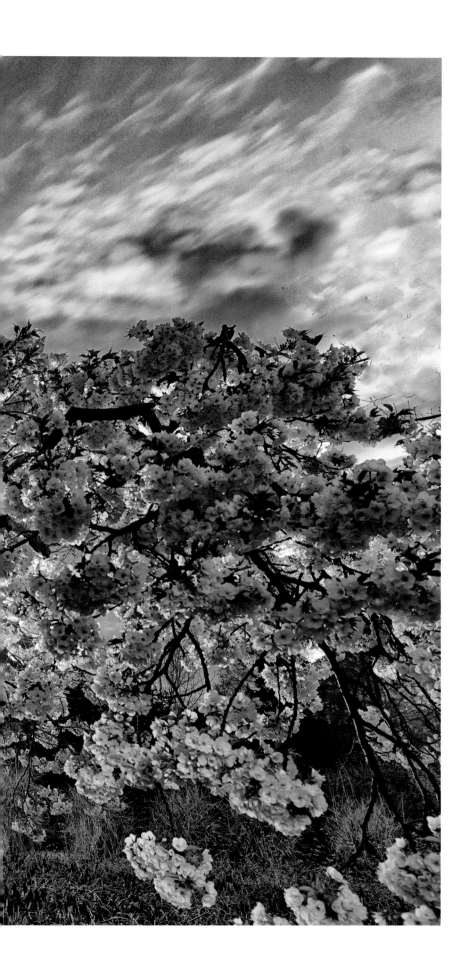

MOUNT FUJI CHERRY

(*Prunus* 'shirotae')

COMMON NAMES
Mount Fuji cherry, Kojima

FAMILY
Rosaceae

DESCRIPTION
A small deciduous tree with a weeping form;
blossoms are white; semi-double and bright
green leaves turn yellow/orange in autumn

HEIGHT
4–8m

Non-native

In its native Japan, cherry blossom is a symbol
of renewal and regeneration, bringing friends
and family together to plan for the year ahead.

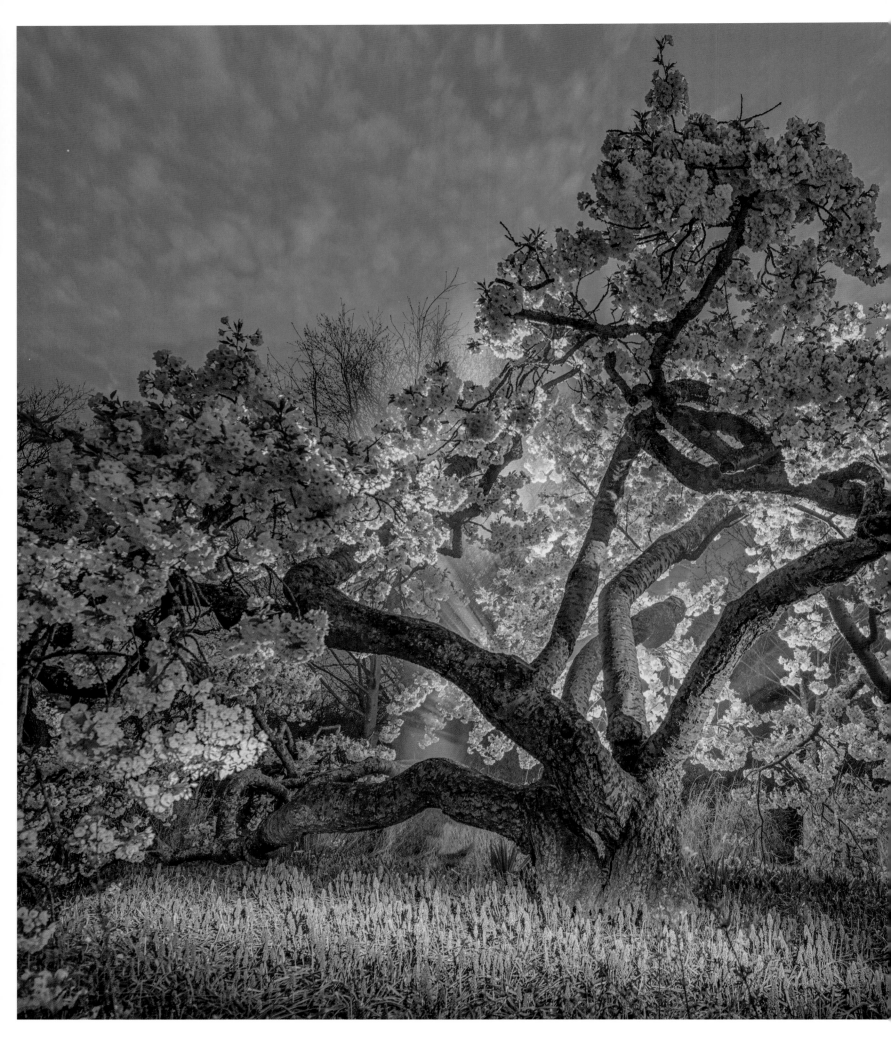

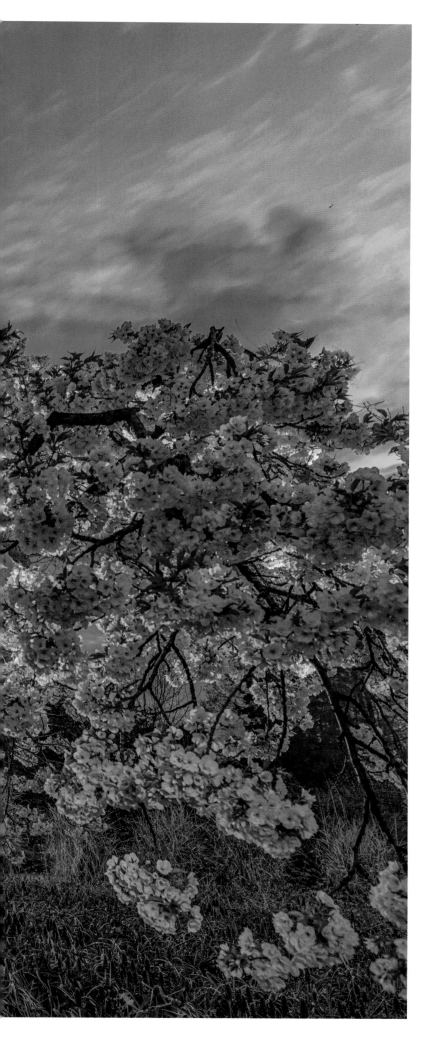

'The snow-white clusters of flowers which are seen in April are arguably the most appealing feature of the Mount Fuji cherry (Prunus 'shirotae'). However, with age, its broad habit and gently arching branches give this tree added stature, beauty and appeal. Older trees generally flower profusely and at a height where all can appreciate the intensity of flowering as well as being lured by their subtle fragrance. Its only then when you're close to the branches that you can appreciate the ruggedness and complexity of its bark and branch framework, and understand why a tree's beauty is so often enhanced by its age.'

JIM GARDINER

Donated to the Royal Horticultural Society in 1903 by Sir Thomas Hanbury, a wealthy Quaker, Wisley is its flagship garden. Set over 240 acres, Wisley is a paean to inspirational and bold planting, an ornamental garden with a reputation for outstanding horticultural displays. Of equal importance is Wisley's role in education. The Home of Gardening Science (opened in June 2021) and the School of Horticulture have been established there to train people for careers as professional gardeners.

On entering Wisley, visitors are treated to an avenue lined with Yoshino cherry trees, with pure white flowers and a light perfume in the spring, chosen for their beauty and resilience. The Mount Fuji cherry pictured here was around 60 years old when this photograph was taken. With its honey-scented white blossoms, it was a highlight in this glorious garden, located on Seven Acres adjacent to the lake. Japanese cherry trees are not long living, and this beautiful specimen has, sadly, subsequently died.

THE CHERRY blossom is always a sight to behold. What caught my eye about this tree was not only the blossom but also the *Muscari* (grape hyacinth) below the tree. With a mackerel sky behind, it makes for a dramatic combination of nature.

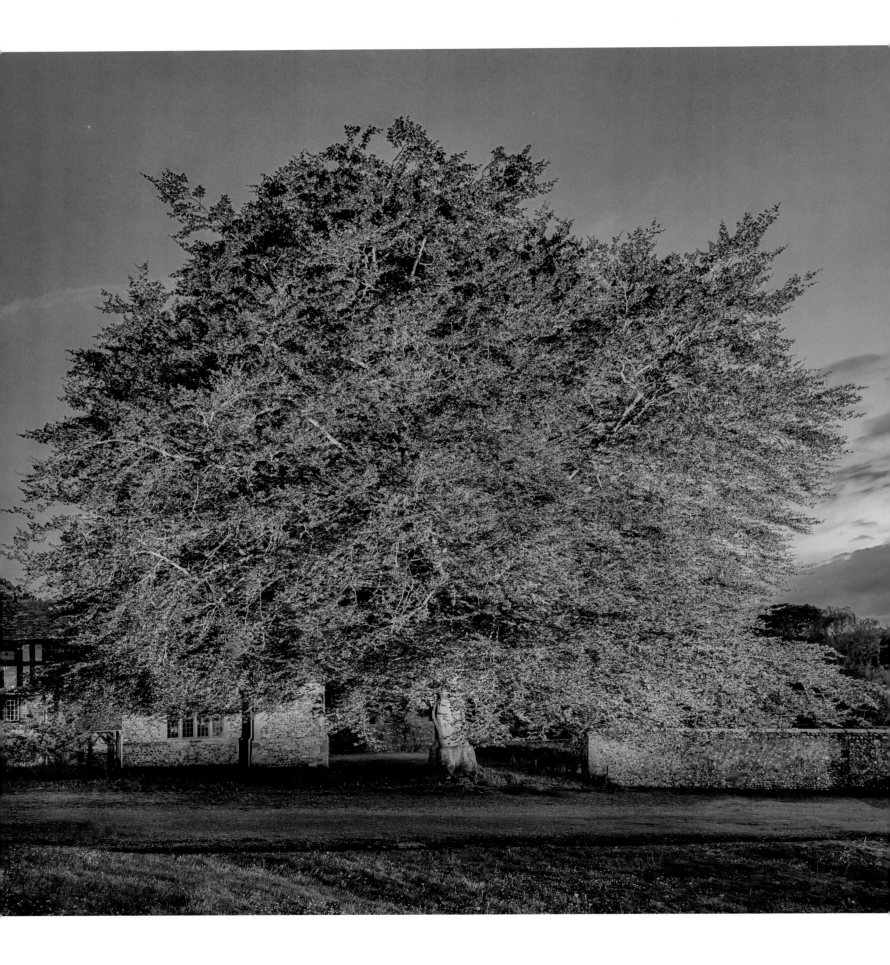

COPPER BEECH

(*Fagus sylvatica* f. *purpurea*)

COMMON NAMES
Copper beech, purple beech

FAMILY
Fagaceae

A cultivated form of common beech
with distinctive purple leaves

HEIGHT
Over 40m

Non-native

The copper beech has occurred as a natural variation of the
common beech in some parts of Europe from the 15th century.
In the UK, you may find a copper beech growing
among green common beech in woodland.

'Arriving at our place in Sussex my heart immediately lifts at the sight of the huge copper beech. The area is full of beech trees that love the chalky soil, but when this one is at its best, just in full leaf, with its perfect canopy and copper colour, it is truly majestic and very beautiful. When the sun hits copper beeches they glow and glisten, and standing beneath them you can't help but smile.'

OLGA POLIZZI, CBE

The copper beech growing at the edge of the drive to Olga Polizzi's house in East Sussex is at least 100 years old, and while she says that the tree is at its best in the spring as the light copper leaves start unfolding, Olga also loves the tree during the winter, when the 'rust-coloured leaves hold on for months in their wrinkled dry state, a burning bush in the Sussex countryside'.

The glorious colour of this magnificent tree has been bred into the tree as it is an ornamental cultivar, yet some copper beeches can occur naturally. While the reason behind this is unknown, some natural colour variation in beech trees does materialize, particularly in the south-east of England. Usually, this appears as one purple branch on a mature common beech, or a new sapling that produces mostly purple leaves rather than green.

Whatever the explanation is for this, the rich colour of the beautiful copper beech in any form is captivating. As Olga Polizzi notes, 'this wonderful out-stretching, joyous tree seems to welcome us as we arrive.'

IN MAY, the beech was turning into its full glory. It stands over the house, keeping it cool in the summer and sheltering it in the winter.

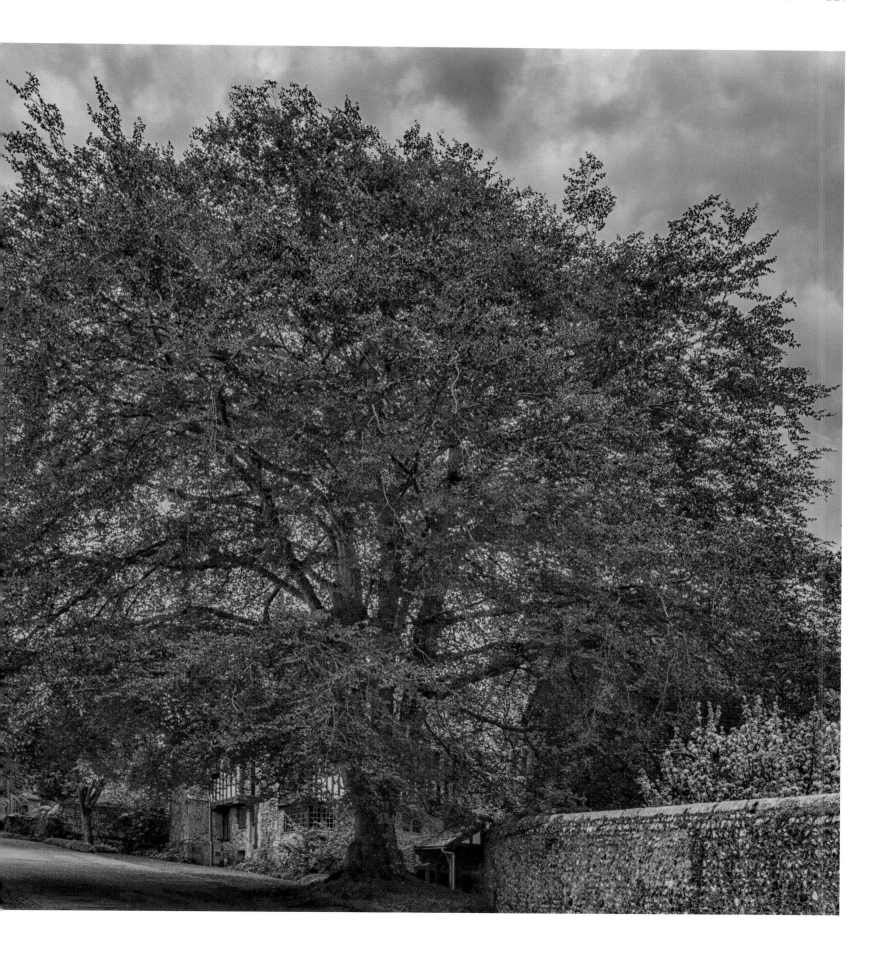

TURKEY OAK

(*Quercus cerris*)

COMMON NAMES
Turkey oak, Austrian oak

FAMILY
Fagaceae

DESCRIPTION
A deciduous broadleaf tree with dark
green leaves and distinctive acorns

HEIGHT
30m

Non-native

First introduced to the UK in the 1700s,
the Turkey oak has now become naturalized,
often found growing closely with the native
English oak and sessile oak.

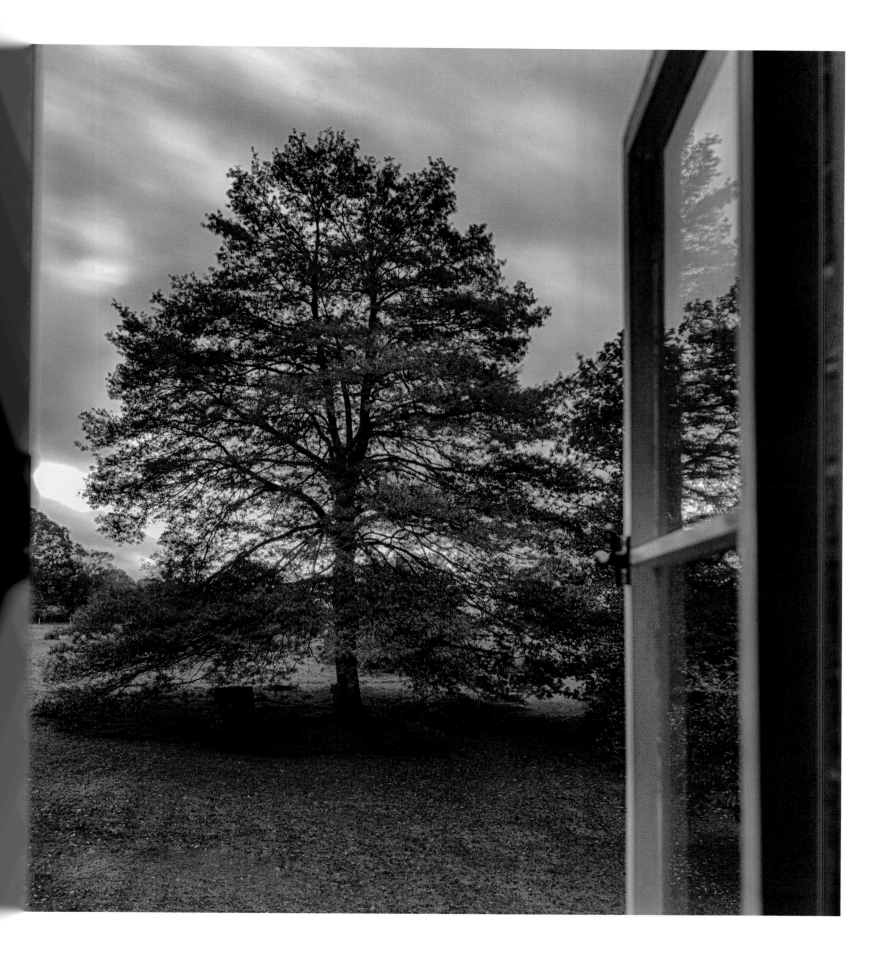

Widely cultivated in the UK since the 18th century in large gardens, parks and estates, the Turkey oak wasn't recorded in the wild until 1905. Distinguishable from the English oak by its distinctive acorns, which look like they are covered in shaggy moss, the Turkey oak is mainly used as an ornamental tree. With its long straight trunk, slender branches and unusual bark streaked with orange, the Turkey oak strikes an elegant note in many a garden, as seen here at the home of Timothy and Alison Stow, and their son, Richard.

A PEST PROBLEM?

Sadly, the Turkey oak is a host to the gall wasp, an insect that damages the acorns of the native oaks here in the UK, reducing their ability to reproduce. This detrimental impact to the native oak population means that Turkey oaks are planted less frequently these days and may need to be carefully monitored in the future to avoid aggressive colonization.

'Since we arrived at my parents' happy house in 1975, my bedroom has always been in the same place with a view out over the great turkey oak. It was a magical place for a young boy arriving from deepest suburbia to a house where the nearest road was half a mile away and we were completely surrounded by fields and ancient forests.

Dawn rises through its branches and on a misty day this can be breathtaking. It also marks the edge of some of the most beautiful parts of the woods where I loved to play, as my daughters do today. So do all the many animals living in the ancient place.

A lot has changed over the 57 years that we have been at the house, especially in the area outside my window. We have had ponds, orchards, pigpens, goose runs, croquet lawns and badminton courts. Currently it is the domain of my daughters' three pet Ouessant sheep who have learned to climb in its lower branches to steal yet more leaves.'

RICHARD STOW

WHEN I asked Richard Stow about his favourite tree, he explained that it was the turkey oak that he could see through his bedroom window. Framing this view was important. I wondered if the tree had been planted there for that very reason.

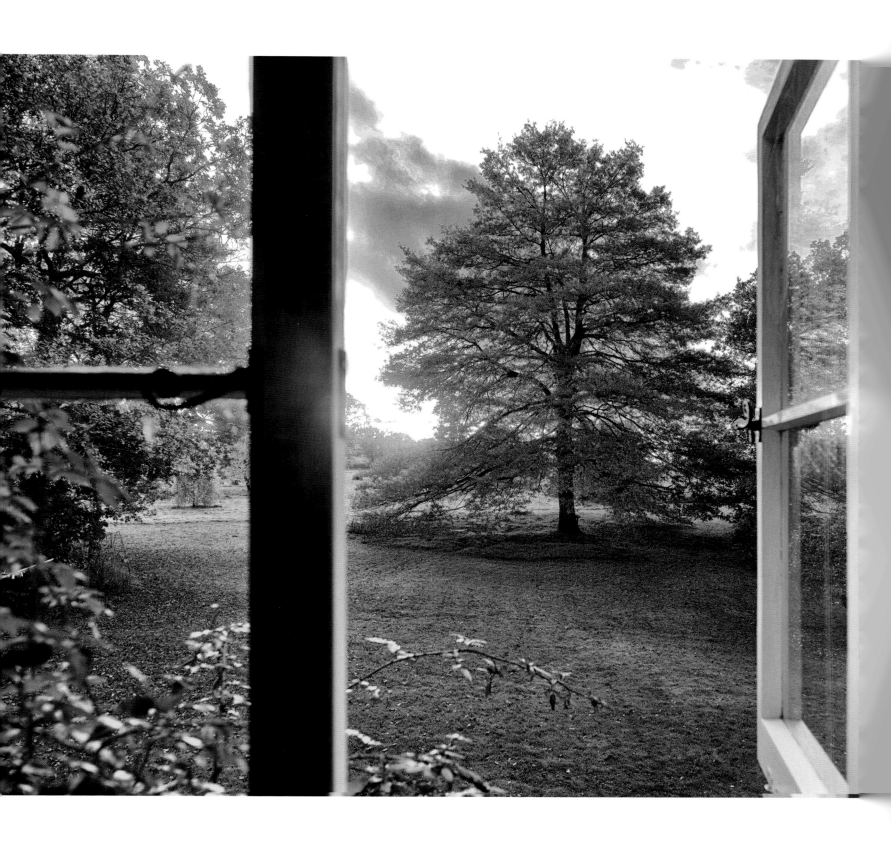

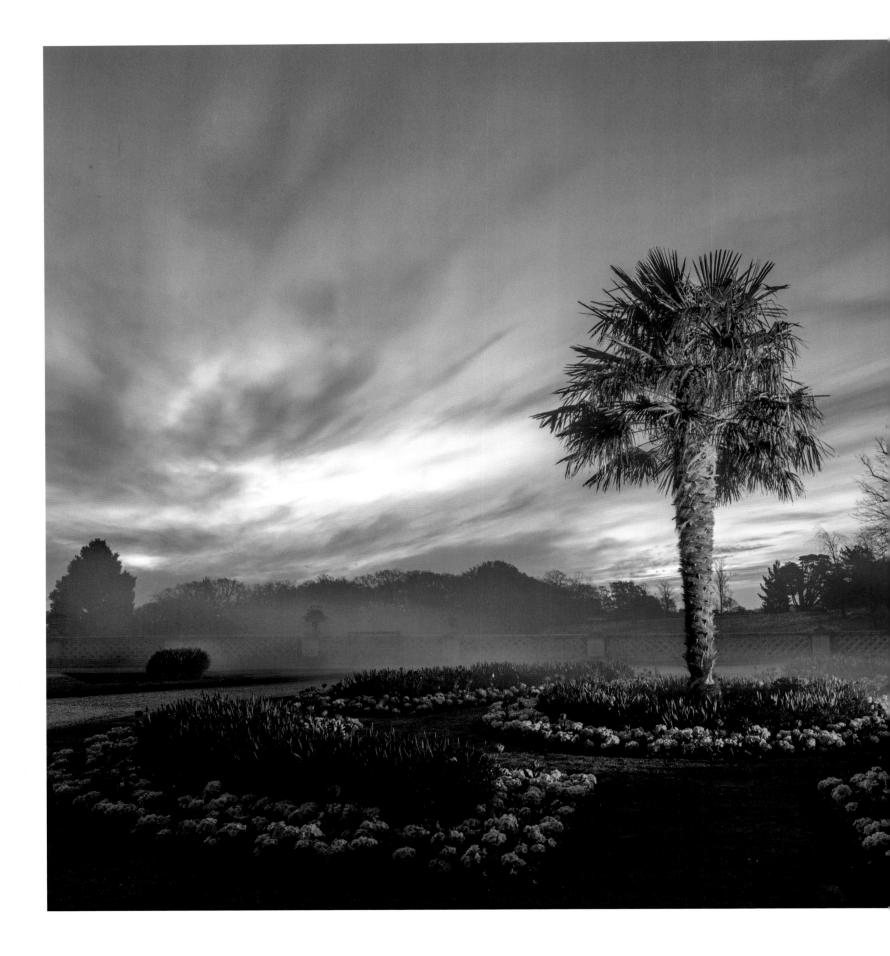

CHUSAN PALM

(*Trachycarpus fortunei*)

COMMON NAMES
Chusan palm, Chinese windmill palm, hemp palm,
Nepalese fan palm, windmill palm

FAMILY
Arecaceae

DESCRIPTION
An evergreen palm with fan-shaped dark green leaves
and large arching sprays of small yellow flowers

HEIGHT
Over 12m

Non-native

Introduced to the UK in 1843, at the height of
the Victorian plant-hunting period, the
Chusan palm has proved popular – a hardy
palm tree for the UK climate.

'If you go to Osborne House on the Isle of Wight, you will be able to submerge yourself into the world of Queen Victoria and Prince Albert. There are superb summer bedding schemes, great views down the sloping landscape towards the Solent and the Swiss Cottage with a kitchen garden where Prince Albert encouraged his children to grow fruits and vegetables. There are also hundreds of stately trees, many of them planted by kings, queens, princes and princesses during the time that Queen Victoria lived there. She died in the house in 1901, and shortly afterwards it was opened to the public courtesy of King Edward VII.

If you walk down the steps to the broad terrace in front of the house and turn to your right, passing underneath a wooden pergola, you will find in the centre of a flowerbed a towering specimen of the Chusan palm, Trachycarpus fortunei. It was planted by Her Majesty Queen Elizabeth II to celebrate the centenary of the garden being opened to the public. The Queen had an assistant in the operation. Me. Well, to be honest, and without impugning Her Majesty's horticultural prowess, I did the lion's share of the work as she looked on. Quite right, too. The tree was around 6 feet when we planted it 20 years ago. Now it must be 20-odd feet tall. Every time I see it, I feel a sense of pride, and have a memory of a wonderful day on an island where I now have a home and spend at least a third of the year. It is a magical place, and our tree – Her Majesty's and mine – is really rather special.'

ALAN TITCHMARSH, MBE

The Osborne Estate on the Isle of Wight was bought by Queen Victoria and Prince Albert in 1845 as a seaside retreat where they could escape from court life. As the existing house was too small, Prince Albert commissioned Thomas Cubitt to build a new palatial building, which was completed in 1851.

The gardens at Osborne were of equal importance as the residence to the royal couple, and Prince Albert personally supervised the design of the formal gardens around the house, as well as the parkland and pleasure grounds beyond.

The mild Mediterranean climate at Osborne allows for a rich variety of planting, including camellias, magnolias, the famous myrtle that has featured in the bouquets of many royal brides and a host of interesting trees, including the Chusan palm on the lower terrace. This magnificent specimen, planted in 2004, is a direct descendant of the Chusan palm planted here by Queen Victoria in 1851, a gift from King Ferdinand of Portugal.

THE SYMMETRY of this palm and flower beds with Queen Victoria's summer home in the background is what struck me at first sight.

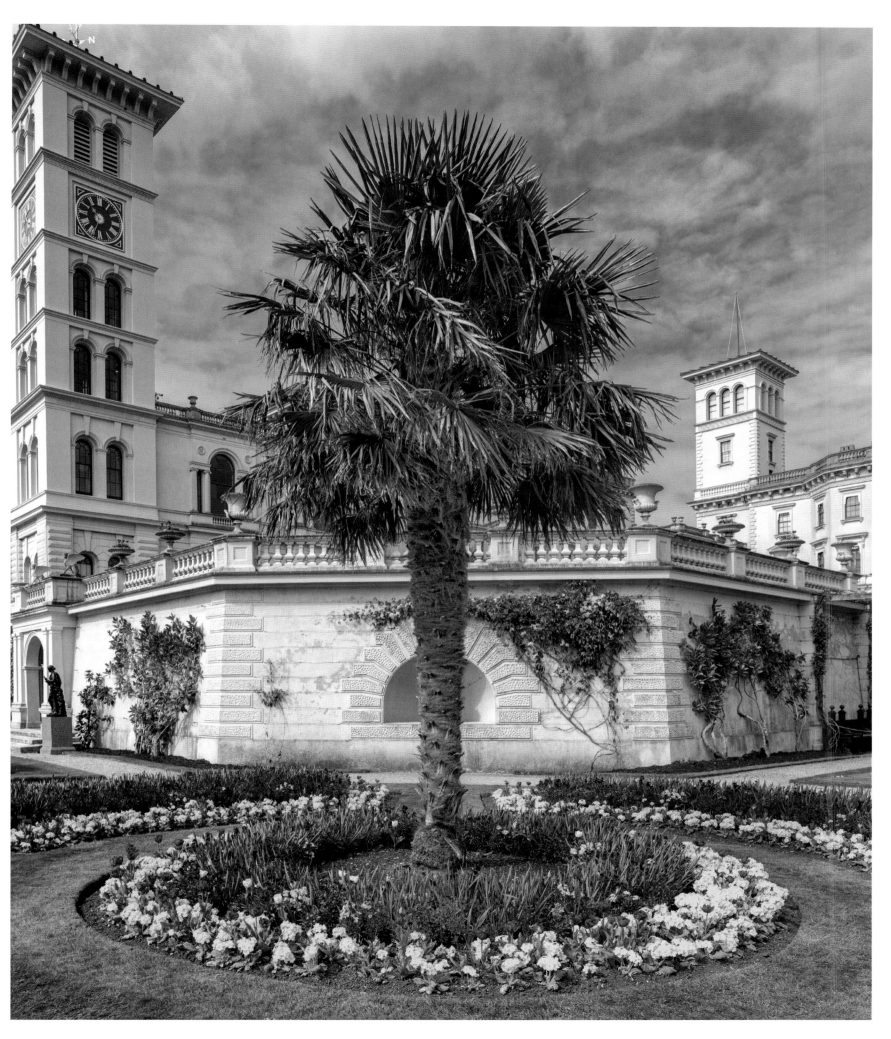

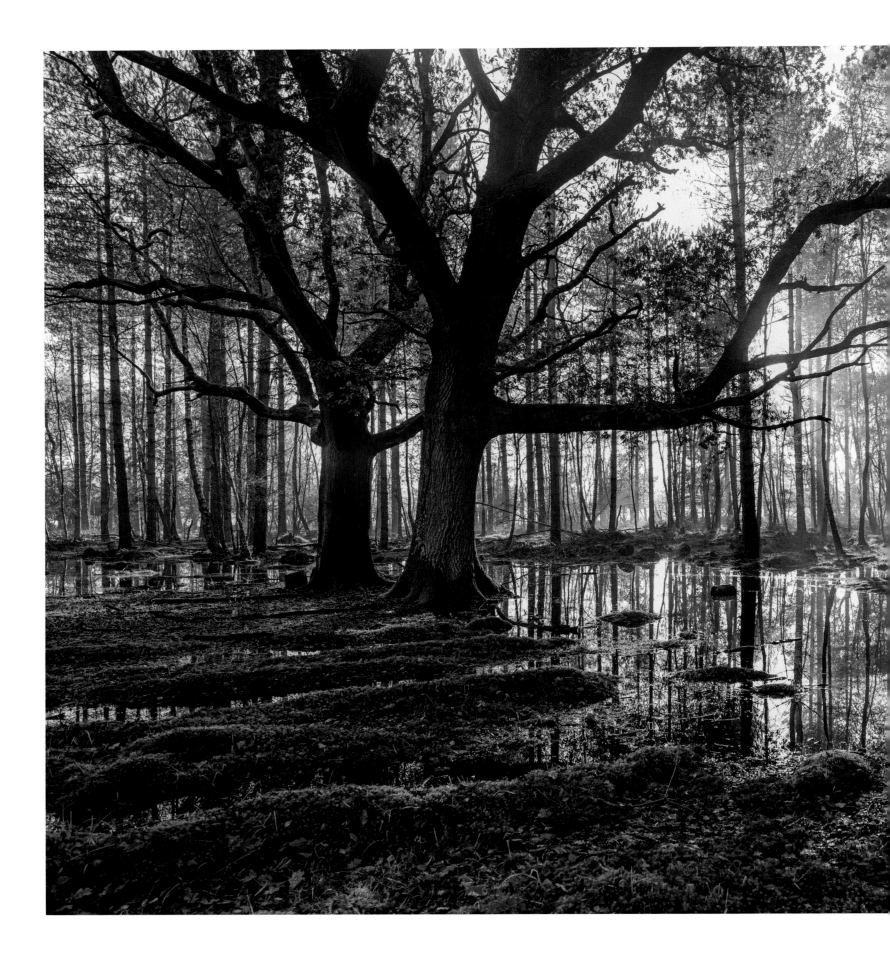

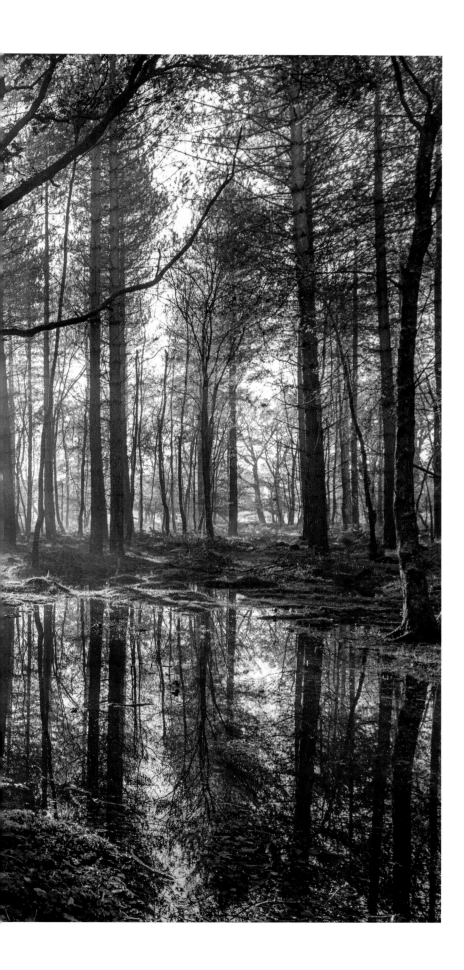

ENGLISH OAK

(Quercus robur)

COMMON NAMES
English oak, common oak, pedunculate oak

FAMILY
Fagaceae

DESCRIPTION
Deciduous tree with broad crown and lobed leaves;
catkins are followed by acorns

HEIGHT
20–40m

Native

Woodland cover in the UK currently represents
13 per cent of total land area, up from 5 per
cent in 1919 after large-scale deforestation
during the First World War.

'*The New Forest is one of the last remaining unenclosed pasture lands in south-east England. Once proclaimed the playground of William the Conqueror, today it remains a habitat for many rare birds.*

In this photograph, the way the light shines through the trees with the oaks silhouetted is mesmerizing. This beauty and tranquillity have stayed with me ever since I walked through the New Forest for the first time. One of the best therapies one can have is a simple walk in the forest gazing at the trees.'

JORI WHITE

The New Forest's ancient woodlands are home to many age-old trees and are reputed to house the highest concentration of ancient trees in western Europe. Some of the oldest here, perhaps, are the English oaks, and among the most long-established are the Knightswood Oak, the Eagle Oak and the Adam Oak. Indeed, the Knightswood Oak, also known as the Queen of the Forest, is believed to be around 600 years old and, according to legend, once provided shelter to Henry VIII during a deer hunt.

As well as supporting a variety of flora and fauna, the veteran trees of the New Forest provide a natural calmness and quietude that are a balm for the senses. Trees have long held a deep cultural and emotional significance for people, and these immense English oaks of the New Forest, full of wisdom and charisma, call to mind the words of Robert Louis Stevenson from his *Essays of Travel*, 'It is not so much for its beauty that the forest makes a claim upon men's hearts, as for that subtle something, that quality of air that emanation from old trees, that so wonderfully changes and renews a weary spirit.'

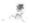

THE FOREST floor in late October reflected the autumn colours against the vibrant green moss, emanating the beauty of nature.

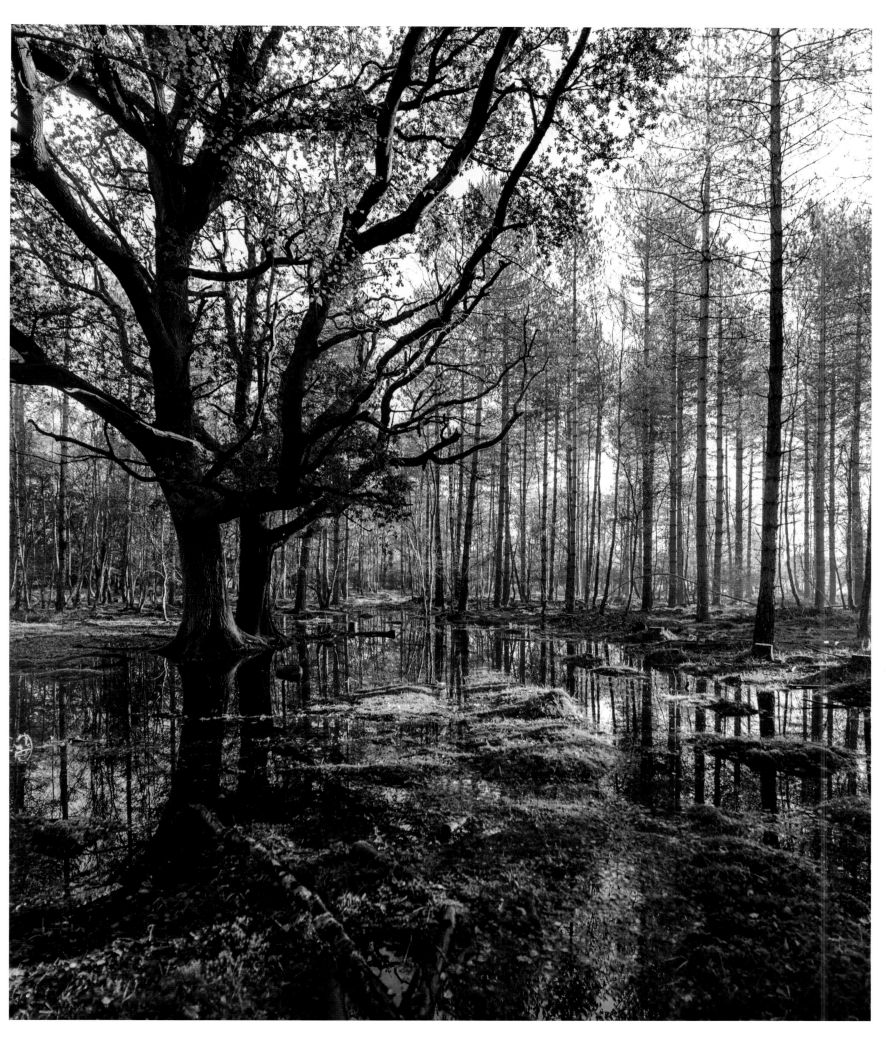

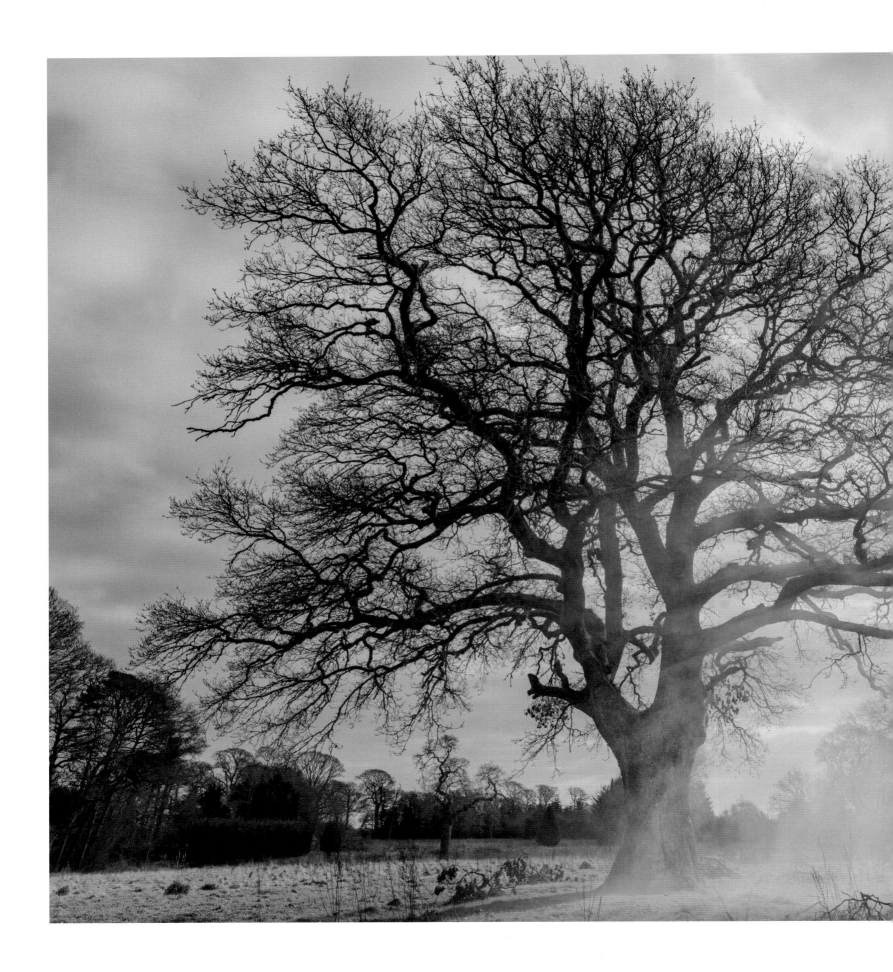

ENGLISH OAK
(*Quercus robur*)

COMMON NAMES
English oak, common oak, pedunculate oak

FAMILY
Fagaceae

DESCRIPTION
Deciduous tree with broad crown and lobed leaves;
catkins are followed by acorns

HEIGHT
20–40m

Native

With its sturdy, often low-hanging branches,
the English oak has been adored by adventurous
tree-climbing children down the generations.
The most famous climber must surely be
Charles II, who famously hid from his pursuers
in the branches of an oak tree following the
Battle of Worcester in 1651.

The formidable English oak tree, which grows up to 40 metres tall and has broad, strong branches that spread out beneath its crown as it matures, must surely be one of the best trees to climb. With research showing that allowing children to climb trees helps them to develop socially, physically and creatively, and with increased resilience, it seems that getting up close to nature in this way can be truly beneficial.

It's something that inspired four-time World Tree Climbing Champion Josephine Hedger from a young age, when she was captivated by this magnificent oak tree that stands on land owned by her father in Hinton, Hampshire, where she grew up from the age of four. 'It stands with an adjacent oak in the middle of a field, where my father used to keep red deer. I spent a lot of time there as a child. It has a traditional shape and form and is a perfect example of an English oak. I have admired it ever since I was a child.'

While the lack of low branches in the tree meant that Josephine never managed to climb it as a child, this particular oak was never far from her mind: 'When I became an arborist it was a tree I wanted to climb – to be the first person to sit at the very top. Knowing that this had potentially stood here for 350 years and was virgin territory was a unique feeling – knowing that I was the first person to be privileged to climb to the very top.'

'*When I started competing in tree climbing competitions I spent time in this tree, learning to run and swing along its huge limbs. It taught me a lot and I am close to the tree, knowing it helped me to achieve four World Tree Climbing titles.*

In 2016 I got married and we had a blessing in the tree, with a large group of friends and family present to witness our love for this tree. I would like to share this tree's beauty with others, who can admire its large strong structure.'

JOSEPHINE HEDGER

THIS OAK has been climbed many times, so it has probably had more human contact than most trees. Seeing its structure in the winter months was key to this photograph.

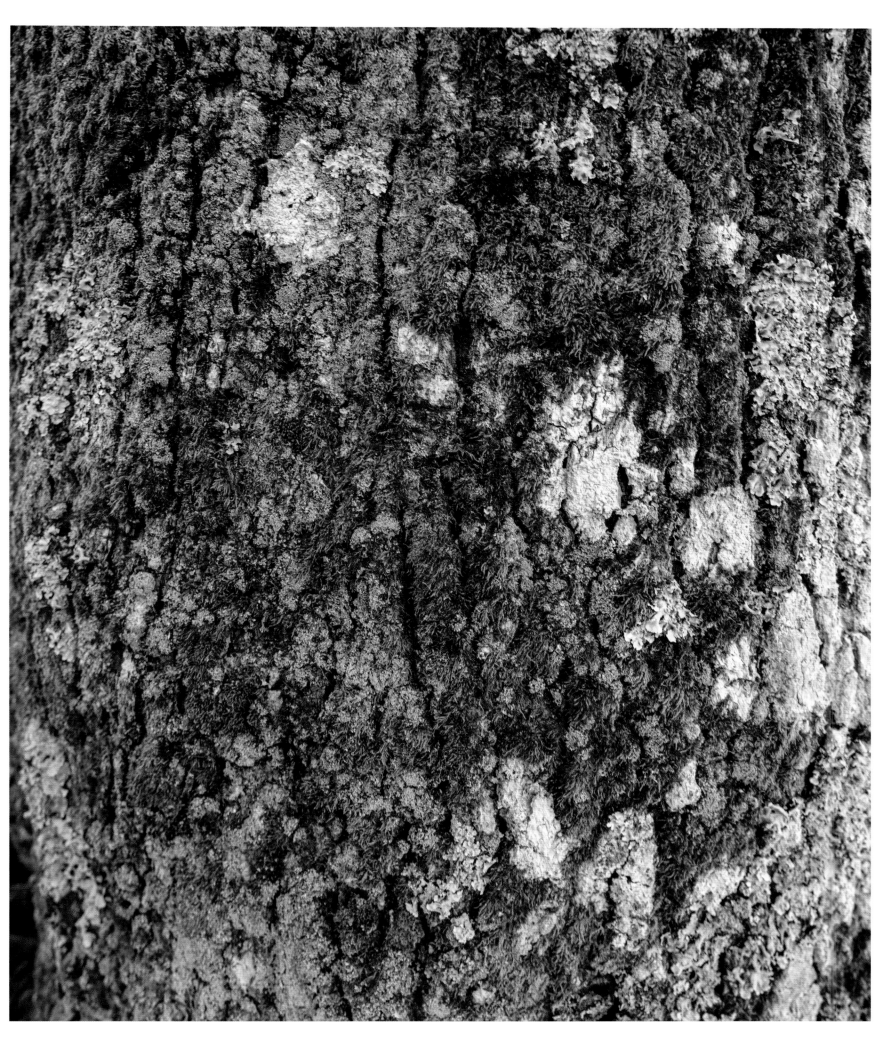

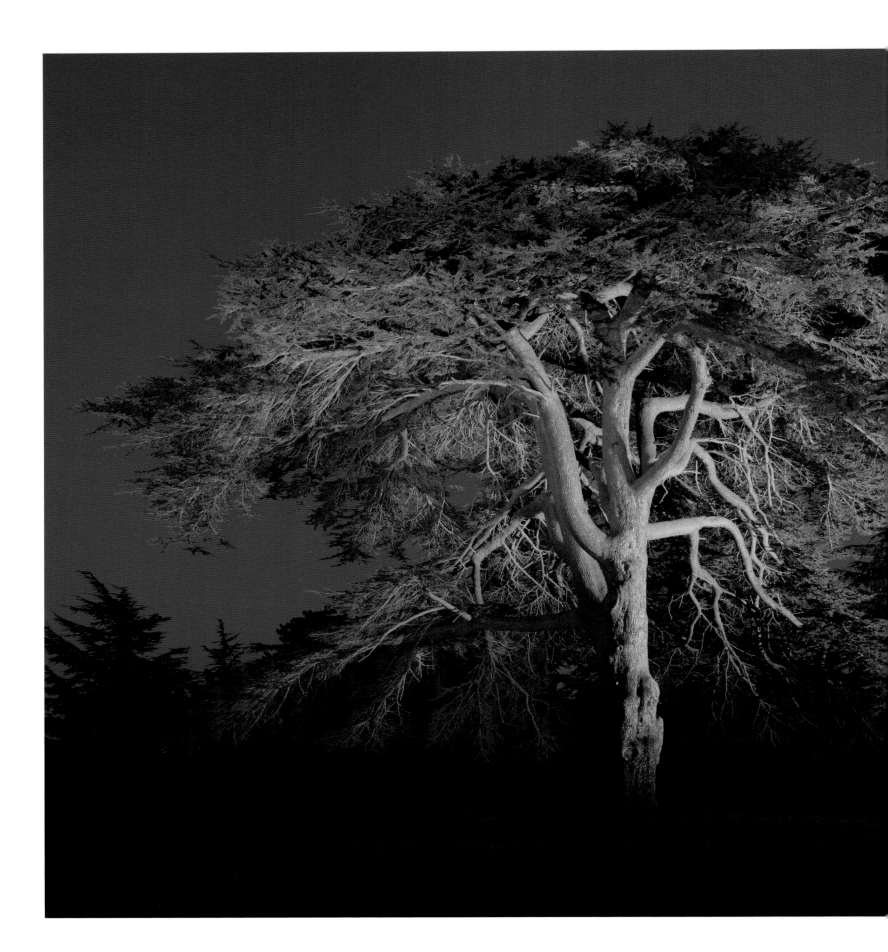

CEDAR

(Cedrus libani)

COMMON NAMES
Cedar, cedar of Lebanon, Lebanon cedar

FAMILY
Pinaceae

DESCRIPTION
Evergreen conifer with a wide canopy of layers
of branches; foliage made up of green-grey
needles, with barrel-shaped cones in winter

HEIGHT
Up to 35m

Non-native

The symbol of Lebanon, found at the heart of
the national flag, this gigantic member of the pine
family became a much-prized feature of 18th-century
English stately gardens – and continues to
dominate these landscapes today.

'Cedars of Lebanon are the iconic trees dominating the 18th-century landscape of Highclere Park. They have a timeless beauty whatever the season and can look majestic in high summer or when covered in frost in mid-winter. They complete the story in the towering vision landscapes of the 18th-century landowners whose foresight we enjoy today, but these trees also remind us of the very beautiful country from whence they came and all the war-torn sorrows of Lebanon and the wider region.'

LORD CARNARVON

Exploring the historic Highclere Castle, visitors may find the grand surroundings strangely familiar. If you're wondering why you recognize the sweeping oak staircase or the state dining room, the answer may be found in your primetime TV viewing. The impressive home of the Earl and Countess of Carnarvon served as the setting for the highs and lows of the fictional Crawley family in Julian Fellowes' *Downton Abbey*.

The 1,000 acres of sweeping parkland that surround the castle also featured in the television drama, providing a suitably imposing backdrop to the family strife and high drama. The 18th-century park was masterminded by much-renowned landscape gardener Capability Brown, and today is dominated by the majestic cedar trees, so in vogue at the time that Brown planted them over 150 years ago.

Members of the pine family, cedars of Lebanon are slow growing, reaching maturity at around 50 years. It is not until this point that they take on the shape of their unique multi-layered canopy. The grey-green giants at Highclere are well established, and tower over the parkland, spreading their pine-needle branches out wide in a tiered skirt around the main trunk, complete with aromatic scent from the large, barrel-shaped cones.

A hardy tree able to withstand harsh conditions, the cedar has traditionally been a symbol of incorruptibility and eternal life. However, these trees are facing new challenges in their native home of Lebanon as climate change limits their natural growing territory and introduces new threats from insect infestations. The importance of these trees was recognized by UNESCO in 1998 with the designation of the Forest of the Cedars of God (Horsh Arz el-Rab), north Lebanon, as a World Heritage Site. This ancient forest is one of the few sites where this species still grows; of many thousands of square miles of forest that once flourished in the region, only 6½ square miles remain.

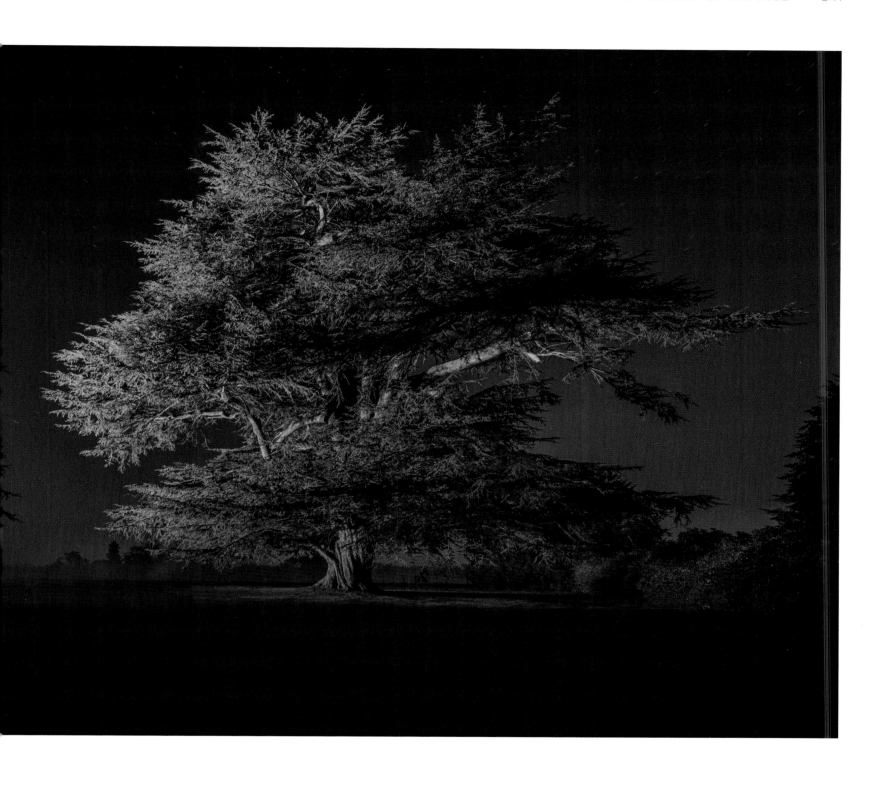

THESE BEAUTIFUL cedars were photographed at dusk to bring out their stately presence.

FIELD MAPLE

(Acer campestre)

COMMON NAMES
Field maple

FAMILY
Sapindaceae

DESCRIPTION
Sturdy broadleaf tree with five-lobed
leaves and large winged fruits

HEIGHT
Up to 20m

Native

The only maple tree native to the UK, the field
maple is particularly striking in the autumn, when
its large lobed leaves turn a rich golden colour.

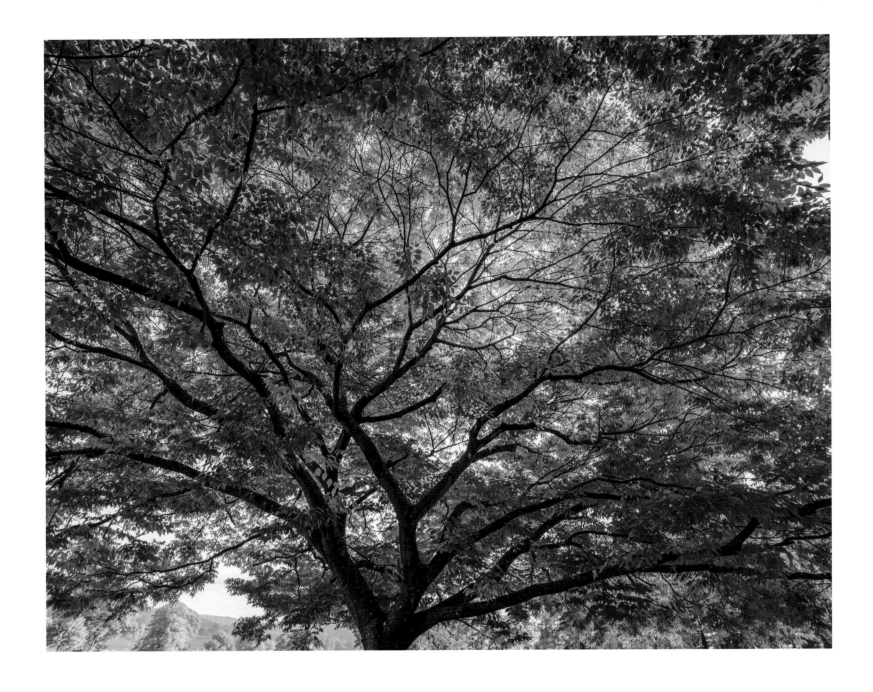

LOOKING UP into a field maple as all
the autumnal colours are beginning to
shine through is a wonder in itself.

'*The field maple at Wardour Castle was in fruit when I first saw it. The little helicopter wings immediately took me back to my childhood, when we would stick them on our noses as horns or watch them twirl down to the ground in their dizzying dance. It was the first time I remember being struck by the magic of nature's myriad engineering.*

This particular tree always reinforces that magic. How incredible that the branches can reach so far without falling – wings stretching to protect all within and beneath it. How deeply rooted she must be to allow for such gracious capacity. My favourite time to enjoy her splendour is in the autumn when she stands in golden glory, daring me to give everything a bit more of a push before winter draws in, and I with it.'

IZZY WINKLER

Built in the 14th century by Lord John Lovell, the once resplendent Old Wardour Castle in Wiltshire is, sadly, now a ruin, but it is still impressive to see today. Having been acquired by the influential Arundell family in 1547, the castle survived the English Civil War and two sieges before it was finally abandoned for New Wardour Castle, which was built approximately a mile away.

Old Wardour Castle was left as a ruin and integrated into the surrounding parkland of New Wardour Castle as a picturesque centrepiece of the new formal garden and woodland. Visitors to the castle today will find many mature trees in the grounds, including the field maple, which can live for up to 350 years. While the field maple is relatively small and unassuming, it has the hardest timber of all European maples and as such is traditionally used in wood-turning and carving. It is also particularly attractive to aphids and, therefore, a very useful tree for their predators, such as ladybirds, hoverfly and many bird species.

COPPER BEECH

(Fagus sylvatica f. purpurea)

COMMON NAMES
Copper beech, purple beech

FAMILY
Fagaceae

DESCRIPTION
A cultivated form of common beech
with distinctive purple leaves

HEIGHT
Over 40m

Non-native

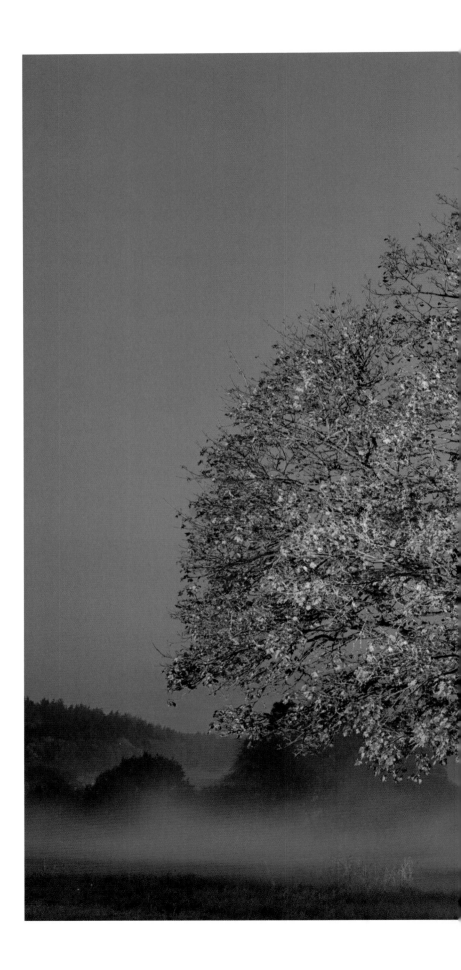

The oval leaves of the copper beech are a
deep purple colour in the spring yet turn to
a glorious burnished copper in the autumn.

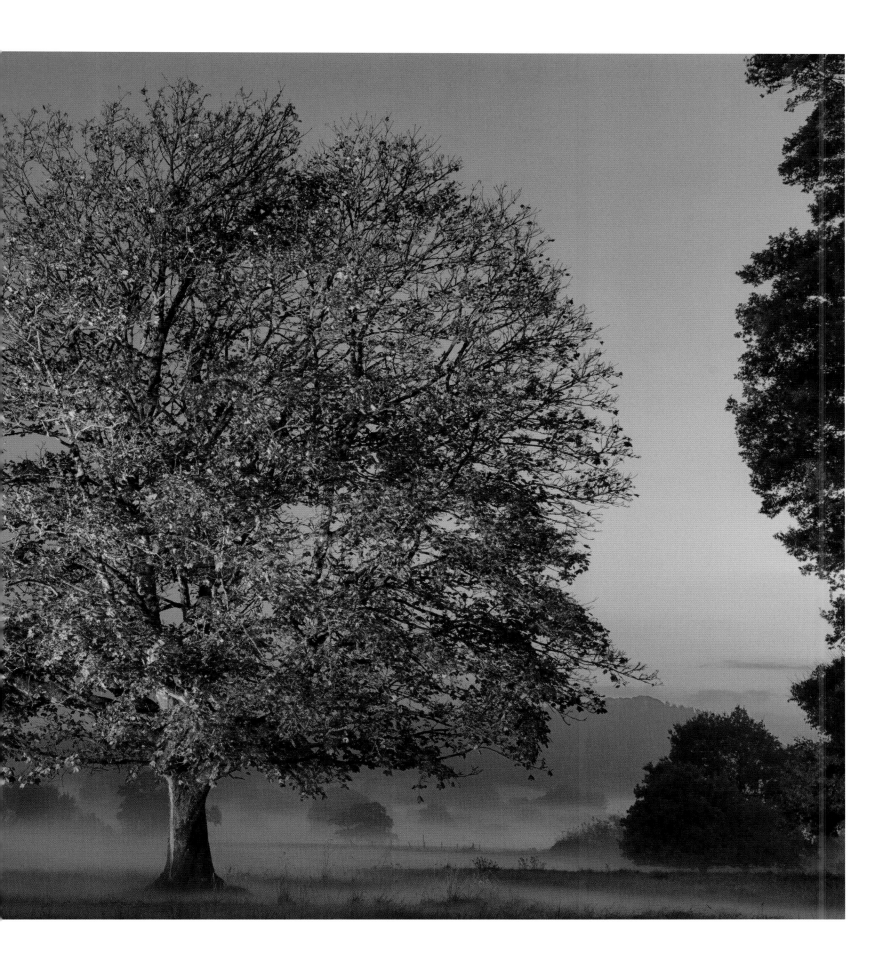

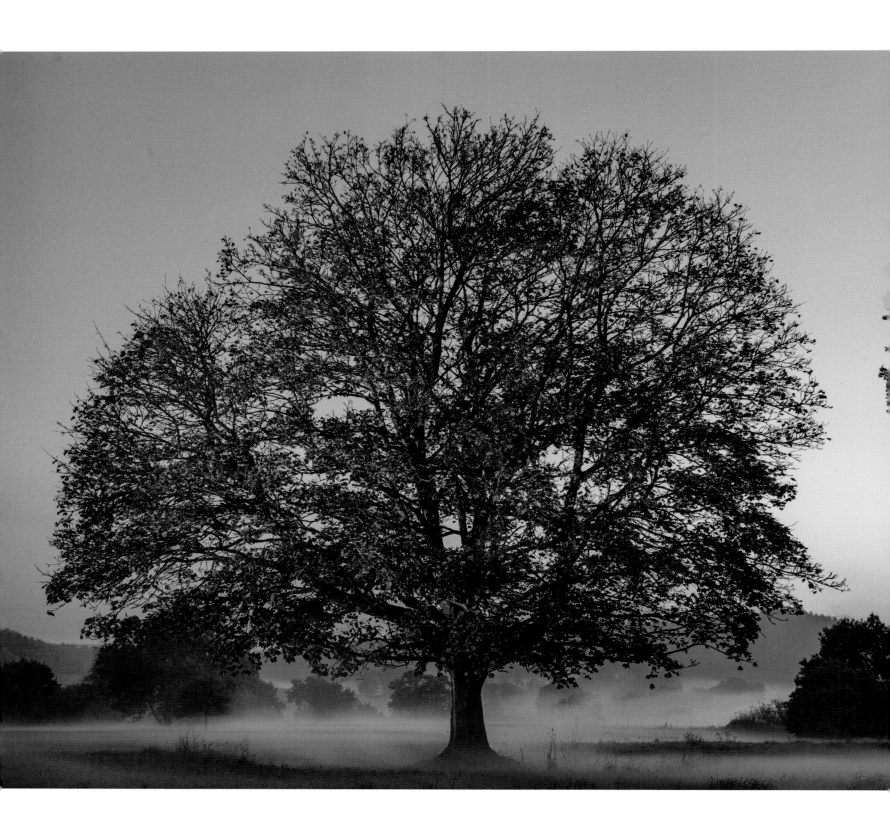

'This tree lies conveniently about 20 metres outside my bedroom window, so it is the first and last thing I see during the day. Through the dark winter months, its bare branches make up a rather satisfying shape against cold blue skies, then when spring comes the leaves go quickly from green to a rich deep red – this is the period when I sit under it and contemplate the horizon. Finally in the autumn it produces a prolonged firework display of reds, oranges, golds and browns which are sensationally beautiful. This is nature at its best for me.'

JASPER CONRAN, OBE

New Wardour Castle was built by the Arundell family in the late 18th century as a replacement for their former residence, Old Wardour Castle, which had been rendered uninhabitable after the English Civil War (see page 234). Designed by the noted English architect James Paine, this spectacular Grade I-listed country house was built in the Palladian style, with strong emphasis on the classical temple architecture of the Ancient Greeks and Romans. Its most notable feature is its impressive rotunda staircase, which measures 144 feet across.

The gardens at New Wardour Castle include the remains of the medieval castle and are set within a medieval deer park. Noted landscape designer Richard Woods created the formal gardens, with input from Capability Brown in the 1770s. While the New Wardour Castle is now privately owned, the grounds are open via public footpaths. Visitors today will discover many mature trees in the scenery here, including the dramatic copper beech with its purple leaves.

SET IN a parkland created by Capability Brown, this copper beech, with its autumn leaf, radiates in the early evening twilight as the mist descends over the landscape.

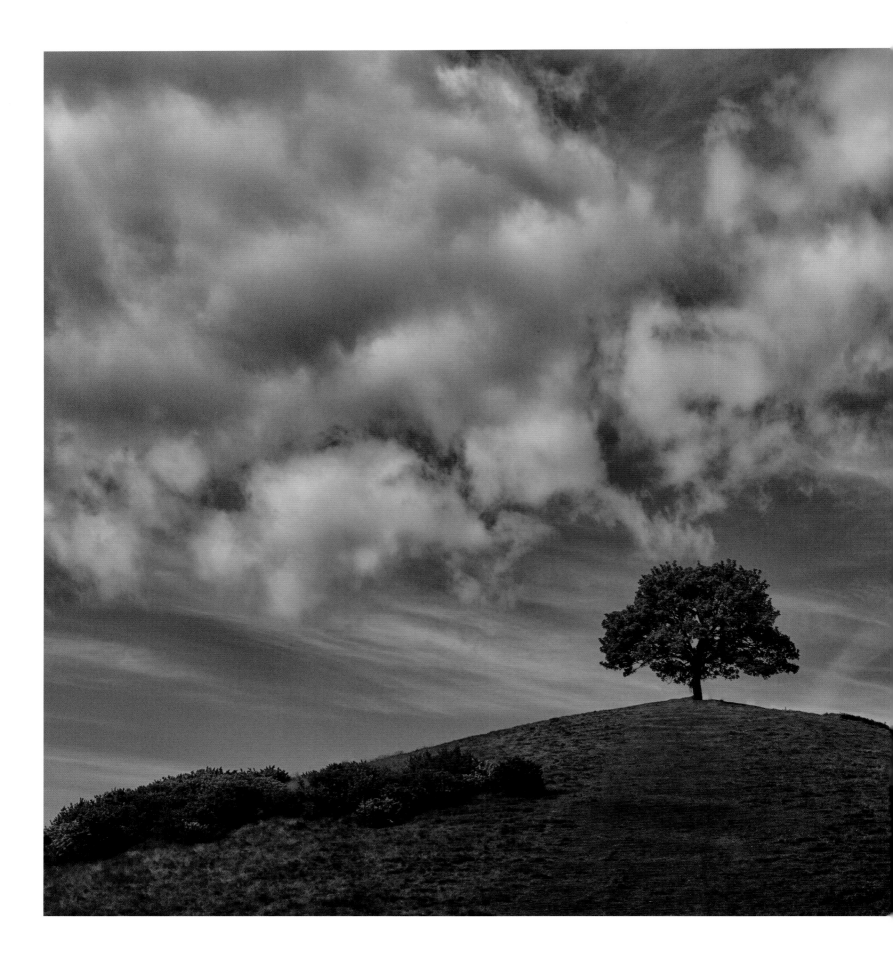

SYCAMORE

(*Acer pseudoplatanus*)

COMMON NAMES
Sycamore

FAMILY
Sapindaceae

DESCRIPTION
A wide-canopied broadleaf tree with distinctive
winged fruits known as samaras

HEIGHT
Up to 35m

Non-native

Native to central, eastern and southern Europe,
it wasn't until the 1700s that the sycamore was
widely planted in the UK. It has now become
widespread in many areas and woodlands.

'This beautiful sycamore tree sits nobly on top of Burrow Hill at our family's cider farm and can be seen from miles around. It's the most breathtakingly magical spot I know and sits directly on three mystical ley lines. It has 360-degree views of the Somerset countryside, the cider farm and all the orchards it rules over, the Somerset levels, Glastonbury Tor, Ham Hill and the Blackdown Hills.

My siblings and I will always be deeply connected to this place which was a gift upon marriage from our father to our mother. We drink cider under the tree in the summer, toboggan from it in the winter and egg roll from Easter. It's where I always go to think and be at peace.'

ALICE TEMPERLEY, MBE

Growing up to 35 metres in height and potentially living for up to 400 years, sycamores are noted for their tolerance of cool climates and wind, which is perhaps why they can be seen as here: a solitary tree, stoic and exposed, on the top of a hill. This particular hardy and distinctive tree stands weather-beaten but indomitable, overlooking the wetland area of the Somerset levels, an area of rich biodiversity.

While not a native tree to the UK, the sycamore makes a valuable contribution to this biodiversity – its flowers provide pollen for bees and insects, its seeds are eaten by birds and small mammals, and its leaves are a key source of food for the caterpillars of a number of moth species. It also provides a useful habitat, as the bark of the sycamore tree cracks and fissures with age to produce a beautifully patterned and textured surface, providing perfect nooks and crannies for countless insects to hide.

THIS SYCAMORE is perfectly positioned, and capturing it in its different moods, in different seasons, is reminiscent of the joy it has brought to all those who have played under it.

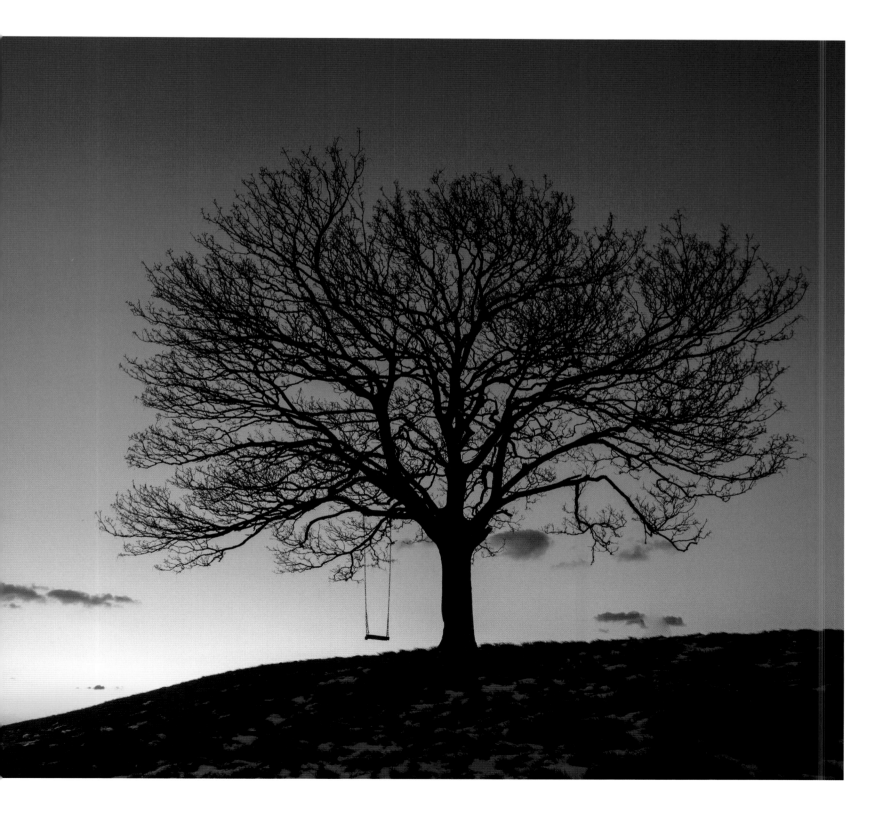

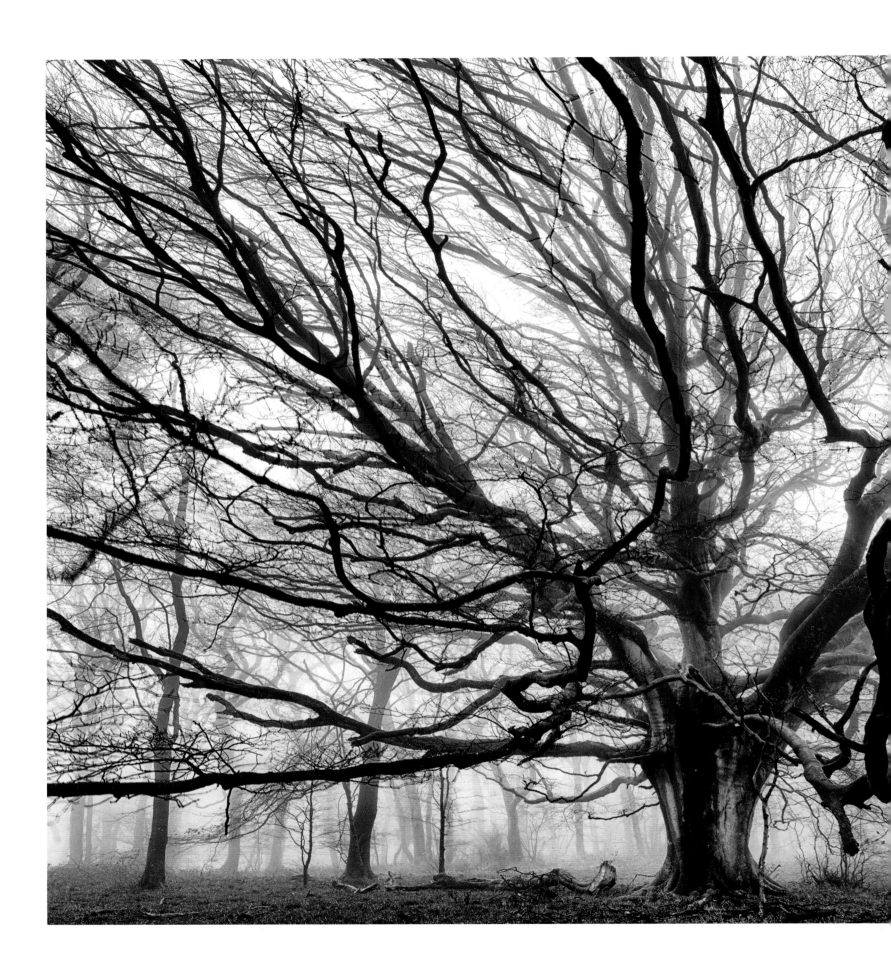

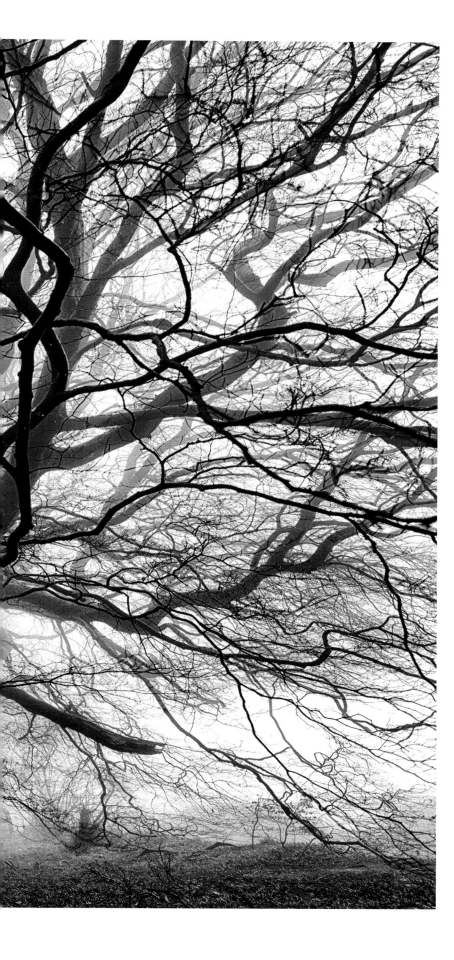

COMMON BEECH

(Fagus sylvatica)

COMMON NAMES
Common beech

FAMILY
Fagaceae

DESCRIPTION
A deciduous tree with a dense, leafy canopy
and branches that stretch upwards; often
retain their leaves during winter

HEIGHT
Over 40m

Native

In Roman mythology, the beech tree was
sacred to Diana, the goddess of hunting,
woodlands and wild animals.

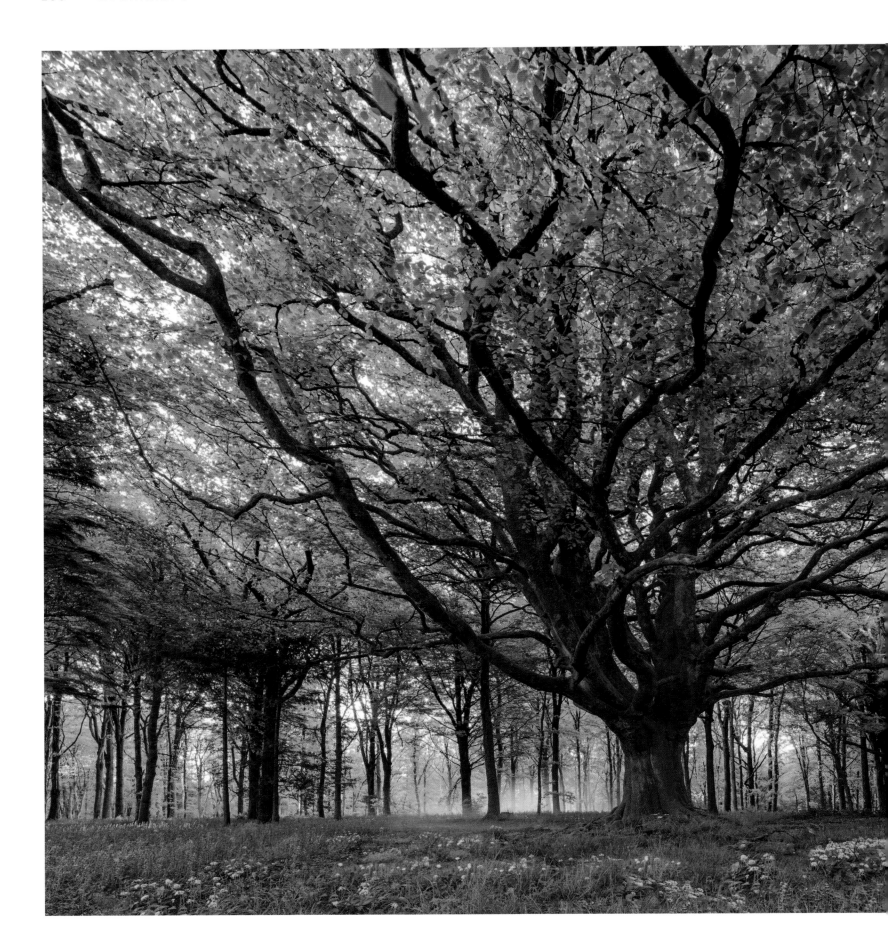

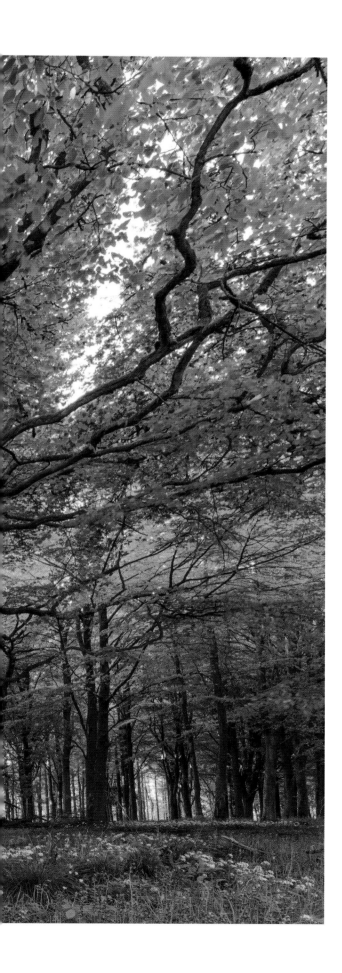

THE LONG limbs of this beech tree almost call you towards it, giving a true sense of its majesty.

'For more than 20 years we lived in a tiny brick-and-flint cottage in a 60-acre wood in Chettle, Dorset, one of the most remarkable villages in England. Until a short while ago it was owned by one family and the woodland was quite productive. We used to harvest firewood, and others would coppice hazel for fencing and charcoal, too, with a giant metal charcoal burner.

But the star of the show is a beech tree which borders a track known as Chalk Walk on the edge of the wood. At a guess it must be 500 years old. It is huge, so much so that you can clamber up the trunk and sit in the middle. The village children used to do this and they also attached a swing to one of the branches. My own children, Jack and Lara, were endlessly fascinated by it and they used to play in it. I once took them for a picnic in the tree. It is a thing not only of beauty but of immense power, and the wood – even in summer – is dark, and a spooky air pervades around my old beech tree.'

DOMINIC & ROSE PRINCE

Growing to a height of more than 40 metres once mature, the common beech is one of the UK's tallest native trees. In woodland, its dense canopy grows tall and broad, with its pretty oval leaves turning a glorious golden brown in the autumn months. Shady beech woodlands are usually covered in a soft carpet of fallen leaves and nuts, known as beechmast, which allows only shade-tolerant plants to grow beneath them. Rare plant species such as box and orchids are often found in beech woodland, along with native truffle fungi and numerous mosses and lichens.

YEW

(*Taxus baccata*)

COMMON NAMES
Yew, common yew, English yew

FAMILY
Taxaceae

DESCRIPTION
Evergreen with needle-like leaves and a peeling,
reddish-brown bark; flowers in March and April; seeds
are enclosed in a red berry-like fruit known as an aril

HEIGHT
Up to 20m

Native

Ancient and venerated, the yew is the longest-lived
native tree species in Europe and can live up
to an incredible 3,000 years old.

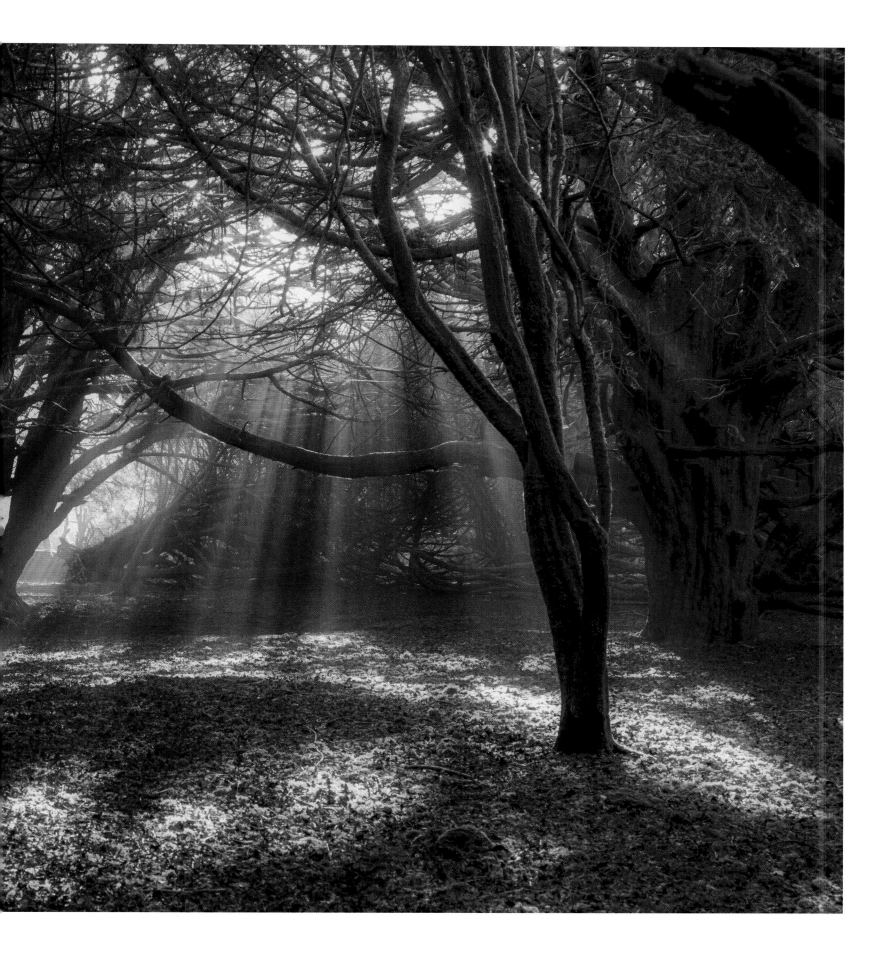

THIS WOOD of yew trees is quite unusual: nothing grows below their poisonous pines. Picking out one tree when surrounded by so many was difficult, but the shafts of light help frame the picture of these ancient trees. Living so long, they are our sacred souls.

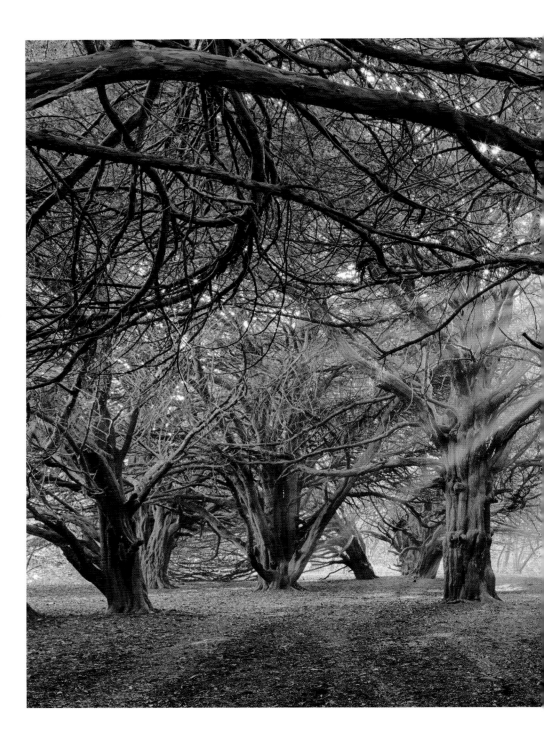

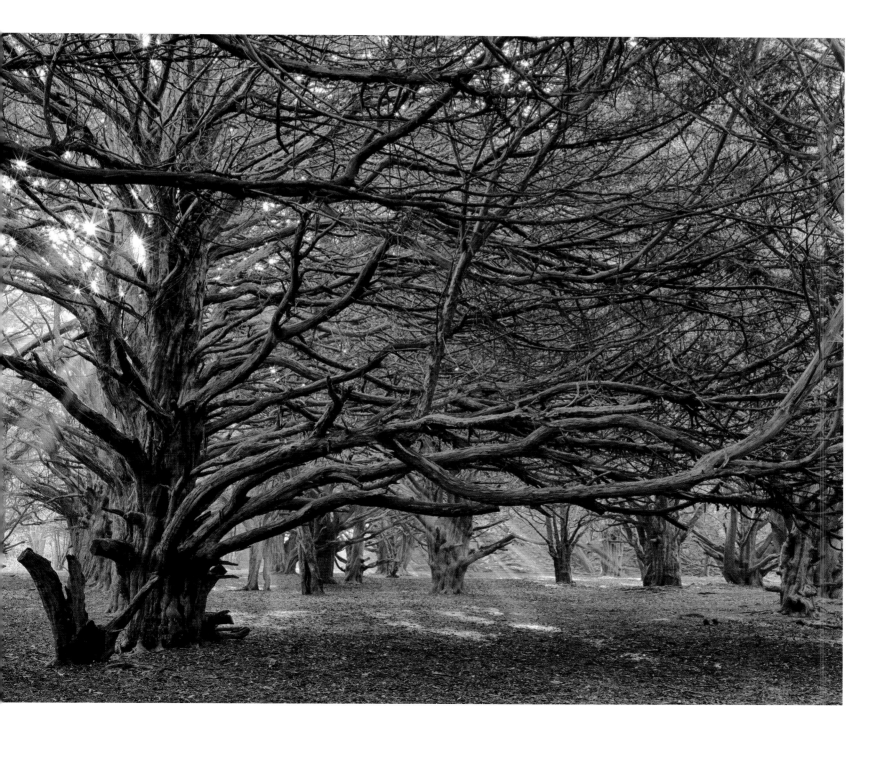

Cranborne Chase, designated an Area of Outstanding Beauty, covers 380 square miles of countryside across the neighbouring counties of Dorset, Wiltshire, Hampshire and Somerset. This diverse landscape is prized for its valuable wildlife habitats, natural heritage and scenic vistas, and includes rolling grasslands, chalk river valleys and ancient woodlands.

With some specimens growing in the area since the late Saxon period, the ancient yews of Cranborne Chase dominate the woodlands here. Their thick canopies combine to create dense dark groves offering safe haven, food and shelter for many local woodland creatures. Often associated with immortality throughout history, no doubt due to their longevity, yews have also been perceived as omens of doom. Wandering among the tightly entwined branches of the woodland at Cranborne Chase, it's not hard to believe that these solemn entities might inspire both dread and wonder.

THE BARK of a yew is flakey and thin, with furrows that deepen over time.

'The ancient yew tree becomes even more mysterious when surrounded by its contemporaries. In this wood the yews' evergreen and entwined branches blot out much of the sunlight, making it hard to see the individual specimen in the daylong gloaming. Yet, framed by Adrian Houston, one sole yew is picked out in this secret woodland and its magic makes you think of Tolkien's Ents or of druids and prehistory.

Normally associated with churchyards, yews are also often seen in the West Country along old tracks; according to one old boy, these poisonous trees were planted by drovers as shelter against the elements for their animals on the way to market.'

NED CECIL, VISCOUNT CRANBORNE

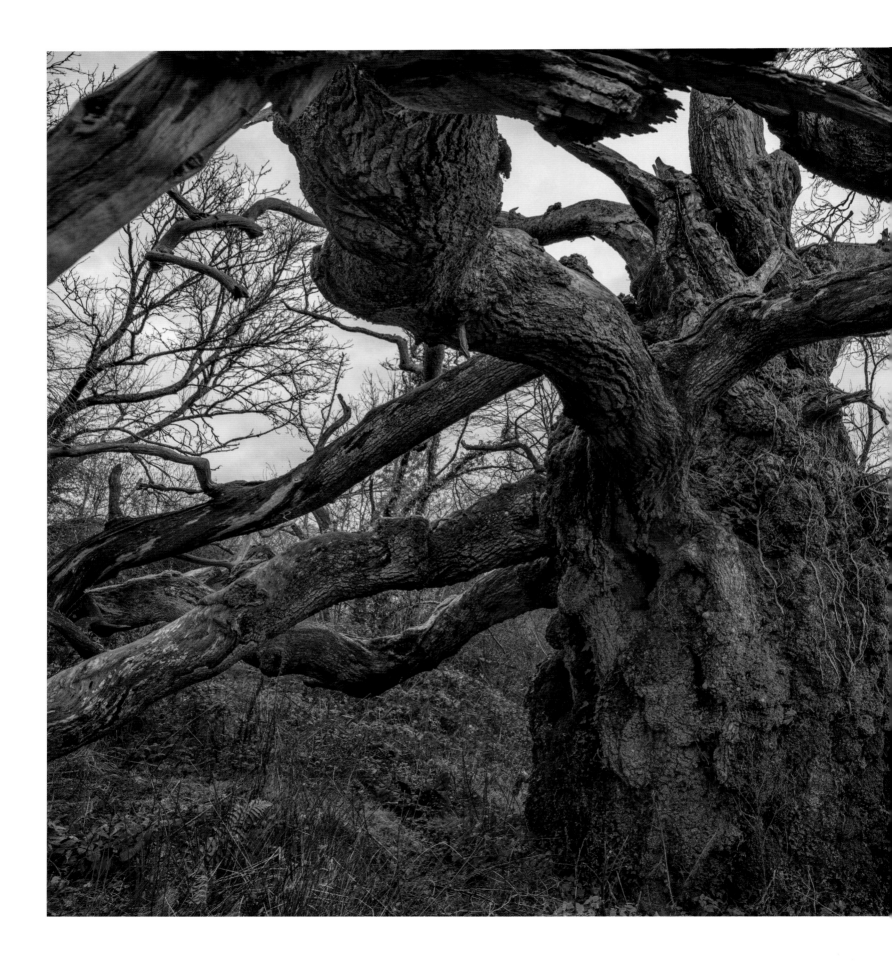

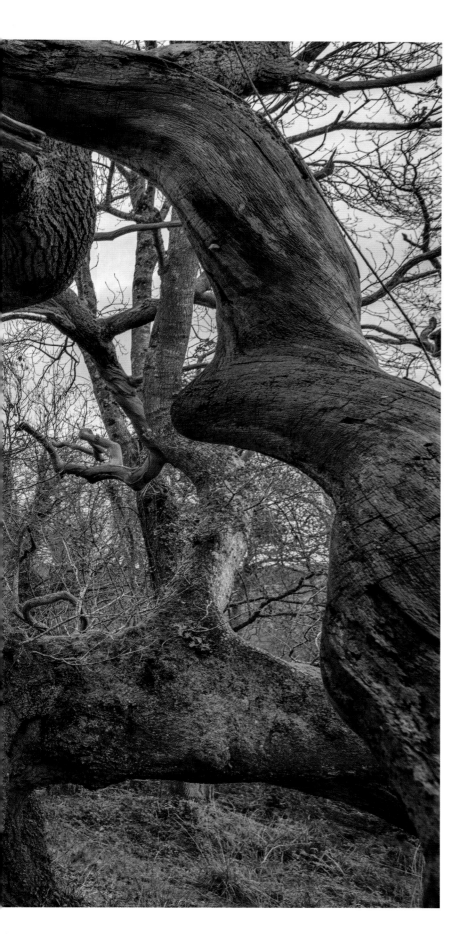

ENGLISH OAK

(*Quercus robur*)

COMMON NAMES
English oak, common oak, pedunculate oak

FAMILY
Fagaceae

DESCRIPTION
Deciduous tree with broad crown and lobed leaves;
catkins are followed by acorns

HEIGHT
20–40m

Native

The King John's Oak has borne witness to many kings and queens of England, surviving since the reign of King John through the turbulent Tudor period, when the park at Shute was confiscated by Queen Mary I from the family of the unfortunate 'Nine-day Queen', Lady Jane Grey.

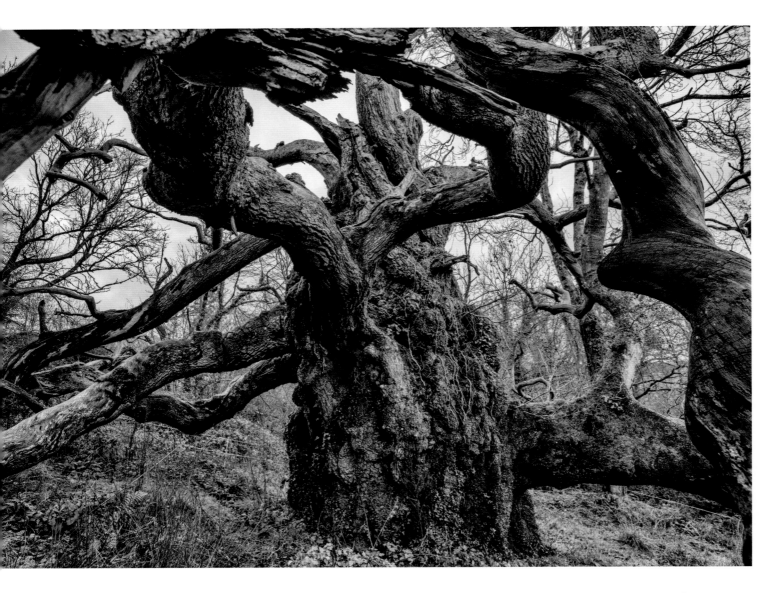

Woodend Park in Shute, Devon, is a now private park but was once a royal deer park during the medieval period. It is a very special landscape, according to ancient tree, forest and wood pasture specialist Dr Jill Butler – a place of international significance with many ancient and large-girthed oaks within the park, putting it in the top 25 of such sites in England.

One such ancient tree in Woodend Park is the 900-year-old King John's Oak. Based on its huge girth, which is more than 10 metres, it is one of the greatest trees in Europe. Trees of this size are rare.

The King John's Oak is also host to an exceptionally rare heart-rot fungus – *Phellinus wahlbergii*. This fungus is found on only a handful of trees in the UK, all of which are in historic, medieval landscapes. As Dr Butler says, 'The fungus is likely to be of advantage to the tree – helping to recycle the non-living wood so that the nutrients can be reused.' Indeed, it is now recognized that fungal decay in trees is a natural and beneficial part of the aging process. Most importantly, fungi and lichen are essential for the successful functioning of woodland ecosystems. This ancient giant is a unique habitat for plant, insect and animal life.

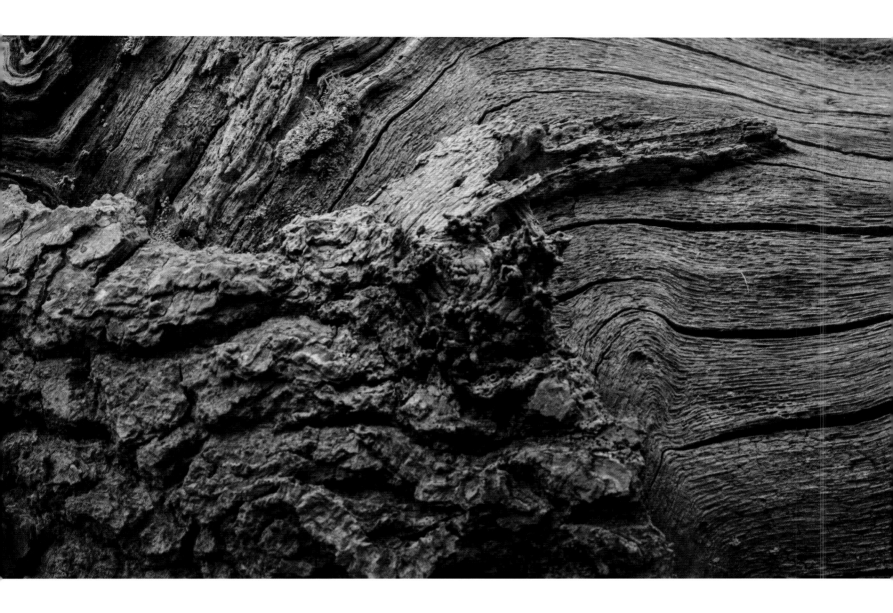

THIS ANCIENT oak took some time to find as it sits near the bottom of a hill in a parkland full of ancient relics. Spending time with your subject is important, as you will always get the best out of them once you get to know them.

'The tree has an amazing open-grown structure demonstrating that it has lived in grazed parkland all its long life. Massive side branches snake out, almost horizontally, from all sides over a huge area, giving it an appearance of a medusa.

It is the only ancient oak named after one of the most notorious Norman kings, John. Many conquerors' oaks have disappeared or died, and although there are several Queen Elizabeth I oaks, they are named after a much later monarch.'

DR JILL BUTLER

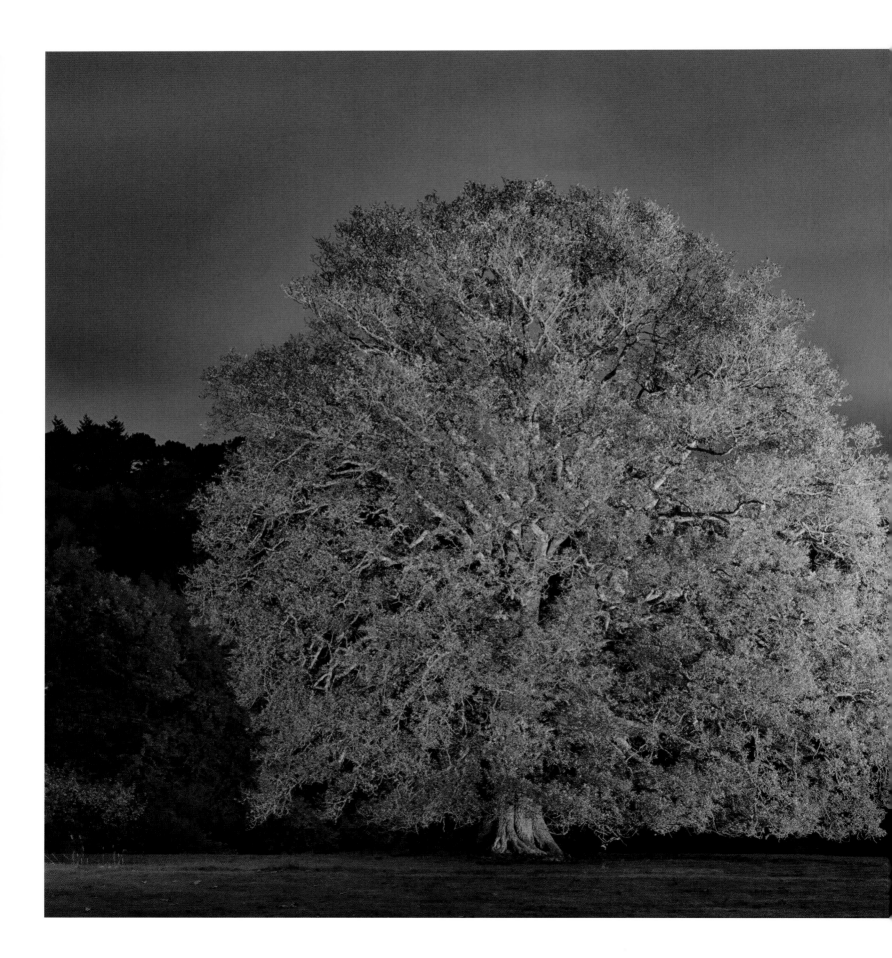

ENGLISH OAK

(Quercus robur)

COMMON NAMES
English oak, common oak, pedunculate oak

FAMILY
Fagaceae

DESCRIPTION
Deciduous tree with broad crown and lobed leaves;
catkins are followed by acorns

HEIGHT
20–40m

Native

The seasonal cycles of the mighty oak
teach us to wait patiently for change that
brings with it hope, rebirth and certainty.
As Sir Harry Studholme encapsulates,
'Each year is a lesson in life.'

'Five generations of my family have lived at Perridge, and when we arrived the oak in the field in front of the house was already old. The symmetry and simplicity of its form belie its vast scale and age. Larger than any of the trees in the woods around, it moves with the seasons, a home for birds and insects and a shelter for sheep. I have known the oak all my life; climbed it as a child, gathered mushrooms each autumn from around its roots and looked out on it most days.'

SIR HARRY STUDHOLME

As former chairman of the UK Forestry Commission, Sir Harry Studholme is passionate about trees, how they shape our countryside and cities, and provide us with a powerful weapon in the fight against climate change.

At Perridge House, near Exeter in Devon, which has been home to the Studholme family since 1907, there are a number of fascinating trees within the grounds of the estate, but for Sir Harry, the majestic oak tree stands out. 'The oak tree is a natural totem, a reminder of our transience and smallness and at the same time of the healthiness of constant change and rebirth,' he says. 'Every year out of the bare dead-looking winter branches emerge, unfailingly every spring, the pale yellow-green new growth of spring. This fresh beauty cannot and does not last but turns into the deeper greens of summer, before the glorious last fling of autumn colour and leaf fall. Each year is a lesson in life. None of the seasons, whether fruitful or barren, go on for ever, each contains the seeds of its own end but also the hope and certain expectation of the rebirth of the next spring.'

THIS PERFECTLY shaped oak, in its autumn glory, sits on the edge of a woodland landscape. Picking out the tree from its background helps convey its outline.

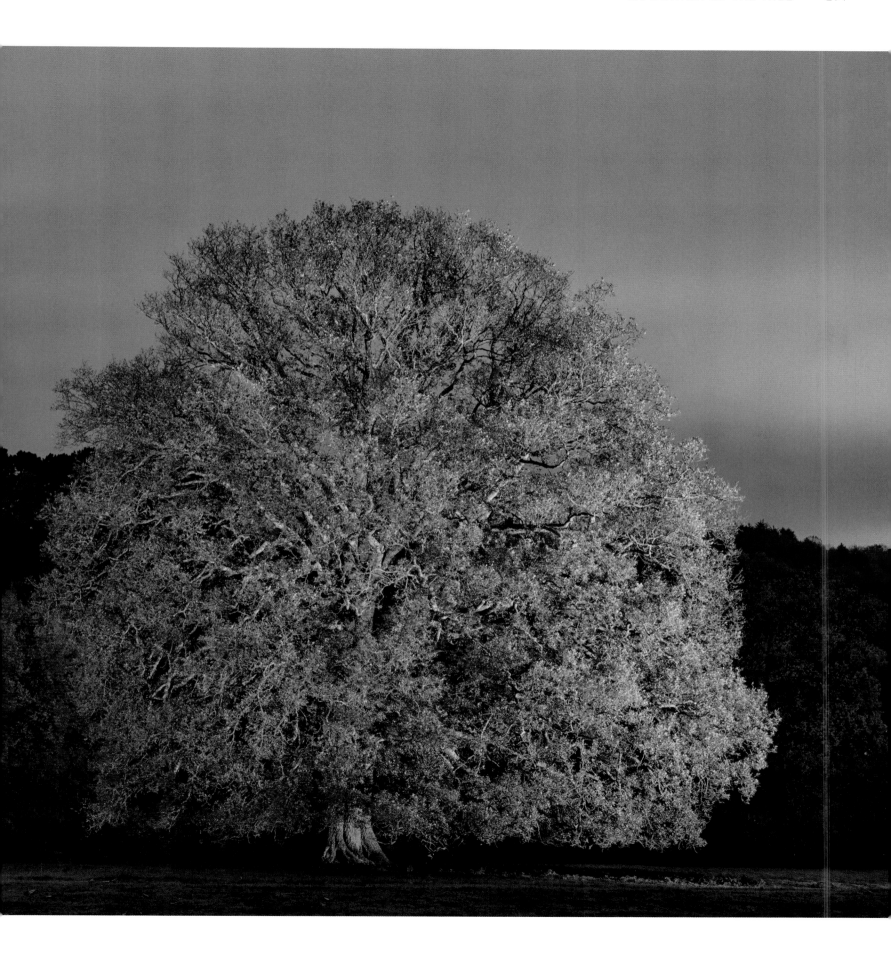

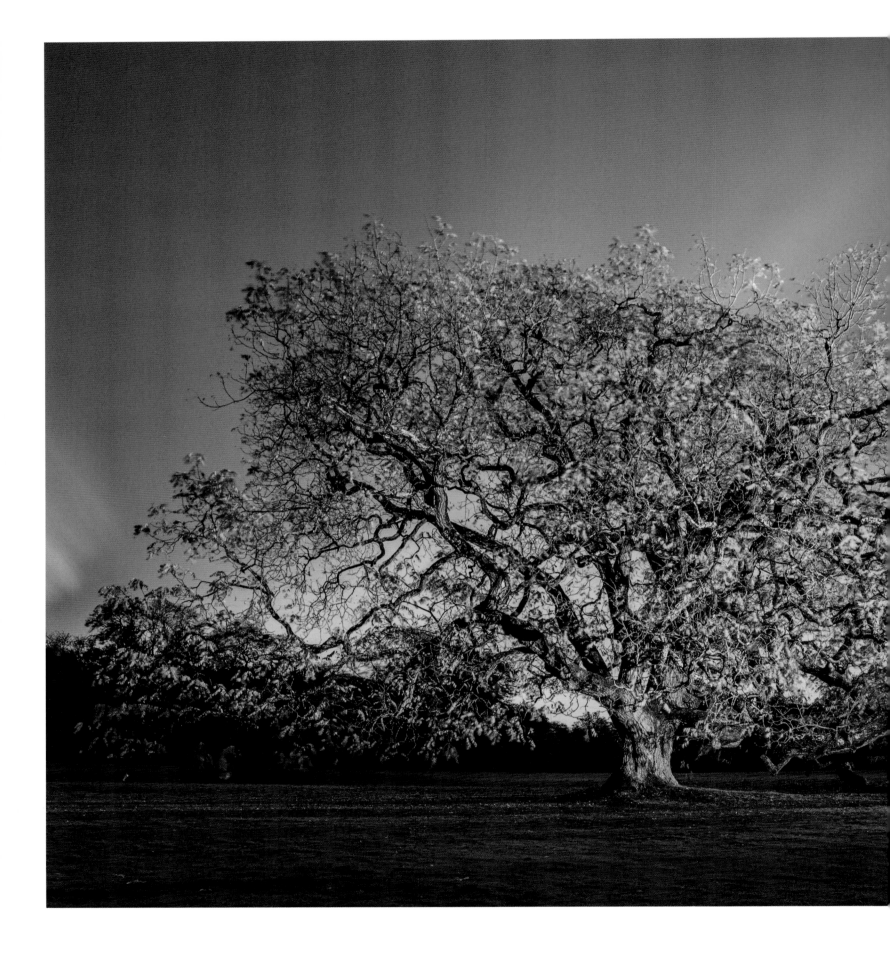

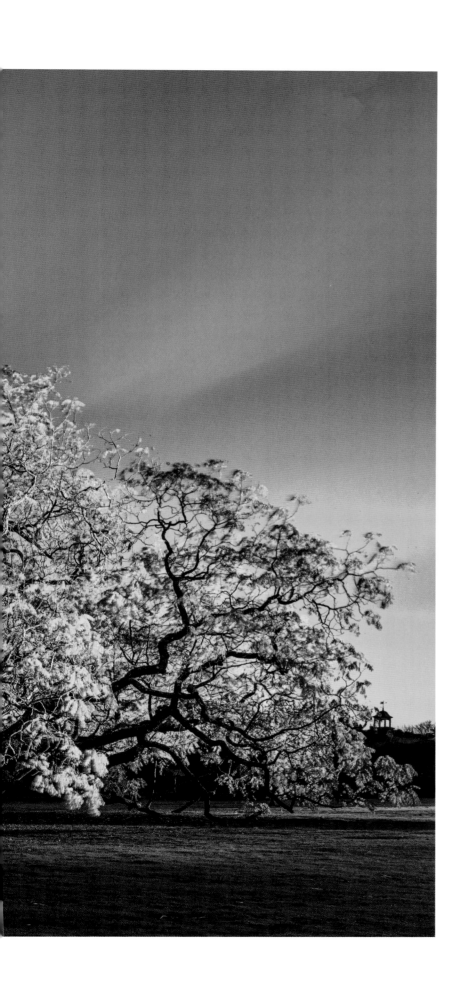

BLACK WALNUT

(*Juglans nigra*)

COMMON NAMES
Black walnut

FAMILY
Juglandaceae

DESCRIPTION
A large, broadleaf tree with large
brown-green, plum-like fruits

HEIGHT
30–40m

Non-native

A native of North America, the black
walnut was first introduced to
Europe in the early 17th century.

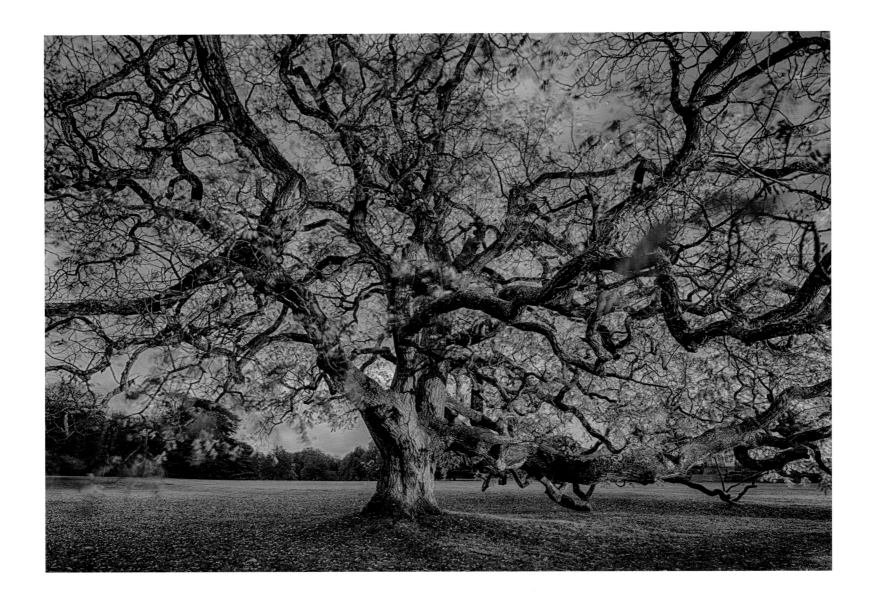

'The black walnut originally comes from
eastern and central North America.
The one at Antony was probably planted
in the 1780s. It has had the freedom to
develop its natural size and dominate
the main lawn in full view of the house.
Its spectacular shape is enhanced in
the autumn by its golden-coloured leaf.'
SIR RICHARD CAREW POLE

THIS MAGNIFICENT tree, with its
long limbs, was photographed in
winter and autumn. Its structure is
an art form in itself.

Antony, an 18th-century house in Cornwall, has been home to the Carew Pole family – who have owned the estate since the mid-16th century – for 600 years. The statuesque stone house is thought to be one of the finest remaining Queen Anne buildings in the West Country.

The grounds at Antony include a formal garden and woodland planting that were conceived by renowned Georgian landscape designer Humphry Repton. As the self-professed 'successor' to Capability Brown, Repton's work demonstrated a love of naturalistic and dramatic landscapes. The magnificent black walnut tree in the main lawn at Antony embodies this sense of the dramatic, with its dark branches stretching tall and wide across the landscape.

Native to eastern regions of North America, here in the UK, the black walnut is best suited to the warmer climes of the south, thriving in fertile, lowland soil with plenty of sunlight. Prized for its ornamental qualities, this handsome tree is also medicinally valuable, with all parts of it used for its healing properties, from treatment of kidney ailments and toothache, to use as a mosquito repellent.

THE SHADOWS on this detail of the trunk are caused by the long limbs of the tree.

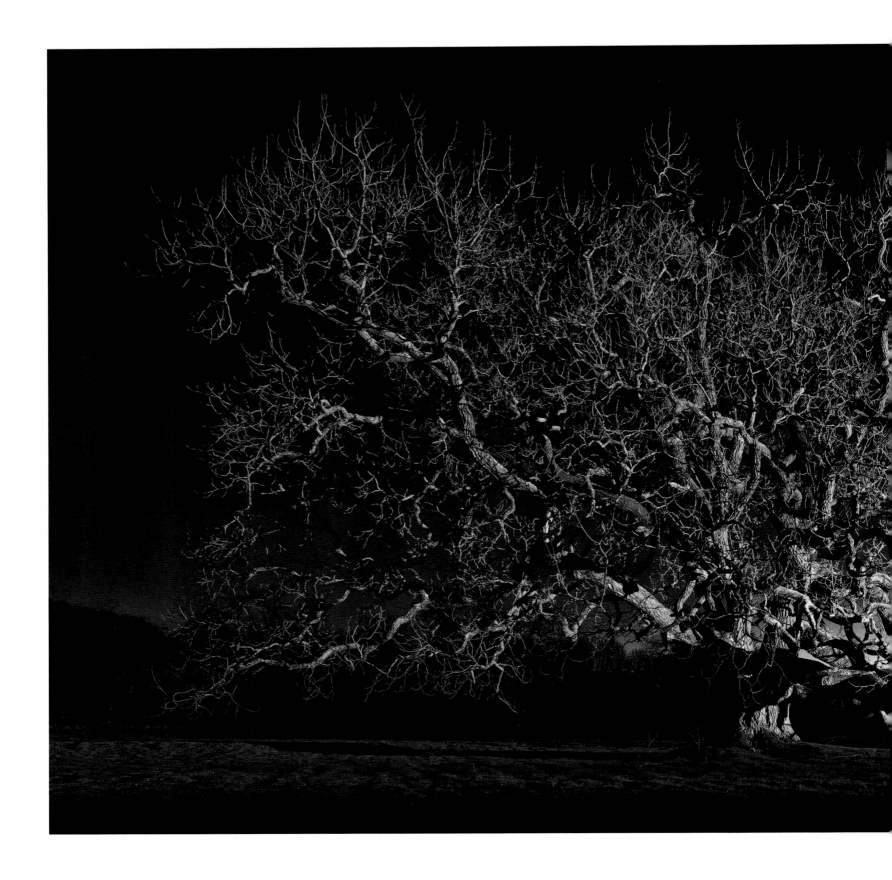

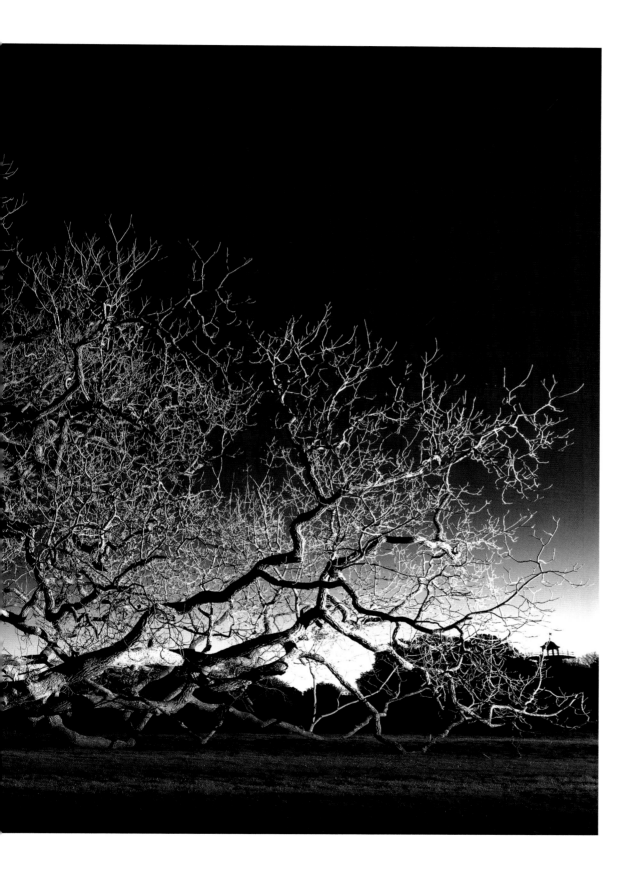

PHOTOGRAPHING THIS tree as the dawn broke over the horizon enhanced the sculptural structure of the tree.

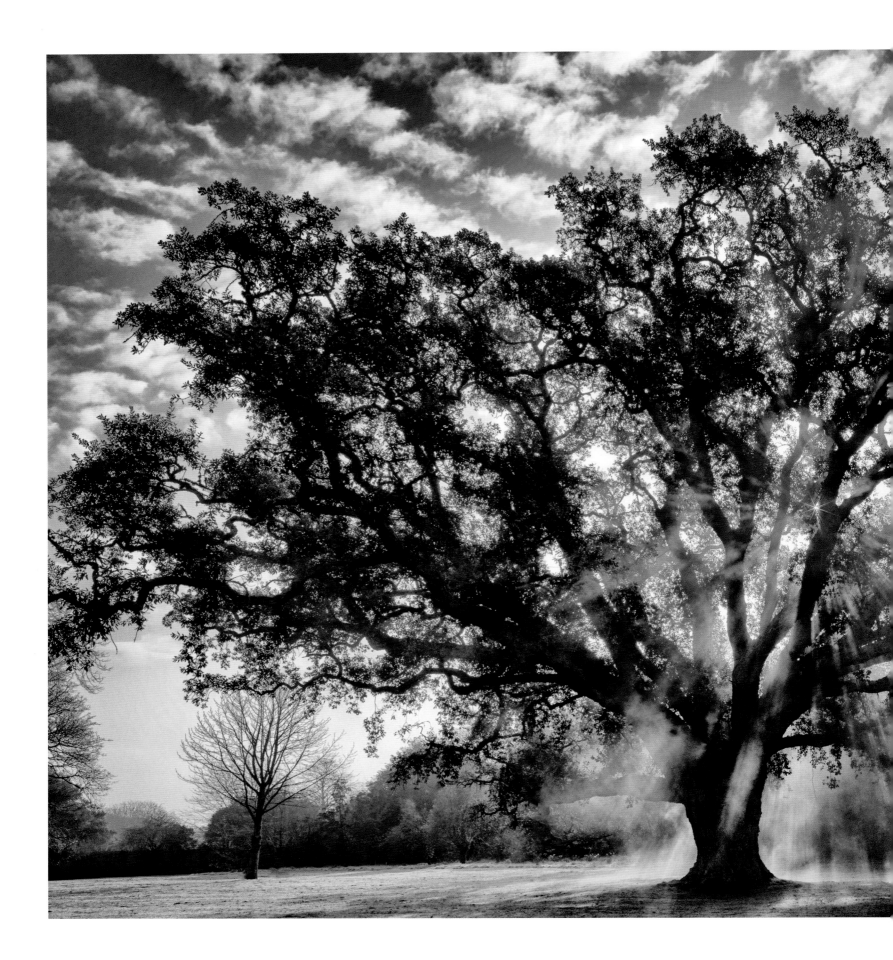

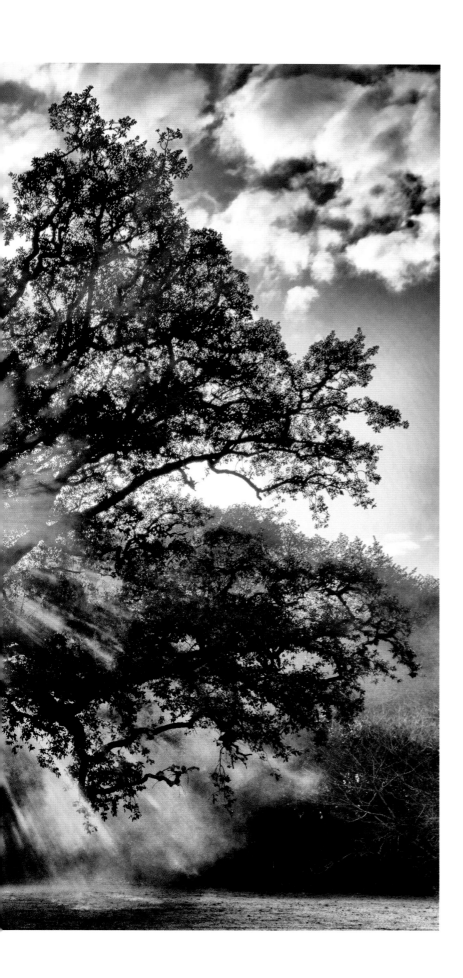

CORK OAK

(*Quercus suber*)

COMMON NAMES
Cork oak, sorbriero

FAMILY
Fagaceae

DESCRIPTION
An evergreen tree with thick,
grey, knobbly bark

HEIGHT
Up to 26m

Non-native

Cork oaks were treasured as
symbols of freedom and honour in
Ancient Greece and, as such, only priests
were allowed to cut them down.

Grown since the Middle Ages in Portugal and Spain, the cork oak is rare in that it is one of the few trees that can regenerate its bark. Once the tree reaches 25 years of age and the trunk has grown to a diameter of 70 centimetres, the outer bark – the cork – can be stripped every nine years. As the cork oak has an average lifespan of over 200 years, a single tree can be harvested over 16 times. Impermeable to liquids and gases, cork is an incredibly useful and sustainable timber product; a completely natural, biodegradable raw material with multiple uses.

The cork oak is typically found in south-western Europe and north-western Africa, thriving in hot, dry summer temperatures and cold, moist winters. Portugal is home to the largest collection of cork oak forests, which also provide a vital habitat for a great diversity of species, including endangered species such as the Iberian lynx and Iberian imperial eagle.

Not often seen in the UK, the cork oak at Antony House in Cornwall demonstrates a typical broad, more or less rounded crown, as well as the species' distinctive groove-filled bark. Once the bark has been harvested, the trunk displays a fiery red colour before the bark is restored to its former greyish-brown fissured glory.

'The cork oak (Quercus suber) is an exceptional tree. The date of planting is unknown but thought to be during the second half of the 18th century. It is mostly cultivated in Spain and Portugal for commercial use. At Antony it has the space to grow and expand to its natural shape.'
LADY CAREW POLE

THIS CORK oak was captured just after a partial eclipse of the sun, with the light filtering through its branches in the eerie silence that follows these events. The detail image shows the textured bark in all its glory.

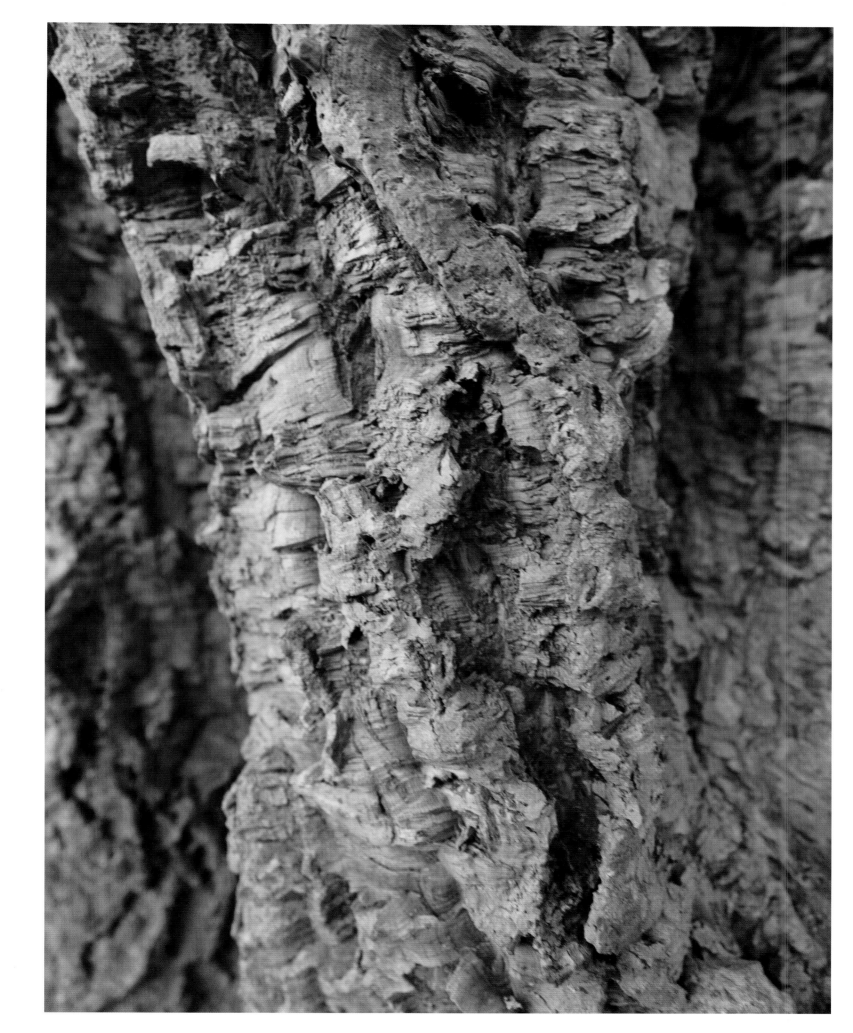

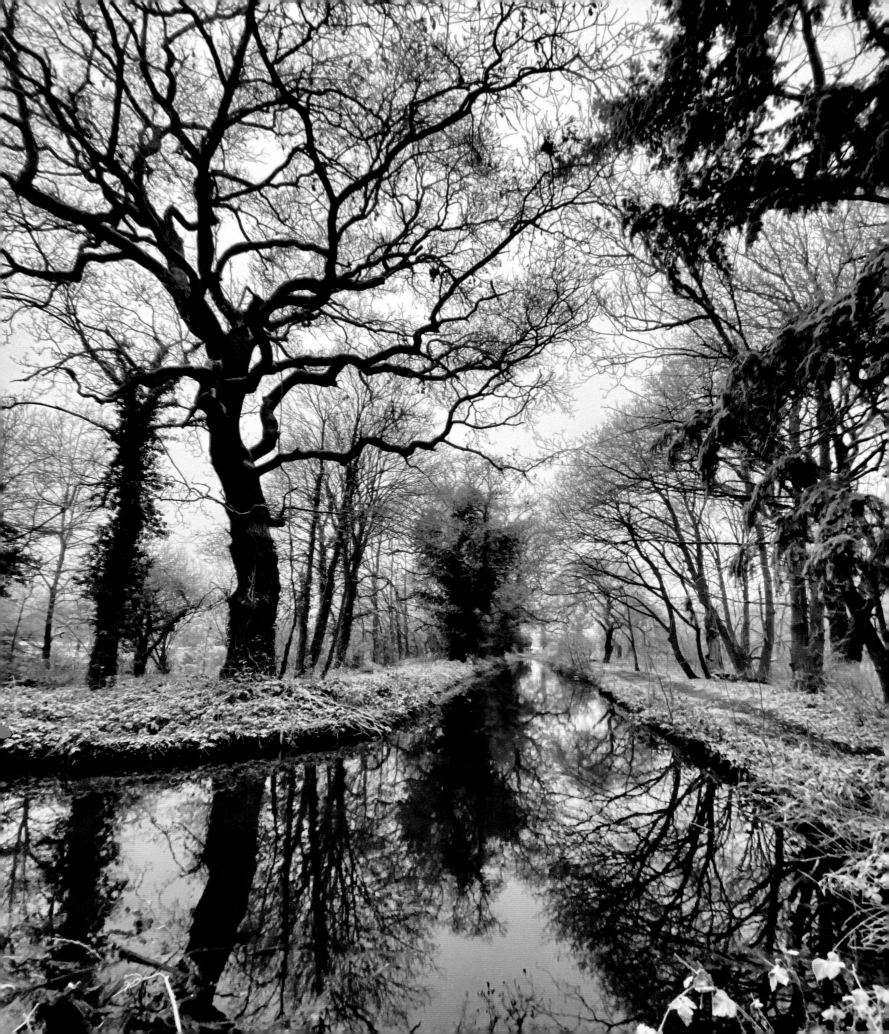

AFTERWORD:
HOW YOU CAN HELP

Trees matter. They are the sentinels of our past, present and future.
They have quite literally stood the test of time and borne witness
to hundreds of years of human impact on the planet – both good
and bad. Trees are our constant companions, in both rural and
urban areas, marking the changing of seasons and the passing of
time. Their bursting blossom and unfurling leaves herald the birth
of spring, a period of renewal and a celebration of life that continues
through the sultry summer days, to the turning of leaves in autumn
that herald the winding down of the year, and the sculptural beauty
of bare tree branches in winter, as nature hibernates until the cycle
begins once again.

Yet this cycle of life is under threat. Climate change, deforestation,
inappropriate development and attacks from tree diseases and
pests mean that some of our most valuable trees and woodland
areas are at risk of disappearing. In fact, some of our most precious
assets such as ancient woodlands, which are irreplaceable
areas of biodiversity that provide shelter and food for many
vulnerable wildlife species, are seriously under threat. In the UK,
only 2.4 per cent of the country is covered by ancient woodland,
and around 1,250 ancient woods are currently at threat from
development.

However, all is not lost, and it's important to remember that you can
help. There are three practical ways you can help to tackle this crisis
and support the cause to save our trees.

1. PLANT TREES
Anyone can plant a tree. You can plant one in your garden or outdoor
space, if you have one and you have enough room. However, It is
important to consider whether the space is suitable for the tree you
are planting and whether you will be able to manage and care for it.
Do your research to make sure you choose a species of tree that is
best suited to your area, as some will require certain soil types and

weather conditions. Also, think carefully about where you source your trees. It's important the plants and trees you use are free from pests and diseases. Where possible, get your plants from nurseries with clear plant health management standards in place including, for example, nurseries with Plant Healthy certification or similar. If you are without any outdoor space in your home, you can still get involved in projects to plant trees within your neighbourhood. You may be able to plant trees at schools in your area or in community woods. Or you could even ask friends or family if they would be interested in planting trees on their land. The Woodland Trust provides many helpful links for getting started, or you may find useful information about local projects on your council website.

2. CAMPAIGN

The UK government is aiming to achieve a carbon net zero target by 2050. In order to achieve this, more trees will be essential – they lock up carbon emissions, help protect against flooding and cool our landscapes. You can add your voice to the call on our government to commit to this target and to take proper action. Ask the government to plan for an expansion of woodland across the UK and call on them to support funding for natural woodland regeneration. Write to your local MP and urge them to take action.

3. DONATE OR FUNDRAISE

Funding can make all the difference to creating change. If you're able to donate to one of the many organizations that are committed to fighting climate change and protecting our trees and woodlands, you would be helping to encourage real progress. Alternatively, you can fundraise for one of the fantastic causes. There are many organizations you could support, but just a few to look at include Action Oak, the Woodland Trust's Big Climate Fightback, the Future Trees Trust, the Woodmeadow Trust, Rewilding Britain, The National Forest, Woodland Heritage and National Trust Plant a Tree.

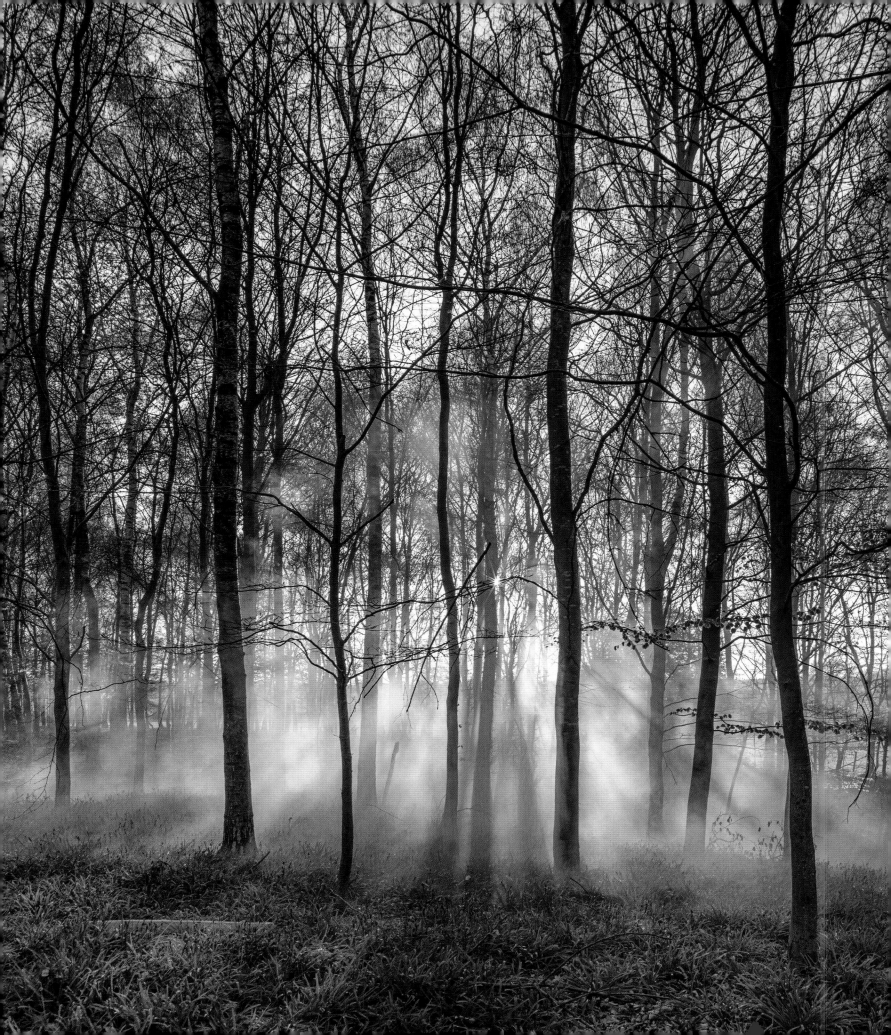

THE CONTRIBUTORS

SCOTS PINE, GLEN ALLADALE, PAGE 16
Paul Lister established The European Nature Trust with a focus on environmental and educational projects in Scotland and Romania. In 2003 he purchased Alladale Wilderness Reserve in the Scottish Highlands, which is now the focus of a pioneering rewilding and ecotourism initiative. Lister is also a trustee of Foundation Conservation Carpathia.

SILVER BIRCH, GLEN COE, PAGE 28
Helen Scott runs a vintage business called Lovage & Lace with her husband Tom. They are based near Edinburgh in Scotland. Helen is an avid gardener and nature lover, having been brought up by creative parents who bucked the trend of seeking gratification from a material world and instead sought inspiration from, gained solace in and nurtured an appreciation of the beauty of nature.

GIANT REDWOOD, ROYAL BOTANIC GARDEN EDINBURGH, PAGE 32
David Knott is Curator of the Living Collection, Royal Botanic Garden Edinburgh (RBGE). He is currently involved in RBGE's contribution to the Global Strategy for Plant Conservation Target 8 project work in Scotland, and has undertaken fieldwork in China, Japan, Korea and Nepal. He is a member of the RHS Bursaries Committee and is currently President of the Royal Caledonian Horticultural Society.

ASH, GUNNERSIDE, PAGE 36
Emmeline Hallmark trained as an art historian before working in London for 15 years and then as a fine art curator based in the Cotswolds. Having moved further into rural Herefordshire, Emmeline is now studying to be a child psychologist and Forest School Lead in order to work with art and the natural environment with children as an eco-art therapist. Alongside this, she will also soon launch her online gallery specializing in the tree, appropriately named The Tree Art Gallery.

HAZEL, ESCRICK PARK, PAGE 40
Rosalind Forbes Adam has a background in arts administration and PR, and more recently in horticulture. She is co-founder of the pioneering woodmeadow site, Three Hagges Woodmeadow, near York, and founded the charity Woodmeadow Trust in 2013. In addition, she has developed the garden at Skipwith Hall, in Yorkshire, over the past 20 years, and has also been a partner of a rural estate, Escrick Park.

ENGLISH OAK, ROOKERY HALL, PAGE 44
Adrian Hallmark is the Chairman CEO of Bentley Motors Ltd, and prior to this he was the Group Strategy Director at Jaguar. Since joining Bentley Motors, Adrian has spearheaded the company's mission to become end-to-end carbon neutral by 2030 and to make its operations centre in the UK climate-positive.

SWEET CHESTNUT, CHIRK CASTLE, PAGE 48
Julian Freeman-Attwood is a tree planter, conservationist and mountaineer. He runs an estate as a nature reserve in the Berwyns of Snowdonia, where he has planted 20,000 oaks and many other species throughout the landscape and in the hedgerows, in an attempt to create a biodiverse wildness that links up to the heather moorland and blanket bog. He believes we must plant many more trees throughout our farmland and that we must let the trees of the future grow to an old age or risk losing something very precious to humanity.

SYCAMORE, TALGARTH, PAGE 52
Dylan Jones, OBE, is a *New York Times* and *Sunday Times* bestselling author and has written or edited over 20 books. In the 1980s, he was one of the first editors of *i-D*, before becoming a Contributing Editor of *The Face* and then Editor of *Arena*. He spent much of the next decade working in newspapers – principally *The Observer* and *The Sunday Times* – before embarking on a multi-award-winning tenure at *GQ*. A former columnist for *The Guardian* and *The Independent*, he is a Trustee of the Hay Literary Festival, a board member of the British Fashion Council, a former Chair of Fashion Rocks and an occasional television producer. In 2012 he was awarded an OBE for services to publishing.

ENGLISH OAK, DINEFWR CASTLE, PAGE 56
Iolo Williams is a Welsh naturalist, broadcaster, public speaker and writer. He is most widely known as a popular member of the *Springwatch*, *Autumnwatch* and *Winterwatch* presenting team and for presenting series such as *Wild Wales* and *Great Welsh Parks* for BBC2. Williams has written several books on Welsh wildlife and he is a regular contributor to several magazines, including *BBC Wildlife*.

ENGLISH OAK, HADDON HALL, PAGE 60
ASH, HADDON HALL, PAGE 64
Lord & Lady Edward Manners live at Haddon Hall, a fortified manor house in the Derbyshire Peak District that dates back to the 12th century. The surrounding estate is rich in diverse habitats and is managed in a way to maximize biodiversity for the benefit of nature and humans. In 2009, they began a project to restore the 14th-century park surrounding Haddon Hall, converting it to organic and regenerating previously intensively farmed land. Their ambition is to develop scientifically based methodologies for the regeneration of land in the wider landscape.

ENGLISH OAK, SHERWOOD FOREST, PAGE 70
Sharon Durdant-Hollamby, FICFor, is President of the Institute of Chartered Foresters and a Chartered Arboriculturist. She specializes in trees and construction, protected trees, tree root investigations, and trees and well-being. In 2019 she took her place on the board of the Institute of Arboricultural Studies Hong Kong, as an advisor.

HOLM OAK, WOLVERTON HALL, PAGE 74
Nicholas Coleridge, CBE, is Chairman of the Victoria and Albert Museum, Chairman of Condé Nast Britain and an Ambassador for the Landmark Trust. Coleridge is also Patron of the Elephant Family, which seeks to protect the natural habitats of Asian wildlife in danger of extinction.

ENGLISH OAK, RAVENINGHAM ESTATE, PAGE 78
Sir Nicholas Bacon, OBE, was President of the Royal Horticultural Society for seven years, a council member of the National Trust and Deputy Lieutenant of Norfolk in 1998. In 2005 he was appointed to the Prince's Council of the Duchy of Cornwall and served as High Sheriff of Norfolk.

ENGLISH OAK, KIMBERLEY HALL, PAGE 82
Robbie and Iona Buxton own 18th-century Kimberley Hall and its Capability Brown-designed deer park, where they have run a successful events and wedding business for the last 20 years and previously a music and arts festival, widely recognized as the blueprint for many of the modern festivals. Robbie manages the estate, farm and parkland and Iona is the author and editor of several architectural books.

SYCAMORE, HIGH HOUSE, PAGE 88
Antony Gormley is a British sculptor. Some of his works include the *Angel of the North*, a public sculpture in Gateshead in the north of England, and *Another Place*, on Crosby Beach near Liverpool.

ENGLISH OAK, HELMINGHAM HALL, PAGE 92
Lord Tollemache is an English peer and landowner. He is the present owner of Helmingham Hall, the Tollemache principal ancestral seat.

BLACK POPLAR, CAMBRIDGESHIRE, PAGE 96
David Lindo is a broadcaster, writer, speaker and tour leader. Also known as the Urban Birder, he is a regular contributor to *Bird Watching* magazine and has written a number of books, namely, *The Urban Birder* and *How to be an Urban Birder*.

ENGLISH OAK, ROSS-ON-WYE, PAGE 100
Rory Spowers is a writer and campaigner specializing in systems change and consciousness issues. His books include *A Year in Green Tea and Tuk-Tuks*, covering the creation of Samakanda, an ecological learning centre in south Sri Lanka, and *Rising Tides*, a history of ecological thought.

ACONBURY WOOD, HEREFORD, PAGE 104
Geraint Richards, MVO, is the Head Forester for the Duchy of Cornwall, where he is responsible for the management of the trees, woodlands and forests across the Duchy's landholding in England and Wales. In 2019 he was awarded the Royal Forestry Society Gold Medal and made a Fellow of the Institute of Chartered Foresters.

ENGLISH OAK, DAYLESFORD ORGANIC FARM, PAGE 108

Carole Bamford is the founder of the Daylesford Organic Farmshops chain and the Bamford brand of women's products. In addition, Lady Bamford is a director of the family business, JCB, and has been a hardworking supporter of the NSPCC for over 35 years. In 2004 she received an OBE, and in 2012 she was honoured with an International Leadership Award at the Global Green Millennium Awards.

ORIENTAL PLANE, COLESBOURNE GARDENS, PAGE 112

Sir Henry Elwes is the owner of Colesbourne Park and farmed most of the estate during the 1970s and 1980s. In addition, he takes a particular interest in forestry on the estate and in the arboretum planted by his great-grandfather, Henry John Elwes.

ENGLISH OAK, DIPPLE WOOD, PAGE 116

Isabelle Miaja is a renowned interior designer and founder of Miaja Design Group. Every project undertaken follows core principles such as designing for energy efficiency, low environmental impact, waste reduction, longevity and flexibility, as well as providing healthy environments. Chosen as one of the world's most influential designers, her portfolio includes award-winning city hotels and resorts. Inspired to write by her grand-uncle Federico Garcia Lorca, the National Poet of Spain, Isabelle's poems reflect her deep belief that each of us can make a difference and that preserving Mother Nature is essential for our future.

CEDAR, LE MANOIR AUX QUAT'SAISONS, PAGE 120

Raymond Blanc, OBE, is Chef Patron at Le Manoir aux Quat' Saisons, a hotel-restaurant in Great Milton, Oxfordshire. The restaurant has two Michelin stars and is the only UK country house hotel to have retained two Michelin stars for over 35 years. Raymond is President of the Sustainable Restaurant Association – a not-for-profit organization aiding food-service businesses to work towards sustainability.

CEDAR, GREAT TEW ESTATE, PAGE 124

Nicholas Johnston is the owner of the Great Tew Estate in North Oxfordshire and the Bantham Estate in South Devon. There is a shared ethos across both estates to uphold the highest environmental principles in all activities, in order to protect and enhance their respective landscapes and heritage assets for future generations to enjoy. Among other commitments, this includes miles of new hedges and thousands of new trees being planted every year. The Bantham Estate forms a core part of the South Devon AONB and much of the land is farmed organically while the estuary that splits that estate is within a Marine Conservation Zone.

COMMON BEECH, HENLEY WOOD, PAGE 128

Nigel Houston lives in a cottage in the woods near Henley-on-Thames. He has restored the woodland meadow forming part of the garden with two natural clay-lined ponds and recently planted silver birch, rowan and horse chestnut trees. The fallow deer wander in and out of the garden and there are mallards, greebs and mandarin ducks on the ponds. Nature and the environment have always been an important part of his life; being able to step out of your front door into a woodland paradise is paradise its self. When not in the woods, he builds and restores custom motorcycles.

ENGLISH OAK, CORNBURY PARK, PAGE 132

Joanne Vidler is the Creative Director at Secret Productions, which produces award-winning festivals Wilderness and the Secret Garden Party.

ENGLISH OAK, KING'S WALDEN, PAGE 136

Aljos Farjon is a world-renowned botanist particularly known for his work on conifers. He carried out much of this work while on the staff of the Royal Botanic Gardens, Kew, and continues with it in retirement as an Honorary Research Associate at Kew. Farjon has also written a number of books including *Ancient Oaks in the English Landscape* and *A Handbook of the World's Conifers*.

ENGLISH OAK, HATFIELD HOUSE, PAGE 140

Lord Salisbury is a Conservative politician. During the 1990s he was Leader of the House of Lords. Lord Salisbury is the owner of Hatfield House, built by Robert Cecil, 1st Earl of Salisbury, in the early 17th century.

HORNBEAM, HATFIELD HOUSE, PAGE 144

Lord Valentine Cecil is Chairman of the Eastern Africa Association and Brookwood. A career military officer with the British Armed Forces, Cecil served in incrementally more responsible positions that included roles within NATO and the Ministry of Defence regarding Europe and Africa.

COPPER BEECH, ESSEX, PAGE 148

Penny Lancaster is a model, photographer, TV personality and special constable. In 2019 Penny joined the Care of Police Survivors (COPS) as a patron of the charity.

ENGLISH OAK, GILWELL PARK, PAGE 152

Dwayne Fields is a presenter, naturalist, adventurer, explorer and OS Get Outside Champion. Fields has been awarded the Freedom of the City of London for his work with young people, and in 2010 he became the first black Briton to walk over 400 miles to the magnetic North Pole.

MAGNOLIA 'LEONARD MESSEL', REGENT'S PARK, PAGE 156

Matthew Williamson is an award-winning interior designer known predominantly for his unique use of pattern and colour. In 2015 he collaborated with Blake's Hotel Kensington to create Hendrick's Horticultural Oasis.

SWEET CHESTNUT, KENSINGTON GARDENS, PAGE 160

Ian Rodger, the Royal Parks arboriculturist, manages the 170,000 native and exotic trees in the parks, taking into account all aspects of biodiversity.

LONDON PLANE, HYDE PARK, PAGE 164

Joanna Lumley, OBE, is an actress and presenter. In addition, she is an advocate and human rights activist for Survival International and the Gurkha Justice Campaign. She supports charities and animal welfare groups, such as Compassion in World Farming and Vegetarians' International Voice for Animals.

MAGNOLIA 'LEONARD MESSEL', ST JAMES'S CHURCH PICCADILLY, PAGE 168

Reverend Lucy Winkett is an Anglican priest, currently Rector of St James's Piccadilly. As well as this, she is a patron of The Quiet Gardens Movement, which nurtures access to outdoor space for prayer and reflection.

MAGNOLIA 'LEONARD MESSEL', HAMPSTEAD HEATH, PAGE 172

Annette and Nick Mason, CBE. Nick is a founder member of the band Pink Floyd and an ambassador for the Roundhouse project in North London, which enables local kids to access mentoring and creative tools related to the performing arts.

MIMOSA, LONDON, PAGE 176

Danny Clarke is a horticulturist and presenter. He regularly co-hosts the BBC's *The Instant Gardener* with Helen Skelton, and he previously presented the BBC's *RHS Chelsea* and *RHS Flower Show Tatton Park*.

ENGLISH OAK, RICHMOND PARK, PAGE 180

Annabel Croft is a former professional British female tennis player and current radio and television presenter.

MONTEZUMA BALD CYPRESS, ROYAL BOTANIC GARDENS, KEW, PAGE 184

Tony Kirkham, MBE, VMH, is the Head of the Arboretum, Gardens and Horticultural Services at the Royal Botanic Gardens, Kew. In 2015 he was awarded Honorary Lifetime fellow of the Arboricultural Association, recognizing the significant and positive impact he has made to arboriculture.

HORNBEAM, BUSHY PARK, PAGE 188

Sara Lom is CEO of The Tree Council. She works with the board, team, volunteers, partners and supporters to get everyone working together for the love of trees. Formerly she was CEO of The Royal Parks Foundation.

ENGLISH OAK, ADDLESTONE, PAGE 192

Juliet Sargeant is a presenter and award-winning garden designer. In 2016 her design, The Modern Slavery Garden, was the first show garden by a female black gardener to be exhibited at the Chelsea Flower Show, where it won an RHS gold medal and was voted the winner in the BBC's People's Choice Award.

ENGLISH OAK, HARPSDEN, PAGE 196

Max Gottschalk is the co-founder and CEO of Vedra Partners. Gottschalk is also the co-founder of Ocean 14 Capital, an investment fund that works in collaboration with the UK's Blue Marine Foundation to invest in sustainable ocean businesses.

BLUEBELL WOOD, DIPPLE WOOD, PAGE 200
Anabel Cutler is a freelance editor, brand consultant and journalist. Her writing has featured in a number of publications including *House & Garden*, the *Telegraph* and the *Daily Mail*.

ASH & ENGLISH OAK, HIGH WOOD, PAGE 204
Professor John Rogerson is an advisor to the Institute of Complementary Medicine UK, co-founder of The Centre for Human Energy Field Research and a Professor at the Zoroastrian College. Rogerson is an ambassador for the World Peace Centre and an environmental campaigner.

ENGLISH OAK, WINDSOR GREAT PARK, PAGE 208
Dr George McGavin is a zoologist, author and broadcaster. McGavin was the presenter of BBC4's *Oak Tree: Nature's Greatest Survivor* and multi award-winning *After Life: The Science of Decay*. Acknowledged as an engaging and entertaining speaker, he regularly speaks to audiences about insects, ecology, evolution and conservation.

MOUNT FUJI CHERRY, RHS GARDEN, WISLEY PAGE 214
Jim Gardiner, VMH, Vice President (RHS). Formerly Director of Horticulture and Chief Curator for all RHS Gardens. Prior to this, he was Curator at Wisley for 22 years and Curator at the Sir Harold Hillier Gardens. He is a trustee of TROBI (Tree Register of the British Isles) and Borde Hill Garden.

COPPER BEECH, SUSSEX, PAGE 218
Olga Polizzi, CBE, is a British hotelier and interior designer. She is the Deputy Chairman and Director of Design of Rocco Forte Hotels, which comprises hotels worldwide including Brown's in London, the Savoy in Florence and Tresanton in Cornwall.

TURKEY OAK, SURREY BORDERS, PAGE 222
His Honour Timothy Stow QC is retired from a career as a successful barrister and judge. He, together with his wife Alison, continue to personally manage their 30-acre smallholding, over half of which is woodland. They have been doing this in a totally organic and low impact way since 1975.

Richard Stow is a financial entrepreneur. He moved to the property when he was six and pretends to have been of great assistance with its management. Certainly, he (and his daughters) still play and find peace in the beautiful old woodlands, which have had a fundamental impact on his whole approach to life.

CHUSAN PALM, OSBORNE HOUSE, PAGE 226
Alan Titchmarsh, MBE VMH DL, is a gardener, writer, broadcaster, poet and best-selling novelist. He has presented such varied BBC programmes as *British Isles: A Natural History*, *Ground Force*, *Gardeners' World*, coverage of The Proms and The Chelsea Flower Show and can currently be seen on ITV in *Love Your Weekend* and *Love Your Garden*. He presents the Classic FM Saturday breakfast show and gardens in Hampshire and the Isle of Wight.

ENGLISH OAK, NEW FOREST, PAGE 230
Jori White founded her eponymous PR agency in 1995 and has since worked for clients all over the world. She has been actively involved in environmental issues for many years, long before it became fashionable to do so. In 2008, she launched Acorn House, London's first truly eco-friendly training restaurant. Since then she has worked on a number of similar campaigns, most recently the 2021 openings of Middle Eight and The Guardsman, two hotels whose desire it is to drive a more engaged, responsible and purposeful era. For the last five years, *PR Week*'s *UK Power Book* has named Jori one of the top five most influential players in the luxury and hospitality fields.

ENGLISH OAK, HINTON, PAGE 234
Josephine Hedger is an arborist and founder of Arbor Venture Tree Care. As well as this, Josephine is a four-time World Tree Climbing Champion and five-time European Tree Climbing Champion.

CEDAR, HIGHCLERE CASTLE, PAGE 238
Lord Carnarvon is a British peer and arable farmer. His family seat, Highclere Castle, has achieved notability as the primary filming location for the television series *Downton Abbey*.

FIELD MAPLE, OLD WARDOUR CASTLE, PAGE 242

Izzy Winkler is a transformational coach and co-founder of eco-retreat West Lexham. Inviting clients to build a deeper connection with nature is a non-negotiable part of the healing process. The shift that occurs when we learn to see ourselves as a part of, rather than independent from, nature makes the difference between blind consumerism and conscious choices.

COPPER BEECH, NEW WARDOUR CASTLE, PAGE 246

Jasper Conran, OBE, is a British designer and hotel owner. Throughout his career Jasper has diversified from womenswear into menswear, collections for the home and performing arts. In 2008 Conran received an OBE for his services to retail, and in 2010 his debut book *Country* was published, a photographic and written portrait of a year in the English countryside.

SYCAMORE, BURROW HILL, PAGE 250

Alice Temperley, MBE, is a fashion designer based in London. Her fashion label, Temperley London, was launched in 2000.

COMMON BEECH, WINTERBORNE VALLEY, PAGE 254

Dominic Prince is a freelance journalist, author and documentary maker. He regularly writes for the *Guardian*, *Telegraph*, *Spectator* and *The Sunday Times*.

Rose Prince is a food writer, author, cook and activist. She has a weekly column in the *Daily Telegraph*, and she has also contributed to the *Daily Mail*, the *Spectator* and *The Times*. Her published works include *The New English Kitchen: Changing the Way You Shop, Cook and Eat*, published in 2015, and *Dinner & Party: Gatherings. Suppers. Feasts*, published in 2017.

YEW, CRANBORNE CHASE, PAGE 258

Ned Cecil is an explorer and resident of Cranborne Manor Estate in Dorset.

ENGLISH OAK, WOODEND PARK, PAGE 264

Dr Jill Butler is an ancient tree, forest and wood pasture specialist. In 2020 Butler was the winner of the Arboricultural Association Award for her significant and positive contribution to the arboricultural profession.

ENGLISH OAK, PERRIDGE HOUSE, PAGE 268

Sir Harry Studholme is a forester, businessman and owner of Perridge House. He is Chairman of the Forestry Commission, which manages the UK's state-owned forests and is the country's largest land manager. In 2012 Studholme co-conducted the Independent Forestry Panel report on the future of the UK's state-owned forests after the government announced plans to sell off the British state forests.

BLACK WALNUT, ANTONY HOUSE, PAGE 272
CORK OAK, ANTONY HOUSE, PAGE 278

Sir Richard Carew Pole became President of the Royal Horticultural Society in 2001 after having been elected to the Council of the RHS in 1999. He currently sits on the Floral 'B' Committee, which advises on hardy trees and shrubs, and the Gardens Committee, which agrees plans for the development and maintenance of the RHS gardens.

Lady Carew Pole is the past President of the Royal Cornwall Show.

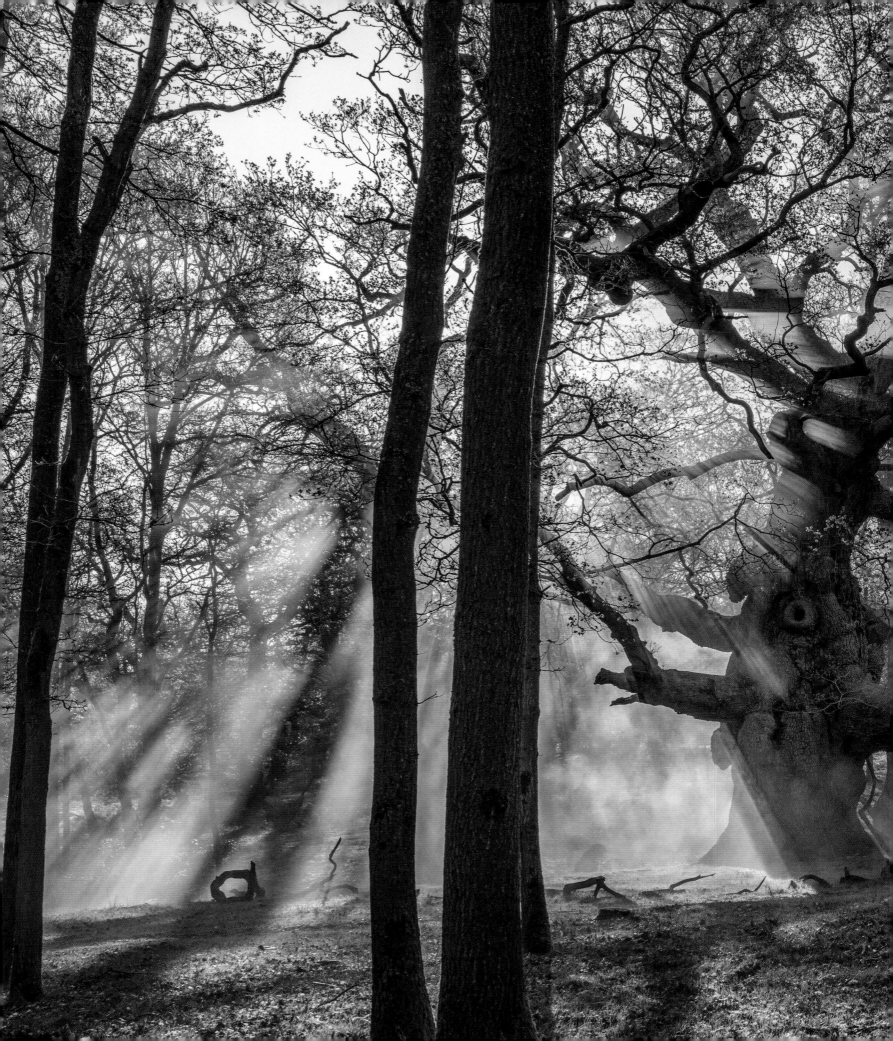

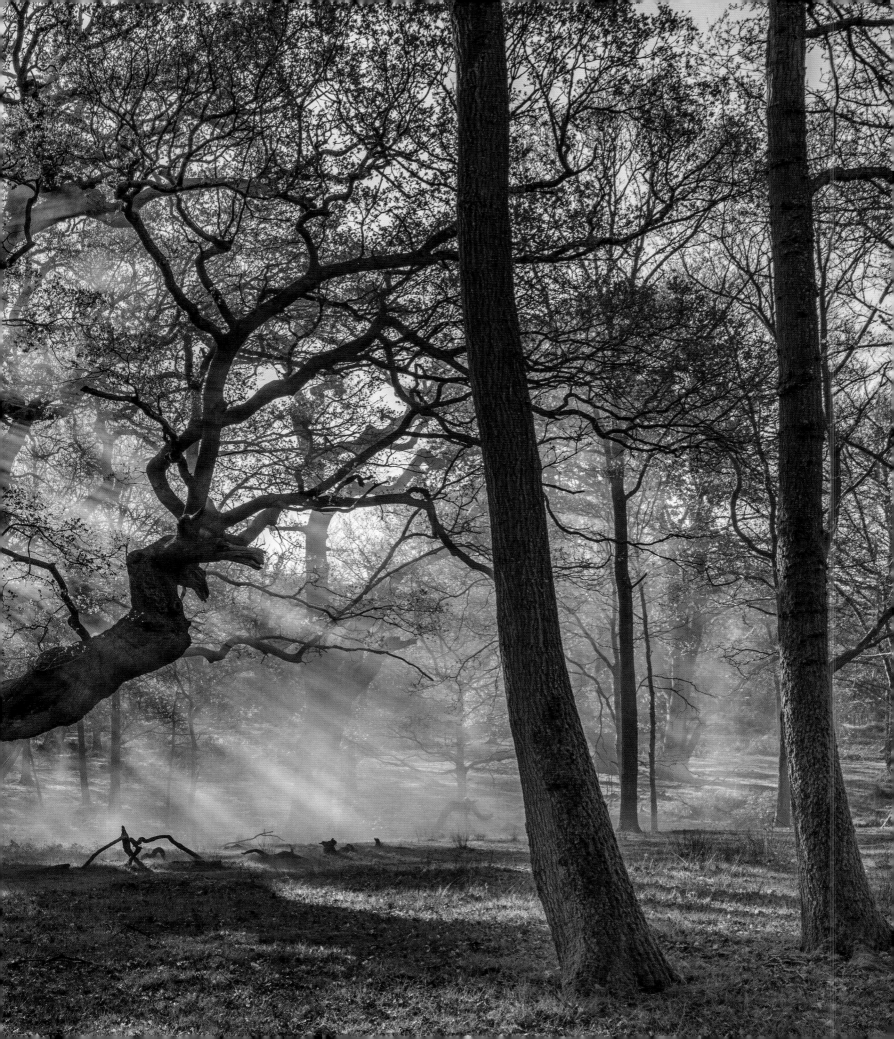

FEATURED LOCATIONS

ALLADALE WILDERNESS RESERVE
Ardgay
Sutherland
IV24 3BS
Telephone: 01863 755338
Website: www.alladale.com

—

Alladale has three fully catered lodges available for hire for exclusive use for groups of between 2 and 30 guests.

ANTONY HOUSE
Torpoint
Cornwall
PL11 2QA
Telephone: 01752 812191
Website: www.nationaltrust.org.uk/antony

—

Antony is a National Trust property and is open to visitors at selected periods during the year.
Please see the website for further details.

BUSHY PARK
Middlesex
TW12 2EJ
Telephone: 0300 061 2250
Website: www.royalparks.org.uk/parks/bushy-park

—

Bushy Park is open to visitors 24 hours a day, all year round, except during September and November, when pedestrian gates open at 8am and close at dusk, Monday–Friday.

CHIRK CASTLE
Chirk
Wrexham
LL14 5AF
Telephone: 01691 777 701
Website: www.nationaltrust.org.uk/chirk-castle

—

The castle and gardens are open to visitors between March and October

COLESBOURNE GARDENS
Colesbourne
Nr Cheltenham
Gloucestershire
GL53 9NP
Telephone: 01242 870567
Website: www.colesbournegardens.org.uk

—

The gardens at Colesbourne are open to visitors on specific open days throughout February for the snowdrop season. Private guided tours of the gardens and arboretum can be booked throughout the year on enquiry.

DAYLESFORD ORGANIC FARM
Near Kingham
Gloucestershire
GL56 0YG
Telephone: 01608 731 700
Website: www.daylesford.com

—

Daylesford Organic Farm is open to visitors daily and amenities include an award-winning farmshop & café, cookery school, wellness spa, cottages to rent, a dedicated workshop space, as well as over 2,000 acres of farmland to explore.

DINEFWR CASTLE
Llandeilo
SA19 6RT
Website: www.cadw.gov.wales/visit/places-to-visit/dinefwr-castle

—

The castle ruin is open daily for visitors.

GREAT TEW ESTATE
The Estate Office
Quarry Farm
Great Tew
Chipping Norton
OX7 4BT
Telephone: 01608 683636
Website: www.greattewestate.com/explore

—

There are a number of walks around the estate at Great Tew that can be accessed by the public. Further details and maps can be found online: greattewestate.com/the_estate/walks

HADDON HALL
Bakewell
Derbyshire
DE45 1LA
Telephone: 01629 812 855
Website: www.haddonhall.co.uk
—

Open daily between April and October.

HAMPSTEAD HEATH
London
Telephone: 020 7332 3322
Website: www.cityoflondon.gov.uk/things-to-do/green-spaces/hampstead-heath
—

There is free access to Hampstead Heath 24 hours a day, 7 days a week, all year round.

HATFIELD HOUSE
Hatfield
Hertfordshire
AL9 5HX
Telephone: 01707 287010
Website: www.hatfield-house.co.uk
—

The house and gardens are open for visitors at certain times of the year. For further information and details check the website.

HELMINGHAM HALL GARDENS
Stowmarket
Suffolk
IP14 6EF
Telephone: 01473 890799
Website: www.helmingham.com/the-gardens
—

The gardens along with the deer park are open for visitors between May and September.

HIGHCLERE CASTLE
Highclere Park
Newbury
RG20 9RN
Telephone: 01635 253204
Website: www.highclerecastle.co.uk
—

The castle, gardens and grounds are open to the public at selected times during the year. There are also a number of public footpaths open throughout the year in the park. See the website for further details.

HYDE PARK
London
W2 2UH
Telephone: 0300 061 2114
Website: www.royalparks.org.uk/parks/hyde-park
—

The park is highly accessible via public transport and open all year round.

KENSINGTON GARDENS
London
W2 2UH
Telephone: 0300 061 2000
Website: www.royalparks.org.uk/parks/kensington-gardens
—

The gardens are open daily from 6am, all year round. Closing times vary throughout the year.

KIMBERLEY HALL
Wymondham
Norfolk
NR18 0RT
Email: events@kimberleyhall.co.uk
Website: www.kimberleyhall.co.uk
—

Kimberley Hall provides an exclusive and private environment for events of all natures.

LE MANOIR AUX QUAT'SAISONS, A BELMOND HOTEL
Church Road
Great Milton
Oxford
OX44 7PD
Telephone: 01844 278881
Website: www.belmond.com/hotels/europe/uk/oxfordshire/
belmond-le-manoir-aux-quat-saisons
—

Reservations can be made to enjoy dining, overnight stays
or cookery school courses.

NEW FOREST
Hampshire
Website: www.thenewforest.co.uk
—

The New Forest is free to access all year round, and
information point, maps and guides can all be found
on the website.

OLD WARDOUR CASTLE
Nr Tisbury
Salisbury
Wiltshire
SP3 6RR
Telephone: 01747 870487
Website: www.english-heritage.org.uk/visit/places/
old-wardour-castle
—

An English Heritage property, Old Wardour Castle is
open to the public at selected times throughout the year.
See the website for further details.

OSBORNE HOUSE
York Avenue, East Cowes
Isle of Wight
PO32 6JT
Website: www.english-heritage.org.uk/visit/places/osborne/
—

Osborne House is open to visitors daily from 10am–5pm.

RAVENINGHAM GARDENS AND TEA ROOMS
Norwich
NR14 6NS
Telephone: 01508 548480
Website: www.raveningham.com
—

The gardens at the Raveningham Estate are usually open for
visitors from 11am–4pm from February to September.

REGENT'S PARK
London
NW1 4NR
Telephone: 0300 061 2300
Website: www.royalparks.org.uk/parks/the-regents-park
—

The park is free to access and the park's pedestrian gates are
open from 5am all year round. Closing times vary depending
on the season and further information can be found on the
website.

RICHMOND PARK
London
TW10 5HS
Telephone: 0300 061 2200
Website: www.royalparks.org.uk/parks/richmond-park
—

Richmond Park is open all year round and pedestrian
gates are open 24 hours except during the deer cull in
November and February, when gates open at 7.30am
and close at 8pm.

RHS GARDEN, WISLEY
Woking
Surrey
GU23 6QB
Telephone: 01483 224234
Website: www. rhs.org.uk/wisleywhatson
—

Open daily (except 25th December). See website rhs.org.uk/
gardens for further details.

ROYAL BOTANIC GARDEN EDINBURGH
Arboretum Pl
Edinburgh
EH3 5NZ
Telephone: 0131 248 2909
Website: www.rbge.org.uk
—

The garden is open daily except 25 December and
1 January.

ROYAL BOTANIC GARDENS, KEW
Richmond
London
TW9 3AE
Telephone: 020 8332 5655
Website: www.kew.org
—

The gardens are usually open between 10am and 5pm
or 6pm daily depending on the season.

SHERWOOD FOREST NATIONAL NATURE RESERVE
Edwinstowe
Nottinghamshire
NG21 9RN
Telephone: 01623 677321
Website: www.visitsherwood.co.uk
—

The forest can be accessed all year round. The visitor centre
is open 10am–5pm from March to October and 10am–4.30pm
from November to the end of February.

ST JAMES'S CHURCH PICCADILLY
197 Piccadilly
London
W1J 9LL
Telephone: 020 7734 4511
Website: www.sjp.org.uk
—

The garden at St James's is open to visitors throughout
the year from 8am to 6.30pm

WESTBURY COURT GARDEN
Westbury-on-Severn
Gloucestershire
GL14 1PD
Telephone: 01452 760 461
Website: www.nationaltrust.org.uk/westbury-court-garden
—

The garden is usually open Wednesday to Sunday at selected
times throughout the year. See website for further details.

WINDSOR GREAT PARK
Telephone: 01753 860 222
Website: www.windsorgreatpark.co.uk
—

The park is open daily from dawn until dusk.

INDEX

ABOUT THE AUTHOR

Adrian Houston is known for his warm, atmospheric photographs that fire the imagination. Adrian's work has been exhibited around the world including at The National Gallery and The Royal Academy of Arts. Adrian's passion is conservation. His work has seen him travel to some of the world's most unexplored and inhospitable terrains, with his powerful photographs subsequently gracing everything from fine art to advertising campaigns. In addition, the stunning images that resulted from him witnessing the eruption of Mount Kilauea on Hawaii's Big Island were used to memorable effect in one of the Discovery Channel's highest rating documentaries, *Discovery People*.

IMAGE ON P2: The ancient Knights Templar Cedar of Lebanon at Fordell Castle, Scotland

IMAGE ON P4–5: An ash grove, Gunnerside, North Yorkshire

IMAGE ON P8: Flora in Glen Alladale, Scotland

IMAGE ON P13: Weeping oak at Balnagown Castle, Scotland

IMAGE ON P14–15: Limes trees planted by W.E. Gladstone at Dalmeny House, Scotland

IMAGE ON P292-3: Ancient oak in Windsor Great Park, Berkshire

IMAGE ON P298-9: Pine forest in the Moorfoot Hills, Rosebery Estate, Scotland

IMAGE ON P303: Rocket Houston, our West Highland Terrier, posing with an ash tree in Dorset

Published in association with Action Oak

First published in Great Britain in 2021 by Greenfinch
An imprint of Quercus Editions Ltd
Carmelite House
50 Victoria Embankment
London EC4Y 0DZ

An Hachette UK company

A CIP catalogue record for this book is available from the British Library

HB ISBN 978-1-52941-258-1
ebook ISBN 978-1-52941-259-8

10 9 8 7 6 5 4 3 2 1

Design by Sarah Pyke

Printed in China

FSC
www.fsc.org
MIX
Paper from responsible sources
FSC® C016973

Papers used by Greenfinch are from well-managed forests and other responsible sources.